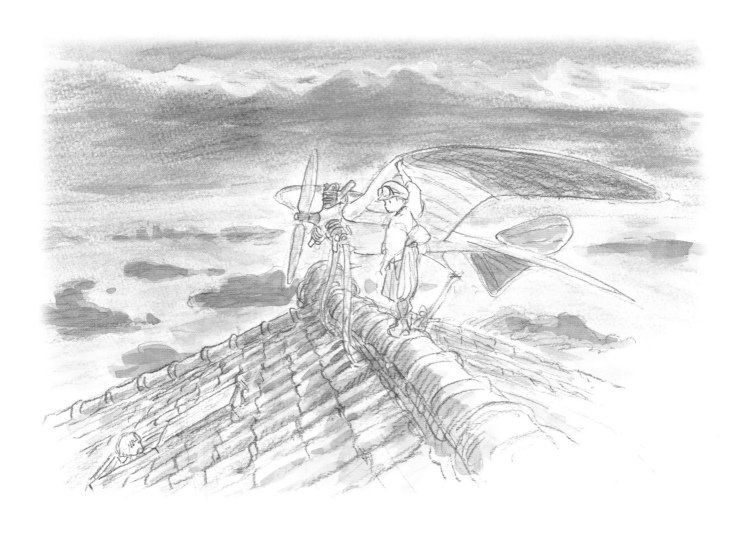

THE WIND RISES

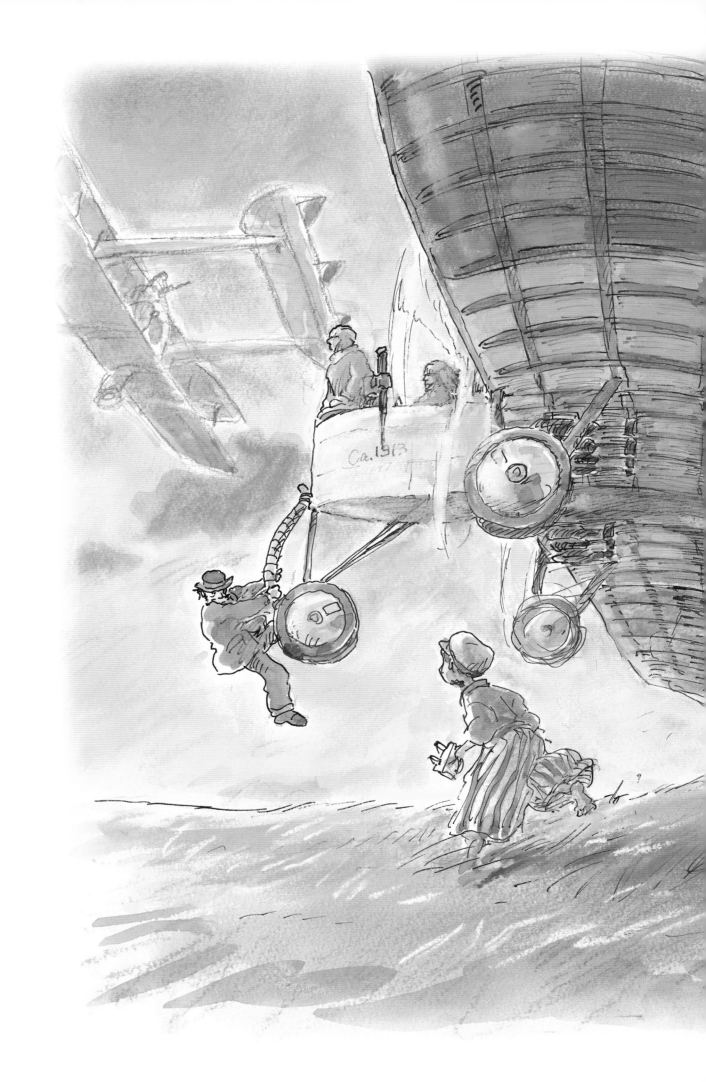

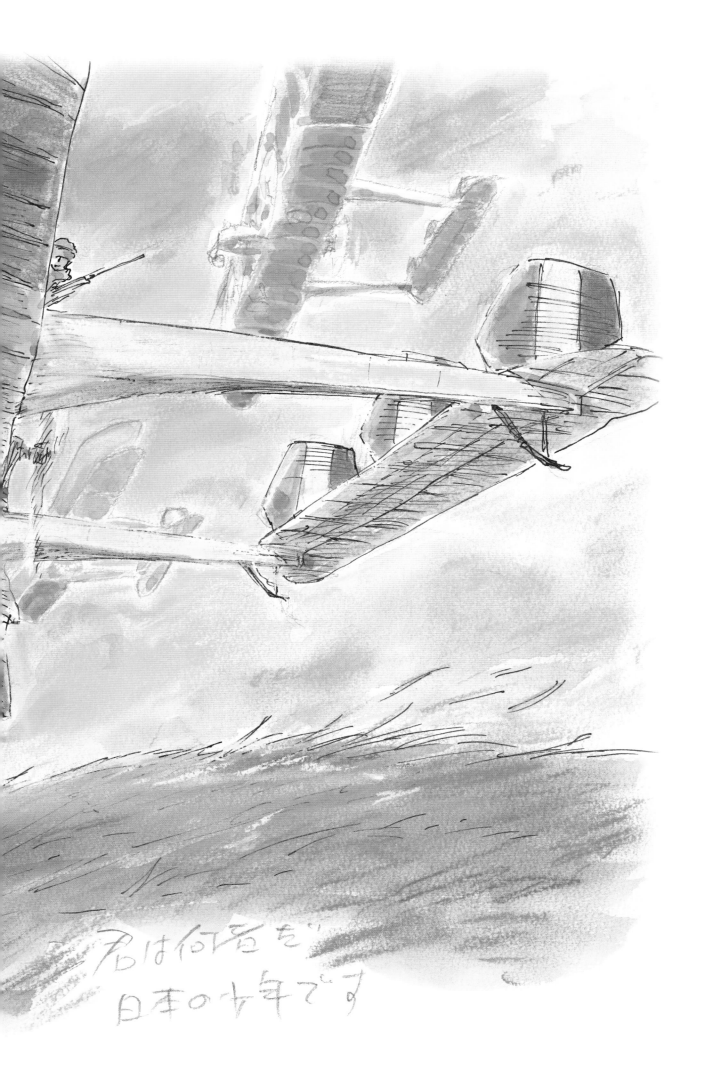

君は何者を
ですか。日本四十年です

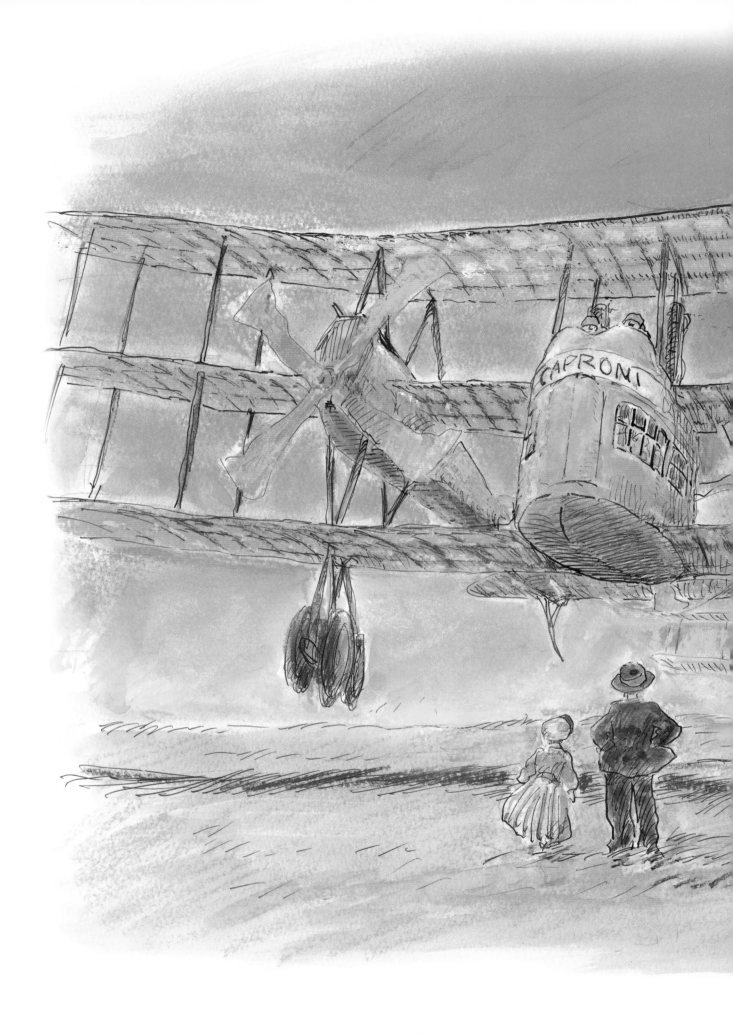

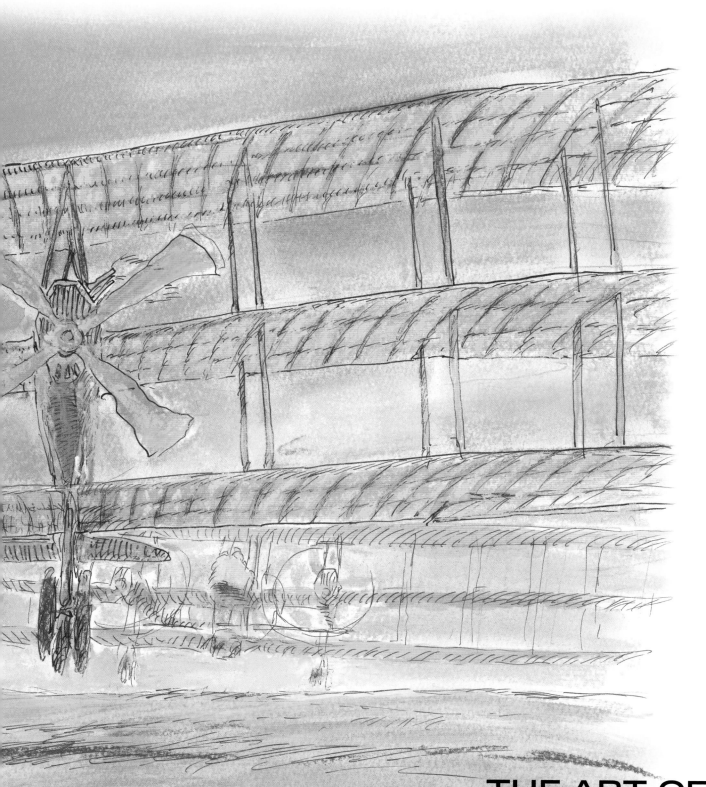

THE ART OF
THE WIND RISES

㊀ 北重ですね

㋕ 美しかろう

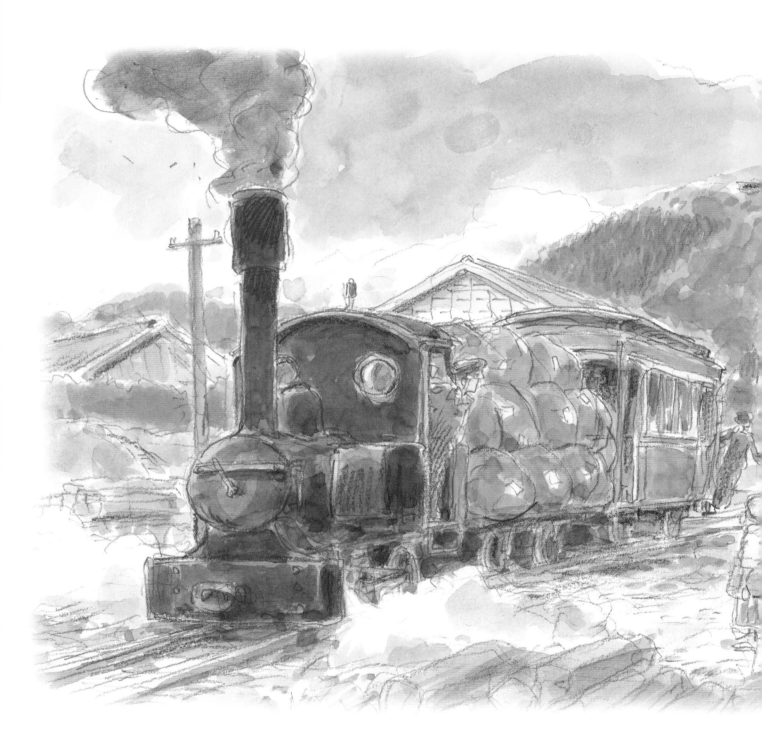

P1/Jiro and the bird-shaped plane on the roof, from the initial dream sequence. His younger sister Kayo poking her head out from the door was in the initial concept art, but not in the film. [Concept sketch]
P2, 3/The scene where Jiro and Caproni meet in the dream. [Concept sketch]
P4, 5/One after another, the planes Caproni is so proud of appear before Jiro, who is deeply moved. [Concept sketch]
P6/Near the train crossing at the station the tiny train passes on the narrow gauge railway, from Jiro's route to school. [Concept sketch]

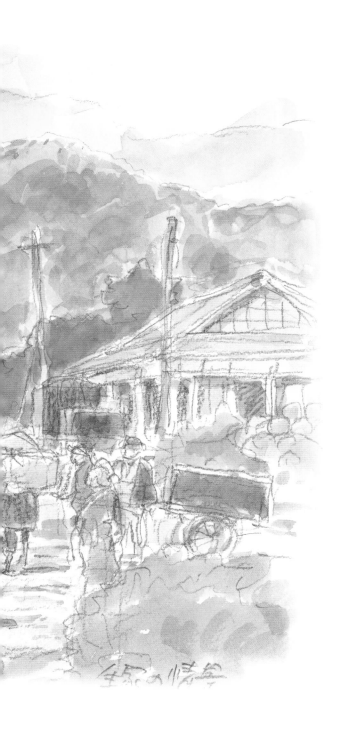

Contents

*Jiro's age includes estimates for some parts.

About this book

This collection of concept sketches, concept art, backgrounds, character and machine designs, and film stills done at the time of the film's production follows the story of Studio Ghibli's animated film *The Wind Rises*. All concept sketches and machine designs are by director Hayao Miyazaki; concept art and backgrounds by the art staff are supervised by art director Yoji Takeshige; and character design is by supervising animator Kitaro Kosaka. In some cases, part of the background was drawn on a transparent cel or a separate piece of paper and overlaid; the former is referred to as a "background + cel book" and the latter as "background + book." Line drawings on cels with texture and color added are called "harmonies." Airplane designs are based on actual planes with details and colorings changed and arrangements added by director Hayao Miyazaki. Images with no other notes are stills from the film.

References
Kaze Tachinu/Utsukushii Mura (The Wind Rises/Beautiful Village, Tatsuo Hori/Shinchosha Publishing)
Reisen no Isan (Heritage of the Zero, Jiro Horikoshi/Kojinsha NF Bunko)
Reisen Sekkeisha ga Kataru Kessakuki no Tanjo
(Birth of a Masterpiece: The Designer Tells the Story of the Zero, Jiro Horikoshi with Masatake Okumiya/Gakken M Bunko)
Nihonkokuki Daizukan 1910–1945
(Illustrated Encyclopedia of Japanese Aircraft 1910–1945, Toshihiko Ogawa/Kokushokankokai)
Aeroplani Caproni: Gianni Caproni and His Aircraft 1910–1983
(Rosario Abate, Gregory Aleqi, Giorgio Apostolo/Museo Caproni)
Ketteiban: Nihon no Jokikikansha
(Definitive Edition: Japanese Steam Locomotives, Koichi Miyazaki/Kodansha)
Shitetsu no Sharyo 2: Odakyu Dentetsu
(Private Railways 2: Odakyu Legends, Iwo Iijima, Ikuo Oyama, Hisashi Morokawa/Neko Publishing)

Project Proposal by Director Hayao Miyazaki
Airplanes Are Beautiful Dreams

Zero plane designer Jiro Horikoshi and his Italian forerunner Gianni Caproni are two men pursuing a common aspiration, bonded by friendship across time and space. The two overcome numerous failures, devoting themselves to realizing their boyhood dreams.

In Japan's Taisho era (1912–1926), a country boy decides to become an aircraft designer. He dreams of building a plane that flies like the beautiful wind.

As a young man he goes off to college in Tokyo, becoming an elite engineer in the huge defense industry. His talent blooms and he ultimately creates a beautiful airplane, one that will leave its mark on aviation history—the Mitsubishi A6M1, later to become the Navy Type 0 Carrier Fighter, better known as the Zero fighter. For three years from 1940, the Zero fighter was the world's finest warplane.

From his boyhood to his youth, the years during which our main character lives are weighed down by a sense of stagnation more intense than the one hanging over Japan today: the Great Kanto Earthquake of 1923, the Great Depression, unemployment, poverty and tuberculosis, revolutions and fascism, suppression of free speech, one war after another. Meanwhile, popular culture flowered; modernism and nihilism, as well as hedonism, were prevalent. Poets fell prey to illness and death in their journeys.

Our protagonist Jiro engaged in airplane design at a time when the Empire of Japan was heading to its destruction and ultimate fall. Yet the intention of this film is not to condemn war, nor is it about stirring up young Japanese with the excellence of the Zero fighter. I have no plans to defend our lead character, such as by saying that he actually wanted to make civilian aircraft.

I want to portray a devoted individual who pursued his dream head-on. Dreams possess an element of madness, and such poison must not be concealed. Yearning for something too beautiful can ruin you. Swaying toward beauty may come at a price. Jiro will be battered and defeated, his design career cut short. Nonetheless, Jiro was an individual of preeminent originality and talent. This is what we will strive to portray in this film.

The title *The Wind Rises* comes from a novel of the same name, written by Tatsuo Hori. Hori took a line from Paul Valéry's poem, "Le vent se lève, il faut tenter de vivre," and translated it into Japanese: *Kaze tachinu, iza ikimeyamo* (The wind is rising! We must try to live). Our film combines Jiro Horikoshi and writer Tatsuo Hori, two actual people of the same era, into one person as "Jiro," our central character. It will be an unusual work of complete fiction that depicts the youth of the 1930s. Our story will be woven using the birth of the later-mythicized Zero fighter as our warp, and the meeting and parting of young engineer Jiro and the beautiful, ill-fated girl Nahoko as our weft. Our good ol' Caproni, transcending time and place, will be there to add some color to the story's fabric.

Hayao Miyazaki

Animated film director. Born 1941, Tokyo. After graduating from Gakushuin University's Faculty of Political Science and Economics in 1963, he began work at Toei Doga (currently Toei Animation). In 1985, he became a founding member of Studio Ghibli. Representative works include *Nausicaä of the Valley of the Wind* (1984), *Castle in the Sky* (1986), *My Neighbor Totoro* (1988), *Princess Mononoke* (1997), *Spirited Away* (2001), *Howl's Moving Castle* (2004), and *Ponyo* (2008). *Spirited Away* won the Golden Bear at the 52nd annual Berlin International Film Festival and Best Animated Feature at the 75th Academy Awards, and Miyazaki received the Golden Lion for Lifetime Achievement at the 62nd Venice International Film Festival. In 2012, he was selected as a Person of Cultural Merit. He was also responsible for the original concept, planning, and production of the Ghibli Museum, which opened in Mitaka in 2001, and he serves as the building's manager.

Characters

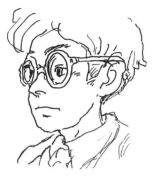

Jiro in his thirties

Jiro Horikoshi (boyhood to middle age)

The film's protagonist is deeply dry, wildly enthusiastic, extremely focused, individualistic, overly self-confident, roiling with realism and idealism, and devoted to freedom, but also brings an extreme calm and clarity to this mix. Stylish and gallant, slightly shy, he carries himself lightly and has a politeness that endears him to others.

There is also something about him reminiscent of the poet Michizo Tachihara, who died young.

He loves the books of Thomas Mann and Hermann Hesse and listens to Schubert. His peers within the large military supply organization recognize his talents, and as he moves through life he always has in his heart a burning ambition to build beautiful planes.

Older Gianni Caproni

A creator of airplanes known around the world and active from the dawn of the Italian aviation industry until the 1930s, Caproni appears in Jiro's dreams as someone who inspires and advises Jiro; he is also the mouthpiece for Jiro's interior. This man does not age.

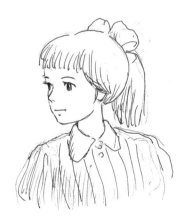

Nahoko

A beautiful, cheerful girl, she is riding on the same train as Jiro at the time of the Great Kanto Earthquake. Ten years later, she encounters Jiro again in a fateful meeting and they fall in love. She is sick with tuberculosis. The girl's name comes from Tatsuo Hori's masterwork, *Nahoko*.

Notes on the Film's Look

I want to paint Japan's verdant landscape from the Taisho era to the early Showa era with utmost beauty. The skies then were still clear with lofty white clouds. Water flowed clearly. No litter was to be found in the countryside. On the other hand, poverty was widespread in the cities. I don't want to obscure architecture by using sepia tones; thus we will be bold with East Asian colors of modernism. Roads are bumpy and uneven. Shop signs and billboards line up chaotically. Jumbles of wooden utility poles are everywhere.

This film needs to be a kind of biography of the protagonist's boyhood, youth, and middle years, but a designer's daily life would most likely be quite uneventful. Thus, bold cuts and jumps in time are inevitable, while minimizing the audience's confusion. The film probably will be an interweaving of three types of imagery:

Daily life scenes will be an accumulation of quiet and plain moments.

The dream sequences will be much more free and sensual: swaying time and weather, rolling terrains, and flying objects floating with ease. The dreams will embody the obsessive singular focus of Caproni and Jiro.

Technical explanations and meetings will be caricatured. I have no interest in showcasing facts and trivia about aviation technology, but when needed, they will be presented in a bold, cartoony style. The malady of this type of cinematic work is too many meeting scenes, with individual fates decided in the meeting room. Our work will not have any such scenes. Meetings will be depicted only when absolutely necessary, as cartoons and without dialogue. Our attention will be directed toward the portrayal of people.

I want to create something that is realistic,
 fantastic,
 at times caricatured,
 but as a whole, a beautiful film.

2011, 1, 10 宮崎 駿

January 10, 2011 Hayao Miyazaki

Translation for Project Proposal by Director Hayao Miyazaki and Notes on the Film's Look: Rieko Izutsu-Vajirasarn

Introduction

The Wind Rises is Studio Ghibli's eighteenth animated theatrical feature and director Hayao Miyazaki's first effort in five years, since 2008's *Ponyo*.

The film depicts the life of aircraft designer and engineer Jiro Horikoshi from the age of thirteen to the age of forty–two. It takes as its background the thirty tumultuous years from 1916 to 1945, including World War I, the Great Kanto Earthquake, the Great Depression, the Manchurian Incident, and then World War II.

The protagonist, Jiro Horikoshi, is a character combining the essences of the designer and engineer Jiro Horikoshi—creator of the Zero (Type 0 Carrier Fighter), a famous machine that later made its mark in the history of aviation—and Tatsuo Hori, a man of letters who lived at the same time. Although this protagonist has many experiences and ends up in pieces in the story, which incorporates that of the Tatsuo Hori novel *The Wind Rises*, the film portrays a character who tries to live each day as though it were a precious gift. This is the first time a Studio Ghibli animated theatrical feature has modeled a character after real people.

But it is not only real people in the film; characters from the novel and characters Hayao Miyazaki created for the film also appear for charming scenes in a film that allows these fictional characters to share the stage with real people.

Nahoko, the love of Jiro's life whom he meets during the Great Kanto Earthquake, is the heroine from Tatsuo Hori's novels *The Wind Rises* and *Nahoko*. She is depicted as a woman who lives a short, beautiful life.

Caproni, who occasionally appears in Jiro's dreams to motivate and listen to him, is modeled after the real-life Gianni Caproni, the Italian aeronautical engineer who was active before and after World War I.

Castorp, who plays the role of cupid in uniting Jiro and Nahoko, borrows his name from Hans Castorp, the protagonist of *The Magic Mountain*, the well-known work by German writer Thomas Mann. Castorp's face and voice performance are from the real-life Steve Alpert, who worked in Studio Ghibli's overseas operations. He is a most unique character, a blend of fact and fiction.

Production for *The Wind Rises* started in 2008, with Hayao Miyazaki conceiving of a manga with Zero designer Jiro Horikoshi as the protagonist. The manga was serialized in the monthly magazine *Model Graphix* (Dainipponkaiga) in 2009 under the title *The Wind Rises*, with a total of nine chapters, from April until January 2010.

In the summer of 2010, producer Toshio Suzuki proposed that this manga be made into a film as a new production for a theatrical release, but Hayao Miyazaki opposed the idea, saying that the manga reflected his own personal tastes and wasn't suitable for adaptation into a movie. However, after several conversations with Suzuki, he refined and rewrote the material toward adaptation into a film, and the production was approved on December 28.

"The Wind Rises: Interim Report," issued immediately before this decision on December 21, shows the directionality for setting up production:

Mix Jiro Horikoshi and Tatsuo Hori to portray a completely fictional youth in the 1930s with the warp of the birth of the legendary Zero and the weft of the young engineer Jiro and his meeting with and separation from the beautiful, unfortunate girl Nahoko.

The real Horikoshi appears to have been a balanced, gifted man with a certain charisma as a member of his organization, but in this film, I'd like to make a character with a more complex personality...

The story begins with the fateful meeting of this Jiro and a girl. His love for the girl is both sweet and, at the same time, cursed by the earthquake, causing Jiro to suffer. The girl is afflicted with the untreatable disease tuberculosis. All of Jiro's passion, effort, and devotion cannot save her from this terrible illness; there exists an uncrossable chasm between those who will live and those who will die. The designer of cutting-edge fighter planes does not even have anywhere near enough time just to enjoy life with the girl. Perhaps right from the start, they are unable to live together...

It's the story of young people doing everything they can to live in the 1930s, an era of recession, unemployment, hedonism and nihilism, war, disease, poverty, modernism and backlash, a march toward the ruin of a stumbling and falling empire.

Can we even make an animated film like this...

At the end of the report, two directions toward a film adaptation were noted. The first followed the flow of the manga, featuring Caproni, leaping through space and time, and exaggerating the portrayal of the airplanes in the style of an animated film. The second was a more serious creation, in which Caproni did not appear, depicting Jiro and Nahoko falling in love, a heavy melodrama colored by Tatsuo Hori. These two directions were like water and oil, making a fusion impossible, and tell the story of how Hayao Miyazaki struggled, pressed for a final choice on which way the film would go.

Miyazaki chose the former, and the project proposal (printed on pages 8 and 9) was completed in January 2011. He began drawing the storyboards. Part A, corresponding to about one-fourth of the total film, was completed in May of that same year. The day after he finished drawing the Great Kanto Earthquake scene in the middle of writing part A, the 3/11 Tohoku earthquake and tsunami struck.

The main staff on the film consisted of supervising animator Kitaro Kosaka, who worked on "Mr. Dough and the Egg Princess" (created, written, and directed by Hayao Miyazaki), an animated short for the Ghibli Museum in 2010; art director Yoji Takeshige; color designer Michiyo Yasuda; and Atsushi Okui as director of photography; with Joe Hisaishi joining the crew again for the music.

The storyboards were completed in January 2013. In May of the same year, the animation and artwork was complete. The final number of shots was 1,450, with 161,545 frames of animation, for a running time of 126:35:14. The film then had its first preview screening on June 19 and was released in theaters across Japan on July 20.

A Tribute to Jiro Horikoshi and Tatsuo Hori

Provided by Fujioka Historical Museum

Jiro Horikoshi

Born in Gunma in 1903, Horikoshi entered the Aviation Division in the Department of Engineering at Tokyo Imperial University after graduating from Daiichi High School. Graduating from both high school and university at the head of his class, he then went to work at Mitsubishi Internal Combustion Engine Company (currently Mitsubishi Heavy Industries) and was involved in the design of fighter planes. In 1932, at the age of 29, he designed the Mitsubishi 1MF10 fighter. In 1934, he was responsible for the prototype design for the Mitsubishi B4M1 carrier attack plane, the pinnacle of aeronautic performance in the world at the time. He later designed the Mitsubishi A5M, A6M2 Type 0 Model 21, A6M5 Type 0 Model 52, A6M5 Type 0 Model 54, J2M Raiden, and A7M Reppu, among others. After the war, he was also involved in designing the YS-11 civilian craft. Following his retirement from Mitsubishi, he worked as a lecturer at the Institute of Space and Aeronautics at the University of Tokyo, as a professor at the National Defense Academy, and a professor at Nihon University. He passed away in 1982 at the age of 78. His writings include *Eagles of Mitsubishi: The Story of the Zero Fighter* (Kadokawa Shoten) and *Reisen no Isan* (Kojinsha NF Bunko).

Provided by the Museum of Modern Japanese Literature

Tatsuo Hori

Born in Tokyo in 1904, he faced the Great Kanto Earthquake and lost his mother when he was 18 and still a student at Daiichi High School. While attending Tokyo Imperial University in the Japanese Literature Department, he was involved with small literary journals and exchanged ideas with Ryunosuke Akutagawa, Saisei Murou, Shigeharu Nakano, Tsurujiro Kubokawa, Hideo Kobayashi, and Tatsuo Nagai. In 1930, at the age of 25, he published his first work, *The Holy Family*. He suffered from tuberculosis and often received treatment at Karuizawa. In 1933, he met Ayako Yano there, whom he married the following year. Although they were both hospitalized at a treatment center in Fujimikogen, Ayako died in the winter of 1935. Hori wrote the novel *The Wind Rises* based on this experience. In 1937, he married Tae Kato. *The Wind Rises* and *Diary of a Mayfly* were published the same year, followed by *Nahoko* in 1941. Just before the end of World War II, his tuberculosis took a turn for the worse. After the war, he continued to fight his illness, passing away in 1953 at the age of 48.

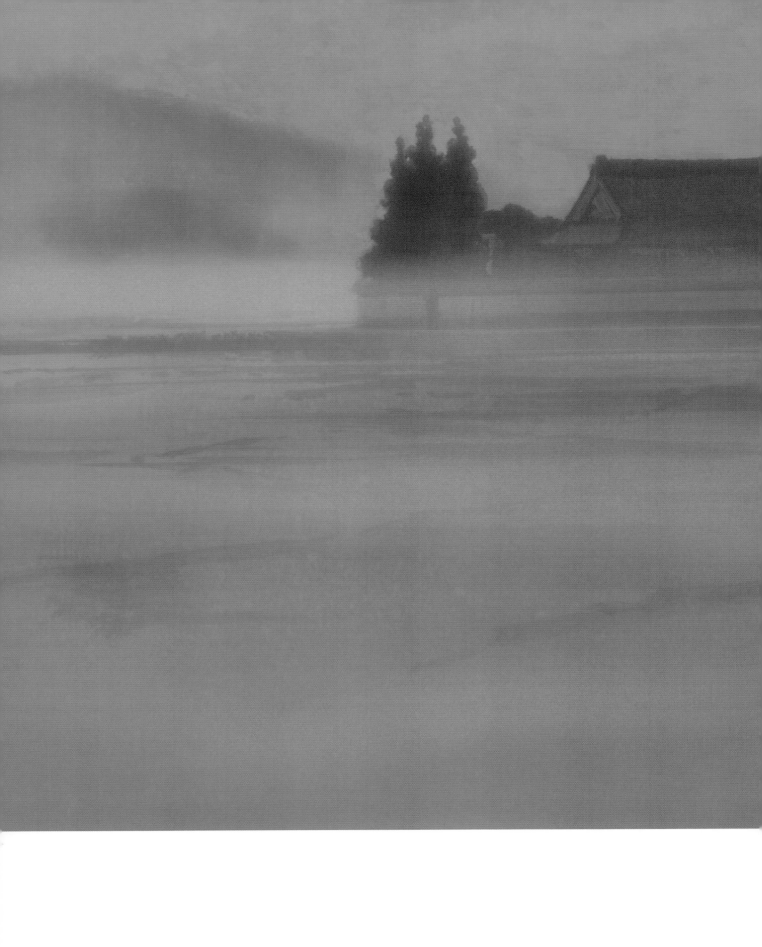

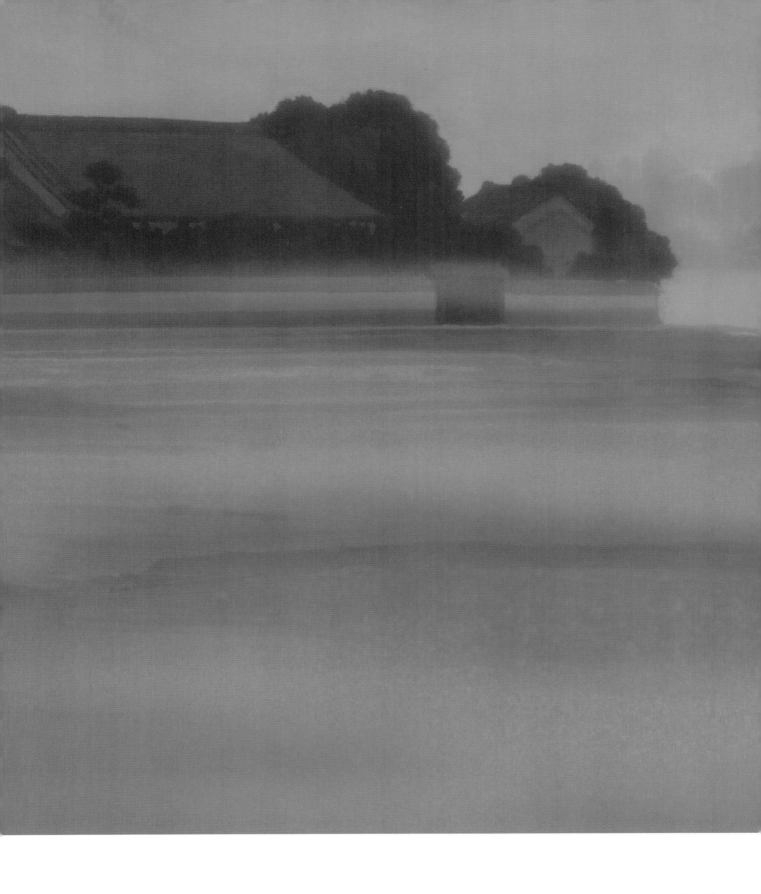

Jiro Horikoshi: *Thirteen Years Old*

The Taisho era. Jiro Horikoshi, born into a wealthy family in the country and spending his emotional boyhood days longing to ride in an airplane, meets the famed Italian airplane creator, Gianni Caproni, in his dreams. "Airplanes are beautiful dreams!" Caproni's words make a deep impression on Jiro, and he sets his heart on work that will give shape to his dreams—he decides to become an airplane designer.

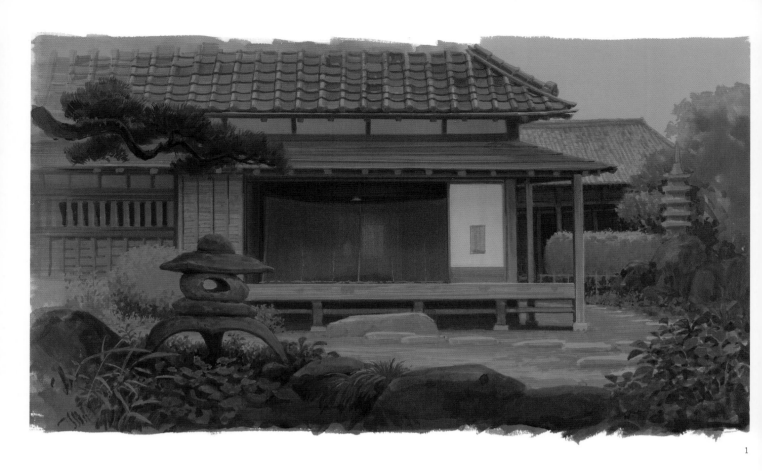

Horikoshi house, rooftop

P12–13/One morning in summer. The silhouette of the Horikoshi home rises up in the faint light in the rolling fog.
1/Seen through open storm shutters, the inside of the house is still quietly asleep. [Background]
2/The top of the roof Jiro climbs onto in his dream. [Background]
3/The rooftop scene he wishes to see. The mountains in the distance are lit by the morning sun. [Background]

Since there are many scenes with sky and clouds in *The Wind Rises*, I focused my efforts on having as much variation as possible. Despite the fact that clouds look different to everyone, in the end, you do tend to be limited by the possible shapes. I decided to set the tone, taking into consideration the feel and time of each place, after which I left it to the judgment of the art staff and had them draw as many different cloud and sky backgrounds as possible. As a theme for us, Miyazaki often talked about the fact that he wanted to bring out a feeling of layers in a sea of clouds, with clouds one on top of another, or conversely, a comfortable feeling of liberation with just light clouds floating by in the sky at Karuizawa. Although it wasn't a particularly new experiment, we added an indigo paint (poster color) we don't normally use, a deep blue color, for shadow areas and the color of the ocean. I thought that by adding indigo, with its slightly dull feel, instead of a vibrant blue like cobalt or cerulean, we might be able to get a Japanese kind of coloring, and I was conscious of this as I used it.

—Art Director: Yoji Takeshige

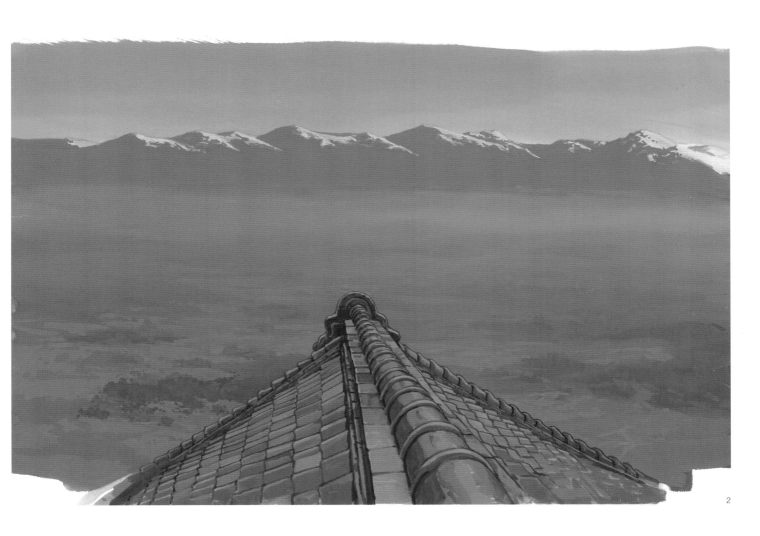

2

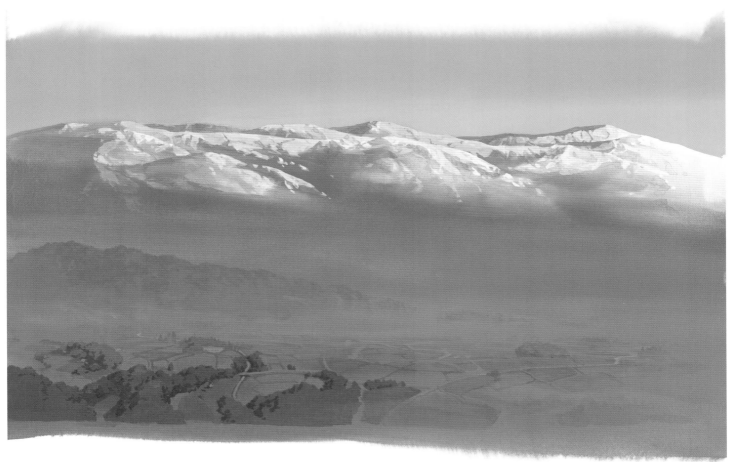

3

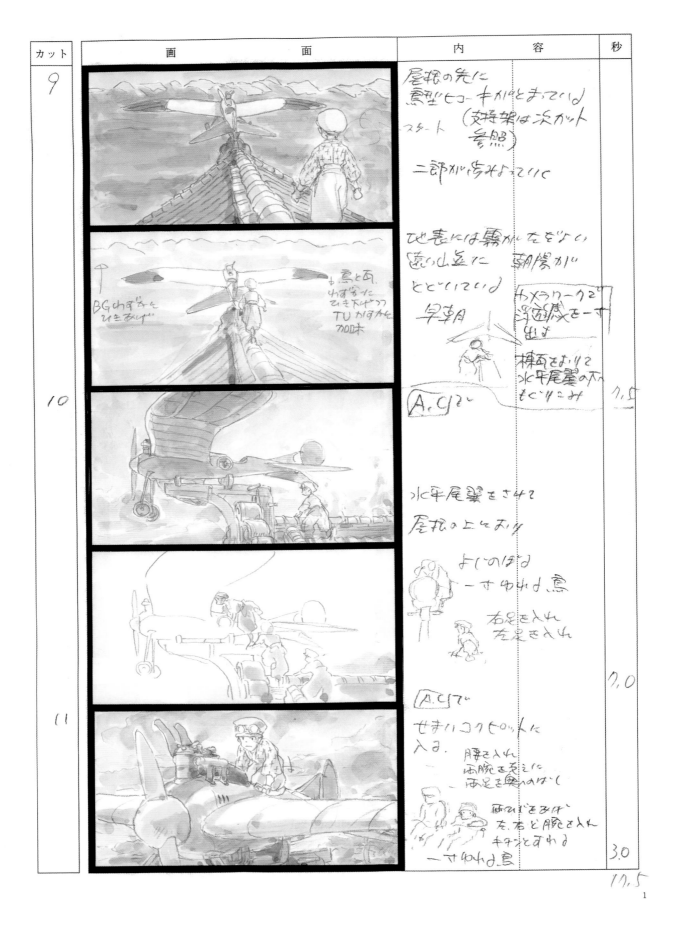

Dream bird

1/The beginning scene in which Jiro takes off in a bird-shaped plane in his dream. [Storyboard by director Hayao Miyazaki]
2–8/Climbing up onto the roof in his *nobakama* pants, Jiro gets into the cockpit and starts the engine. The bird-shaped plane soars lightly in the sky, the wind under its wings.

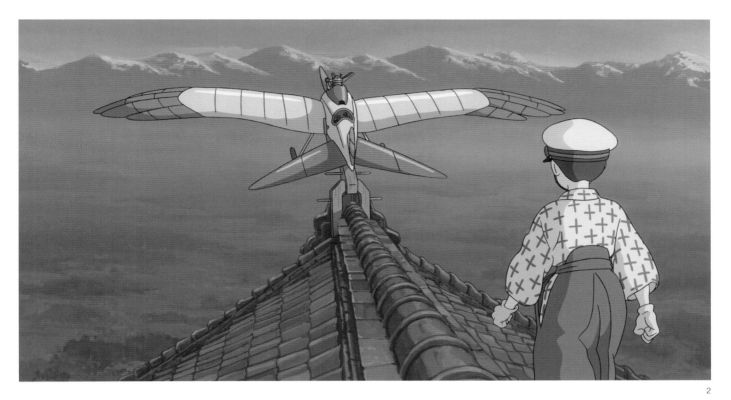

2

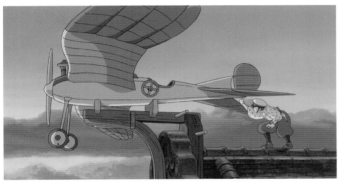

3

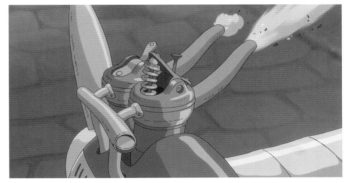

6

4

7

5

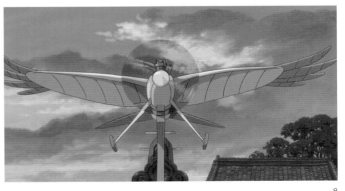

8

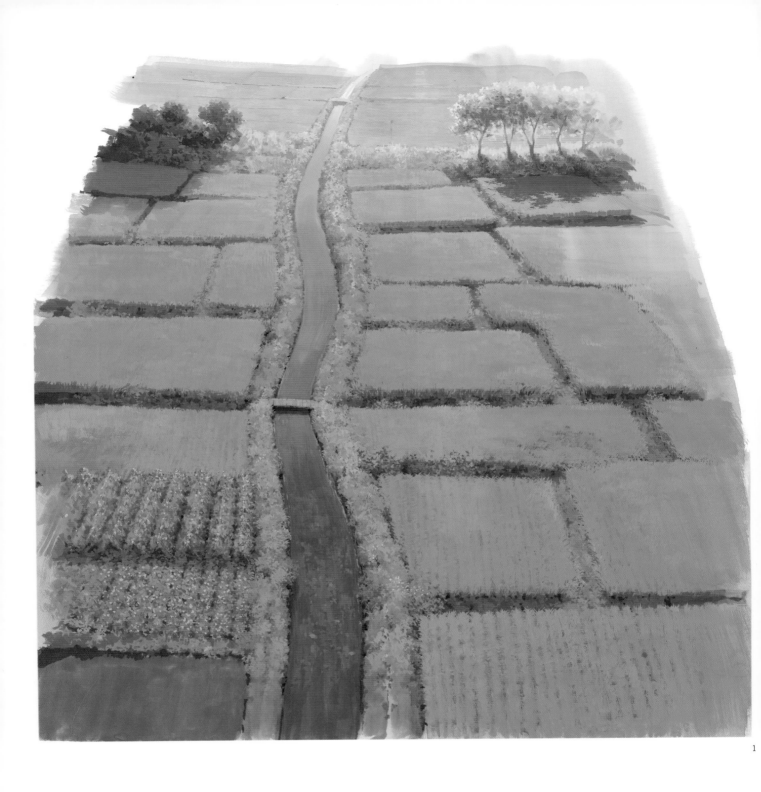

1

From country to town

1/The scenery of the country spreads out below the bird-shaped plane flying nimbly above. [Background]
2/River running between paddy fields. The bird-shaped plane descends to skim the water surface. [Background + cel book]
3/The bird-shaped plane slips under a bridge with people and cows coming and going on it, then rises into the sky again. [Background]

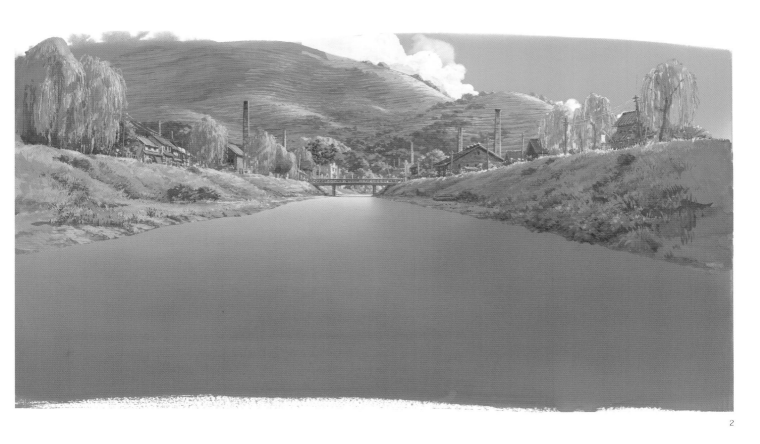

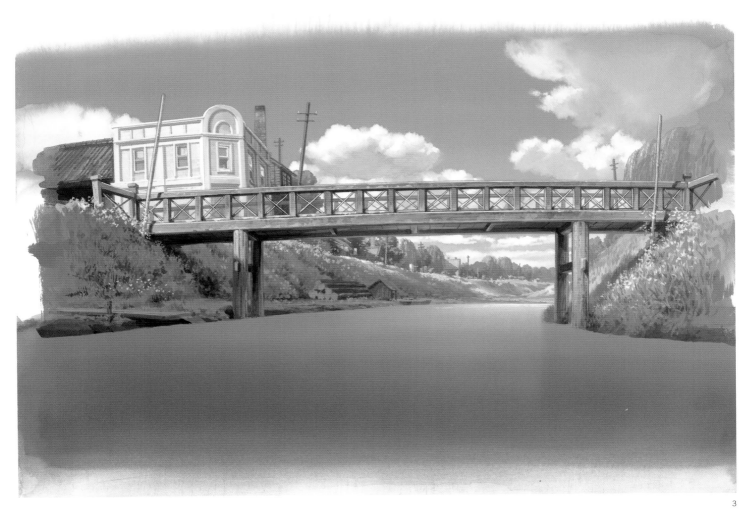

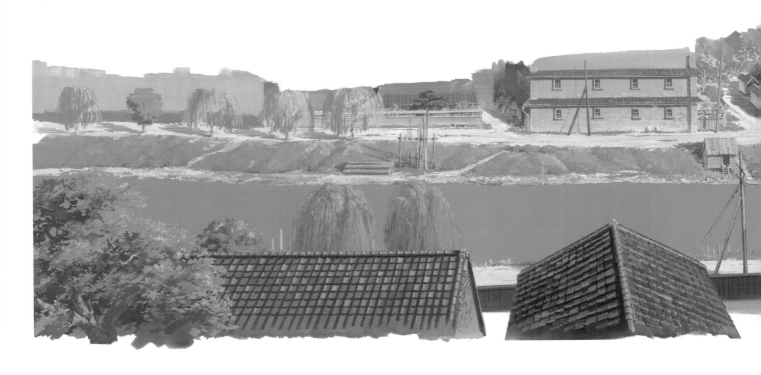

2

1/The town the bird-shaped plane flies above, along the river with a cotton mill. [Background + cel book]
2/The women workers from the cotton mill look up.
3/The scene looking down from the bird-shaped plane. Smoke comes up from the cotton mill stacks. [Background]

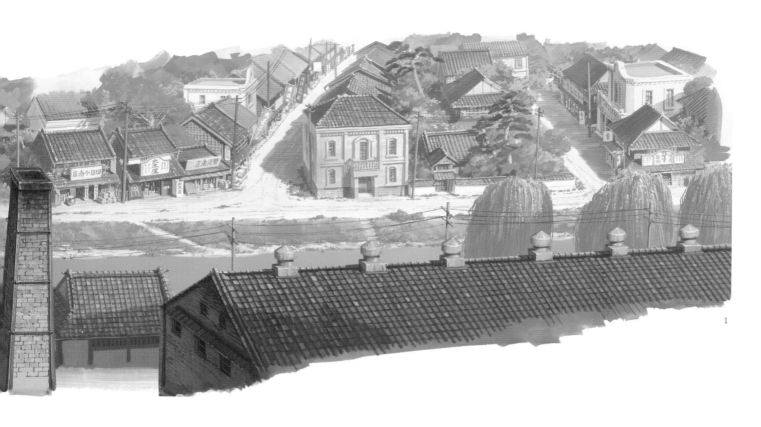

1

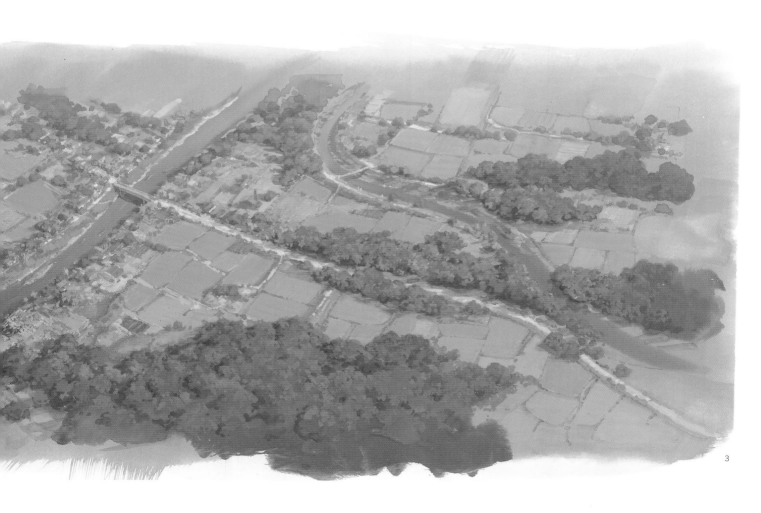

3

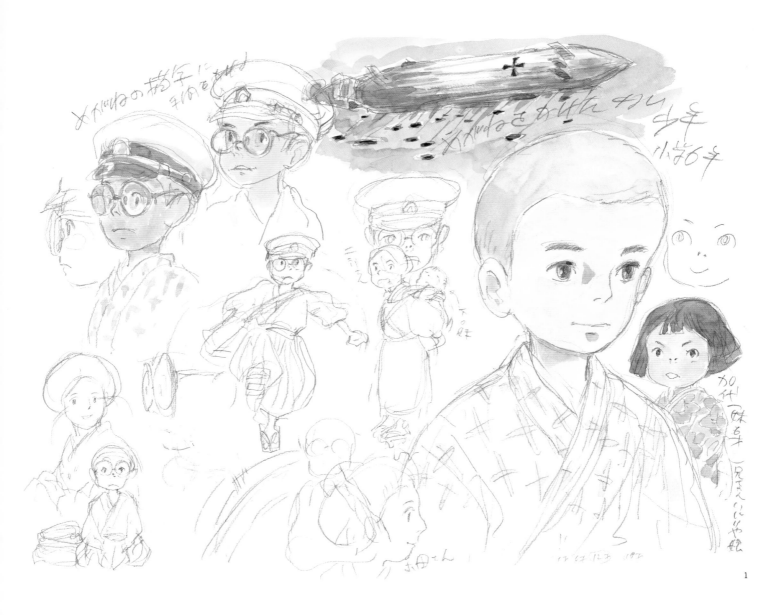

1

Jiro Horikoshi

The film's protagonist, a boy who longs to become an airplane pilot, is very dedicated to his studies, excellent at judo, and has a sense of justice that won't allow him to look the other way when someone is being picked on. The character is a fusion of Jiro Horikoshi, a designer and engineer who supported the Japanese aviation industry both before and after the war, and Tatsuo Hori, a writer who lived at the same time.

1/Rough sketches of Jiro in his boyhood (Grade 6) and his family. [Concept sketches]
2, 3/Collection of young Jiro's facial expressions and his pilot style with *nobakama* pants and gaiters. [Character design]

Since people of this time had to work very hard just to live, I took this serious attitude into basic consideration and made the characters so that they wouldn't have a weak feel to them. Jiro Horikoshi wore glasses, so I made his glasses very conspicuous. I'd also heard that Miyazaki himself has a complex about not being able to see without his lenses, so I made the glasses with this sort of thing in mind as well. Since you end up with a pair of symbolic circles stuck on there if you just draw the glasses as is, I gave the lenses some shadow during animation with the intention of bringing out their physicality.

–Supervising Animator: Kitaro Kosaka

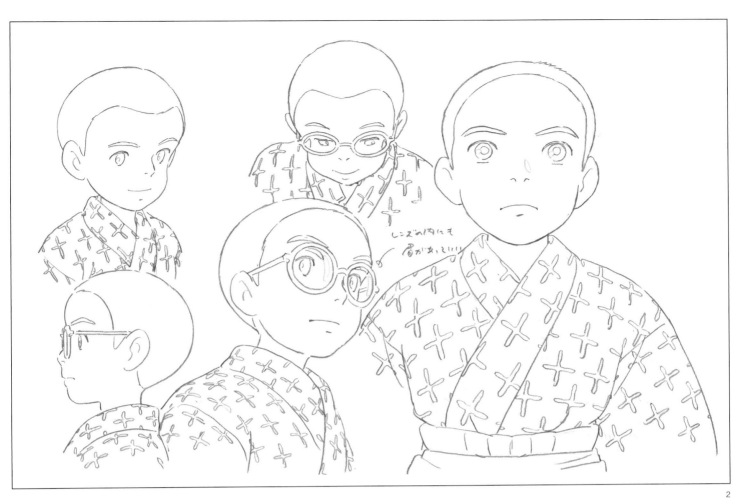

ここでの内側にも
雪があるといい

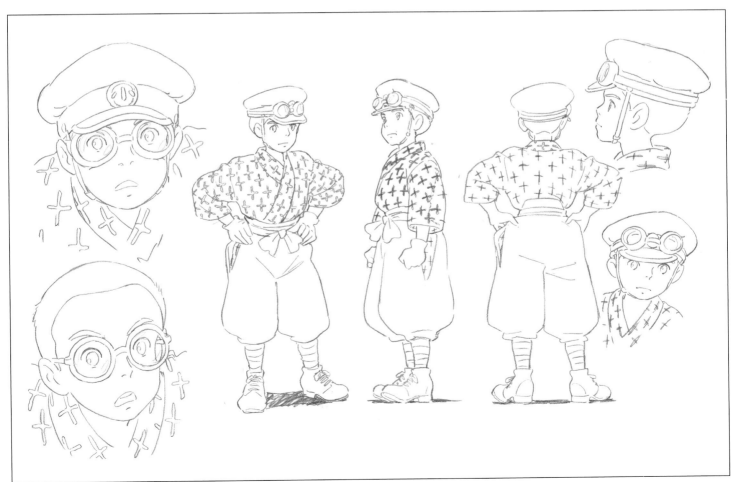

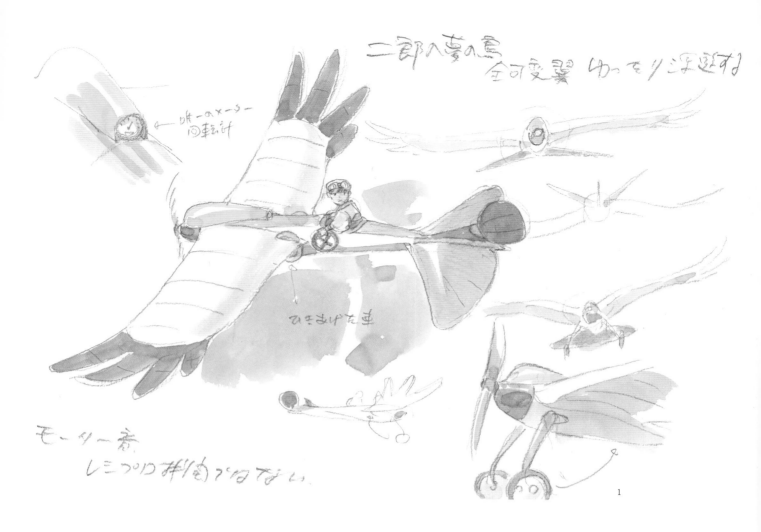

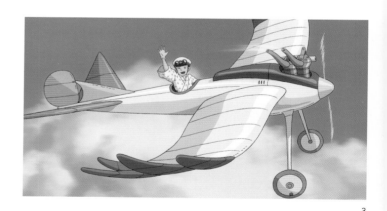

Bird-shaped plane

The streamlined machine with completely variable wings that Jiro sees in his dream. The start switch is made of Bakelite, the latest thing at the time. Flight feathers are attached to the ends of the wings.

1, 2/Rough sketches of the bird-shaped plane with details of the wheels and the propeller drawn in. [Concept sketches]
3/Jiro waving to the women workers from the bird-shaped plane.
4/Details of the engine, etc. [Machine design]

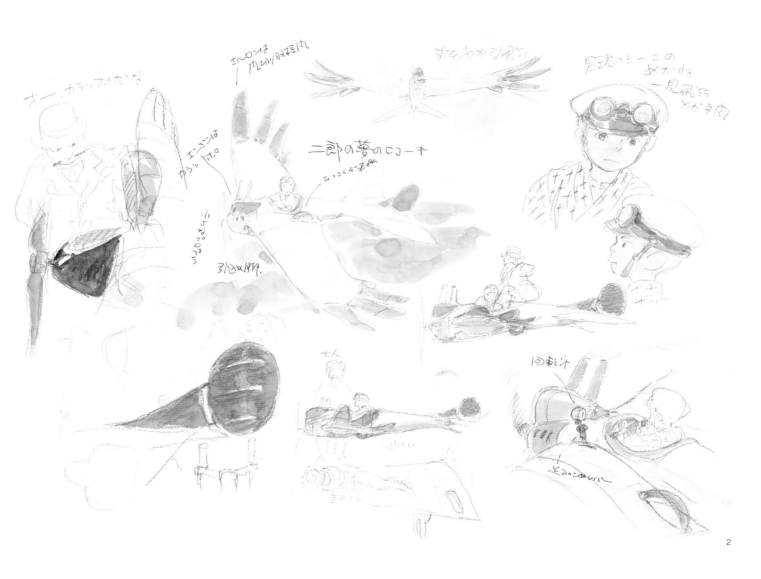

二郎の夢のヒコーキ

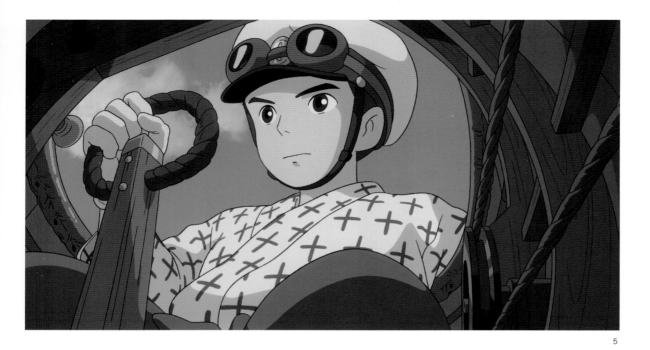

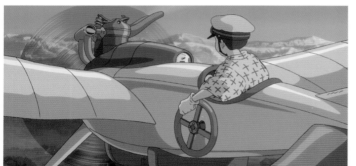

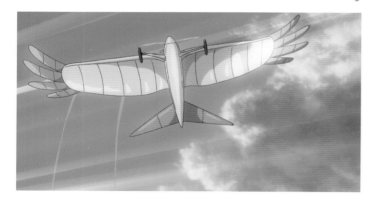

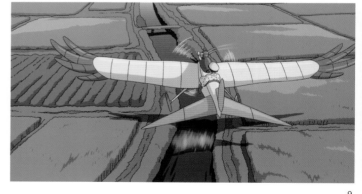

5/Jiro, the dashing pilot.
6/The wings are adjusted using a wheel on the side of the plane body.
7/Riding the air currents higher.
8/The bird-shaped plane flying above the paddies lit up by the morning light.
9/The bird-shaped plane flying toward town following the stream.

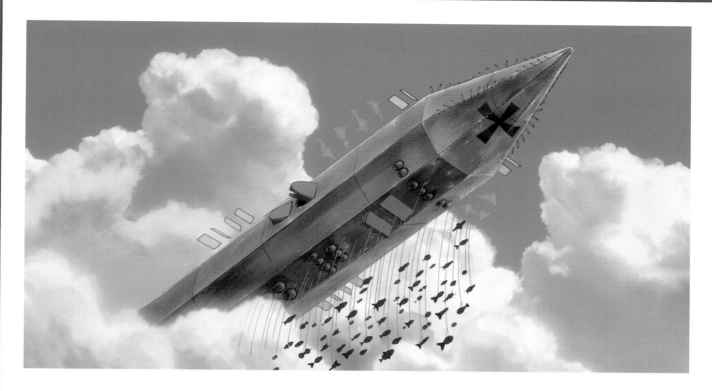

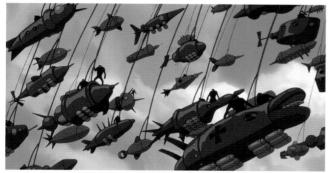
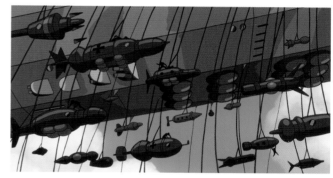

Airship

The airship that appears in Jiro's dream is an original design proposed by Miyazaki. In the storyboards, he made a note for a "fantastical Zeppelin," and the front of the ship bears a German/Prussian iron cross. The Zeppelin-shaped airship was originally developed by the German count Ferdinand von Zeppelin. The Zeppelin LZ 1, a large, rigid airship with an aluminum frame, was completed in June 1900. Although at the time the objective for the airship was to transport large numbers of travelers, with the start of World War I in 1914, it was used as a cutting-edge weapon. One hundred and twenty were produced during the war.

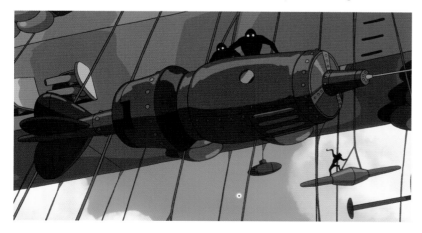

Bomb bugs

Fantastic creatures ride on the explosive weapons hanging from the airship on wires like the sticky strings of *natto* beans. Jiro's bird-shaped plane collides with the bug bombs and ends up in pieces.

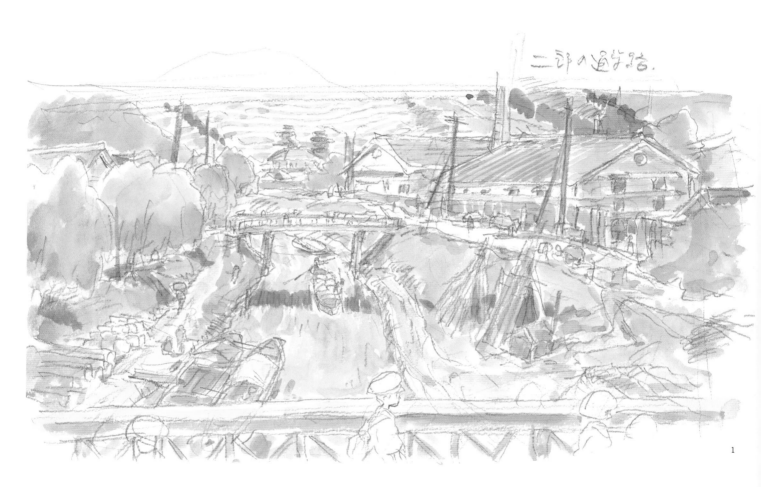

1

Taisho era views

1/Jiro's road to school. There is a cotton mill and a wharf along the river, and boats carrying goods move up and down the river. [Concept sketch]
2/Jiro and others wait for the tiny train to pass at the crossing at a narrow-gauge railway station. The train has one passenger car and one freight car.
3/Some of the people crossing the bridge are students at the same school as Jiro. This is the usual morning scene.

Noboru Yoshida was mainly responsible for the backgrounds of the scenes of Jiro's boyhood, such as when he goes to school, when he takes on the bad kids by the river, or when he climbs in his bird-shaped plane in his dream and flies above the factory. He's really good at drawing warm views, so I basically just left it to him. You could say I was working on the opposite end of the spectrum, on something brutal, the areas that were burnt out and the mountains of bricks left after the earthquake. I had no intention of making anything that felt too scary, but some of it was hard for me to draw as I remembered what I'd seen as a volunteer in Tohoku after the earthquake and tsunami there.

—Art Director: Yoji Takeshige

Miyazaki explained to us that the boats and things that appear in these scenes had all been used for ages, so they were sort of blackened and beat up. I used duller colors than we would have normally for the wood of the wooden boats. I did these scenes thinking it would be great if these vehicles and boats could be a part of the background, if they could somehow blend into this luxurious scenery.

—Color Designer: Michiyo Yoshida

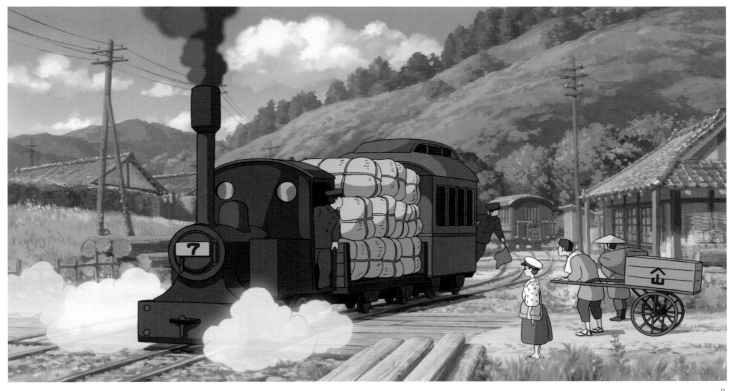

2

3

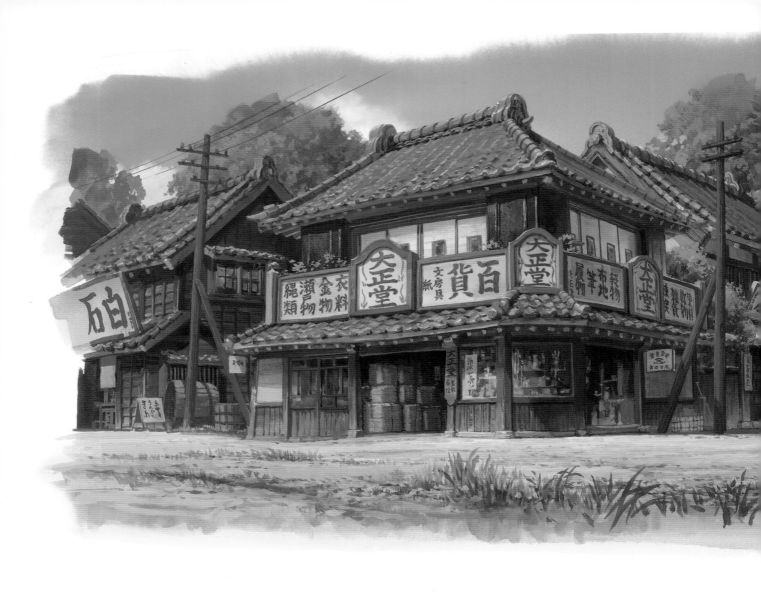

Jiro's elementary school

1/Afternoon in a tranquil town. The school Jiro attends is down a street lined with shops. [Background]
2/The hallway after school. [Background]

1

1

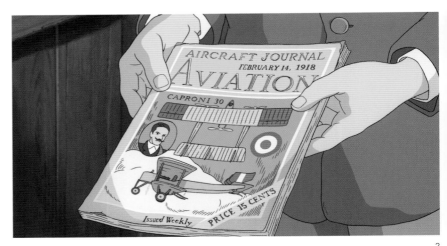

2

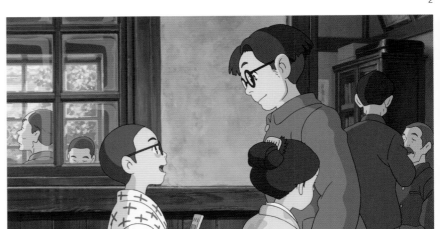

Jiro's elementary school

1/The entrance of the teachers' room where Jiro goes to borrow a magazine. [Background]

2/The foreign aviation magazine the young teacher hands over to Jiro. It contains an article on Caproni, whom Jiro holds in esteem.

3/"May I borrow it?" "Of course, but it's in English." "That's okay. I have a dictionary." "All right, give it a try."

3

1

2

3

4

34

5

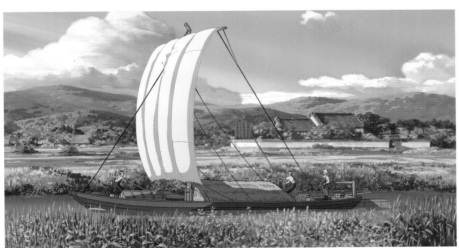

6

Riverbank

P33-1/The road home along the embankment. Jiro sees Takayama from his class and two other thugs tangling with a student from a lower grade. [Background]

P33-2/The grassy embankment Jiro runs down to try and help the younger student. [Background]

3/One angle of the embankment where sacks of charcoal are piled up and Jiro comes in to stop the thugs. [Background]

4/The embankment that serves as the road to school for Jiro and other students. [Background]

5/The bank of the river bathed in afternoon light. Jiro's house can be seen on the other side. [Concept art]

6/A scene, quiet like a dream. A riverboat with its sails up drifts slowly forward.

二郎の生家。
構造を決めなくて可。
この一つのカットが余分かも
近くていい。
いい地方の素封家。

1

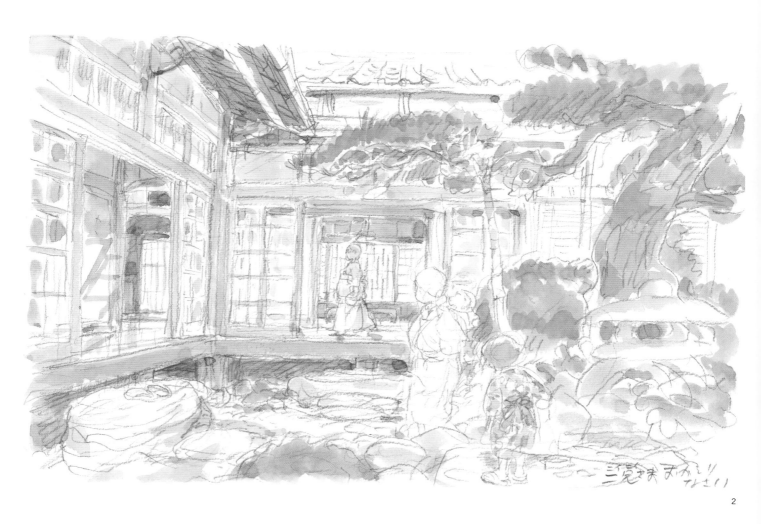

三兄さまおかえり
なさい

2

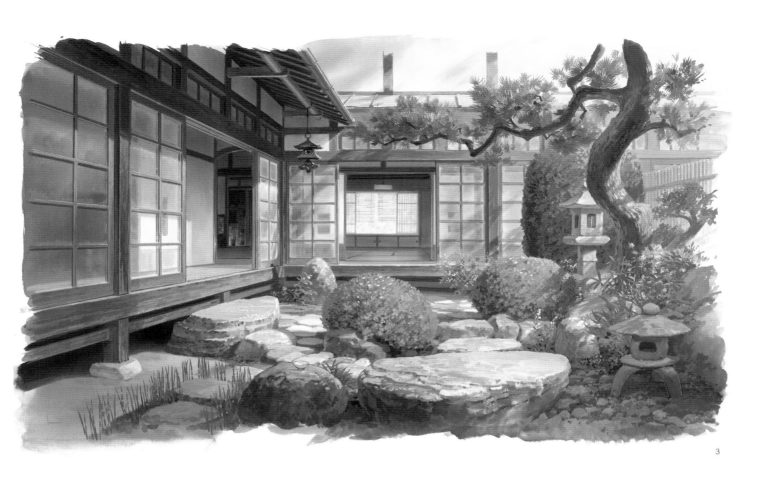

3

Jiro's house

1/View of the Horikoshi home and surroundings from a distance. [Concept sketch]
2/Kayo, Jiro's younger sister, and the housekeeper/babysitter O-Kiyo, welcoming Jiro home from school. [Concept sketch]
3/The Horikoshi garden with stone lamps and plants. Jiro passes down the hallway with a plate of snacks and goes up to the second floor. [Background]

For the views of the Taisho era to the beginning of the Showa era, we watched old movies, and the art staff went on sketching trips to Uchiko and Ozu in Ehime Prefecture, where there are still a lot of buildings from the Meiji era, all of which we used for reference. The place Jiro actually spent his youth is in Gunma Prefecture, but the house that shows up in the film reflects the concept of the house in Tochigi Prefecture from which Miyazaki entered the world. Also, the house my own mother was raised in is in Shinonoi in Nagano Prefecture—her father was apparently the village headman—and I remembered the large stones and pond in the garden when I went there as a child when I was deciding on the coloring for Jiro's family home.

–Art Director: Yoji Takeshige

1

Garden, second floor

1/The dried-up pond where Kayo was playing house. Small stones blanket the bottom. [Background]

2/Jiro goes to his mother's room and tells a transparent lie: "Oh, I slipped and fell." [Background]

3/Jiro's room on the second floor. Jiro starts to read his borrowed magazine while looking up English words in the dictionary, and Kayo squirms around him, wanting to play. [Background + book]

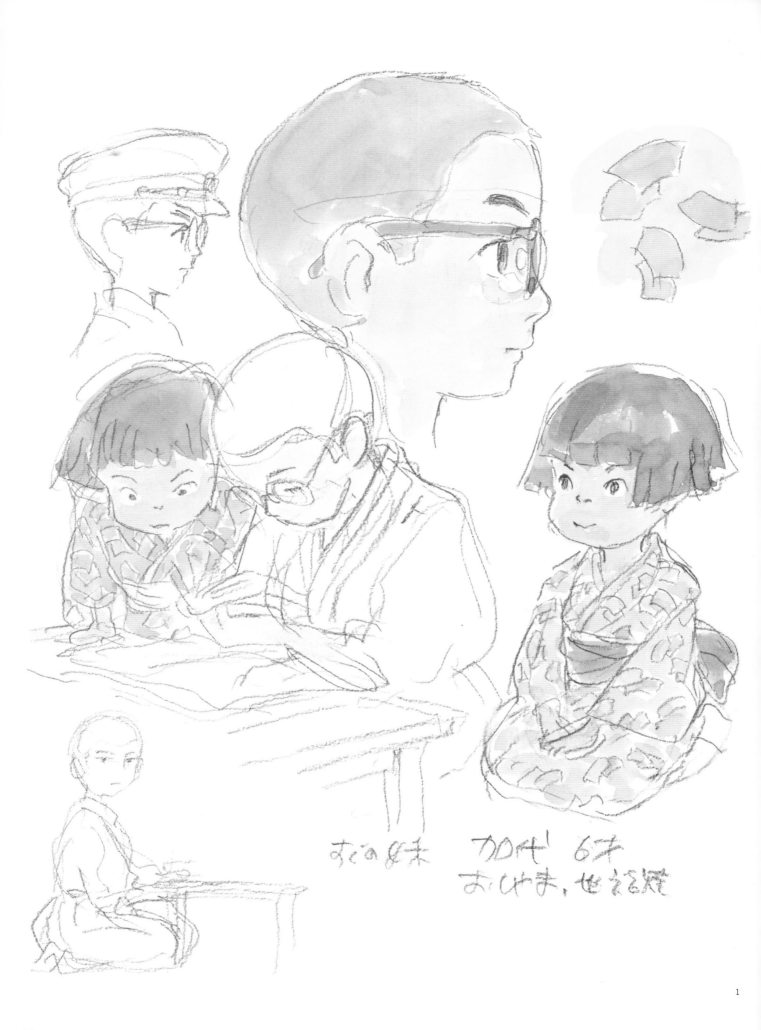

すこし8才　カロ代67才
おじやま、せえる服

1

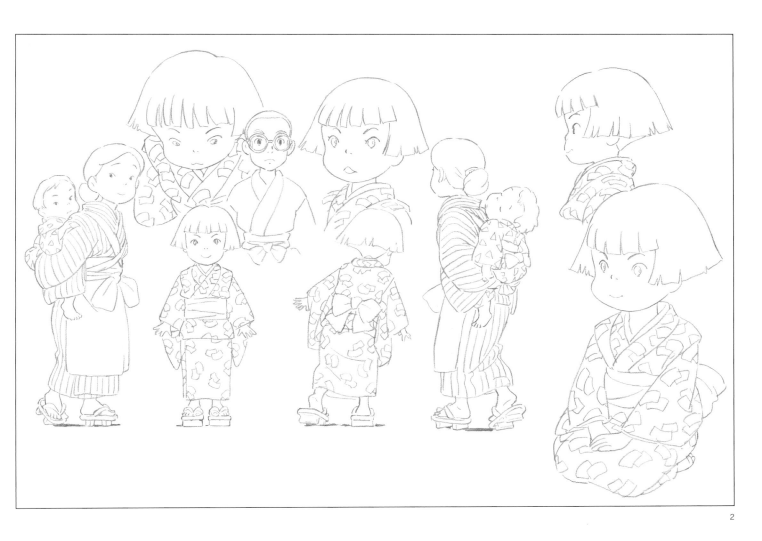

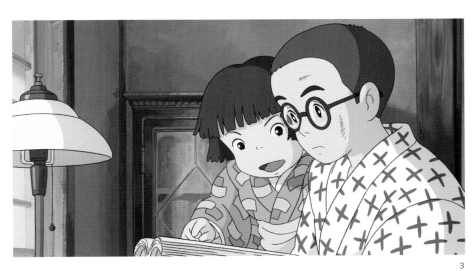

Kayo

Jiro's sister, seven years younger. She adores Jiro and calls him "big brother."

1/Jiro and Kayo, close siblings. [Concept sketches]
2/Kayo and the maid O-Kiyo. [Character design]
3/Kayo, looking at a photo of Caproni and innocently pointing and saying he has a strange mustache.

Right from the start, I was thinking white fabric with a navy design for the kimono when Jiro is a child. The cross pattern on the white cotton/linen blend came from remembering that my father wore a summer kimono with that pattern when I was a child. For Kayo, given her personality, I knew it had to be red, and I matched that with a yellow and blue pattern. It takes more time to do kimono with patterns, but from the point of view of color coordination, it's harder to decide on just one color. I always end up feeling like I could do better, so no matter what it is, having lots of colors makes it easier to strike a balance and make a decision.
—Color Designer: Michiyo Yasuda

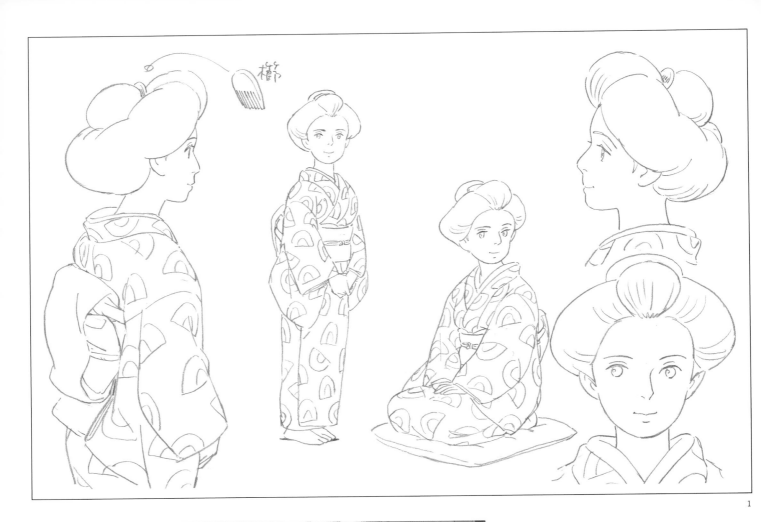

1

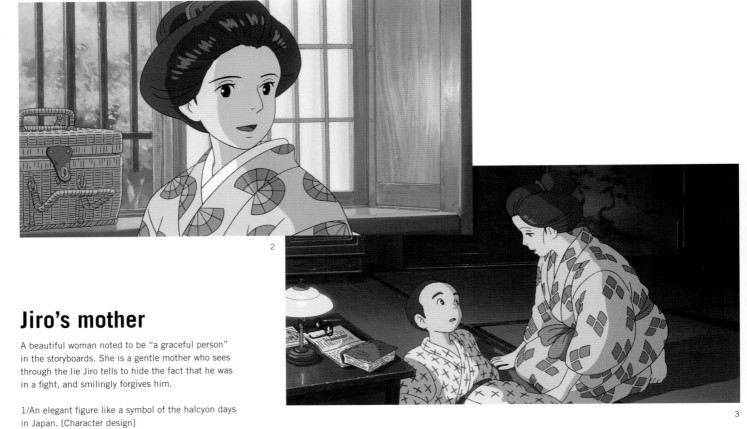

2

Jiro's mother

A beautiful woman noted to be "a graceful person" in the storyboards. She is a gentle mother who sees through the lie Jiro tells to hide the fact that he was in a fight, and smilingly forgives him.

1/An elegant figure like a symbol of the halcyon days in Japan. [Character design]
2/Even seeing Jiro covered in scrapes, she is unperturbed: "You look quite the hero."
3/Mother warmly watching over Jiro when he wakes from a dream.

3

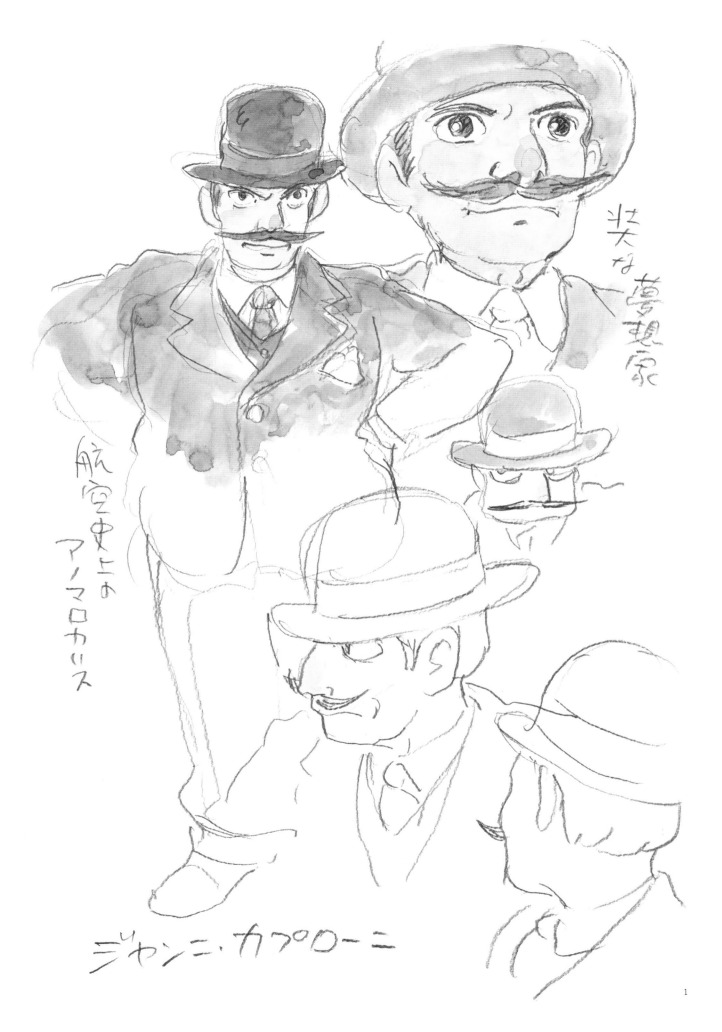

光な夢想家

航空史上の
アノマロカリス

ジャンニ・カプローニ

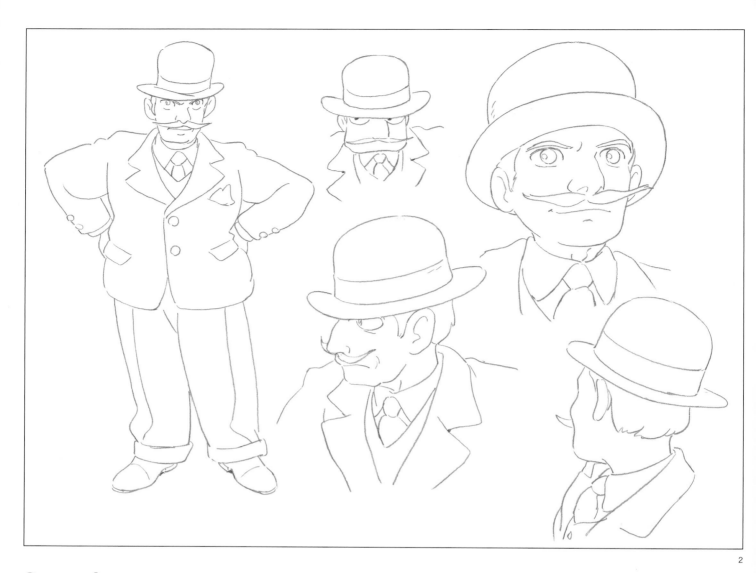

Caproni

A brilliant airplane designer Jiro looks up to. He meets Jiro through dreams and guides him in life. The character is modeled after the actual man, Count Giovanni Battista "Gianni" Caproni (1886–1957). He was the founder of the Caproni company, which produced Italy's first practical aircraft in 1911, and he supplied many bombers and transport planes to the allied nations during World War I. Later, the company began producing automobile and ship engines as well, but these were left behind after World War II. Caproni was a visionary pioneer who dreamed of an era when large numbers of passengers would be transported in enormous planes.

P43-1/Rough sketches of "Uncle Caproni," as Miyazaki fondly referred to him. [Concept sketches]
2/Collection of Caproni facial expressions. [Character design]
3/Article in the magazine Jiro looks at.
4/The dreams of a Japanese boy who loves planes and an Italian design genius are connected, and the two meet by chance in the field Caproni calls "our kingdom."
5, 6/Caproni, relating his dream of a large passenger plane, offers encouragement to Jiro, who worries he won't be able to be a pilot because of his nearsightedness.
7/"Airplanes are not tools for war. They are not for making money. Airplanes are beautiful dreams. Engineers turn dreams into reality." Caproni's words decide Jiro's future.

Miyazaki drew Caproni in his concept sketches, so we pulled him together in a way that didn't wreck the mood created by these images. For this film, as you move along in the second half, things become more realistic, but since Caproni is depicted in the first half, he ends up being a cartoonish character. He also plays the role of the fool.

—Supervising Animator: Kitaro Kosaka

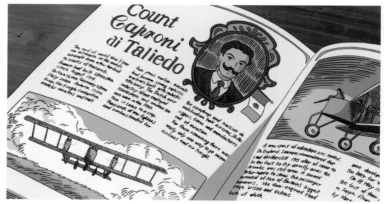

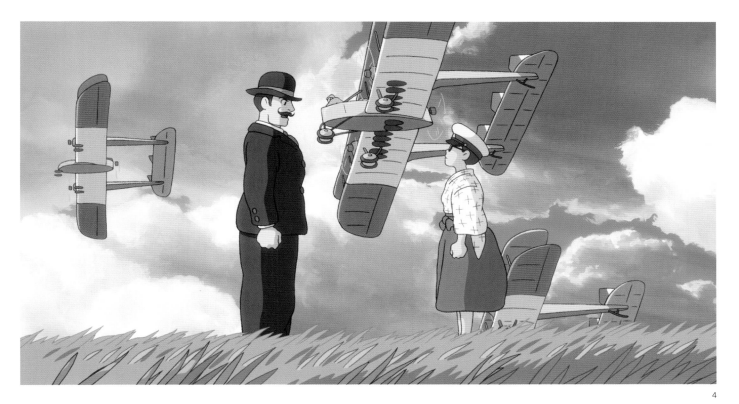

4

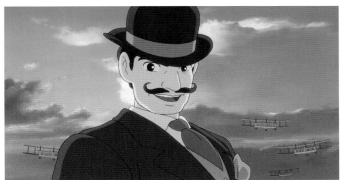

5

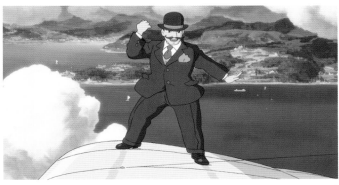

6

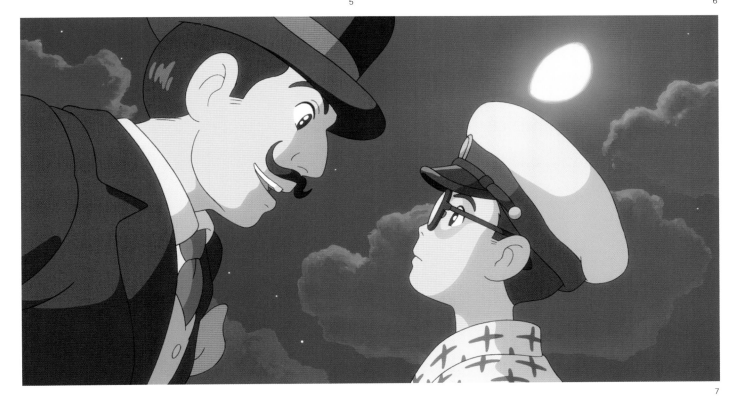

7

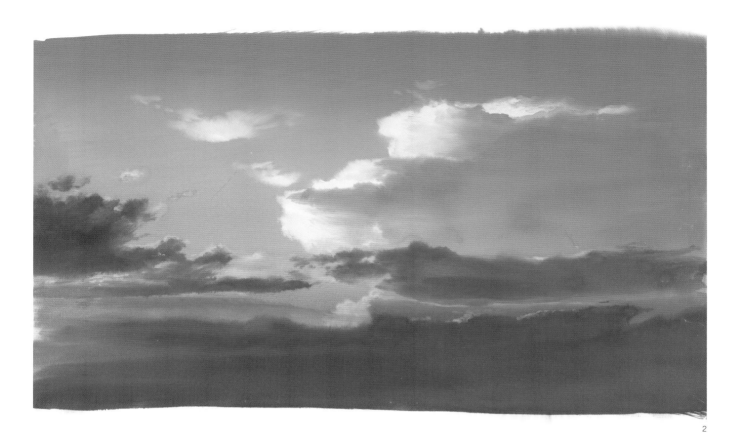

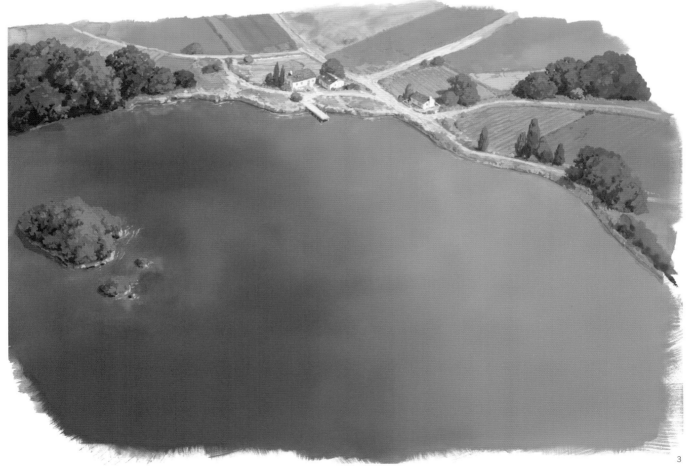

In the dream

1/The starry sky Jiro, wanting improved vision however slight, looks up at with Kayo on the roof. This is connected with the tips of the clouds in the dream. [Concept art + cel book]

2/The sea of clouds spreading out in Caproni's dream kingdom. [Background]

3/Lake thought to be Lake Maggiore seen from the wing of the Ca.48 where Jiro and Caproni talk. [Background]

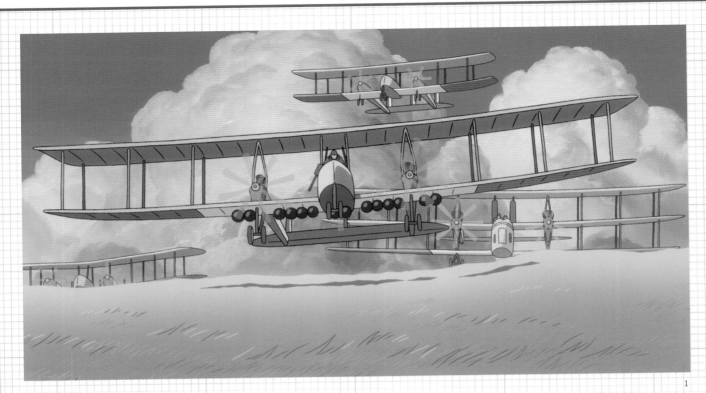

1

2

3

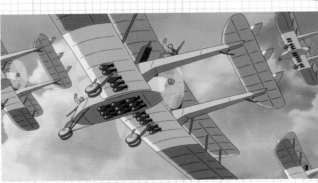

4

Caproni's bomber

The planes here were drawn based on the Ca.3 biplane bomber and the Ca.4 triplane bomber designed by Count Gianni Caproni.

1–4/A group of bombers approaches Jiro standing in the field in his dream.
5, 6/Overall diagram and details [Machine design]

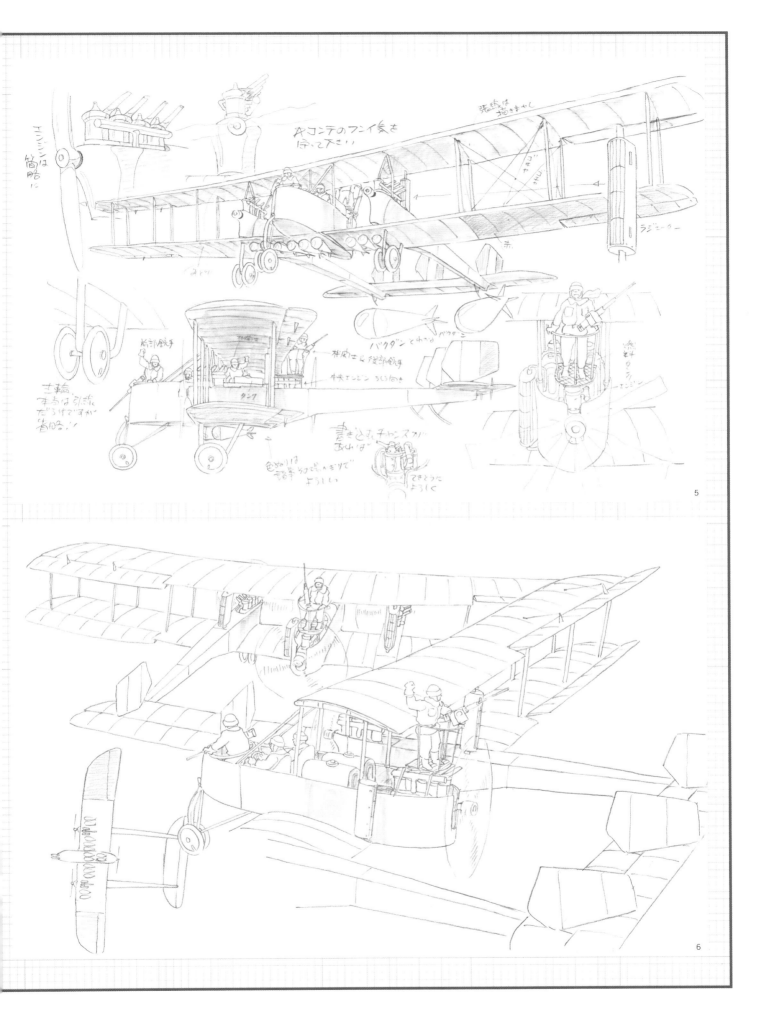

49

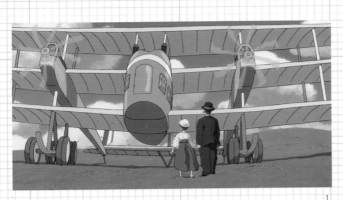

1

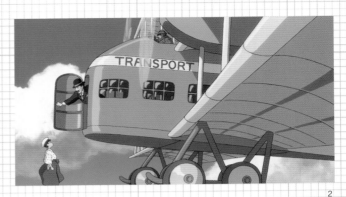

2

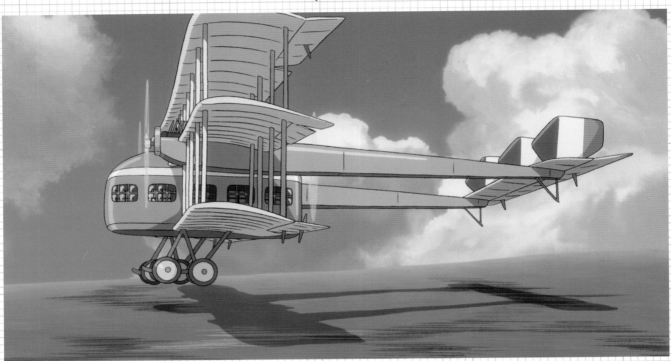

3

4

Caproni's triplane

This plane was modeled after the triplane that was active as the main machine after World War I for Caproni, who was operating a civilian aviation company. In 1919, the plane crashed in an accident near Verona, Italy. Seventeen people were killed, and it was reported as Italy's first aviation accident.

1–4/In Jiro's dream, he rides in the plane with Caproni. The cabin is luxuriously ornate.

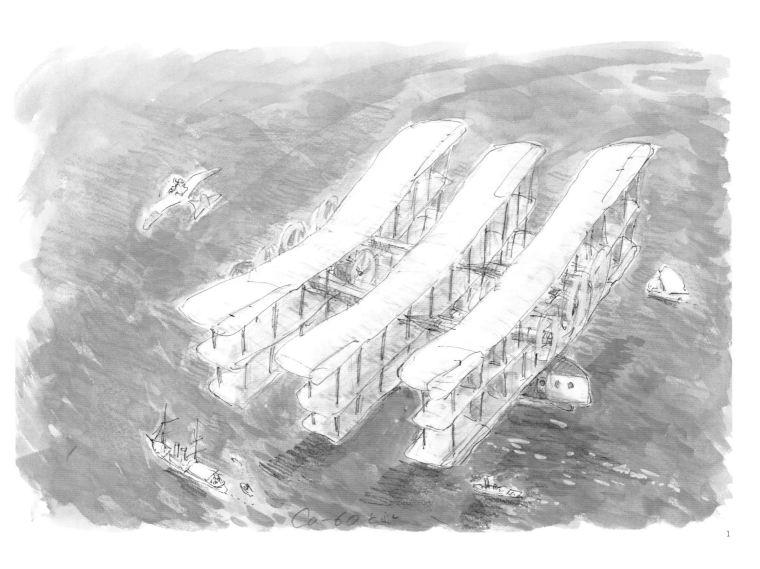

Ca-60 だ

1

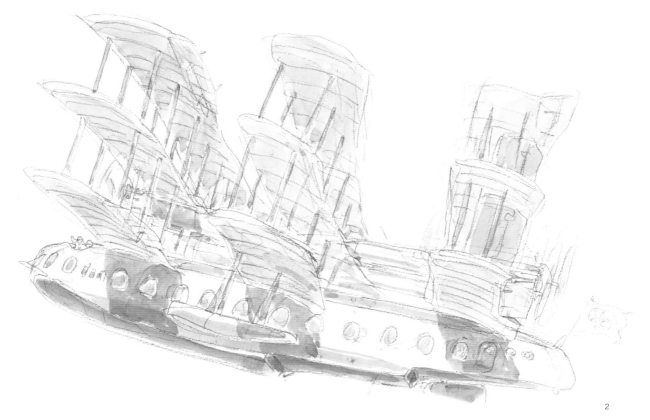

2

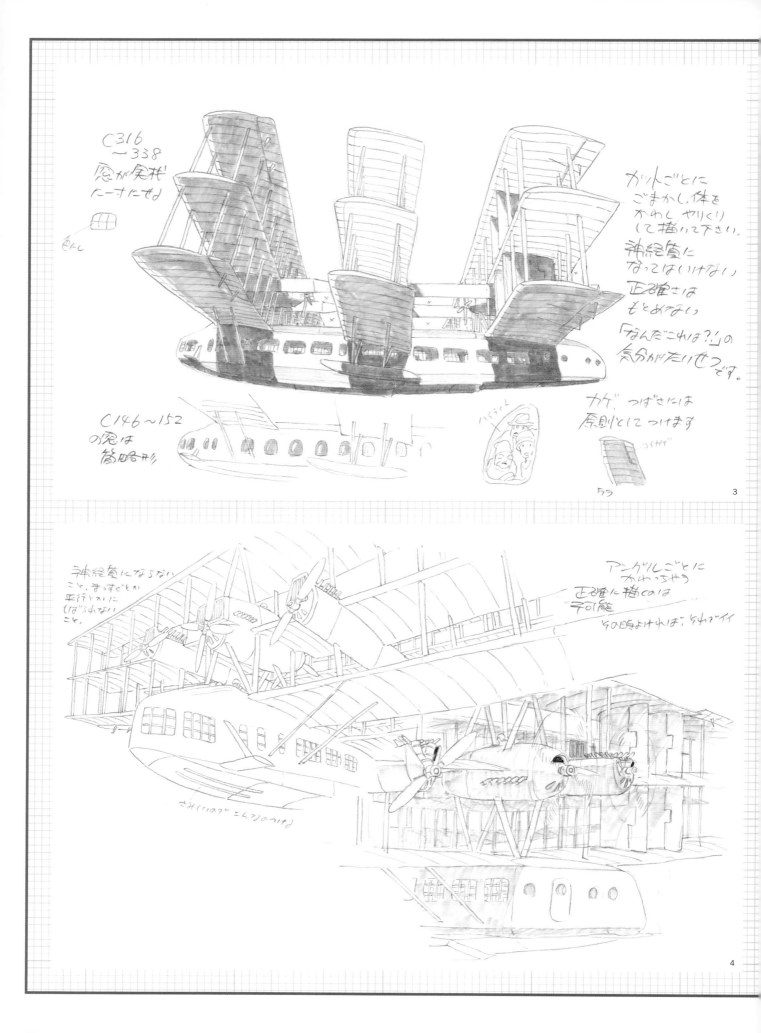

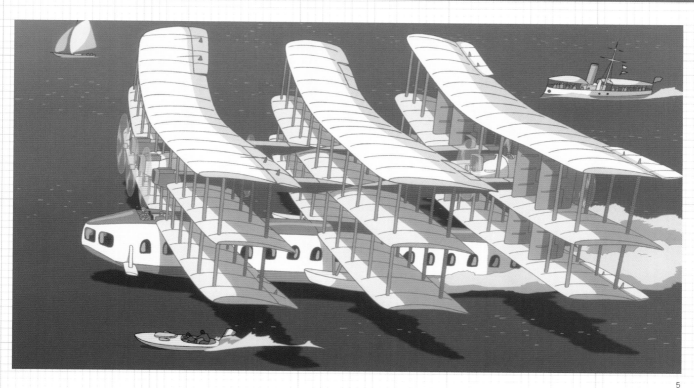

5

6

7

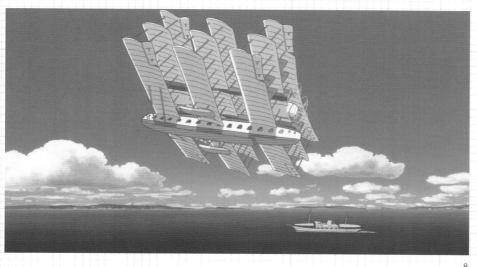

8

Caproni's large flying boat

The flying boat is based on the Ca.60, a large flying boat built by Caproni in 1919. It featured a wingspan of approximately thirty meters, and eight Liberty engines.

P51-1, 2/Large flying boat drawn by Miyazaki. [Concept sketches]
3, 4/Overall diagram and details of large flying boat. [Machine design]
5–8/In the dream, the large flying boat elegantly lifts off the water, but…

Born in 1962 in Yokohama, Kosaka joined Oh! Production after graduating from high school and has been active as an animator ever since. He began working as a freelancer in 1986. For Studio Ghibli, he did key frame for *Nausicaä of the Valley of the Wind* ('84) and *Castle in the Sky* ('86), among others. He was a supervising animator on *Whisper of the Heart* ('95), *Princess Mononoke* ('97), *Spirited Away* ('01), *Howl's Moving Castle* ('04), *From Up on Poppy Hill* ('11), and the Ghibli Museum original short "Mr. Dough and the Egg Princess" ('10). He was also an assistant supervising animator on *Ponyo* ('08). Additionally, he directed the Madhouse films *Nasu: Summer in Andalusia* ('03) and *Nasu: A Migratory Bird with Suitcase* ('07).

Interview
Kitaro Kosaka
Supervising Animator

This was a job for which I felt a strong adherence to the idea of bringing the pictures to life.

I finished work on "Mr. Dough and the Egg Princess" (an original animated short for the Ghibli Museum) with art director Takeshige (Yoji), and then I helped out a bit on *From Up on Poppy Hill*; it was around spring of 2011 when I was approached about taking part in *The Wind Rises*. For a while, I was designing the characters in parallel with doing animation for *From Up on Poppy Hill*.

In creating the characters, I often referred to Miyazaki's concept sketches, though he didn't actually paint that many for this film. But I also had the original work serialized in the magazine (*Model Graphix*), and since the story followed the manga to a certain extent, I used that as a reference as well. I basically made the characters by giving the pig-nosed ones human faces.

I've worked on countless Ghibli productions, but this film was the first time I was working alone as the supervising animator on a feature film directed by Miyazaki. That said, in terms of the work, there was no change from the films I was involved with as a supervising animator assistant, in that the focus of my work was organizing the key frames after they had been checked by Miyazaki. It's always like this for films Miyazaki directs—there's essentially nothing like a stage where we have advance meetings to discuss the film's aim and intention. If we had a clear explanation of the drama, like the theme is this and the protagonist thinks like this, it might make the work easier, but the way we do it instead is to seek out the persuasiveness of an image that makes the viewer feel something in each scene or shot.

This also changes depending on how the key frames turn out. For instance, there's a scene where Jiro's depressed, and if you think about it normally, he should be sort of trudging along, but the way the keys turned out, he's walking with a fair bit of energy. So I end up thinking that maybe this is a bit off from what we were intending, and then Miyazaki says, "No, the shot is good. We'll go with this." Our priority is the feeling the picture (key frame) has sometimes, the persuasiveness of it.

The story flows in chronological order, but doesn't actually depict things like how the protagonist Jiro grows after meeting Nahoko. Instead of structure and movement taking the flow and the development of the story into consideration, we focus on the behavior and movements of the charactes in each scene.

Once the key frames are done, Miyazaki is the first to check them, and what he looks for is the expressiveness of the image as a whole. If he thinks that that's not there, he'll add in drawings, saying things like wouldn't this be more expressive if you added something more like this here. In some cases, we'll redraw.

Even a single still image of food, for example, you somehow need to make look delicious. In this film, we have mackerel cooked in miso, and when we did "Mr. Dough and the Egg Princess," we had the apple, but the second you draw something symbolic, you get "Why would anyone be happy to be served something that looks so unappetizing!" and you're forced to do it over; this happens too.

As one of the main features of *The Wind Rises*, we have a lot of characters wearing kimono. We held kimono-drawing sessions for the young animators who normally don't wear kimono, and we even had a kimono teacher come in and talk to us. But in terms of how to actually draw them, we also had the kimono envisioned by Miyazaki, so there are a few variations from actual kimono. He prefers kimono with puffed up sleeves, and if we drew something that didn't have them, he'd tell us, "That's wrong!" and we'd have to do them again. [*laughs*]

Still, all we've learned about and seen in terms of wearing kimono is from formal occasions (New Year's, coming of age ceremony, etc.), so that's probably different from how they wore their kimono at the time—as everyday clothing. Miyazaki knows this period himself, so I felt we needed to focus on his impressions from that time. Just because it's the correct way of wearing the kimono doesn't mean that it's going to work here.

This idea wasn't just limited to the kimono; I think all of the key animators had their fair share of struggles while working. Miyazaki himself is the type to gradually change his thinking as the work moves forward, so it was definitely hard to follow along with that, and then you get told "one more time" for a shot you've really poured yourself into just because of the thickness of the lines. They're really the tiniest of differences, and when they finally end up as trace lines on the cel, they're even more homogenous than pencil lines, but even so, you have to bring it to the point where they don't lose their expressiveness. This job made me feel that desire not to shave away anything that might have the smallest thing to say, that made me feel a strong adherence to the idea of bringing the pictures to life, even for differences so small most people wouldn't even be able to tell.

Maybe this is an extreme argument, but I wonder if the essential nature of Miyazaki's directorial work is that it's the depiction—not the story—that's everything. In this sense, Miyazaki continues to be an animator and an artist who is also a performer. This work made me realize all over again how amazing that is.

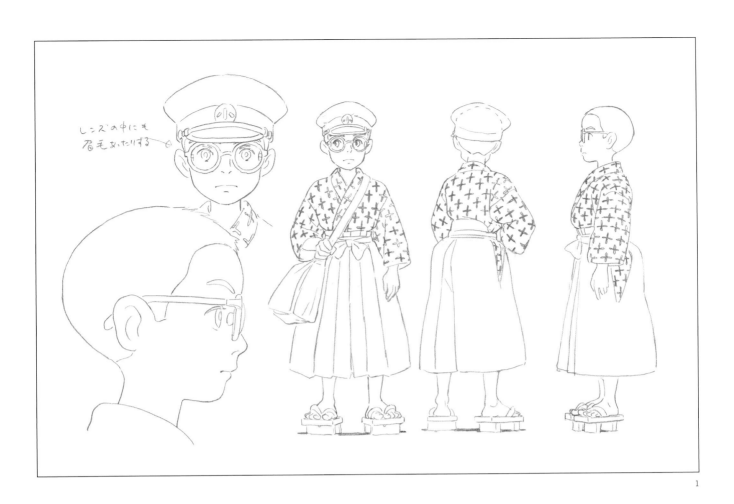

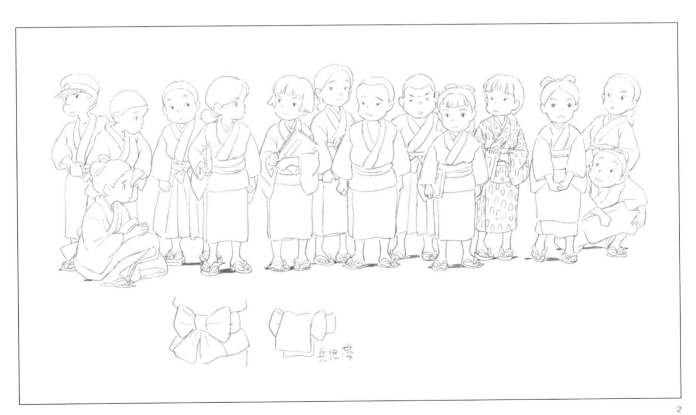

1/Jiro in his boyhood. In his usual clothing for commuting to school. [Character design]
2/Elementary school students. They are all wearing kimono. [Character design]

The Wind Rises Production Process I

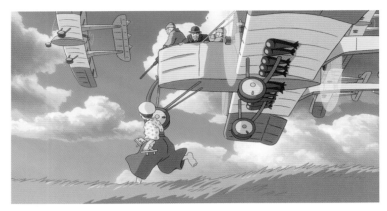

In recent years, animation production has changed significantly from the old hand-drawn cel animation to digital animation through the use of computers, and on top of that, we're now in an age where even the film itself is not necessary. In this shifting world, Studio Ghibli continues to create animation that takes advantage of a hand-drawn style using the pens and paints of the analog era while adopting and incorporating the latest digital technologies. Taking *The Wind Rises* as an example, let's take a look at the actual process of just how Studio Ghibli makes animated movies now.

Completed frame

The example we'll look at here is one shot from the dream sequence at the beginning of the film where Jiro and Caproni meet in the field (C-114/00:00:03:12). In addition to the characters and the airplanes, there is the movement of the clouds and grass in the background, and with the strange color of the light among other things, it is a visual that is symbolic of the theme of the film.

Concept to design

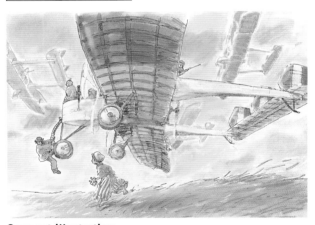

Concept illustration

To start, director Hayao Miyazaki draws initial images that pop into his head as "concept sketches." These are done in the form of sketches on drawing paper using watercolors to show places, characters, and backgrounds that will be key visuals, with additional explanations occasionally noted, such as details about the machinery, character personalities, the background of the era, or lines that will be spoken in that shot. These sketches are posted in the staff room and other areas and are often used to share the concept among the staff. In the case of *The Wind Rises*, a total of eighteen concept sketches were drawn.

Storyboard

Miyazaki then takes the visuals for the film shown in fragments in the concept sketches and creates the entire film, a complete story, in storyboards. The entire film is determined here from configuration and camera work to where to insert dialogue, music, and sound effects; the settings are noted in much greater detail than in the concept sketches, and each area of work for the staff is delineated. In an animated film, the storyboards are the foundation for all work on the film, and though there is also some overlap with the final scenario manuscript, the storyboards are particularly meaningful as a method for Miyazaki to pull together the entire story.

Animation

Layout

After the characters are created based on the concept sketches and the storyboards, work on the animation begins. First of all, the key animator (Shinji Otsuka in the case of this shot) meets with Miyazaki and decides on a layout for the screen configuration. The layout is often drawn on multiple pages because it includes a variety of elements such as the structure, the movement of the characters, and the relationships with the background. For this shot, there were a total of five: the beginning shot for each of the planes in front of and behind Jiro, in addition to two each for the end of the shot, and one depicting the movement of the clouds. Miyazaki checks the layout and once he gives the okay, the animation and art departments begin their work.

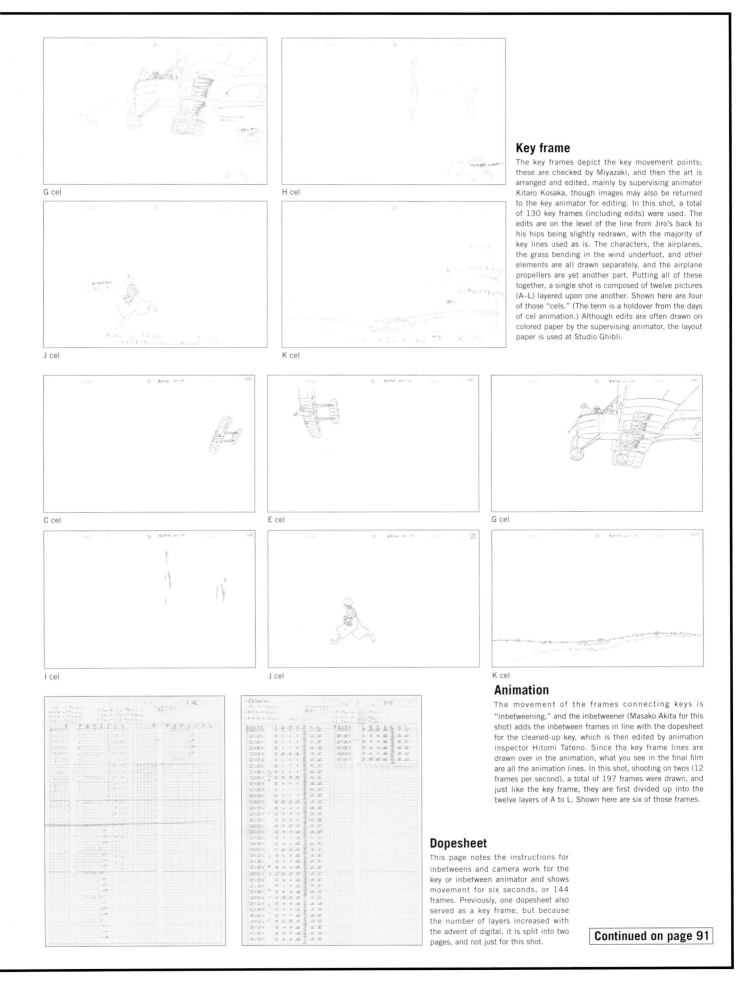

G cel

H cel

J cel

K cel

Key frame

The key frames depict the key movement points; these are checked by Miyazaki, and then the art is arranged and edited, mainly by supervising animator Kitaro Kosaka, though images may also be returned to the key animator for editing. In this shot, a total of 130 key frames (including edits) were used. The edits are on the level of the line from Jiro's back to his hips being slightly redrawn, with the majority of key lines used as is. The characters, the airplanes, the grass bending in the wind underfoot, and other elements are all drawn separately, and the airplane propellers are yet another part. Putting all of these together, a single shot is composed of twelve pictures (A–L) layered upon one another. Shown here are four of those "cels." (The term is a holdover from the days of cel animation.) Although edits are often drawn on colored paper by the supervising animator, the layout paper is used at Studio Ghibli.

C cel

E cel

G cel

I cel

J cel

K cel

Animation

The movement of the frames connecting keys is "inbetweening," and the inbetweener (Masako Akita for this shot) adds the inbetween frames in line with the dopesheet for the cleaned-up key, which is then edited by animation inspector Hitomi Tateno. Since the key frame lines are drawn over in the animation, what you see in the final film are all the animation lines. In this shot, shooting on twos (12 frames per second), a total of 197 frames were drawn, and just like the key frame, they are first divided up into the twelve layers of A to L. Shown here are six of those frames.

Dopesheet

This page notes the instructions for inbetweens and camera work for the key or inbetween animator and shows movement for six seconds, or 144 frames. Previously, one dopesheet also served as a key frame, but because the number of layers increased with the advent of digital, it is split into two pages, and not just for this shot.

Continued on page 91

Jiro Horikoshi: *Twenty Years Old*

Moving on to study in the Department of Aeronautics and Astronautics of the Faculty of Engineering at Tokyo Imperial University, Jiro encounters a young girl, his future partner Nahoko Satomi, on his way back to Tokyo. But as the train they are riding approaches Tokyo, an unprecedented disaster, which will later be called the Great Kanto Earthquake, strikes. In the confusion, their first meeting leaves them not knowing one another's name.

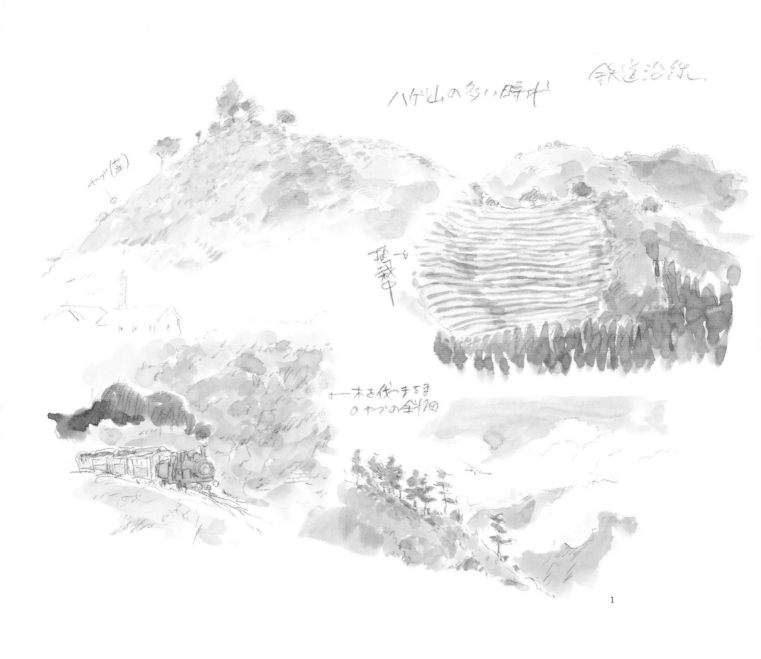

ハゲ山の多い時代

鉄道沿線.

ヤブ(生)

播種中

←木を伐ったまま
のヤブの全ツ70

1

To Tokyo

P58–59/The train Jiro is on heads toward Tokyo.
1/The scene along a Taisho era railway. [Concept sketches]
2/The mountains that can be seen along the way from the carriage. [Background]
3/Near the door where Jiro and Nahoko exchange their first words. [Background]

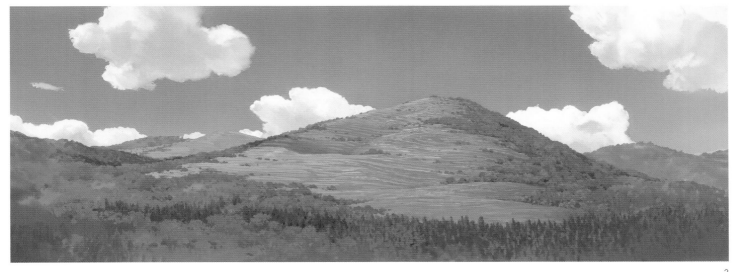

2

3

Twenty-year-old Jiro

1/In the crowded third-class car, Jiro gives up his seat to a woman, goes out onto the deck between his car and the second-class car, and starts reading.
2/Jiro's summer clothes as a student at Tokyo Imperial University (now known as the University of Tokyo). [Character design]

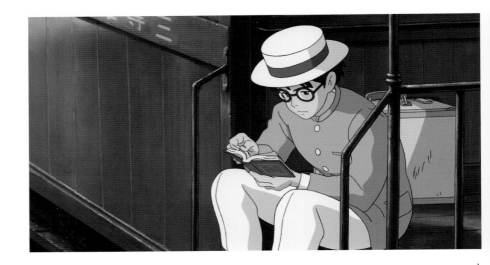

1

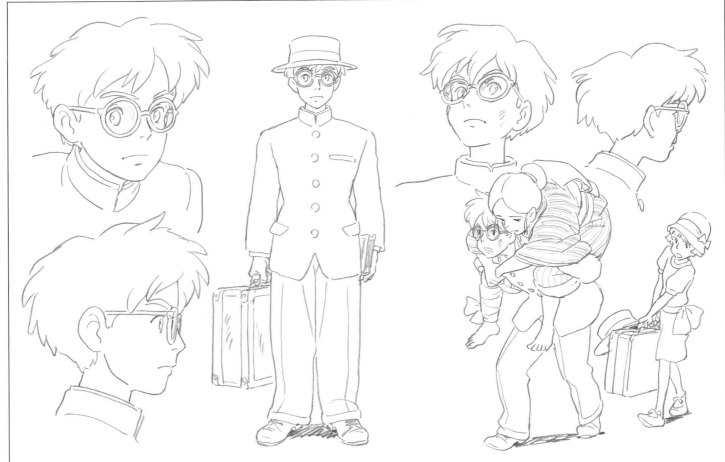

2

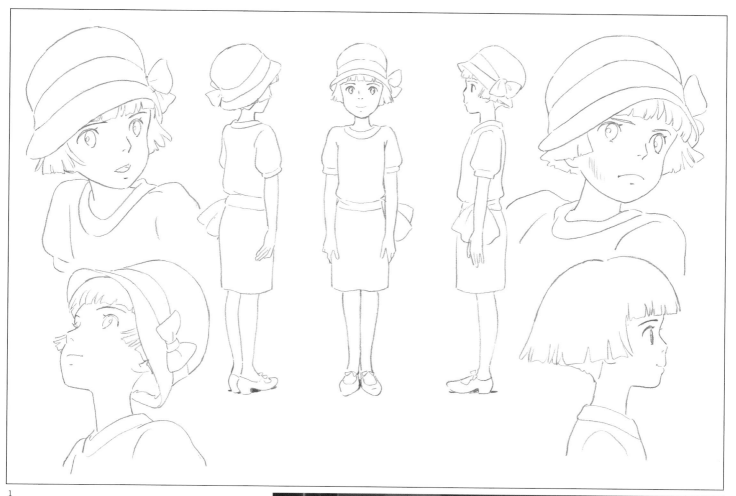

1

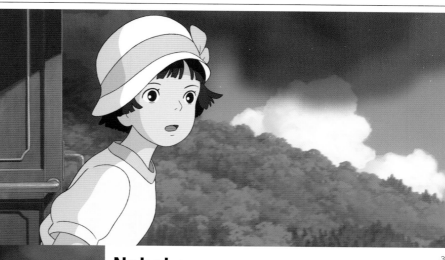

2

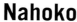

3

Nahoko

Nahoko Satomi, the girl who has a fateful encounter with Jiro. She is about thirteen at the time. A precocious, cheerful, and sporty girl. Jiro's first impression is that she is a tomboy like his sister, Kayo.

1/Nahoko in Western clothes. From the fact that she and her attendant (O-Kinu) are riding in second class, it is clear she was raised in an affluent family. [Character design]
2/Jiro noticing Nahoko and O-Kinu coming out onto the deck.
3/At that time, Jiro's hat is carried off by the wind and Nahoko stretches out to catch it.

First of all, Nahoko had to be cute. That was the major prerequisite, and we drew a lively girl. Miyazaki told me something very abstract, a B-class super dreadnought, but I didn't know whether that was referring to her personality or not. [*laughs*] Since the sense of airiness and the underlying mood of the character is the same for any Ghibli film heroine, I drew her in a similar vein as the others.

–Supervising Animator: Kitaro Kosaka

Meeting

1, 2/Jiro supporting Nahoko and thanking her for his hat. Nahoko suddenly recites a line from a Paul Valéry poem in French.
3/Jiro recites the next line of the poem and Nahoko smiles.
4/O-Kinu, the young maid accompanying Nahoko back to Tokyo. [Character design]

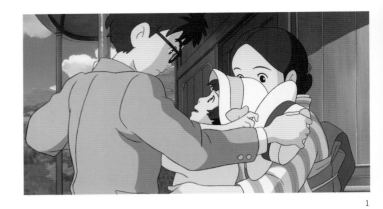

1

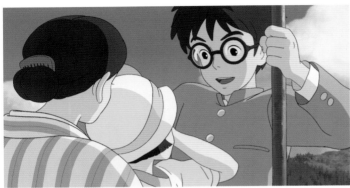

2

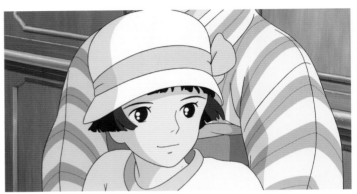

3

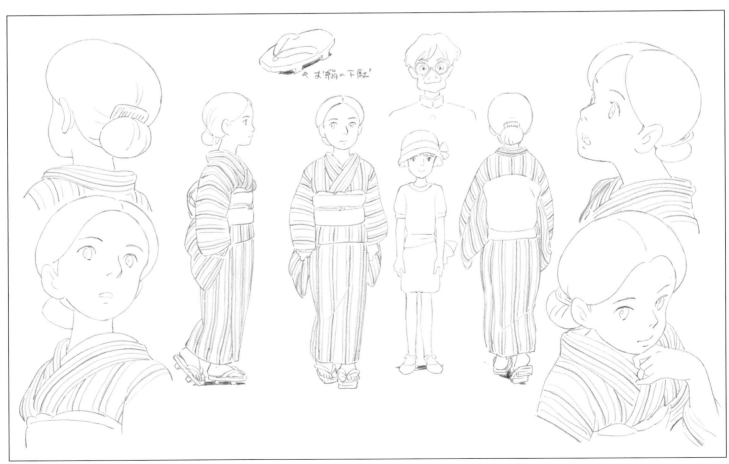

4

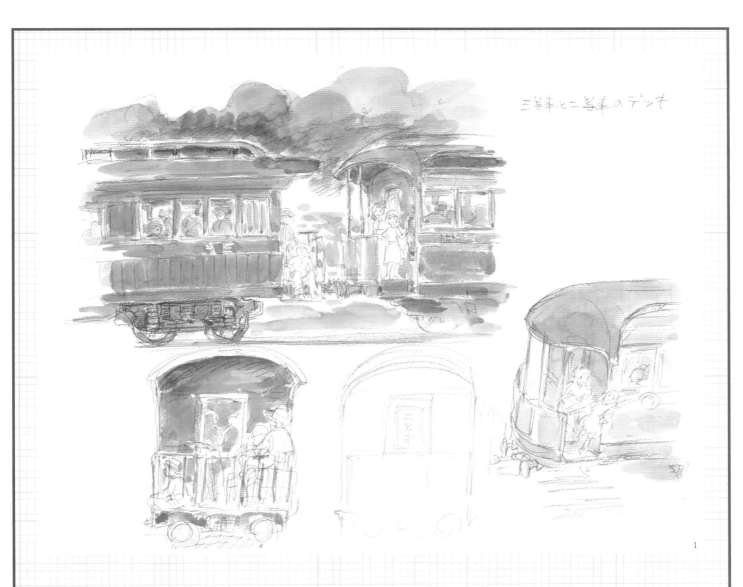

三等車と二等車のデッキ

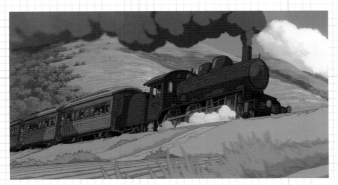

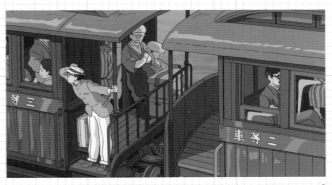

Class 6700 steam locomotive

The first domestically produced train in Japan, built by Kisha Seizo Kaisha and Kawasaki Dockyard in 1911. The locomotive was connected to a coal tender filled with coal and water, and called the Model 2B tender locomotive. Because the main body of the locomotive could hold a great deal of water and coal thanks to a tank-type car equipped with coal and water, it was used for long-distance trips.

1/Around the deck connecting second and third class where Jiro and Nahoko meet. [Concept sketches]
2–4/The carriage of the Class 6700 steam locomotive Jiro is riding to Tokyo. Passengers are squeezed in on the third-class carriages, and Jiro gives up his seat to a woman and moves to the deck.

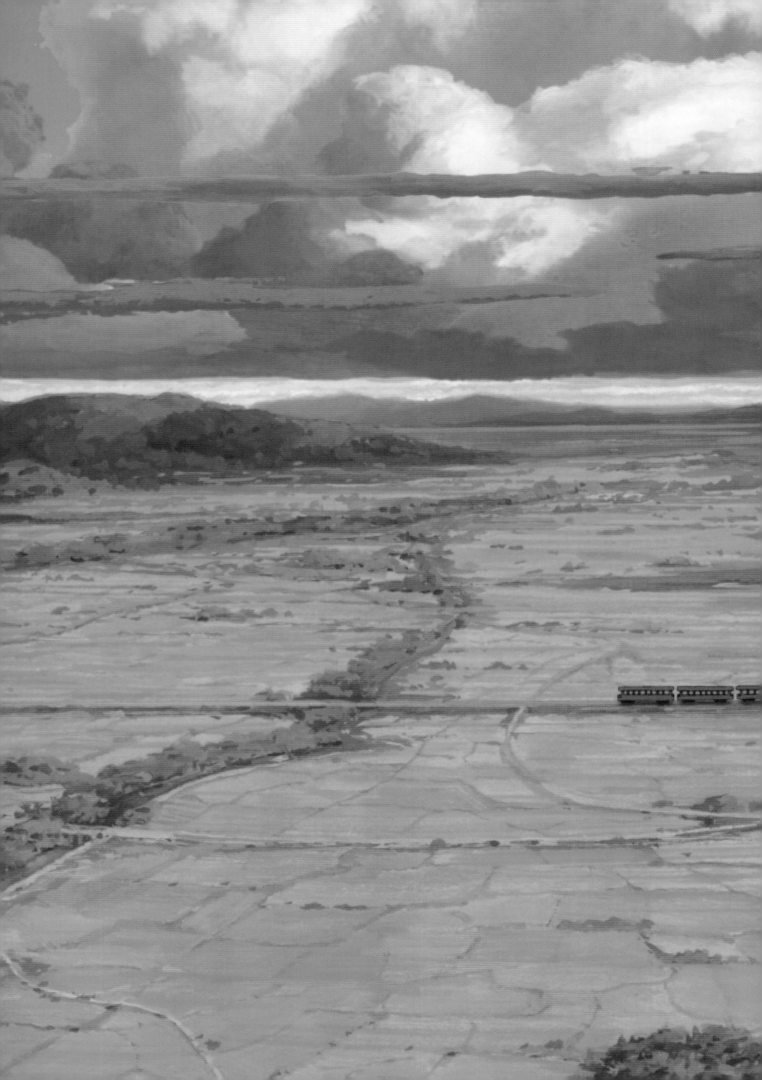

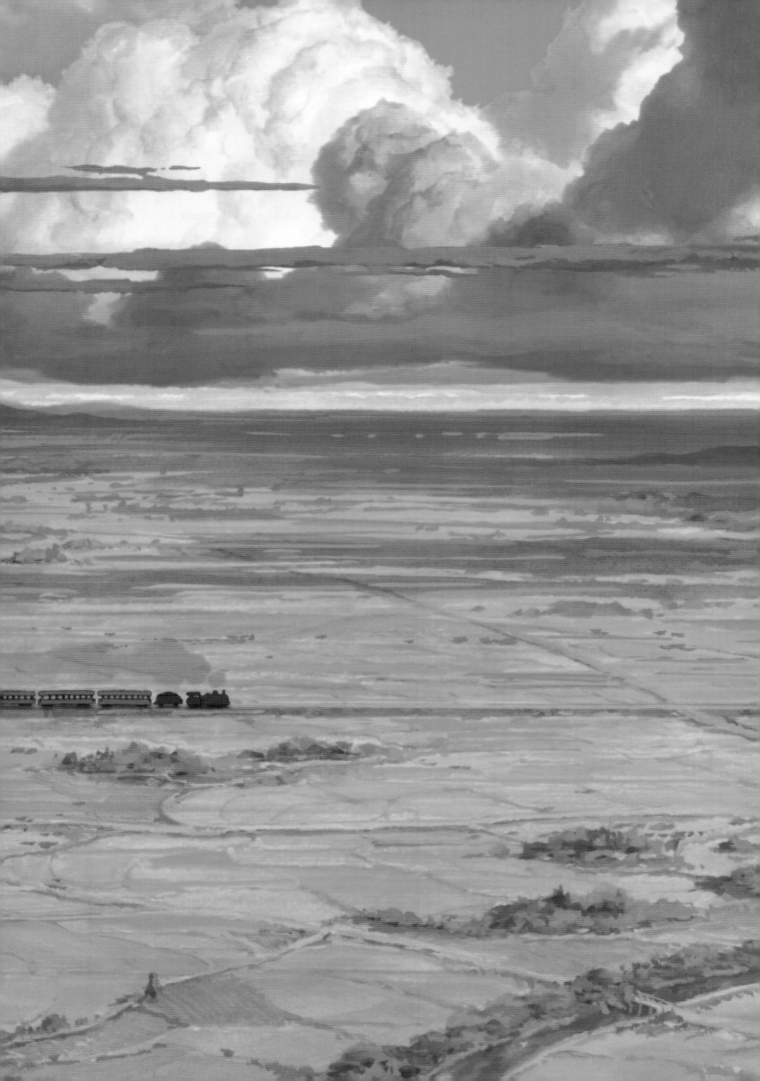

The Great Kanto Earthquake

P64–65/The train running through a large field. There were a lot of clouds that day from the aftermath of a typhoon.
1/Looking down on Tokyo where the greenery of the country was still conspicuous. The powerful wave surges over it from the direction of the bay.
2/The wave of the earthquake pierces the town and its lingering Edo-era feel.
3/The earth itself leaps up and houses are destroyed one after another. Roof tiles fall to the ground, and a thick cloud of dust rises up.
4/The locomotive braking abruptly as the tracks are hit hard by the earthquake.
5/Passengers scramble and flee from the finally stopped train.

We also moved the houses in the animation in the earthquake scene. In the beginning, we weren't drawing tiles on the roofs, but then we decided it would be better with tiles, so we added them in one at a time. And then we realized that moving so violently like this, the tiles would have to go flying too, so I ended up drawing the tiles and making them fly. This shot really took a long time to do.

–Supervising Animator: Kitaro Kosaka

For the Great Kanto Earthquake scene, there are clouds of dust and smoke from fires winding up into the air, darkening the sky, and on top of that, the wind is blowing from a number of different directions, so I was conscious of trying to bring out as much of a sense of weight as possible, so you don't get the impression of the smoke coming from any fixed direction. I drew the place with the clouds rising up like enormous cumulonimbus clouds in the sky above a burning Tokyo based on records from the time, but since they're being hit by the setting sun, I finished it with a kind of disturbing feel. This background was also used in the B29 air raid scene in the later part of the film, after some adjustments were made to it.

–Art Director: Yoji Takeshige

1

2

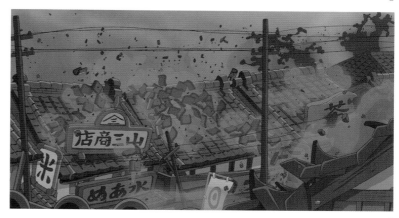

3

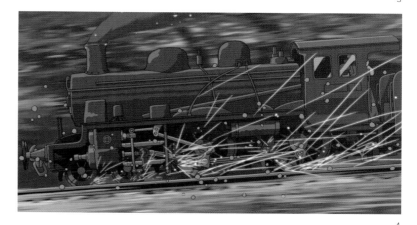

4

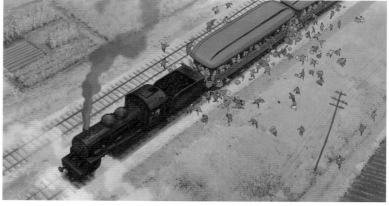

5

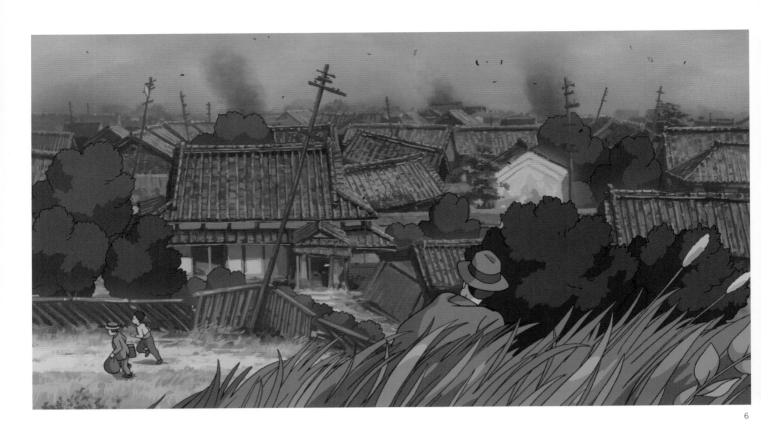

6

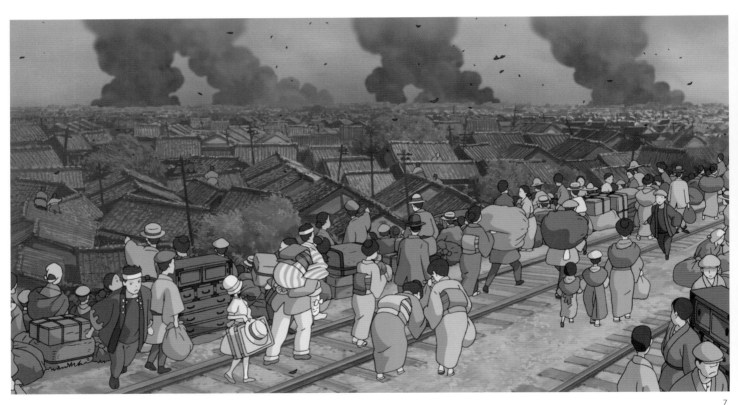

7

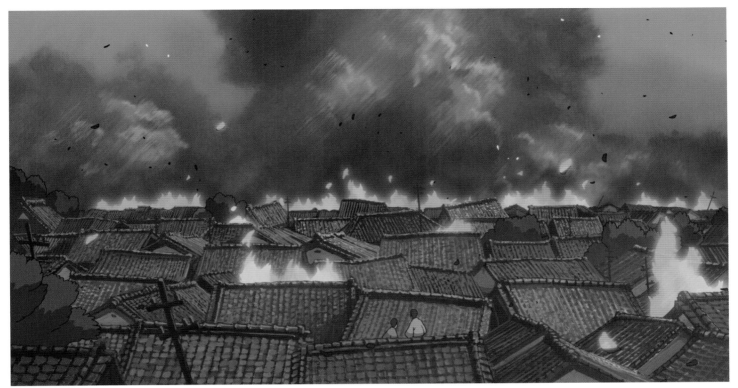

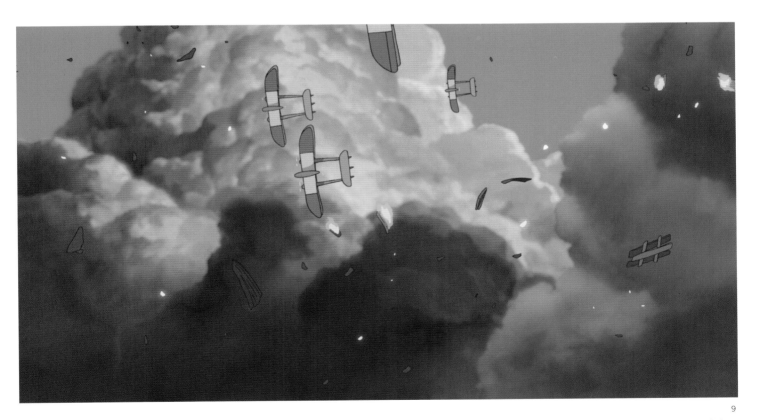

6/As the aftershocks continue, a strong wind blows and the grasses bend. Black smoke starts to rise here and there from the houses in the town that can be seen from the railroad embankment.

7/People fleeing for safety along the railroad embankment. Jiro carrying O-Kinu and Nahoko can be seen there too.

8/In the blink of an eye, the black smoke becomes a large fire that swallows the town.

9/The smoke from the fires coils like a cloud and rises up high into the sky. For a moment, Caproni's triplane bombers are reflected in Jiro's eyes, but this is just garbage aflame, dancing in the sky.

The scene with the crowds of fleeing people is vivid. Miyazaki's experience seeing the beginning of the evacuation and living through the air raids in Utsunomiya when he was young was used in this scene. He says the view from high ground of firebombs falling on Utsunomiya is still vivid in his memory.

–Supervising Animator: Kitaro Kosaka

Evacuation

1–3/After Jiro splints O-Kinu's broken leg with his slide rule as an emergency measure and brings Nahoko and O-Kinu water to drink using the new shirt his mother gave him, he decides to see them to Nahoko's home in Ueno.

4/A long line of people evacuating forms toward a hill with a shrine on it.

5/Jiro, Nahoko, and O-Kinu climb a sunken road with citizens evacuating with their possessions.

I drew the keys for the scene of the mob of people evacuating on one page. If I had split them up into several pages, it would've been too easy to end up with discrepancies, with people bumping into each other and things. I captured the spirit of the mob of people and added a separate existence to it, bringing out a sense of reality.

–Supervising Animator: Kitaro Kosaka

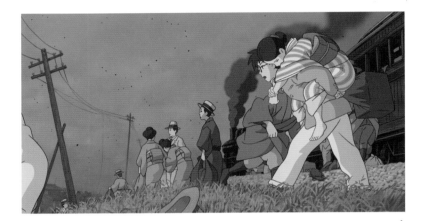

1

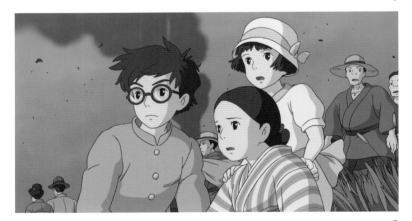

2

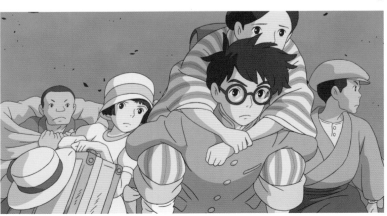

3

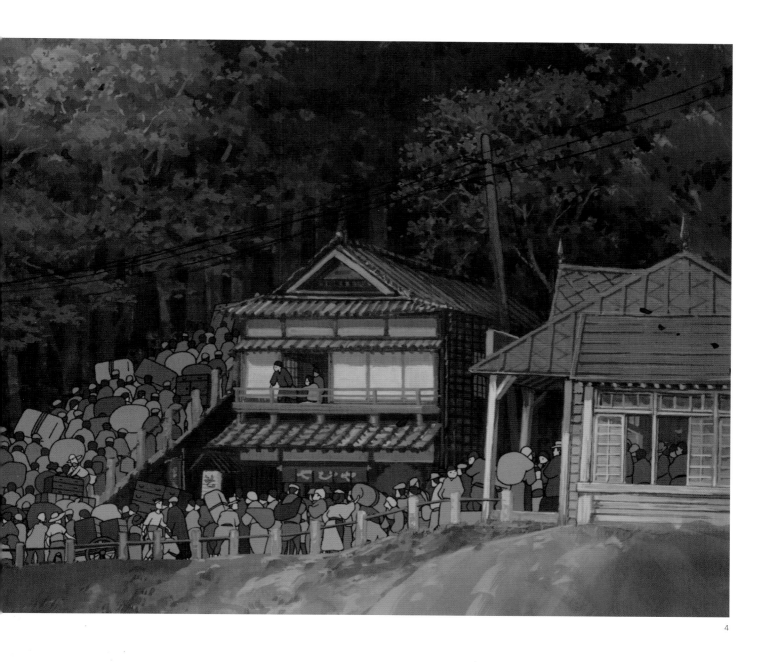

4

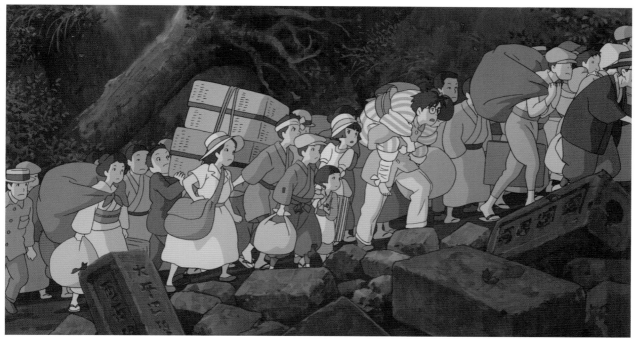

5

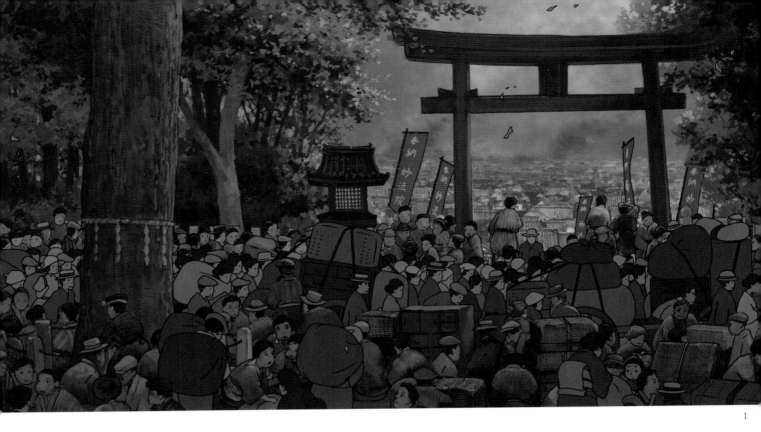

1

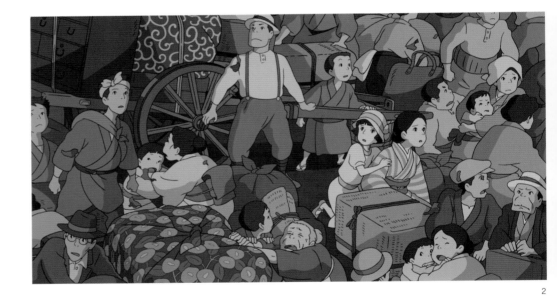

2

Aftershocks

1/The grounds of the shrine overlooking the town. The area is crowded with people evacuating.
2/People afraid of the continuing aftershocks. Jiro decides to go with Nahoko to her house to get help.
3/Tokyo, a sea of fire as seen from the Ueno direction. The smoke from the flames creates a disturbing cloud and covers the sky above the city. [Concept art]

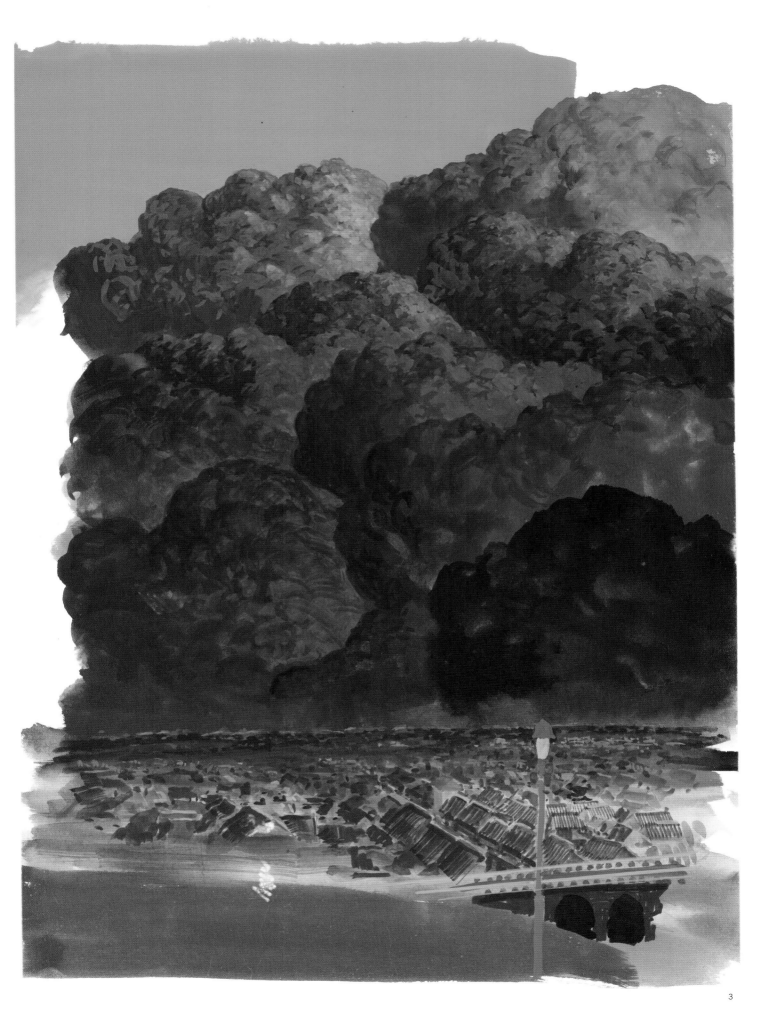

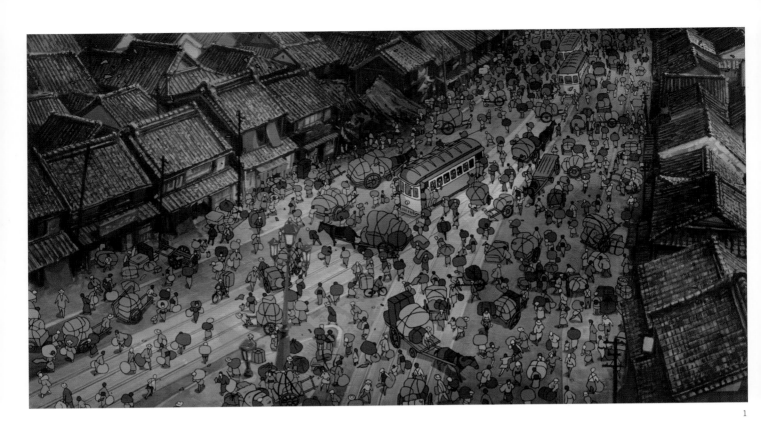

1

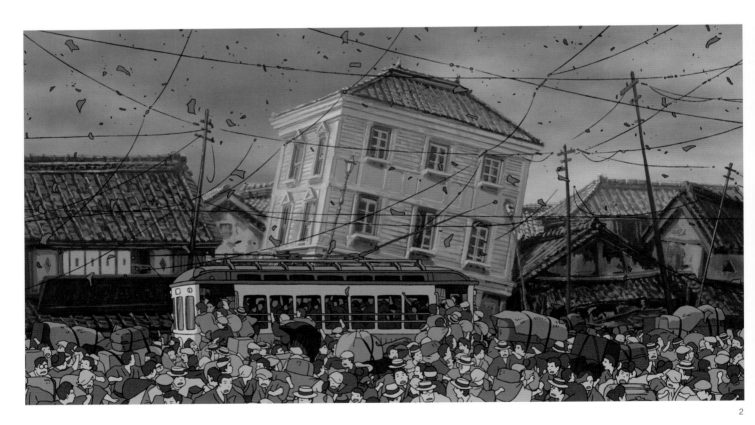

2

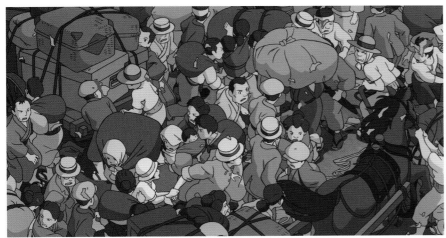

Amid the confusion

1/Main street in Ueno in confusion with crowds fleeing.
2/People coming and going in front of a tilted Western building and collapsed houses. A municipal train pushes forward slowly packed with people.
3/Rough sketches of people evacuating. [Concept sketches]
4/Jiro and Nahoko running frantically through the crowds.

1

2

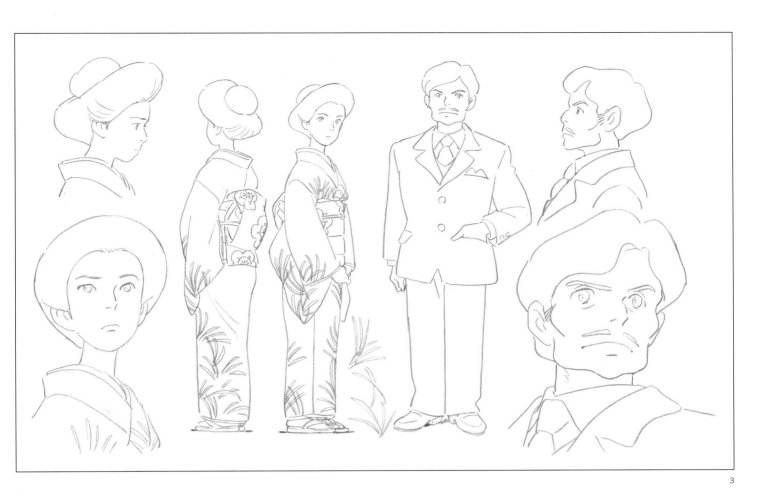

3

4

Residential area

1/One corner of a residential area down an alley from the main road. This is where the Satomi house is, surrounded by hedges and walls. [Background]

2/The road in front of the Satomi house. After seeing Nahoko welcomed home by her family, Jiro returns to O-Kinu, showing the servants the way. [Background]

3/Nahoko's parents. [Character designs]

4/Nahoko tries to go back with Jiro, but her parents hold on to her and she is brought inside.

5/Seeing O-Kinu home safely, Jiro leaves without giving his name. O-Kinu watches him leave while the manservant notes, "That's quite a guy."

Nahoko's father's face is that of Count Cagliostro from *The Castle of Cagliostro*. [*laughs*] Miyazaki himself told me he looked too much like Cagliostro, but in Miyazaki's storyboards his face really is like this, so I said, "But I've already drawn it like this," and we just went with it. In the second half, he has less hair and makes a different impression.

−Supervising Animator: Kitaro Kosaka

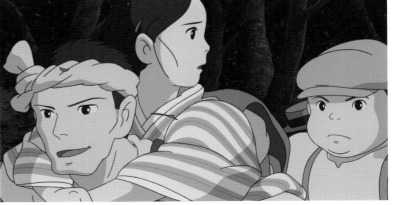

5

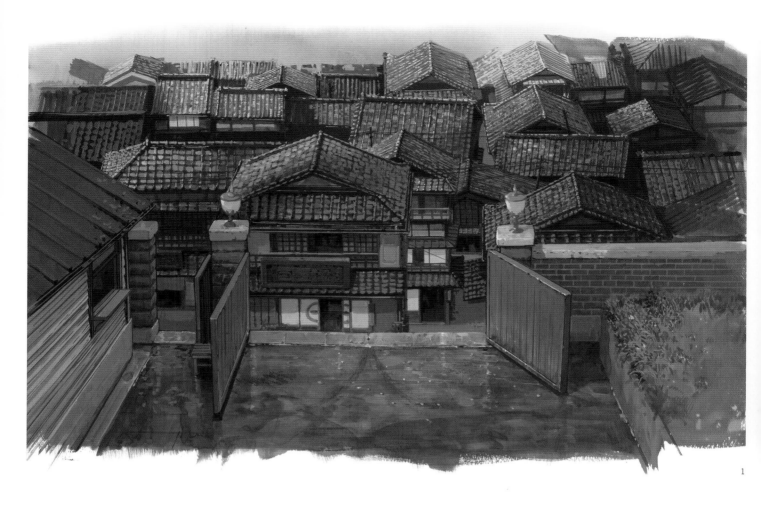

1

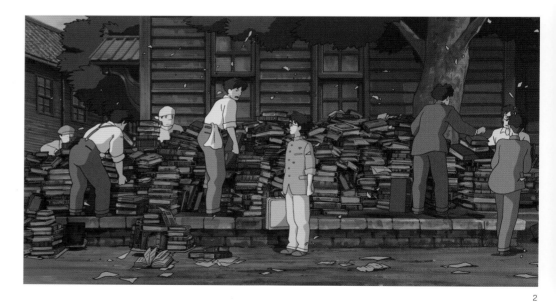

2

University library

1/Near the gates of the Imperial University in Hongo. The paving stones are wet from the water used to fight the fires. After weaving his way through the people running around, Jiro is dumbfounded at the terrible scene on the school grounds. [Background]

2/Honjo, carrying books from the burning library, calls out to him. "Well, if it isn't Jiro. You picked a lovely day to come back." "How bad is it, Honjo?" "Bad enough. The whole east side is burning."

3/The library building with smoke and flames rising up. The strong winds at the scene fan the flames.

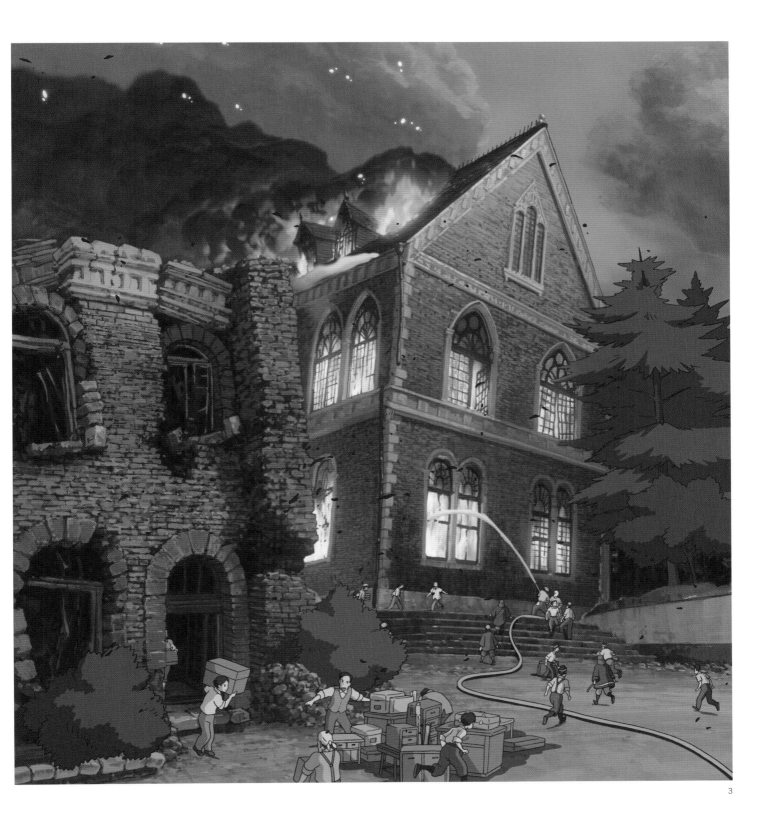

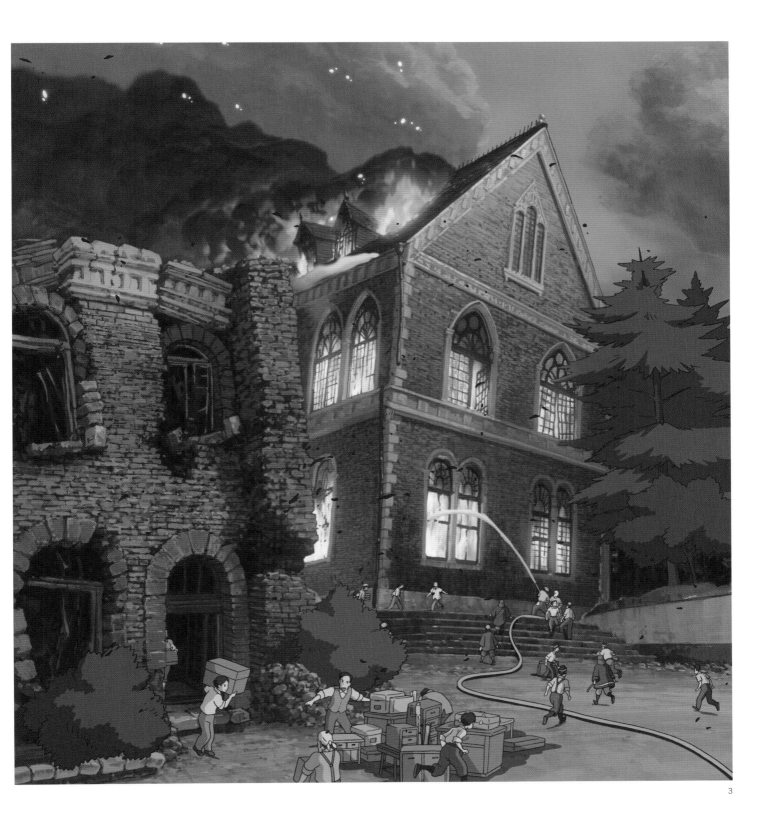3

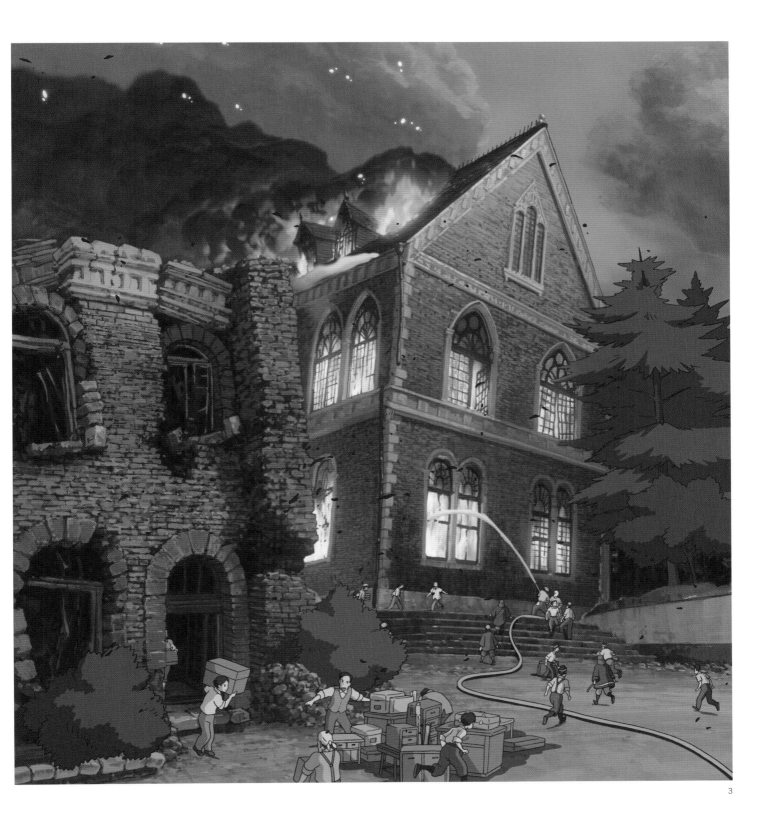81

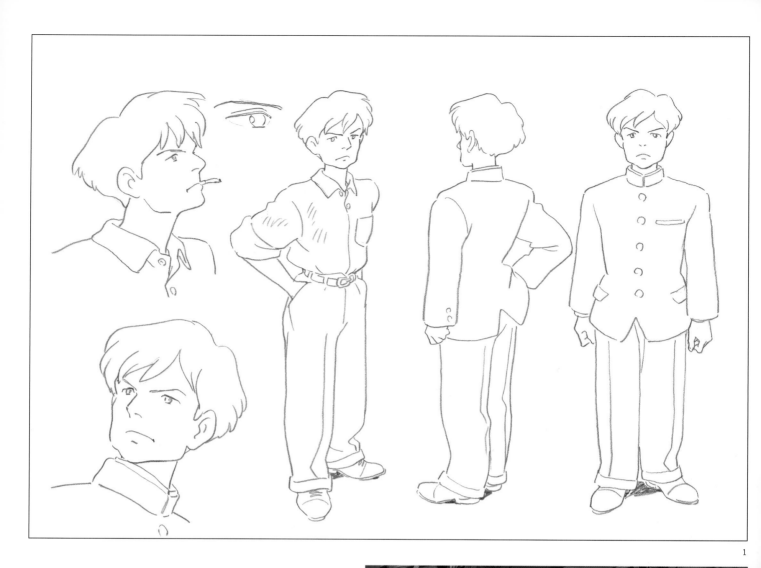

1

Honjo

A student in the same year as Jiro in the Department of Aeronautics and Astronautics in Tokyo Imperial University's Faculty of Engineering and Jiro's friend. They both end up working in the same place as excellent airplane designers/engineers, and Honjo becomes Jiro's good-natured rival. He is modeled after Kiro Honjo, a real person who designed, among other aircraft, the Mitsubishi G4M based on the technologies of the German Junkers company.

1/Honjo during his university days. [Character design]
2/Honjo taking a break from his efforts to smoke a cigarette with Jiro.
3/Standing next to Honjo, as he mutters about how Tokyo has been destroyed, Jiro looks at a fallen postcard. The face of Caproni appears there, haughty as if almost declaring his own genius. "It's as beautiful as it was in the dream. I can't believe he really built it."

I created the character of Honjo referring to the pictures in the storyboards. Honjo's jaw did protrude at first, but as we moved forward with production, it gradually became square, and from the time he starts work at Mitsubishi, his face has changed into something quite crisp. In this scene, Honjo is smoking a cigarette, and in the actual film, there are tons of scenes where people are smoking. I don't smoke myself, but I do love the cool look of smoking. At the time, they would have lit their cigarettes with matches, so there are a fair number of steps before they're actually smoking, and I worked pretty hard to skip those steps but still get the atmosphere I wanted.

—Supervising Animator: Kitaro Kosaka

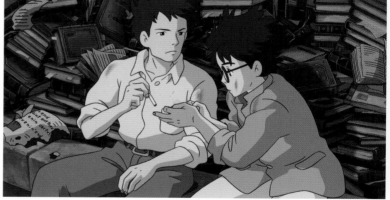

2

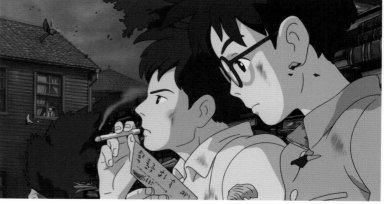

3

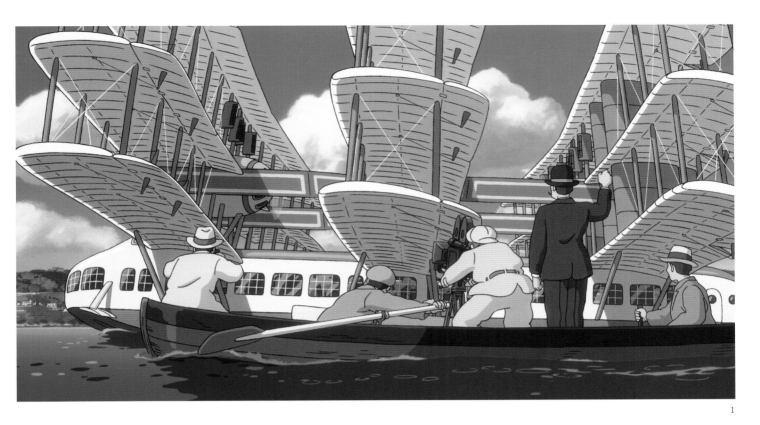

1

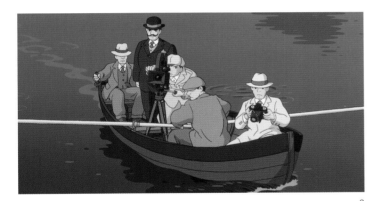

2

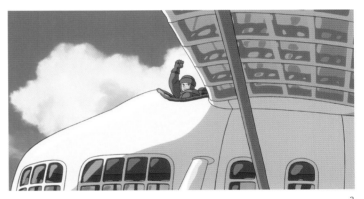

3

4

Setback

1/In 1923, a test flight for Caproni's long-desired giant flying boat took place on Lake Maggiore.
2/Men aboard Caproni's boat to record the event on film and in photos.
3/Pilot giving the signal for takeoff.
4/Caproni raising his fist and cheering him on. The camera starts to roll.

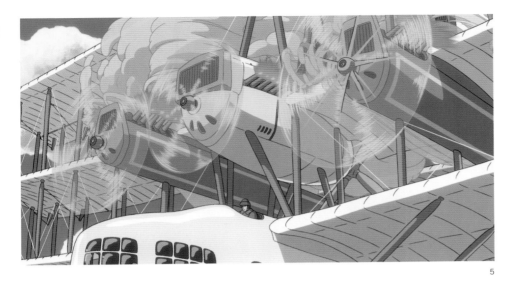

5

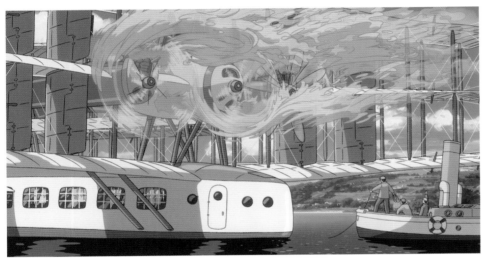

6

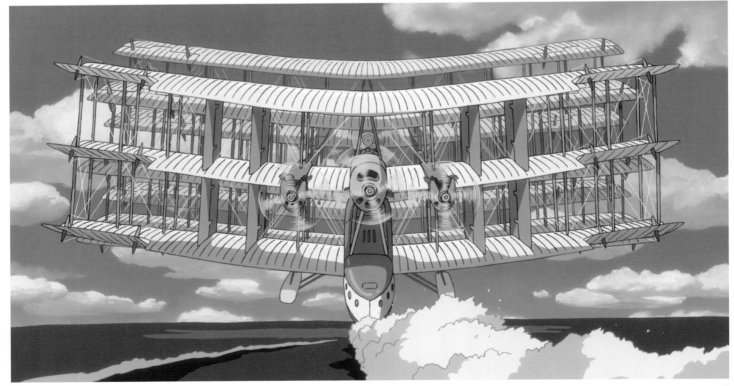

8

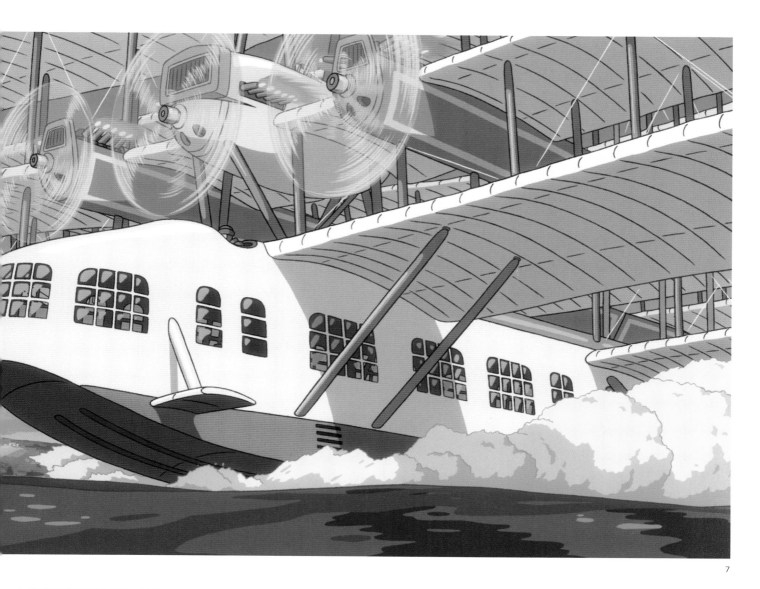

7

9

5/The power units in the front start up.

6/The engines in the rear follow suit, and with the mooring ropes untied, the plane moves away from the launch.

7/The enormous machine, like a magnificent architectural structure, pushes forward to glide across the blue surface of the lake.

8/It looks as though it is moving up into the sky without problems. At that moment...

9/The rear engine units deform, and the wings crumple from the center and collapse.

10/Caproni removes the film recording the failure and throws it in the lake. This man continuing to fight for his dream without getting discouraged lights a flame of hope in Jiro.

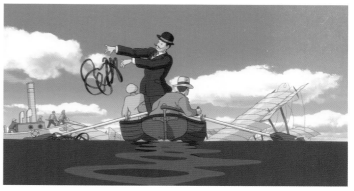

10

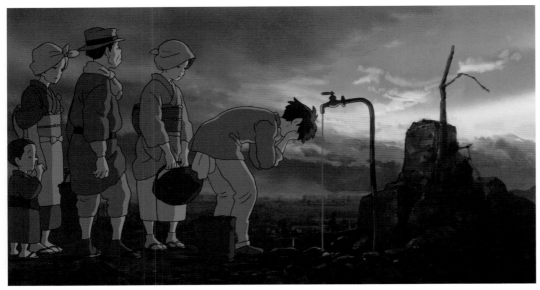

2

Morning in the ruins of the fire

1/Tokyo turned into a burnt-out field. A strangely colored dawn spreads out over the city. [Concept art]
2/Jiro washes his face with water from a tap left in the ruins of a house.
3/The fire finally recedes, and the shadows of people leaving Tokyo to find shelter with relatives cut through the ruins left behind.
4/Hearing an explosion, Jiro looks up to see a Salmson surveillance plane flying above him slowly.

1

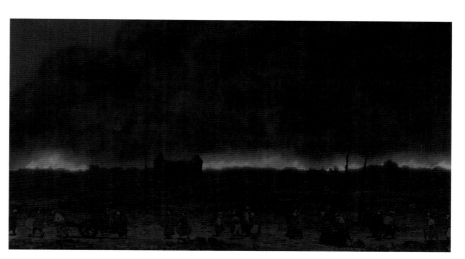

3

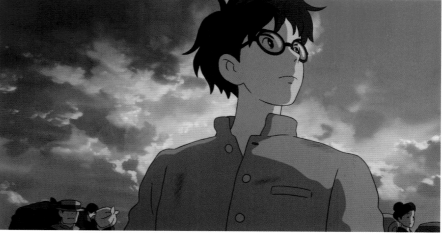

4

Interview
Yoji Takeshige
Art Director

Born in 1964 in Philadelphia, Takeshige dropped out of the Oil Painting program at Tama Art University. His first work on a Studio Ghibli film was doing backgrounds for *My Neighbor Totoro* ('88). His first turn as art director came with the short "On Your Mark" ('95), and he then went on to do the art direction for *Princess Mononoke* ('97), *My Neighbors the Yamadas* ('99), *Spirited Away* ('01), *Howl's Moving Castle* ('04), *Tales from Earthsea* ('06), and *The Secret World of Arrietty* ('10). He has also worked on *Royal Space Force: The Wings of Honnêamise* ('87), *Patlabor: The Movie* ('89), Ghost in the Shell ('95), and *Summer Wars* ('09), among others.

In the beginning, I started with something cartoonish, which changed naturally into something more like a live-action film.

I came into *The Wind Rises* on the heels of working on the short film "Mr. Dough and the Egg Princess" (2010) for the Ghibli Museum; I actually started work on it around the time Part A of the storyboard had been completed. Director Hayao Miyazaki essentially starts production before the storyboards are finished, narrowing down the worldview and story while drawing, but this time, the Tohoku earthquake and tsunami happened coincidentally when he was drawing the part with the Great Kanto Earthquake, and it seemed like a part of him was proceeding with production while wrestling with questions like whether or not it was okay to go ahead and put this to film.

Compared with previous works, Miyazaki didn't do very many concept sketches to set the foundation for the worldview, but the sketches he did do are in color, they look roughly drawn, and they're stuffed with good information. We also had the original manga, so looking at both sketches and manga I came up with my own colorings and drew the concept art in steady communication with the director. Also, about halfway through, I got to take part in the animation meetings, and I feel like I managed to grab hold of the concept and aim of this film while listening to the director talking with the animators and Okui (Atsushi), who was in charge of photography.

The first thing Miyazaki said to me was "Something like the feel of 'Mr. Dough' would be good." So for the dream sequence at the beginning, I was conscious of having a relatively bright and colorful tone, as if to connect to the idea of "Mr. Dough." I thought everything would work out fine if I could manage to create a persuasive worldview from this point, but I struggled in my own way between this and the scenes in reality, particularly with how to bring out the feel of the Taisho and Showa eras.

Since the scenes in this film often shift back and forth between the dreams of Jiro, the protagonist, and reality, I figured it would be best to draw a line between them right from the start. I didn't actually get any direction like that from the director, but I wanted to make the dream scenes special, and so for example, for things like the color of the clouds when Jiro and Caproni first meet, I made them a slightly extreme color. To tell the truth, I even thought about using oil painting techniques to make the dream scenes feel even more different. This was before the real production had begun, and I was painting in oils at home, wondering if making the grass move like this in a picture with this kind of texture would be interesting, different from the usual backgrounds. But when I showed the director these paintings, he shot me down, saying, "They're beautiful, but it would take too much time and effort, and this film doesn't need them." [*laughs*]

And looking at the actual film, the animation of things like the grass bending in the wind near the beginning is a relatively simplified movement, but in the second half, with the addition of the image processing, the depiction is more like it's moving overall. That is to say, at the beginning, we started with a cartoon style, and then the story, with the historical flow toward war with the Great Kanto Earthquake, the border moves forward toward a live-action film with a sense of reality. There was also a change like this in Miyazaki's direction, and as you move through the second half, in the end, the film feels unified with a single tone, losing the clear distinction between dream and reality in both animation and background.

On this point, at first, I was taken up with the thinking that we needed to create a unique kind of portrayal for *The Wind Rises*, but in the second half, I decided instead not to assert myself too much, and I worked to create gentle backgrounds in line with the director's aims. The art staff was made up mainly of young people— there was almost no one in their twenties, though, so maybe calling them young is not quite right—and rather than giving each of them detailed instructions, I adopted a method of working where I had each member of the art staff expand on the concept based on illustrations I had the director okay. To a certain extent, I left things to people with talent who were qualified to lead and focused on summarizing the scenes themselves. In particular, Noboru Yoshida and Tatsuya Kushida, both of whom have more experience than me in their careers as art directors, each have their own ways of making art, so I had them go ahead with the work and get Miyazaki to check it directly.

Although I'm no longer creating Ghibli films or any feature films after *The Wind Rises*, this piece made me think about a variety of things with regard to digital-based background art. There are a lot of problem points unique to digital: the coloring and the look of a single tone are different depending on the model of monitor you're using for the check; brush marks from painting the background and the material texture of the paper show up when you're shooting with a digital camera—although sometimes you use that in the film—and you have issues like how much to draw for both the animation and the backgrounds, or maybe you don't need to draw something at all. I think the opportunity to depict the natural world and the movements of the daily lives of the characters that is so characteristic of Ghibli films will become increasingly important.

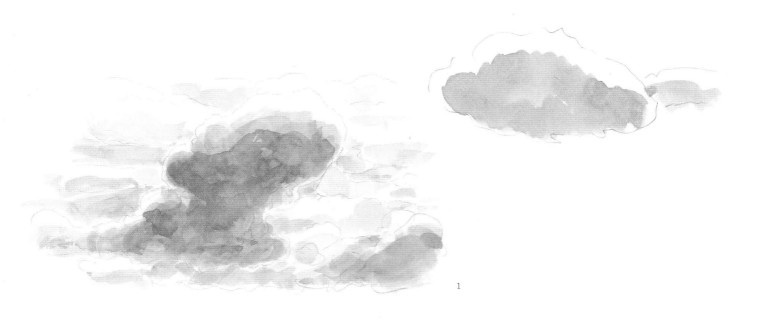

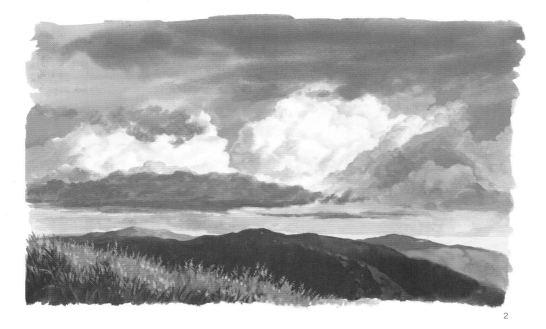

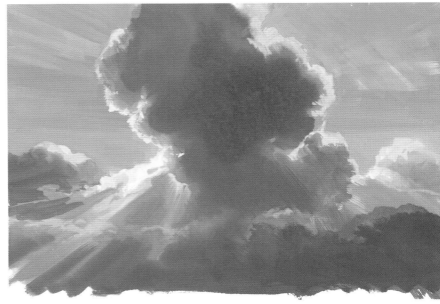

1/The concept for the clouds drawn by Hayao Miyazaki. [Concept sketch]
2, 3/Clouds and sky drawn as explorations for the background art. [Concept art]
4, 5/Concept art drawn to explore the direction for the art for each shot. [Concept art]

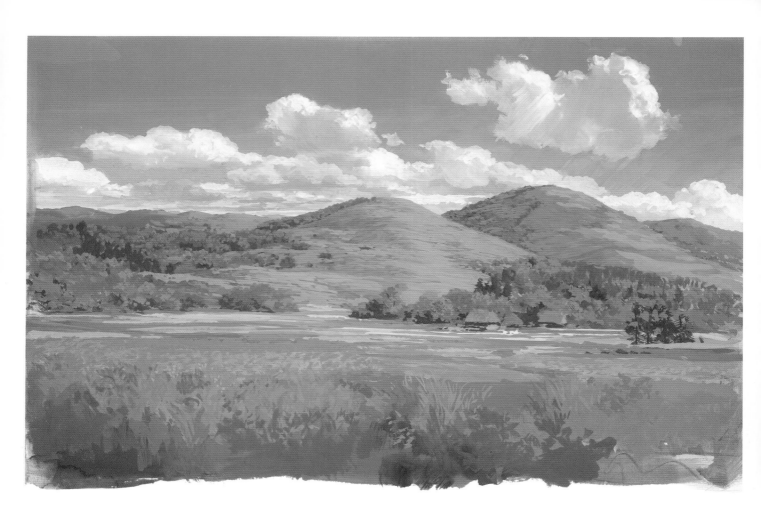

4

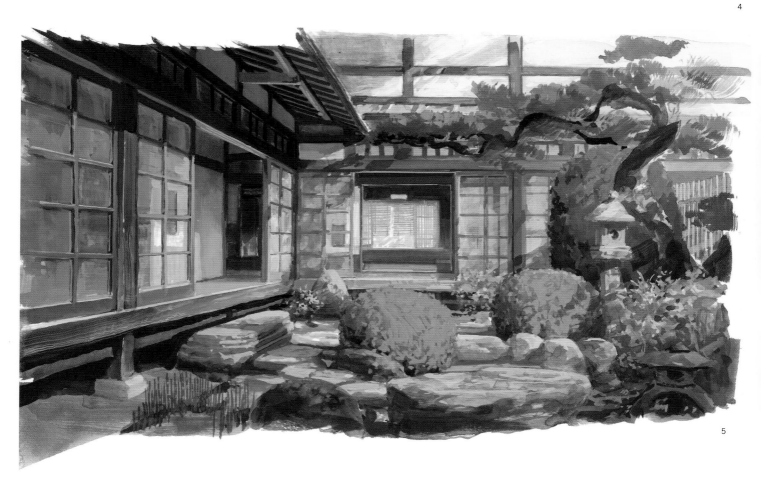

5

The Wind Rises Production Process II

Background art for animation is the creation of detailed pictures of the worldview and settings for the film that the director is imagining. In the beginning, concept art is drawn by the background art staff, centered on art director Yoji Takeshige, based on Miyazaki's concept sketches and storyboards. After exploring a variety of options, the artist in charge of the shot finishes up the backgrounds. Miyazaki checks the finished backgrounds, and after the images are revised by the artist in charge or the art director, they are sent on to photography. Based on the digitized backgrounds, the colors for the characters who will appear against them are set (see page 147), and then digital processing such as fine-tuning light and shadows or adding special effects is done on the computer as necessary.

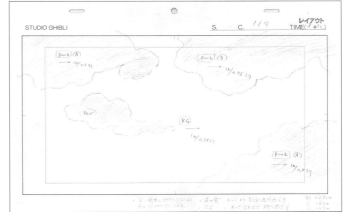

Concept art

Concept art is drawn to decide on the general art concept (background structure, coloring, etc.) based on the storyboards and the layout. These are mostly done by art director Yoji Takeshige (depending on the shot, background artists may also do some), and then these are passed along to the staff actually in charge of the background (Kiyoshi Sameshima in the case of this shot).

Layout

As with the animation, the key animator for each shot draws the layout for the art, Shinji Otsuka in the case of this shot. Since the background also slides along in this shot, moving like the animation of the characters and the machines, instructions for this motion are also noted here. "1K" is one frame (1/24 sec.), and how many millimeters it should move in that time are specified on each cloud part. Depending on the shot, a layout for the art (background key frame) might also be drawn.

Cel book A

Cel book B

Cel book C

Cel book D

BG

Cel books and BG

When there is no movement in the background. everything is drawn in one picture. However, in this shot, in addition to the movement of the camera, the clouds also move, so the clouds are drawn separately on the BG, which is the background base, and are combined on the computer where the motion is added in. In the days of cel animation, only the very bottom background art was drawn on paper, and the pages on which the clouds above were drawn were transparent cels with paint, which were layered on top to form a "book cel" and moved bit by bit to create the movement. With the introduction of digital, the need for cels has disappeared, but for this film, Miyazaki expressed that he wanted to see the shape and movement of the clouds on the actual background art, so the cel book method was adopted. Additionally, although it wasn't used in this shot, drawing the machines and other things on the background art is called a "harmony cel." (Junker G38 on page 136, IMF10 on page 164.) Noriko Takaya was in charge of all the harmonies.

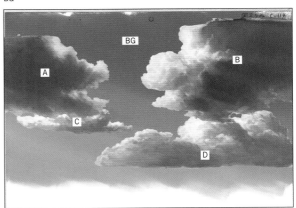

Cel book and BG layered

Continued on page 147

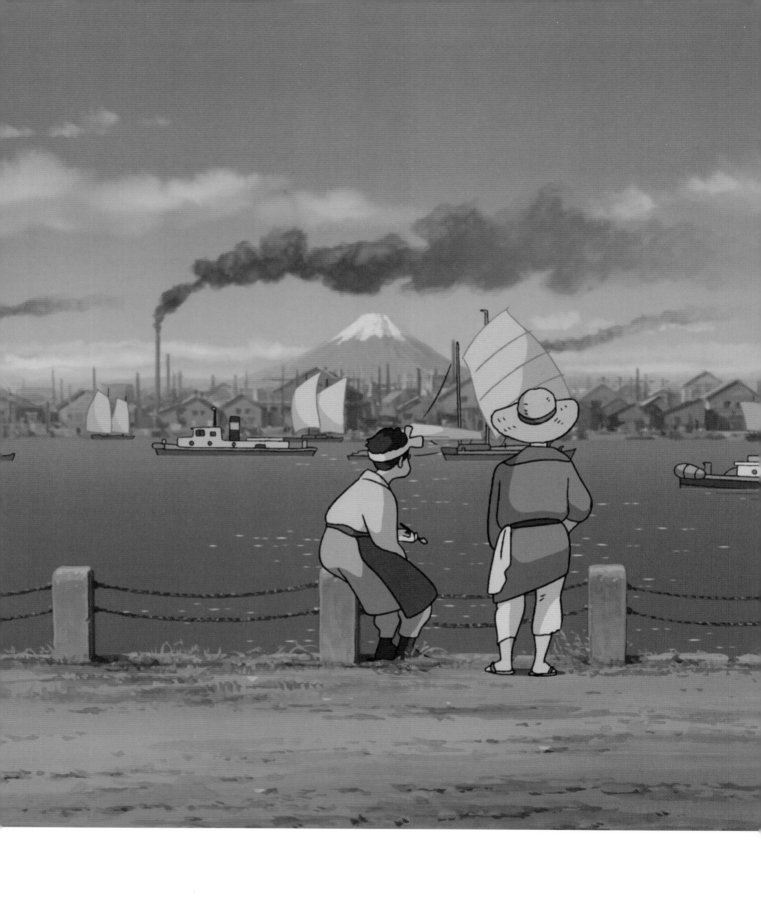

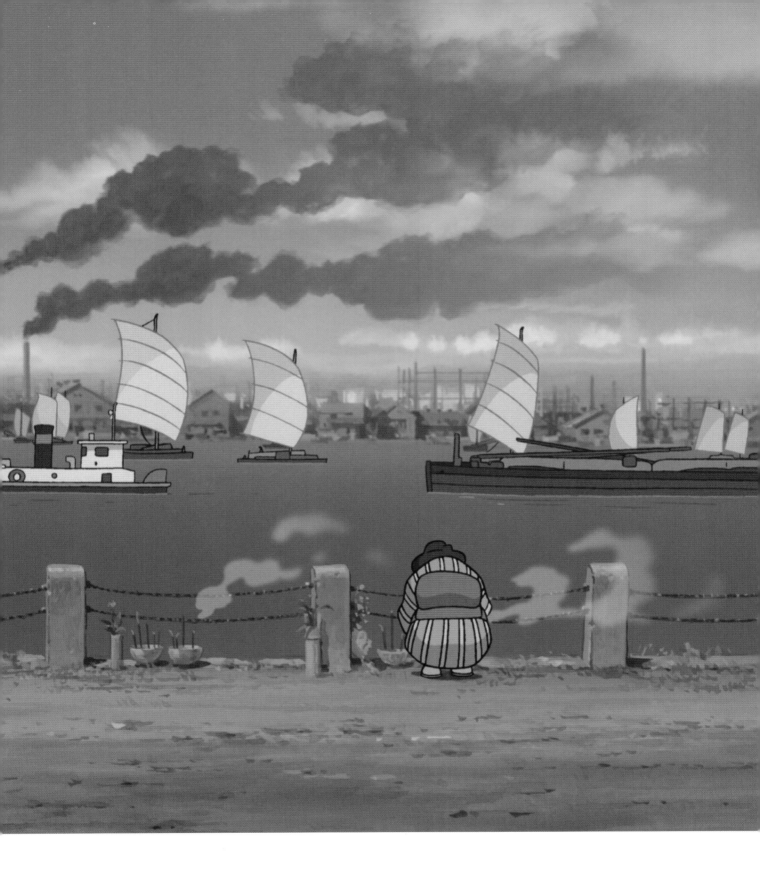

Jiro Horikoshi: *Twenty-Two Years Old*

Two years since the Great Kanto Earthquake, the reconstruction of Tokyo moves forward at a quick pace, and Jiro's life at school continues peacefully. At this time, a letter and a package arrive from O-Kinu. The house of the girl living in the residential area in Ueno was burned to the ground, and when Jiro goes to visit, he has no idea where the family has gone. Waiting for Jiro when he returns to his boardinghouse, deep in thought, is...

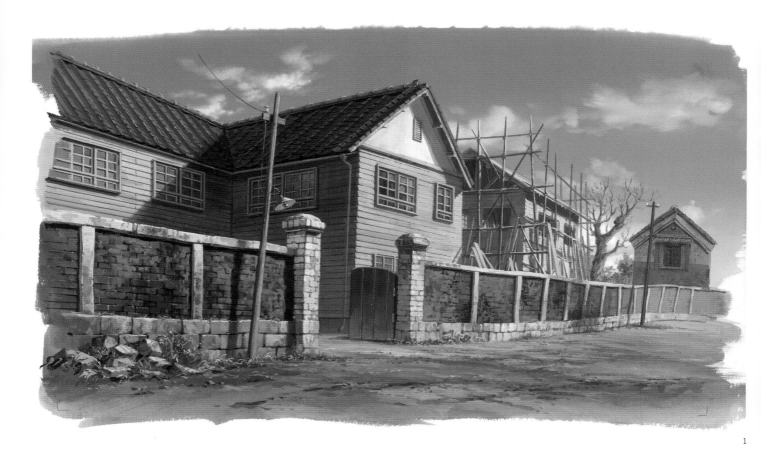

1

2

Tokyo Imperial University Faculty of Engineering, Department of Aeronautics and Astronautics

P92–93/Near the Sumida River in Tokyo, largely recovered two years after the Great Kanto Earthquake.

1/The new school building, facing the Sumida River, that houses the Aeronautics Department of which Jiro is a part. Part of the building is still under construction. [Background]

2/A package wrapped in a traditional cloth arrives for Jiro, who is absorbed in his drawing, slide rule in hand. Inside the package is the slide rule he used the day of the earthquake to bind O-Kinu's leg and a new replacement shirt, along with a letter of thanks.

3/"A present from your girlfriend?" Katayama teases. Honjo, who is not so crude, distracts Katayama with "Gimme a smoke."

4/Near the main gate from which O-Kinu's departing back can be seen after bringing Jiro's things back. [Background]

5/The road in front of the main gate that Jiro comes flying out of, chasing after O-Kinu. [Background]

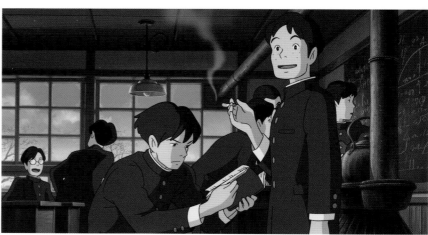

3

4

5

1

2

Mackerel bones

1/The road along which Jiro and Honjo walk to go for lunch. Cheap houses are built here and there along the way. Honjo, seeing an old plane in the sky, curses: "Nothing's changed at all." [Concept art]

2/The restaurant on the outskirts of town the two go to. [Concept art]

3/Inside the restaurant with posters and menu items up on the walls. [Concept art]

4/Honjo criticizes Jiro for eating the same mackerel lunch set as he does every day, the same way he criticizes the university lectures. "Other countries are building metal planes. We're always ten years behind. And you're still stuck on mackerel."

5/Jiro holding up the mackerel bone: "Beautiful, isn't it?" This curve was also adopted in the standards for the US aeronautics agency, the NACA, and ended up being a big hint for Jiro in making planes.

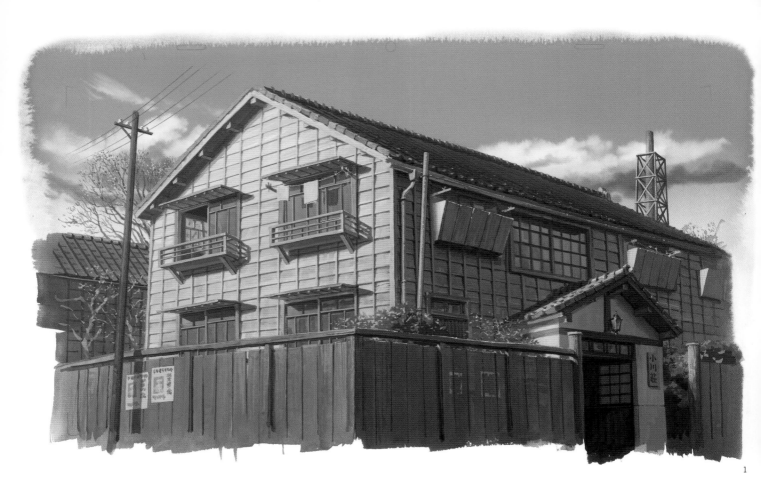

1

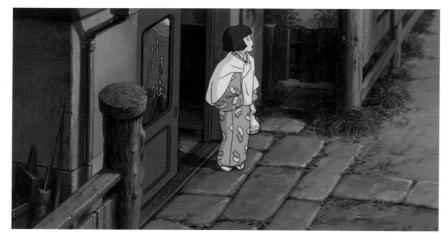

2

A guest

1/The boardinghouse where Jiro lives, Ogawaso. [Background]
2/The entrance to Ogawaso. Because it's late, Jiro decides to see Kayo back to his uncle's house where she's staying with their mother.
3/Jiro's seven-square-meter room. At night, he studies in the light of the lamp he drags over to his desk.
4, 5/A young girl sitting in the window facing the canal, waiting for Jiro to return. This is Kayo, who has come to Tokyo with their mother.

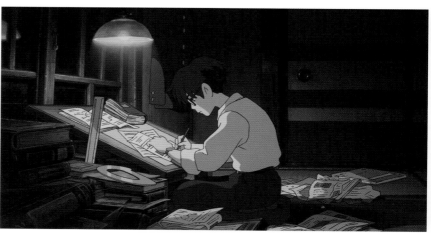

3

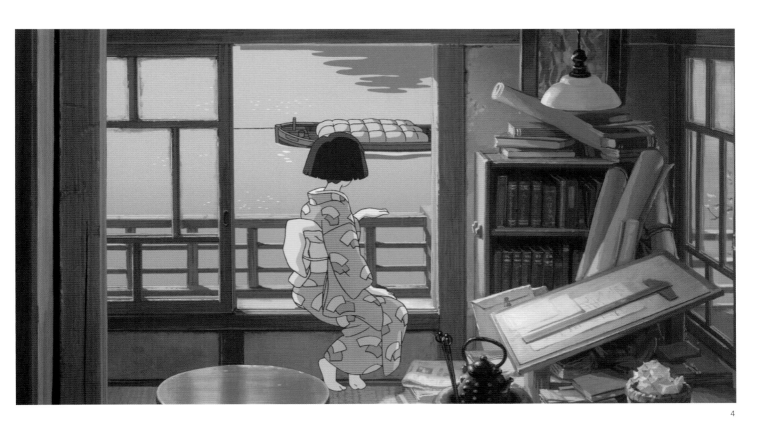

4

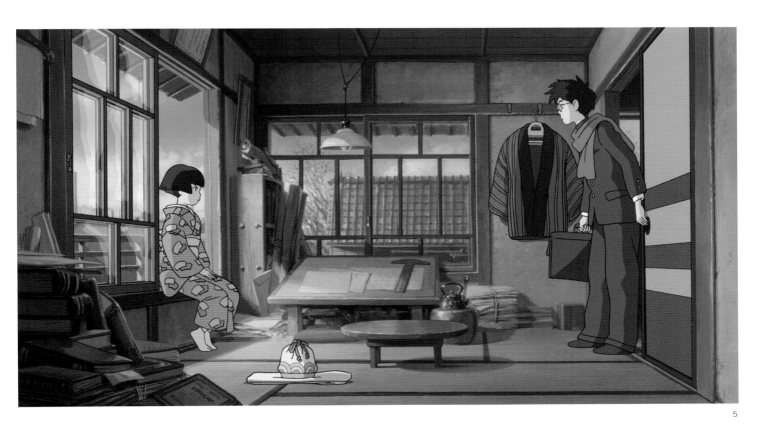

5

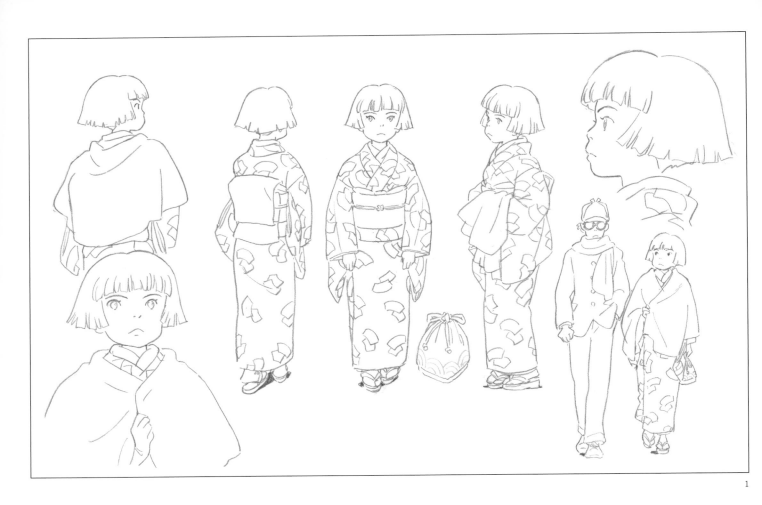

1

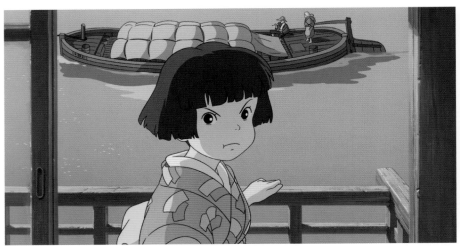

2

Kayo at fifteen

1/Kayo beautifully grown up. Her habit of calling Jiro "big brother" remains. [Character design]
2/"You're so insensitive! I'm still mad at you because you never come home." Kayo grumbles.
3–7/On the penny steamer home, Kayo talks about her dream of studying medicine at university in the future. "I think you'd make a great doctor." "I think so too." Kayo's face lights up at these encouraging words from Jiro.

I drew Kayo as an independent woman, someone who says what's on her mind, while having her still be a tomboy and have the same precocious personality even as an adult. In this film, though, all the characters are basically independent.

—Supervising Animator: Kitaro Kosaka

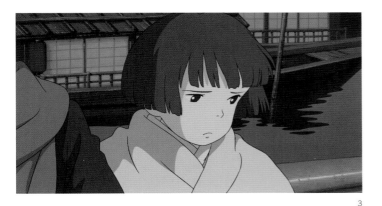

3

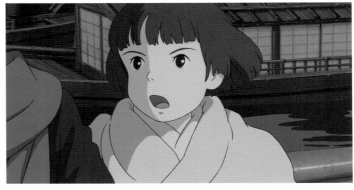

5

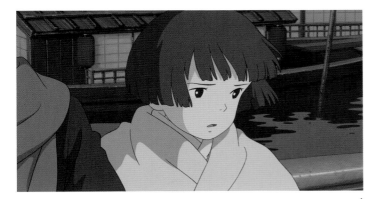

4

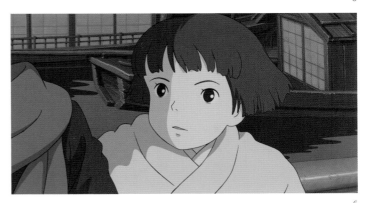

6

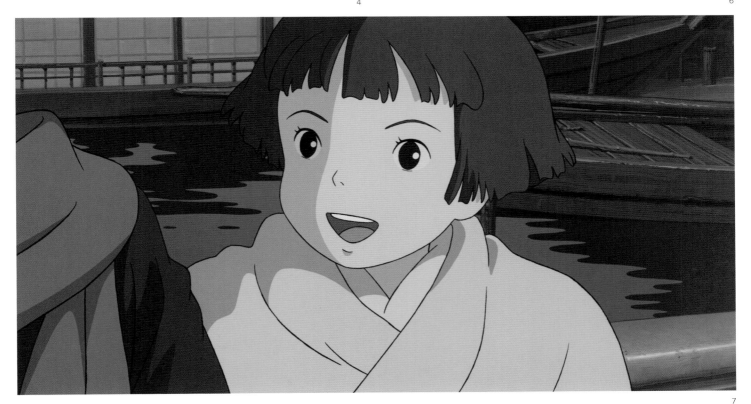

7

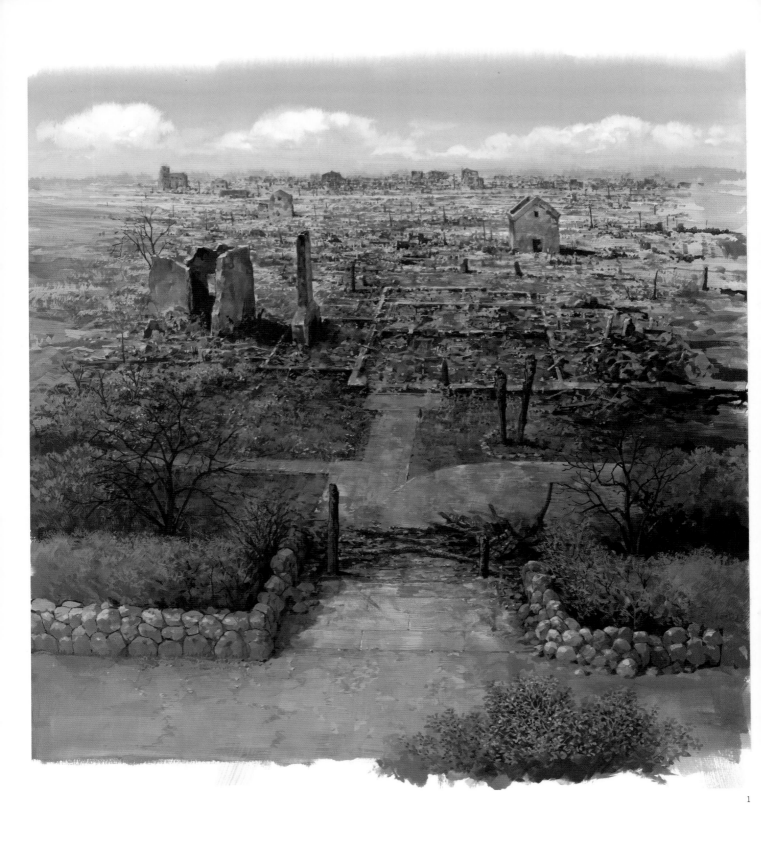

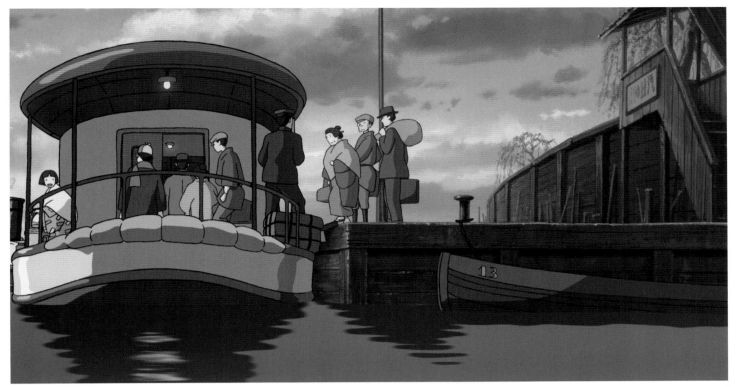

2

3

Canal in twilight

1/Ruins of the fire in the neighborhood where the Satomi house stood. Going down the road to the penny steamer dock, Jiro tells Kayo about the girl he met the day of the earthquake. When Jiro went back to the house, he found he had no idea of the family's whereabouts. [Background]
2/People getting on the penny steamer. Jiro and Kayo are among them.
3/The penny steamer exiting onto the larger river and heading toward Asakusa. The river surface is dyed with the dusk light.

4/The wake of the boat on the canal rocks the water as dusk falls.
5/The boat slips under the bridge while the road with buses and cars
coming and going is shown from the side.
6/Passing by a restaurant on the bank of the river, the boat heads into
the main river.
7/Hanakawado, a sight in Asakusa, comes into view on the other side
of the darkening waterway.

Jiro Horikoshi: *Twenty-Four Years Old*

After graduating from university, Jiro finds work at the Mitsubishi Internal Combustion Engine Company (currently Mitsubishi Heavy Industries) in Nagoya, together with his good friend Honjo. He makes his start as an airplane designer and engineer. It's a time of prevailing unrest with the poor economy and runs on the banks due to the financial crisis, but Jiro, awake to the wonder of creating airplanes, obsessively focuses all his efforts on his work.

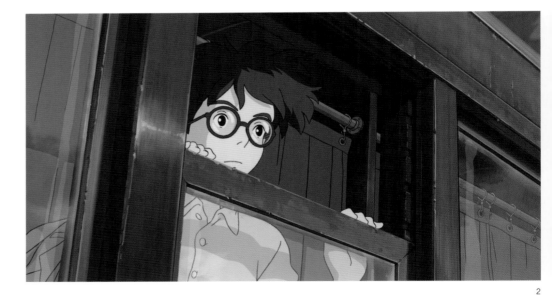

To Nagoya

P106–107/The hustle and bustle in front of Nagoya station welcoming Jiro, who has come to work for the Mitsubishi Internal Combustion Engine Company, an airplane manufacturer.
1/The hallway and washing area in the sleeper car Jiro rides. [Background]
2/Jiro stares out the window after washing his face. The men walking along the tracks hurriedly run down to the embankment. This is a group of unemployed people sleeping outside and heading for the city to look for work.

Since our knowledge of the steam locomotives wasn't as deep as it was with the airplanes, Miyazaki had a very experienced animator, Yasuo Otsuka, come and give us a lecture on drawing locomotives. He explained how the carriages and the arms move while drawing pictures for us, and the details of his talk and the pictures were both incredible. It was a valuable experience.

−Supervising Animator: Kitaro Kosaka

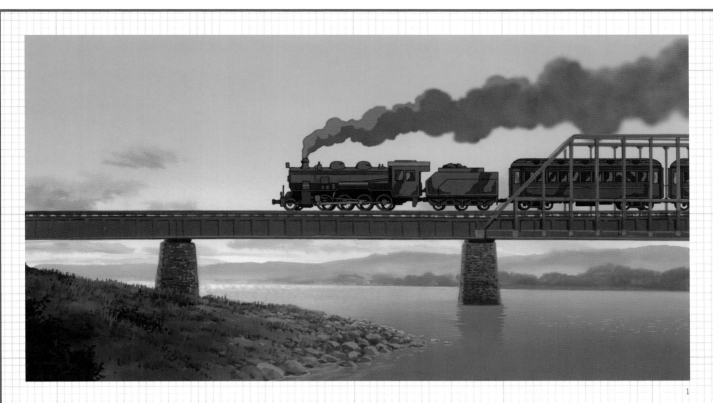

1

2

Class 9600 steam locomotive

A 1D-class tender-type steam locomotive designed and built with only Japanese technologies in 1913. In a modern style with an undercarriage with one axle for the pilot wheel and four axles for the driving wheels and a boiler on board, the train was quite powerful and was mainly used as a freight train. With its superior performance, it was active until the demise of the steam locomotive, finishing its duties in March 1976.

1, 2/The Class 9600 steam locomotive Jiro uses when he goes to Nagoya.
3/Each time a train passes, the many people heading for the city along the tracks to look for work flee down to the embankment.

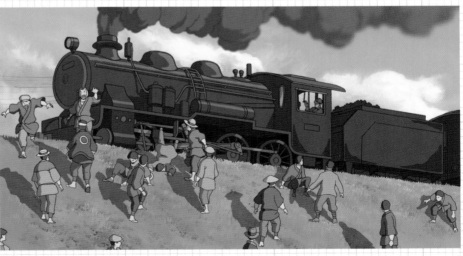

3

In front of Nagoya station

1/Building facing the large road in front of the station. Jiro and Honjo, who comes to meet him, get a taxi here. [Background + book cel]

2/Taxi the pair board that runs within the city of Nagoya. There isn't much traffic, and the streetcar also runs slowly.

3/Jiro and Honjo looking like new employees in their suits. They are elite engineers among the gifted elite the company hires.

4/People pushing in on a run on Kamehachi Bank. Due to the effects of the Great Kanto Earthquake, the recession continues and the financial crisis worsens.

5/The taxi they are riding in and the streetcar are brought to a standstill by the confusion.

2

3

4

5

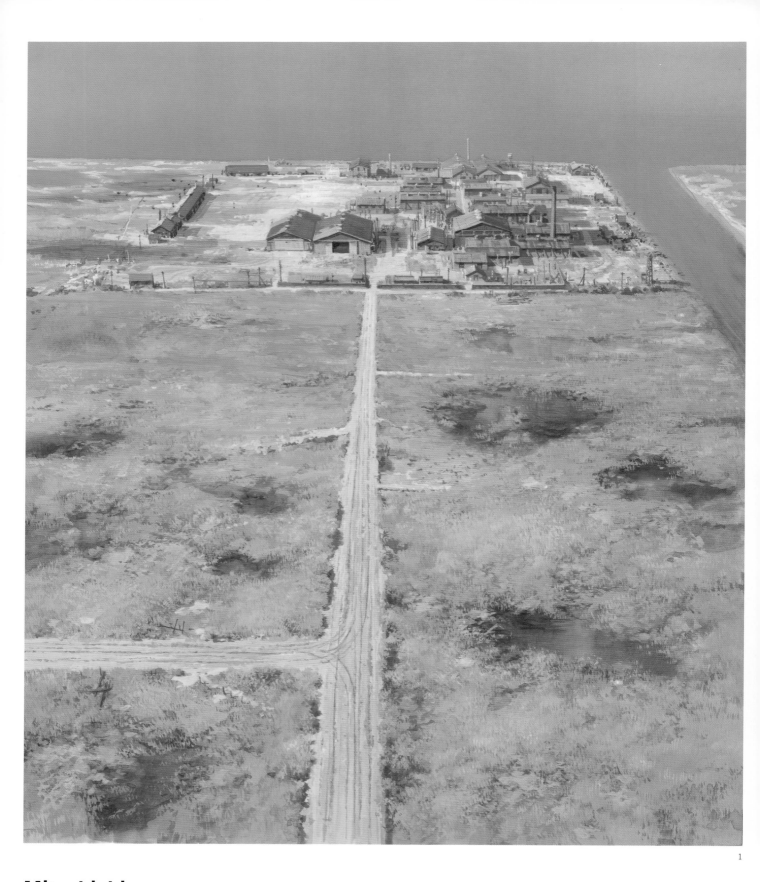

1

Mitsubishi campus

1/Mitsubishi Internal Combustion Engine Company where Jiro and
Honjo work and the surroundings. The company is on reclaimed land
facing the bay, made up of buildings such as the assembly factory.
[Background]
2/The wooden administration building with several chimney pipes
sticking out. [Background]
3/The design office where Jiro works. [Background]
4/Men from the construction division work at drafting tables.

2

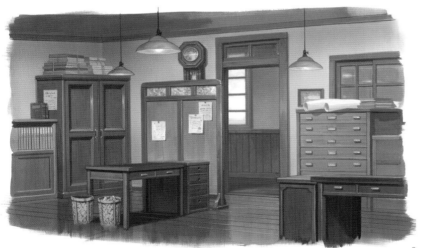

3

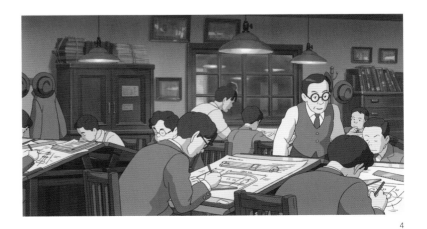

4

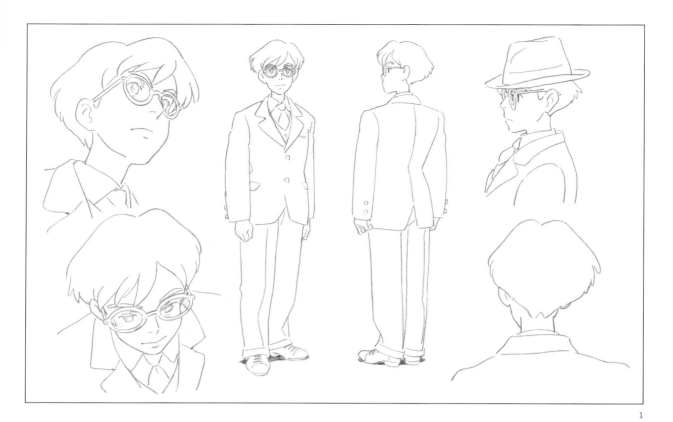

1

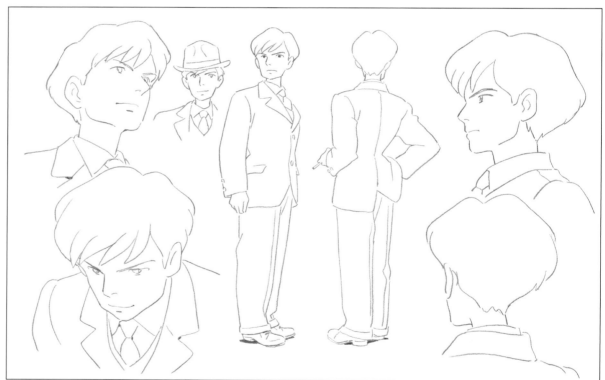

2

Jiro and Honjo, company men

1, 2/Jiro and Honjo in suits. [Character designs]
3/Honjo, who was hired slightly ahead of Jiro, sees Jiro being shown around by senior engineer Kurokawa and grins.

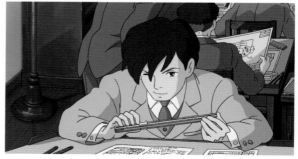

3

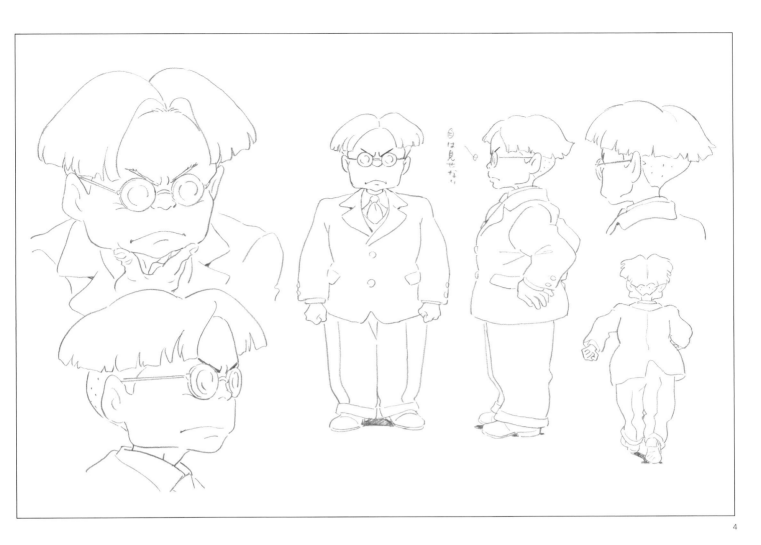

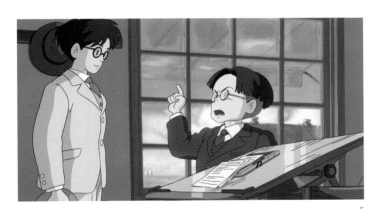

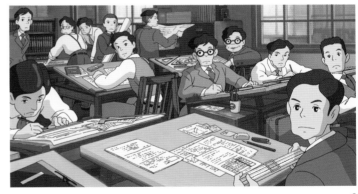

The inhabitants of the design office

1/Senior Falcon Project engineer Kurokawa, Jiro's immediate superior. He's a nag, but he recognizes Jiro's abilities and helps him. [Character design]

2/Kurokawa gives Jiro an imported drafting table no one is using and orders him to design the main wing fittings for the Falcon, which is in the final stages. This is Kurokawa's own brand of hazing.

3/Coworkers in the design office. They are very curious about the appearance of this rumored genius.

4/The young women of the tracing office who say hello to Jiro passing by.

For Jiro's suit, I chose a light purple that's a bit on the bright side. I think nowadays, new employees wear gray or navy suits, but that's not very interesting, so I tried to bring out a certain freshness with a soft and gentle color. In any case, it's a color that definitely suits Jiro. For everyone else in the design office, I went with colors people would normally wear.

–Color Designer: Michiyo Yasuda

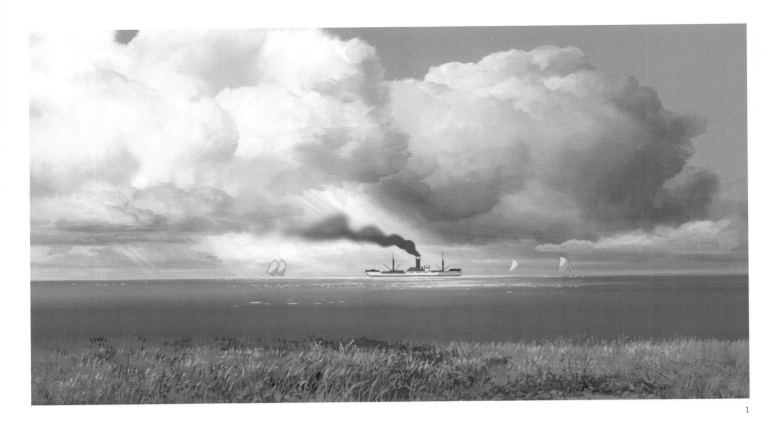

1

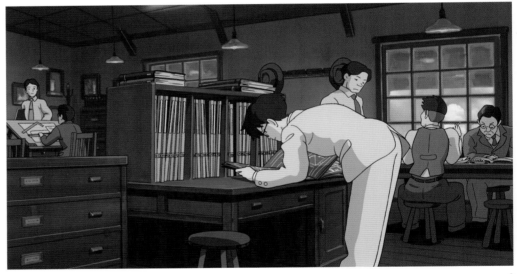

2

Jiro's first task

1/A cargo ship moving along the coast of the reclaimed land.

2/Jiro gazing at blueprints with his prodigious concentration.

3/Kurokawa checking diagrams. Jiro's way of working draws his attention.

4/Jiro seated on a swivel chair starting to use his slide rule.

5/He writes down new numbers for the given data one after another.

6/The wind blows on the ocean with freight ships and boats with sails up passing back and forth.

The model for the senior engineer Kurokawa is Miyazaki. He has a unique hairstyle, and since his stride is short, it swings around his head in pieces when he walks. His body type isn't the polished body of Japanese people now, so it was hard to get a balance with his face and head. His personality shows up in his movement, so I think the key animators had fun with him.

 –Supervising Animator: Kitaro Kosaka

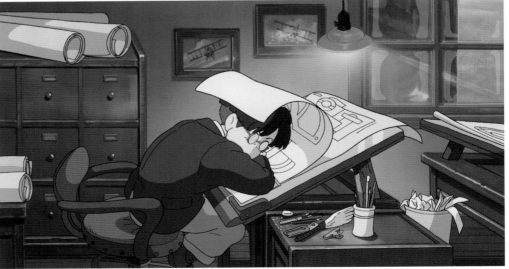

3

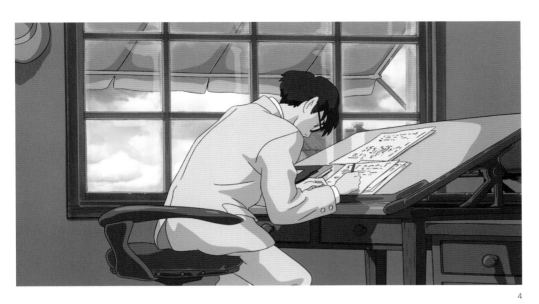

4

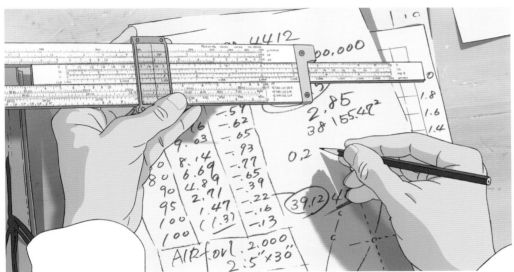

5

6

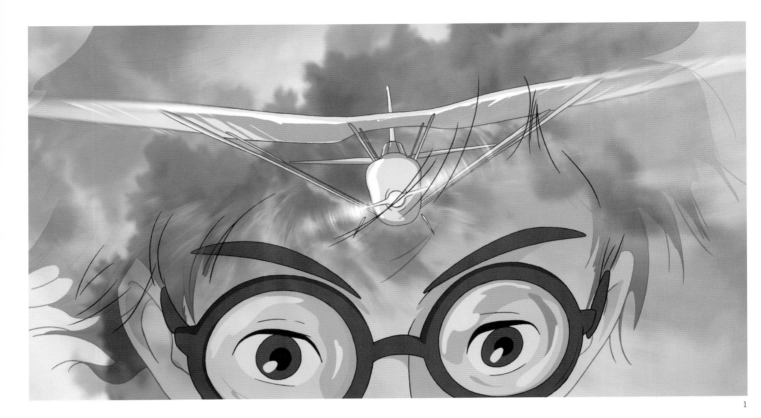

1

2

Imaginary Falcon

1/The Falcon fighter plane appears in Jiro's head as he concentrates on his calculations.
2/Falcon clay model flying in the blue sky.
3/The wooden frame of the Falcon is unable to withstand the high-speed load; the struts on the main wings crack and break apart before falling to the ground.

3

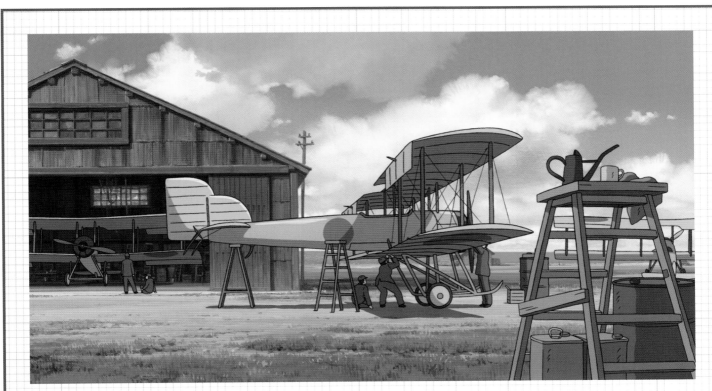

Hanriot training aircraft

A biplane imported from the French Hanriot company in 1913 as an initial flight trainer for the army. It boasted both excellent stability and practicality, and shifted to Japanese production at Mitsubishi.

1/The Hanriot flight trainer undergoing maintenance, cutting across Jiro's field of view when he begins work at Mitsubishi Internal Combustion Engine Company.

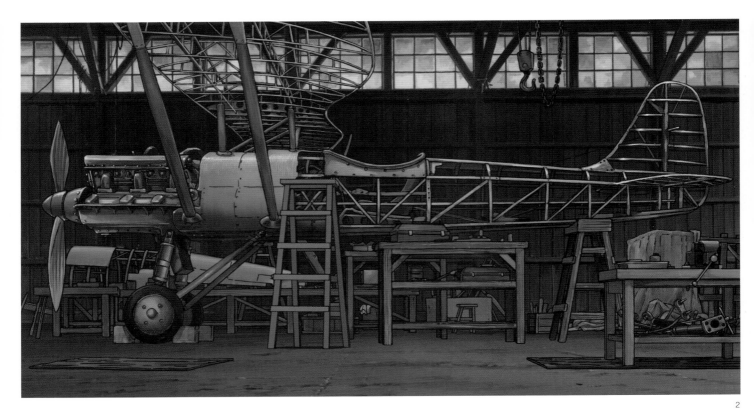

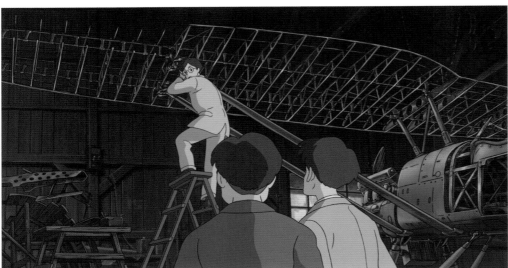

Prototype workshop

P119-1/The prototype workshop where the Falcon is being put together. Returning to himself at the sound of Honjo's voice, Jiro finishes his lunch and the two go to look at the prototype. [Background] 2/The Falcon under assembly in the dim workshop. Only part of it has the duralumin panels attached yet, allowing the frame structure of the wings and the body to be seen before they are covered in material.

3/Jiro gazing intently at the strut attachment. "The strut's already installed." "I knew it. Kurokawa's just hazing you. Is his fitting better than yours?"

4/The pair peering even further into the steel pipes. "Looks solid to me." "Oh this isn't good. It's just like my design." "Then it must be bad." Jiro is totally taken with the workings of the airplane.

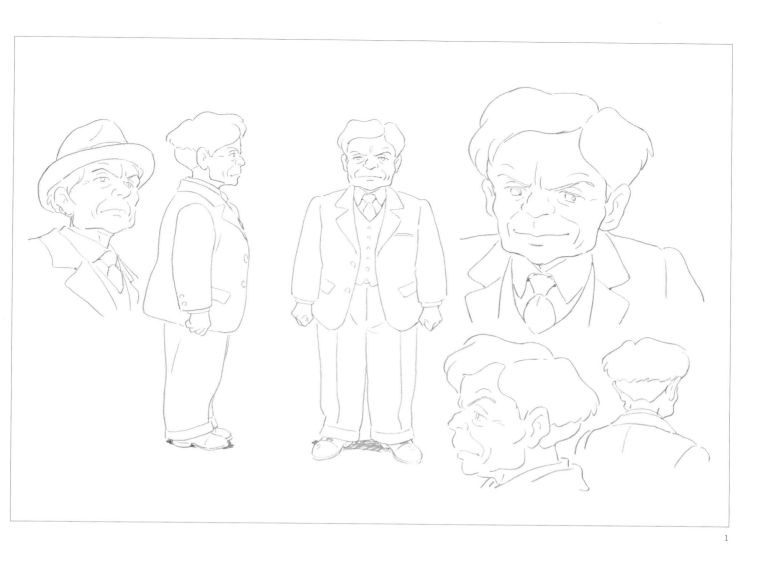

1

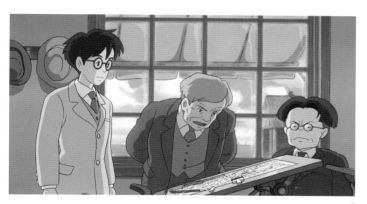

2

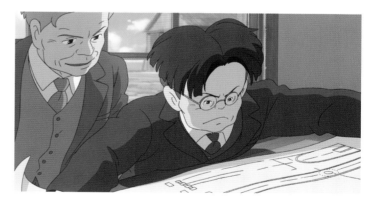

Section Chief Hattori

1/Section Chief Hattori, responsible for the design section. He and Kurokawa have high expectations of Jiro and Honjo's work. [Character design]

2/Hattori realizes that Jiro has been working on something other than the task he was given.

3/Kurokawa gets mad, saying "You're wasting your time," but since Jiro did finish the task he was given, he has no grounds for complaint.

4/The prototype workshop chief welcoming the two: "You young engineers should visit here more often."

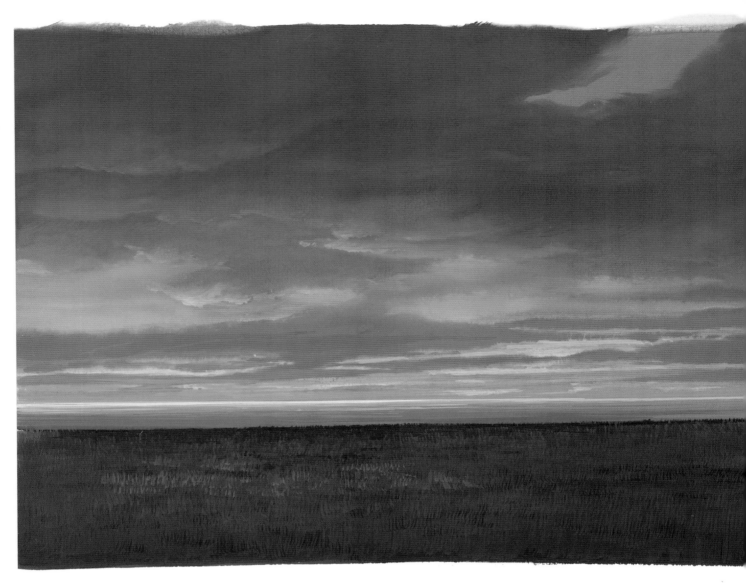

Oxen and Falcon

1/When Jiro and Honjo go outside after finishing work, the sun is already sinking into the sea, and dusk is falling. [Background]
2/When the sky starts to brighten, oxen pull the new Falcon prototype out to the airfield. The process, which takes two days at a speed of about three kilometers an hour, demonstrates Honjo's assertion: "That's how backwards we are."

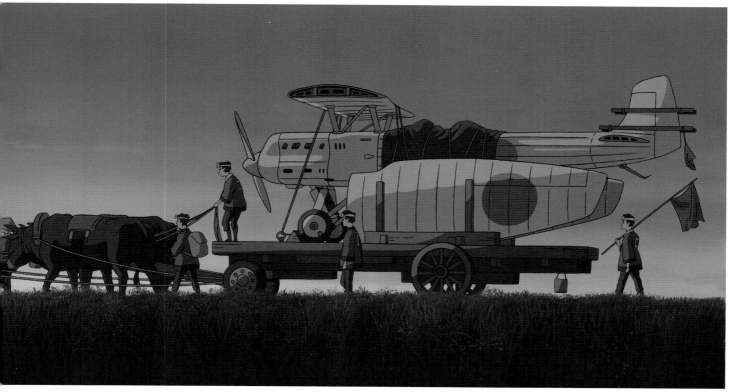

2

Jiro Horikoshi: Twenty-Five Years Old

The Falcon fighter plane developed by Mitsubishi for a military order tragically breaks apart in the air during its test flight. Jiro proposes to Kurokawa the creation of a second model but doesn't get another chance. Dispatched to Germany for observations, Jiro takes his weary heart and body home and is made to realize the poor state of Japan by the figures of a young brother and sister he sees on a street corner.

Test flight

P124-125/The airfield covered in a blanket of green grass. A wind sock flutters in the wind, and civilians and soldiers from the army watch the Falcon test.

1/As if to hint at the results of the test flight, thick clouds begin to spread out in the sky. [Background]

5/Taking on the challenge of a powered dive at a speed of 400 km/h, the Falcon's wings are torn off, and it crashes, losing pieces all the while.

For scenes with planes flying, even in the cases where the background is moved while the plane is a still image, a static, dead picture is no good. This is a peculiarity of digital, but when the picture stops, the screen abruptly stops moving, so no matter what you do, it looks dead. So I tried leaving something where you could feel the wind like a breath by drawing two of the same picture by hand and creating a haziness. Since we're doing this in animation, depending on the person, the haze will be beautiful or it can be too much, which makes it difficult, but we did get a good result.

—Supervising Animator: Kitaro Kosaka

Falcon fighter plane

A prototype in development at Mitsubishi in 1927 when Jiro Horikoshi started work there. A high-wing monoplane, the prototype for a new fighter plane requested by the military was built in competition with the Nakajima Aircraft Company and Kawasaki Aircraft Industries. In the review, Mitsubishi had the best results of the three companies, but in the powered dive test, the plane broke apart in midair.

1

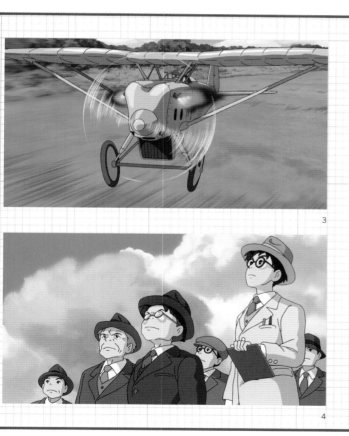

3

4

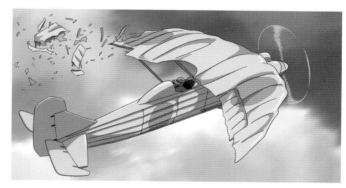

5

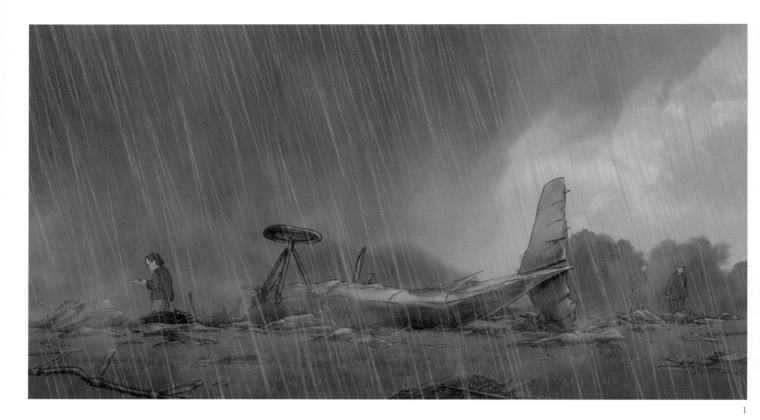

1

2

Rain of despair

1/Large drops of rain fall, and Kurokawa gets soaked as he investigates the wreckage of the Falcon.

2/Although the pilot escaped without injury, the test for the Falcon prototype, which was supposed to rescue a desperate situation, ends in failure. Jiro realizes that the cause was not the metal fittings, but something deeper.

3/The unofficial decision is that the order for the military fighter plane will go to another company. Mitsubishi decides to dispatch a team to observe Junkers fighter planes. "You are going to Germany to study Dr. Junkers' designs. I approved it." This is also evidence of the faith Kurokawa has in Jiro.

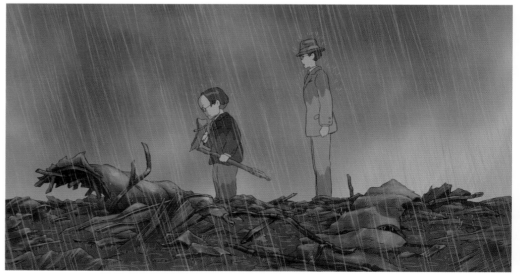

3

1

2

3

4

5

6

Night of heartbreak

P129-1/The city at night. Exhausted, Jiro rides the streetcar home.

2/In the middle of the road facing Jiro's boardinghouse, just one store is still open. [Background]

3/A small shop selling bread and sweets. After buying some sweet bean cake from the familiar master of the shop, Jiro tries to give the cake to a young sister and brother waiting on the dark road for their parents to come home. [Background]

4/The children run off as if fleeing, and Jiro is left behind standing under the streetlamp. [Background]

5/Under the bridge as a freight train passes. At the mouth of the river stand the shacks of people who have lost their houses and jobs.

6/Jiro's room in Dojunso No. 1, the boardinghouse Jiro and Honjo live in. Honjo comes in and judges Jiro's actions to be hypocritical while eating some bean cake. They are able to make airplanes because a poor country wants to have airplanes. Jiro's heart sinks at the unresolvable contradiction thrust before him.

When Jiro buys the sweet bean cake, the old man running the shop licks a finger and pulls down a piece of newspaper hanging there with a snap, but the licking action wasn't in the storyboards, so I asked Ai Kagawa, who was the key animator, if she could just put in a little show of licking, which she did for me. Miyazaki also does this little movement when he's flipping pages.

—Supervising Animator: Kitaro Kosaka

For the historical background, there were few streetlamps at the time and the power was weak, so apparently the nights were really dark, but since we're used to modern brightness, it was hard to do a proper darkness. Maybe it was the nature of the poster colors I was using, but even dark colors ended up with a feel of whiteness popping up, so in the end, I discussed it with the director and Okui during the processing, and we went with the trick of darkening it by narrowing the amount of light at the photography stage.

—Art Director: Yoji Takeshige

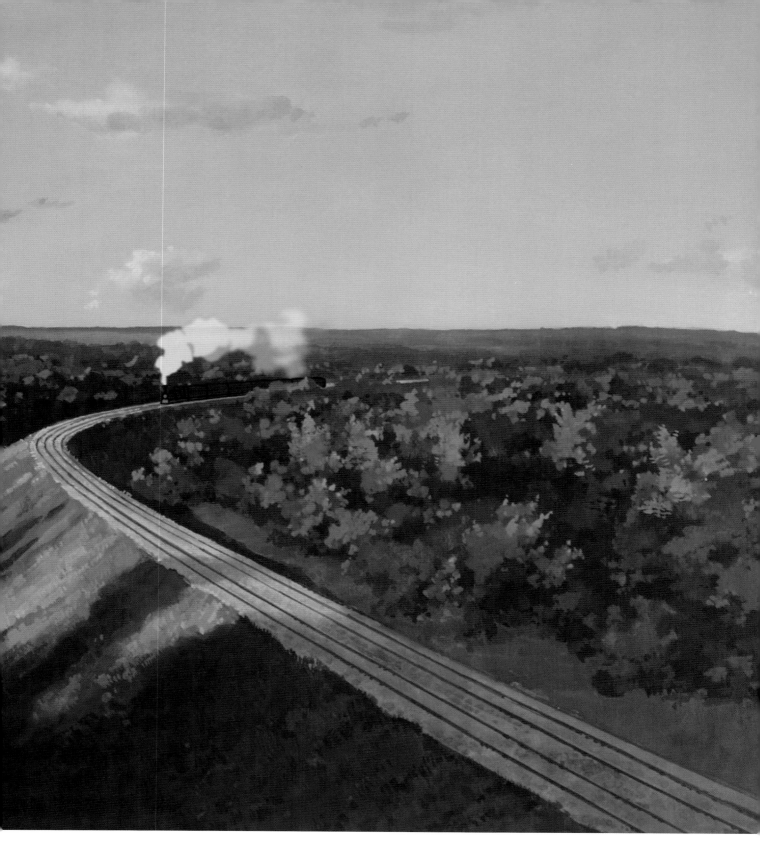

Jiro Horikoshi: *Twenty-Six Years Old*

To build a bomber, a Mitsubishi observation team visits the Junkers factory in Dessau. Part of the team, Jiro and Honjo are made to feel acutely that Japanese aviation technology is at least twenty years behind that of the great powers of the world. However, Caproni once again appears before Jiro, who ends up returning to Japan on a different route from Honjo, and urges Jiro to live his ten creative years with all his might.

1

2

Junkers factory

P132–133/The Trans-Siberian Railway running across the open landscape. Jiro and the
others head for Germany via Russia.
1/Junkers factory in Dessau, a city in the north of Germany. [Background]
2/Enormous hangar on the airfield adjacent to the factory. [Background]

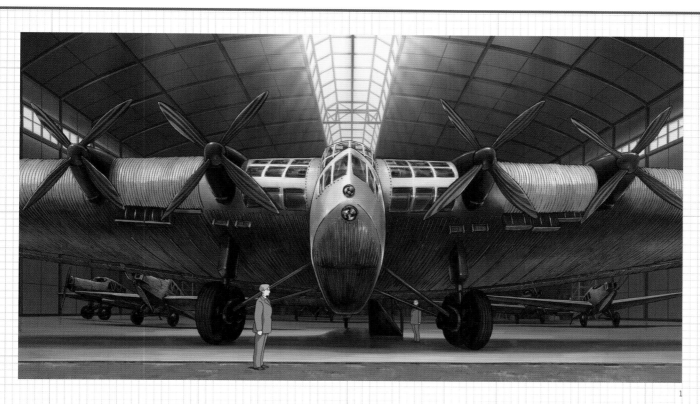

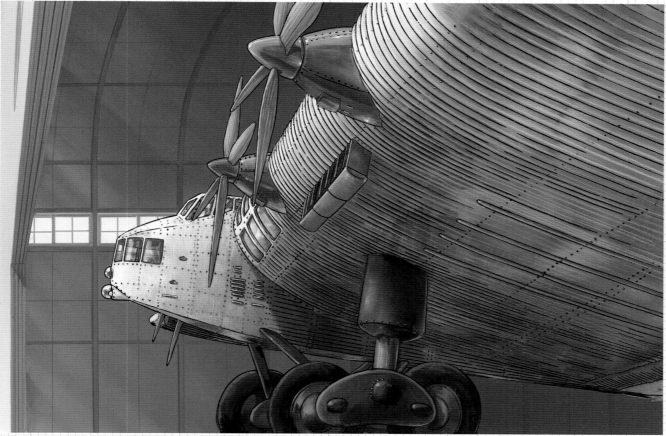

G.38

The large transport plane developed over many years by Hugo Junkers (1859–1935), the founder of the German airplane manufacturing company Junkers. With a body attached to an enormous flying wing base, the plane had a wingspan of 44 meters and a total length of 23.2 meters.

1/The imposing figure of the G.38 in the enormous Junkers hangar.
2/The Mitsubishi observation team is amazed at the incredible size of the G.38. [Background + harmony cel]

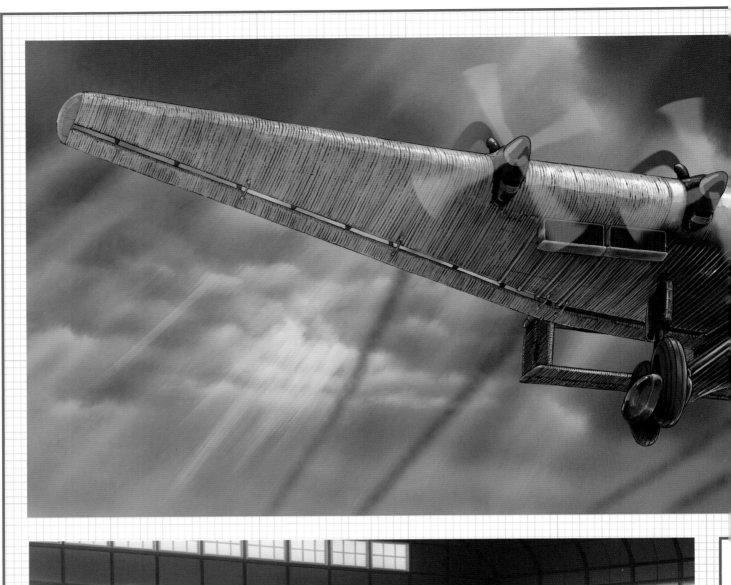

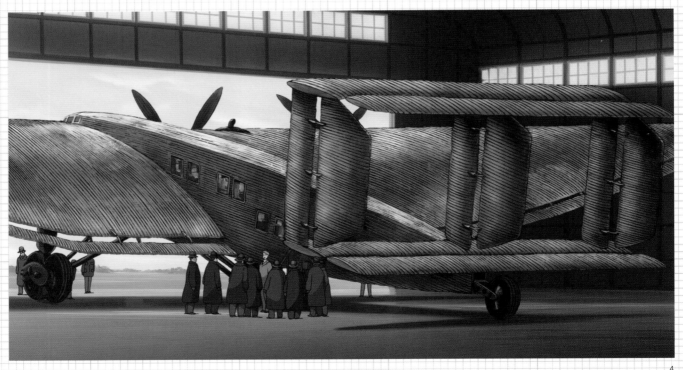

3/G.38 flying with Jiro and the others on board.
4/Honjo admires the G.38 metalworking technology.

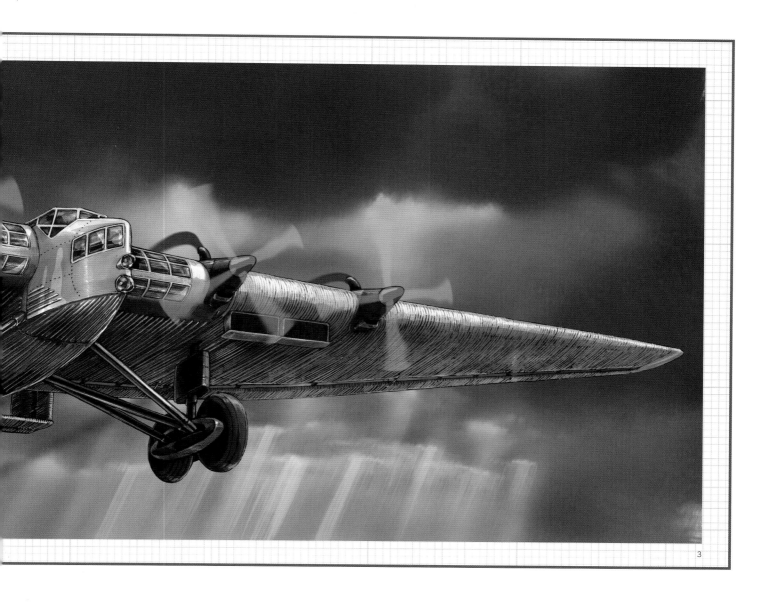

3

5

F.13

An all-metal cantilever-wing monoplane for which Junkers built the prototype in 1919. Although it was originally developed as a military plane, it was later used as a passenger plane. The body was made from corrugated duralumin panels, and the plane had a wingspan of 19.2 meters and a total weight of 1,730 kilograms. The plane could hold four passengers and was used on international routes.

5, 6/Jiro is attracted to the F.13 sitting in a corner of the hangar.

6

1

2

3

4

Guesthouse

1/Zum Allten, the guesthouse where the Japanese observation team stays. [Background]
2/Jiro and Honjo's room. Having discovered the gap in technological strength between the great powers of the world and Japan, the pair think of their own ways to catch up and overtake them. [Background]
3/The town at night where Honjo brings Jiro out for a stroll. They can hear a gramophone playing the Schubert song "Winterreise" in a nearby house. [Background]
4/Strange men run in front of Jiro and Honjo, and their shadows dance eerily on the road. The world is once again preparing to meet a turbulent era.

The scenery in Germany is cold overall with a gloomy feel, and given that the sky is always cloudy and there are many brick buildings and roads with paving stones, I decided to try putting in an overall pinkish light for the night scene, rather than orange. The forest Jiro sees from the train in his dream is harvested in a square shape, but Miyazaki said, "German forests are like this." The passenger seats on the train are made of wood and have a high-quality feel, so I used reds, golds, and yellows. Also, when they are passing through Russia on the Trans-Siberian Railway, I referred to a painting by Isaac Levitan that the director had.

—Art Director: Yoji Takeshige

Bavarian S3/6

Tender-type steam locomotive built by Germany's Royal Bavarian State Railways as an express passenger train. Series *a* through *i* were built, and after World War I, Deutsche Reichsbahn took over the trains, building a further *k* through *o*.

1–2/Jiro, having gotten the order to return to Japan, rides an S3/6, the pride of Germany, and heads for Japan on the western circuit.

Winter journey

1/Jiro walking in a winter wasteland. A Junkers G.38 crashes to the earth, covered in flames.
2/The Japanese Hinomaru mark painted on the enormous bomber wing. This is a nightmare, almost hinting at the future for Japan.
3/The corridor of the train Jiro rides to return to Japan on the western circuit, leaving Honjo to stay in Germany. [Background]
4/Jiro sitting neatly in his compartment.
5/Before he knows it, Caproni is seated next to him.
6/"Is the wind still rising?" "It sure is." "A perfect time to embark on my final flight. Join me."

3

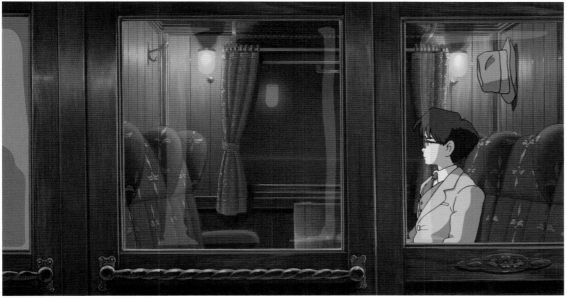

4

5

6

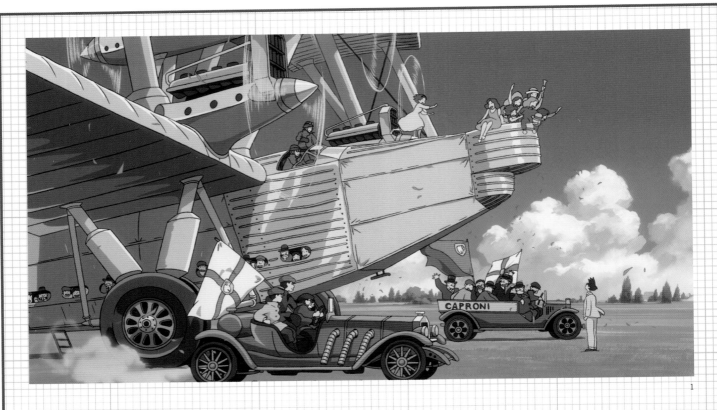

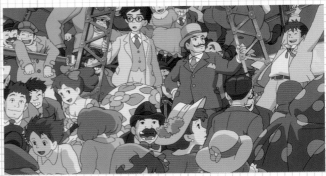

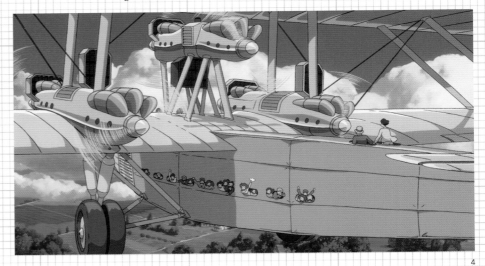

Caproni's Bomber

The world's largest bomber, designed by Caproni and representative of the late 1920s. This was drawn based on the Ca.90.

1–5/Jiro, traveling to Japan by himself, accepts Caproni's invitation in his dream and boards the bomber before it is delivered, moved by its impressive form.

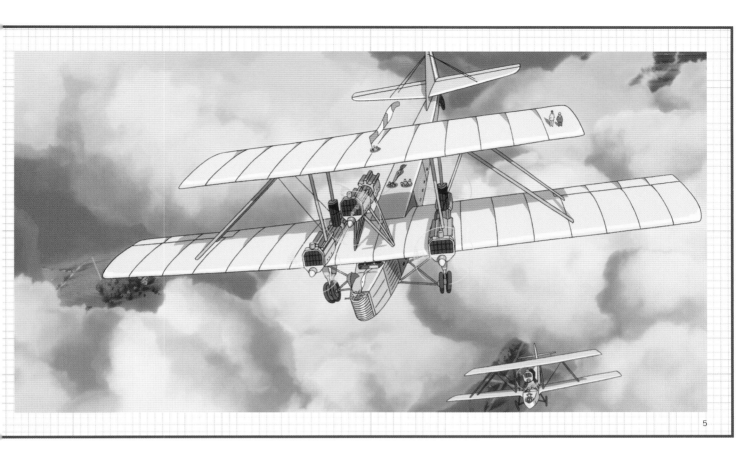

5

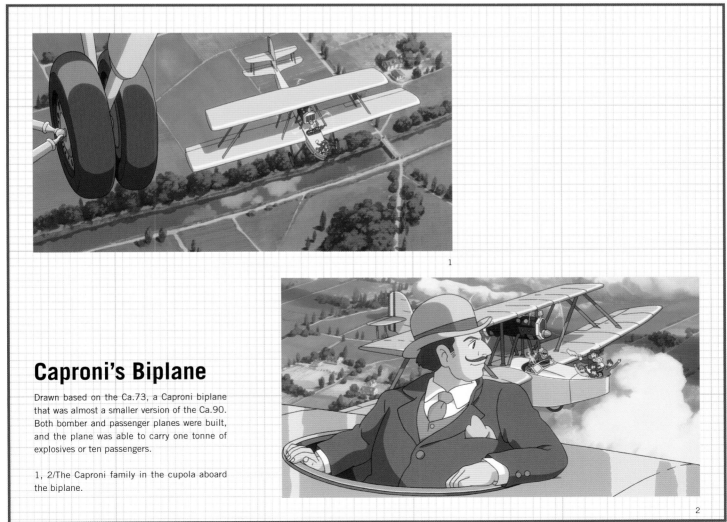

1

Caproni's Biplane

Drawn based on the Ca.73, a Caproni biplane that was almost a smaller version of the Ca.90. Both bomber and passenger planes were built, and the plane was able to carry one tonne of explosives or ten passengers.

1, 2/The Caproni family in the cupola aboard the biplane.

2

Caproni's message

1/When Caproni speaks about their cursed dream, with planes being used as tools of massacre and destruction, Jiro replies that he wants to make beautiful planes. However, Jiro's ideal plane still has not found form. As a farewell gift, Caproni tells Jiro, "Artists are only creative for ten years. We engineers are no different. Live your ten years well."

2/The sea of clouds Jiro's dream plane disappears into, like a white bird riding the wind. [Concept art]

3/The cumulonimbus clouds of the dream kingdom become an enormous glowing cloud and cover Japan. Below, the real city with houses and people crowded together spreads out over the land. [Background + book cel]

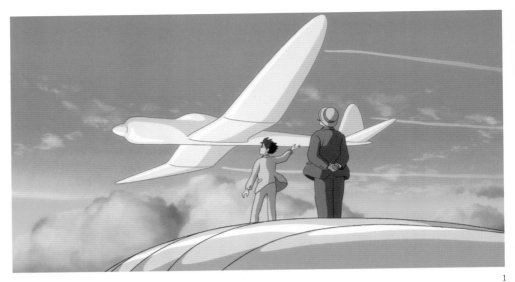

1

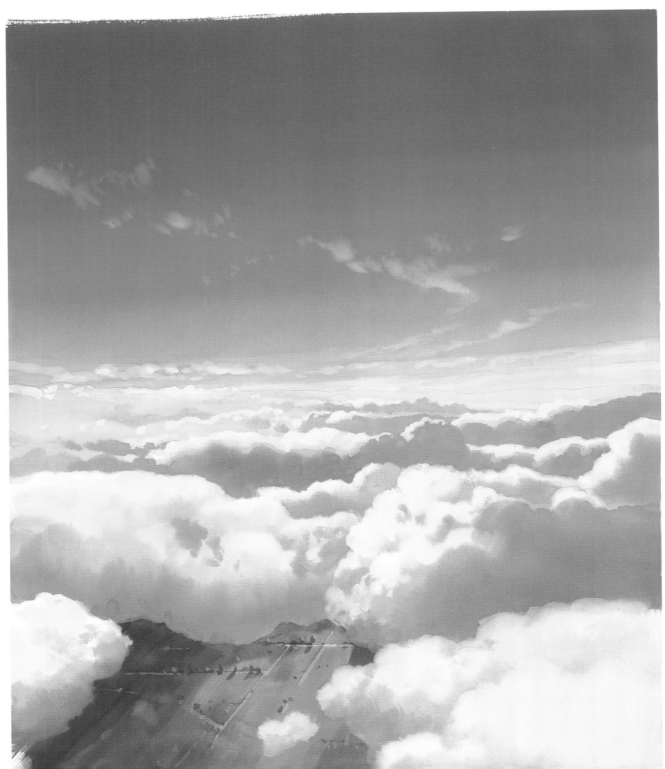

2

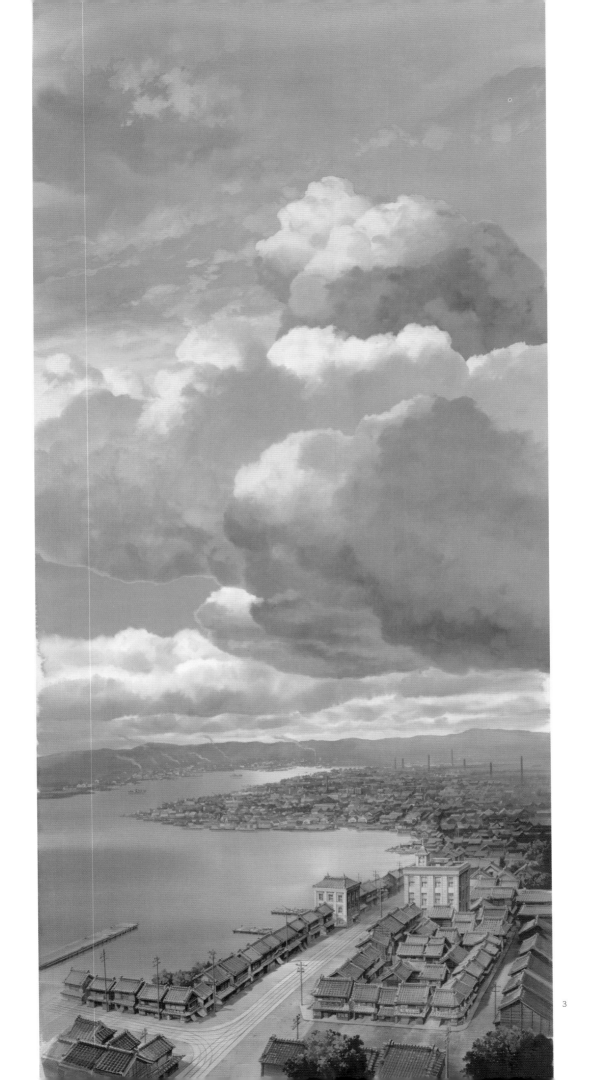

Michiyo Yasuda
Color Designer

I decided to do the work here with the awareness of living in the era that is the setting.

Born in Tokyo, Yasuda started work at Toei Doga (currently Toei Animation) as an inaugural staff member in 1958. Through her work at the company, she came to know Isao Takahata and Hayao Miyazaki, leading to her doing the tracing for *Horus: Prince of the Sun* ('68). She then supervised the color design for every episode of *Future Boy Conan* ('78). From the establishment of Studio Ghibli until the present, she has supported the directors with her work on coloring. Beginning with *Nausicaä of the Valley of the Wind* ('84) and leading up to *Ponyo* ('08), she has overseen the majority of the studio's works as the lead color designer. Although she retired briefly after *Ponyo*, she returned to work as the color designer for this film at the request of Miyazaki.

I retired after finishing work on *Ponyo* (2008), with the intention of not working anymore, so I was living a relaxed life. Miyazaki would sometimes invite me to chat over some wine while listening to a piano or violin performance, and that's where I heard he was thinking about this new project. But the truth is, it was New Year's of 2011 when I heard all the details. Miyazaki called me and said "I'm starting a new project today." I talked with him about a few different things and told him to stay strong, and that was the first step in the whole thing.

A few months later the Tohoku earthquake and tsunami occurred, and he called me up, worried. A little while after that, he told me he had finished Part A of the storyboard and asked if I'd stop by and take a look. I did and found that the storyboard was massive; I was thinking it must have been quite a job, which is when he asked if I wouldn't take it home and read it. That was the progression before I accepted the job; Miyazaki didn't ever come right out and say "Please work on this," and I didn't ask to be allowed to work on it. But looking at the storyboards and doing the project were basically the same thing. There was no hammering out any details, I just started work from these casual exchanges we had.

At the same time as I was re-reading the storyboards and being amazed by them, I was also thinking how hard it was going to be. So rather than just myself, I decided to put together a color direction group and do the work that way, with Kanako Takayanagi, Fumiko Numahata, Kazuko Karube, Yukie Tamura, and Yusei Kashima, with Misa Aida joining us halfway through production.

The story this time takes place from the Taisho to Showa eras, and we did a fair bit of research, but there was almost nothing that could show us what the colors of that time were like. I did things like go to kimono shops in Ginza to look at the fabrics of old kimono, but as a basic way of thinking, I felt I needed to stop feeling like the me in the present was peeping in at the Taisho era, a feeling of nostalgia in thinking of the period as so far back in the past. And more than that, I decided to do the work with an awareness of living in the era, a feeling that I was actually in that era, an awareness of what the scene would be like if the Great Kanto Earthquake happened right now.

In particular, I kept the first half of this film cartoonish, but after Miyazaki had said a few times he wanted to bring out a more realistic feel, I made the latter half more and more like a live-action film. With the color coordination, the way we've done it up to now for instance, you put in a little blue to show transparent glass. This is because the audience understands the notion that water is blue. But this time, we had to focus instead on the sense that the audience would naturally come to see it like this. If it was a dark scene, I had to focus on what I would see, what it would feel like if I was there—this kind of thing.

Conversely, when there was something we wanted to show, the thinking for some scenes was that we didn't even need to put in a proper focal point. For example, the scene where Nahoko puts on her bridal costume and walks down the hall (see page 208), the truth is that the area is dark, so Nahoko herself should be dark too, but, well, I thought it would be all right to put the focus on her beauty, the part we want to show. Initially, the coloring here was a little more pink to match the color of Nahoko's clothing, a coloring that emphasized the red. And Miyazaki did agree to it when I had him take a look, but because the scene is important, I came back to it after a bit and reworked it. Then we were talking and we had the idea of making the whole thing blue since something more conceptual could work; we often had this kind of back and forth for the coloring along the way.

In that scene, it's Kurokawa who sees the bride walking down the hall. In other words, it's the image of Nahoko that Kurokawa sees— it's Kurokawa's feelings. It's not just a bride Kurokawa sees after being told of Jiro and Nahoko's decision. I think it's something more sublime than that. We created the colors here also with the thought of how the audience would be able to see what Kurokawa was feeling.

In a regular movie, you first make the normal colors for the characters, which you then change according to the time and the place. But for this film, as the time and place change quickly even within a single scene, there were really very few places where we could use these normal colors. We always had to create new colors for each scene, so right up until the very end, it was a succession of trial and error as we tried to figure out what to do here and there. Honestly, I got lost so many times, and each time, I would go back to the storyboards, decide the scene would be about like so, and then turn back to the screen.

I would look at the storyboards and think that each and every shot was like a single painting, and in fact, Miyazaki also said the same thing to me. So when I look back on this film now, I wasn't just designing the colors, I was deciding on the colors while thinking about things like what the composition of this scene would be, or how the scene would look. I suppose I could say it was a very thorough job.

The Wind Rises Production Process III

Color design/Finishing

Deciding on all the colors for the things drawn in the animation, like the characters and machines in each scene, is the job of the color designer. It's then the job of the finishing staff to paint each frame of the animation for each shot based on her directions. In the past, paint was applied to the pictures on each cel, but everything is now digital and the coloring work takes place on a computer based on data incorporating the animation, using a program called Toonz.

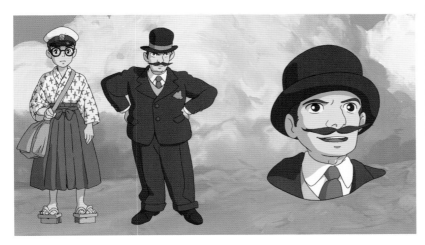

Foundational color samples

Provisional colors are decided on when the main character is set by the director. In the initial stages, the actual backgrounds to be used haven't been finished yet, so backgrounds from past works, like that to the left, are used and concept art created in the previous stage is placed in the backgrounds, to show how the characters and backgrounds fit together. Here, the character's key colors are created, and variations for each scene are made based on these key colors. There are diverse locations and times in this film, in addition to the dream sequences, so there were almost no instances where the key colors were used as is. For Caproni's clothing, the suit he wears in this scene and the one he wears in the scene where he reappears in the middle of the film (page 143) are different colors; the suit returns to the initial color in the final scene (page 222).

Color design "cast list"

Because of the above-noted diverse locations and times in this film, to set the colors, Michiyo Yasuda read the storyboards repeatedly and then asked directorial assistant Riyosuke Kiyokawa to prepare a sort of cast list so she could see at a glance the changes in time and place for each scene. And not just whether a particular scene is in the morning or afternoon, but what time in the morning, are the background materials concrete or wood, etc. The coloring and brightness of the characters in the foreground change ever so slightly due to these kinds of subtle differences.

Color design screen

The actual work of setting the colors and doing the finishing happens on the screen. With the line drawings and backgrounds put together as the base, the colors for each shot are considered and painted in. The top left of the screen is to make colors. The base colors are made by combining R (red), G (green), and B (blue), and given names in the rectangular area sectioned off in the bottom right (for example, "HANE_MIDORI" second from the top). To put it in terms of past techniques, these are like bottles of paint. On the bottom left, the designer can choose the picture level, such as Jiro or the plane here, and work on each part. The center of the screen is where the work is actually done. The work is very detailed; in this shot, although the airplane in the foreground and the airplane in the back are the same machine, rather than exactly the same color, the airplane in the back is a slightly duller color.

Continued on page 183

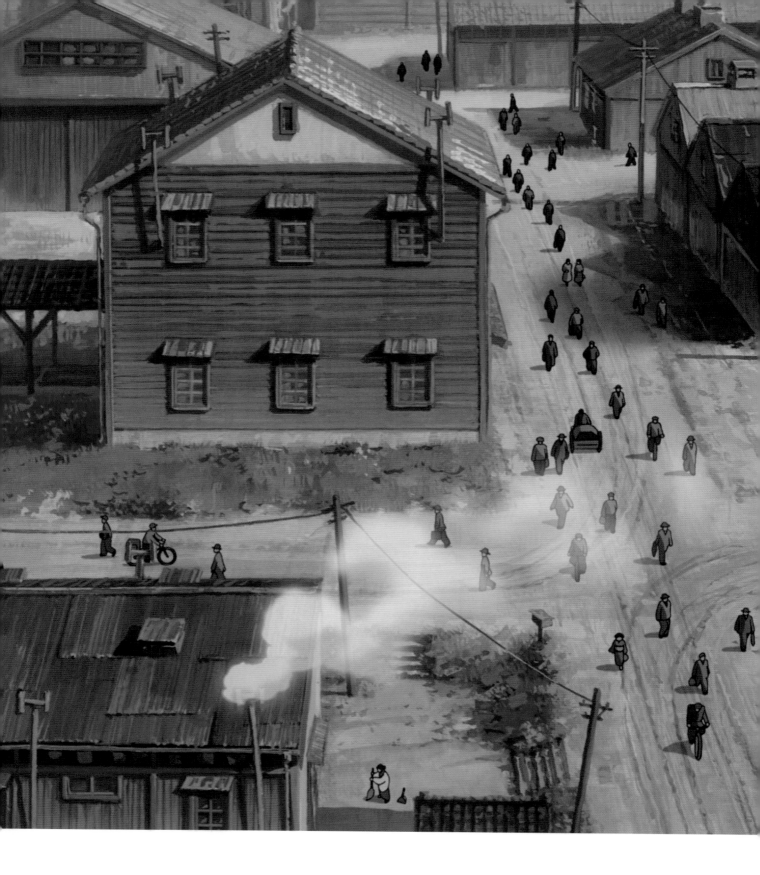

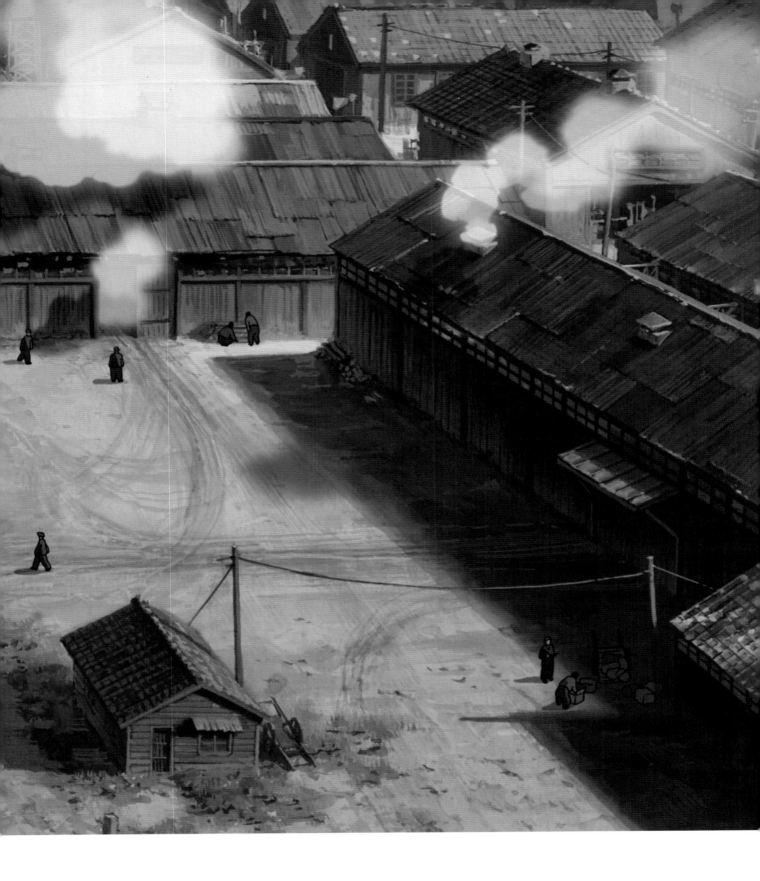

Jiro Horikoshi: *Twenty-Nine Years Old*

Jiro, as he enters his fifth year at Mitsubishi, is selected to be the lead designer for the 1MF10 fighter ordered by the navy in 1932. For reference for the new machine design, Jiro and Senior Engineer Kurokawa from the design section go to study the arrivals and departures of the Nakajima A1N on the small aircraft carrier Hosho, but they only end up dumbfounded at the limits of the old Japanese models.

Café Flyer

P148–149/The season is spring. Steam rises up within the grounds of the Mitsubishi Aircraft Company, operating since early morning.

1/Long view of the Nagoya factory, which has changed its name to Mitsubishi Aircraft. There is a café very nearby the employees frequent, called Café Flyer. [Background]

2/"Zigeunerweisen" plays on the gramophone within the café.

3/Called out by Section Chief Hattori and Senior Engineer Kurokawa, Jiro is assigned to be the lead designer for the new navy fighter plane.

1

3

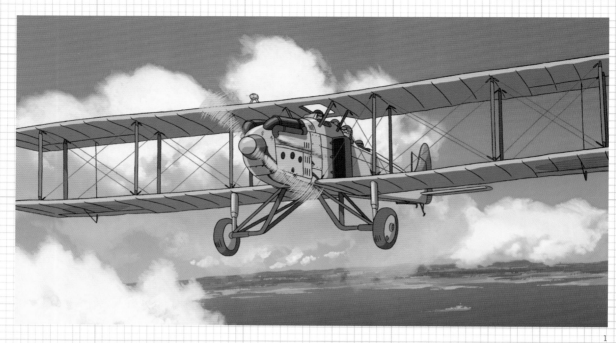

1

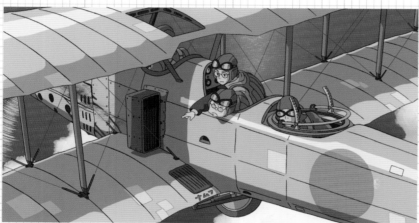

2

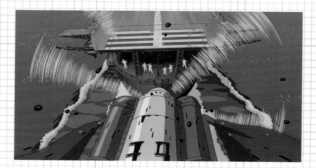

3

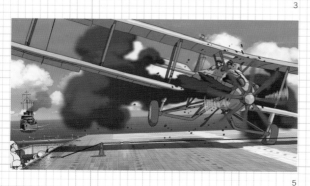

4

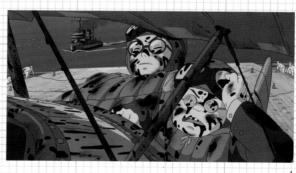

5

Mitsubishi B1M bomber

Biplane completed by Mitsubishi in 1923, which entered service the following year. Extremely practical, the plane was used as an aircraft carrier-based bomber from the 1932 Shanghai Incident until the initial period of the Second Sino-Japanese War. There were types one through three, and type two was nicknamed the Tiger bomber.

1–5/To watch the arrival and departure of the Nakajima A1N, Jiro and Kurokawa board a B1M bomber and head for the aircraft carrier Hosho. The engine has some trouble during the descent and spurts oil onto Jiro and his boss.

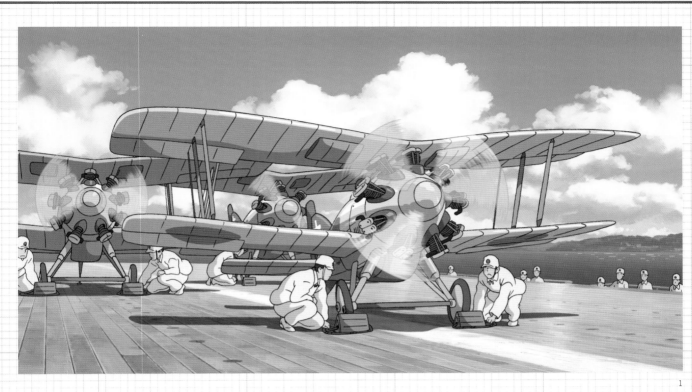

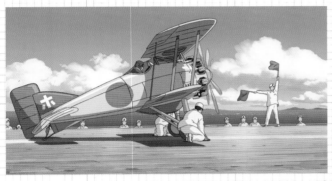

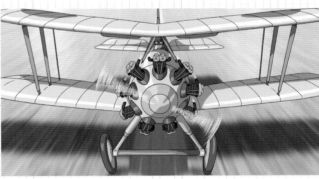

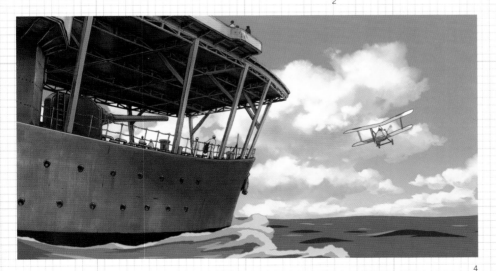

Nakajima A1N

Biplane produced by the Nakajima Aircraft Company (later Fuji Heavy Industry/Subaru) in 1929.

1–4/Nakajima A1N taking off after testing its engines on the deck of the aircraft carrier Hosho.

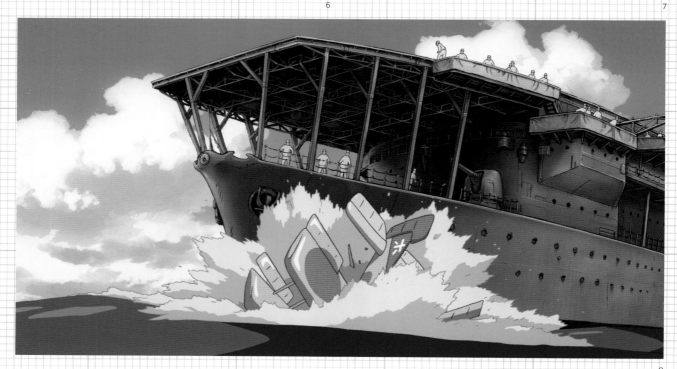

Nakajima A1N2 formally adopted as a new machine to replace the Mitsubishi 1MF used up until then, after a prototype competition among Nakajima, Mitsubishi, and Aiwa (Aircraft). This plane was the first Japanese military plane to be involved in air battles during the Shanghai Incident in 1932.

5–9/The engine on the second machine stops as it is taking off; the plane loses momentum and decelerates, dropping into the ocean.

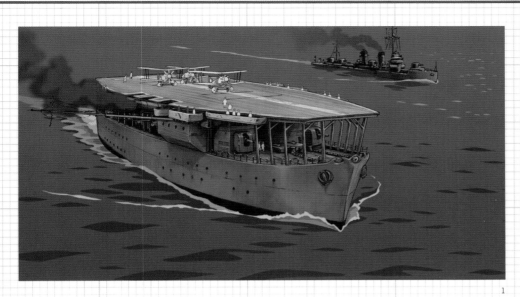

1

Hosho

The world's first purpose-built aircraft carrier, built in 1922. In other countries, commercial ships and battleships were renovated to build aircraft carriers, but Hosho was the first aircraft carrier designed to be an aircraft carrier. It made sorties and saw actual battle in the Shanghai Incident, but around the time of the Pacific War, shipborne aircraft were larger, and it was shifted to use as a training carrier. It survived until the end of the war and was used as a repatriation transport after the war.

1, 2/Hosho moving across the ocean.

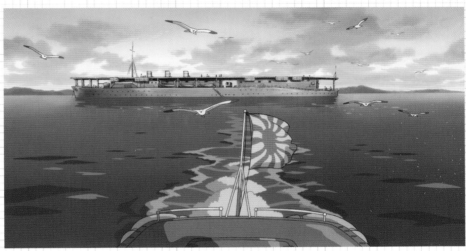

2

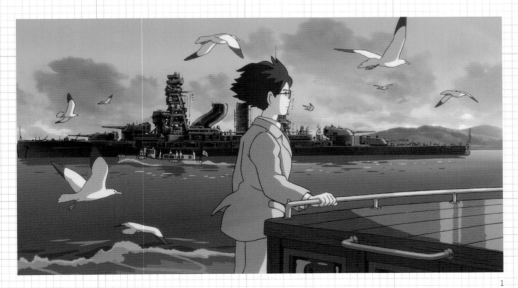

1

Nagato

Dreadnought battleship that was the flagship of the Combined Fleet. Her sister ship was the Mutsu. Built in 1920, she was fitted with the world's first 45-caliber, forty-one-centimeter main armament. She was remodeled in 1925 and given her distinctive bent chimney, so that she was immediately distinguishable from other ships. In an overhaul in 1936, the bent chimney was removed. Together with Mutsu, Nagato was symbolic of the Japanese navy. After the Battle of Leyte Gulf, she returned to her home country and was stationed at the port of Yokosuka. She was the only battleship to survive until the end of the war.

1/The anchored Nagato can be seen behind Jiro who is standing on the deck of a passing ship.

Jiro Horikoshi: *Thirty Years Old*

Jiro's first design, the 1MF10, ends in failure. Visiting Karuizawa for a break, Jiro is reunited with Nahoko, who has grown up into a beautiful woman. A foreigner he meets at the hotel, Castorp, predicts a turbulent future for Japan, and Jiro asks for the hand of Nahoko, who has tuberculosis, in marriage, with the powerful words that he will wait a hundred years for her to get better...

Mitsubishi 1MF10

Prototype for which Jiro is the senior designer in 1932. The navy orders war prototypes for a carrier fighter, an attack plane, a special bomber, and an ocean reconnaissance plane, and Jiro's team puts together the first low wing cantilever monoplane in Japan. However, it is judged to be impractical as a carrier plane, and the project ends with the production of just two prototypes.

1–6/The 1MF10 test flight is carried out as Jiro watches.

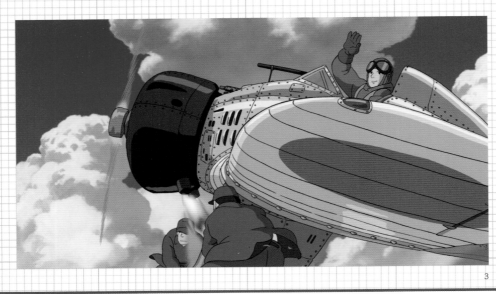

Karuizawa

1/Near the exit of a tunnel with the Abt rack system electric trains run on. [Background]
2/Brick bridge of the Usui Pass. The train Jiro rides passes through here pulled by an electric locomotive. [Background]
3/On top of the hill where Nahoko paints. Jiro walks along the path below. [Background + cel book]
4/Path leading into the forest. Nahoko's father, Mr. Satomi, comes through the woods in the opposite direction from Jiro. [Background]

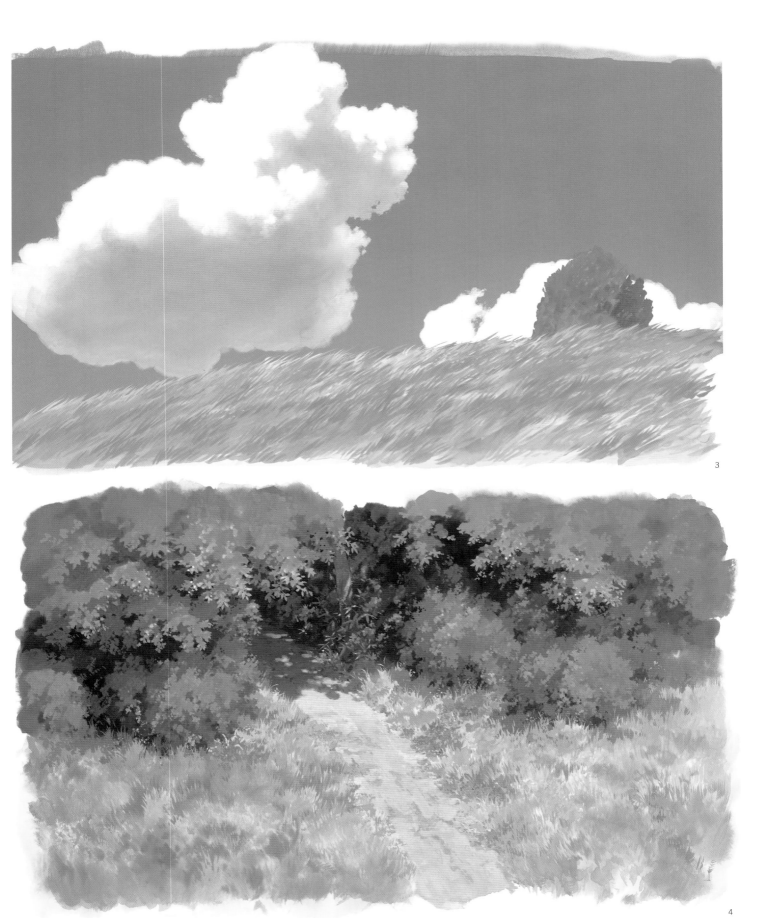

3

4

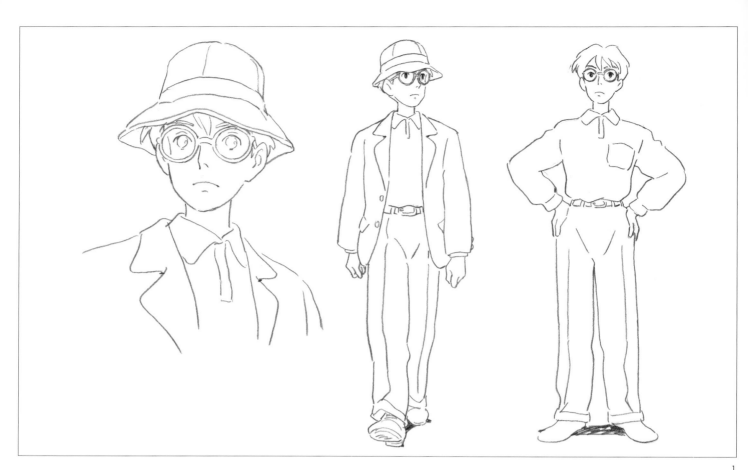

1

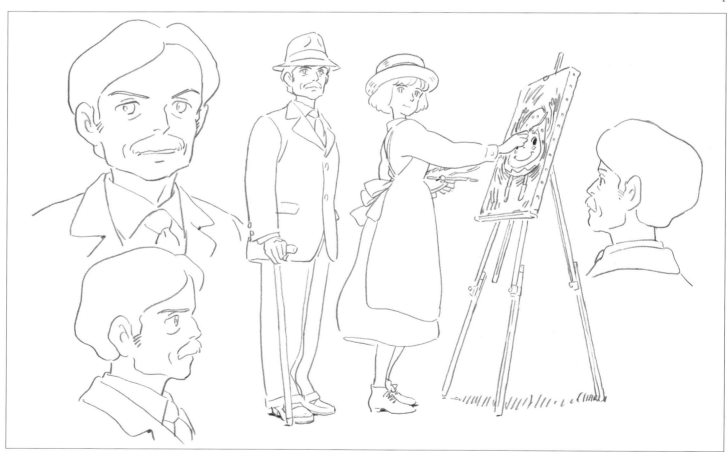

2

1/Jiro's summer clothing when he comes to Karuizawa for a break. [Character design]
2/The Satomi father and daughter who are coincidentally staying in the same hotel, Kusakaru. [Character design]

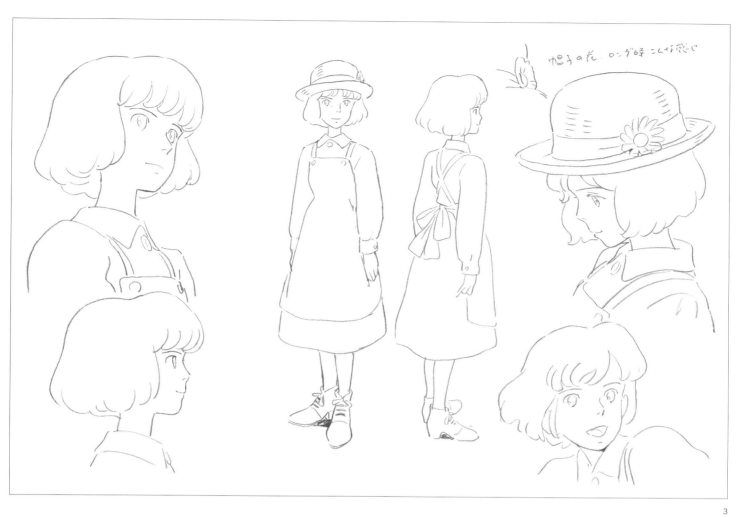

鳩子の花、ロング時 こんな感じで

3

4

5

Nahoko in Karuizawa

3/Nahoko, still girl-like ten years after their first meeting on the day of the great earthquake. [Character design]

4, 5/Nahoko painting on canvas with bold brushwork. At that moment, the wind blows even stronger, sending her parasol flying; Jiro on the path below stops it.

Long break

1/The entrance to Hotel Kusakaru where Jiro and the others stay. The building and the rooms in it are a blend of Western and Japanese, bringing together a variety of styles. [Background]

2/The exterior of the hotel, with a small veranda for each room. Sunflowers are blooming in the garden. [Background]

3/The remains of the 1MF10 collected in the hangar in Jiro's memory. The serious blow of his first failure still haunts Jiro somewhat. [Background + harmony]

2

3

1

2

In the restaurant

1/The hotel smoking room at dusk. Outside, it's raining. [Background]

2/The restaurant in the hotel. Nahoko and Mr. Satomi enter. On the other side of the entrance is a bar. [Background + book cel]

3/Nahoko, being led by the waiter, notices Jiro at a table further in. Jiro is just as he was when they met ten years before.

4/Jiro realizes it is the young woman from that afternoon, and he bows lightly in greeting.

5/At the next table, Castorp eats a large plate of watercress while reading the newspaper.

6/"What is it?" "That man. I know him from somewhere," Nahoko says, somewhat excited.

2

3

Reunion spring

1/The path leading into the forest that Jiro walks down. A sluice for farming irrigation runs along the side. [Background]
2/Near the entrance to the forest where Nahoko's easel and parasol are set up. [Background]
3/Jiro comes to the road along the sluice and heads deeper into the dark forest. [Background + book cel]

Tatsuya Kushida was in charge of the scenery for the woods where Jiro and Nahoko meet again, as well as the area around Kogen Hospital. Kushida polished his technique based on the work of his idol Kazuo Oga, and he's got more of a light touch than the heavier style I favor. He's an artist, like Yoshida (Noboru), who has a completely different directionality from me. He draws with an awareness of everything up to the tip of his brush, and I think it turned out to be a very good experience for the Ghibli art staff to get the chance to come into contact with his work and his solid techniques.

—Art Director: Yoji Takeshige

4

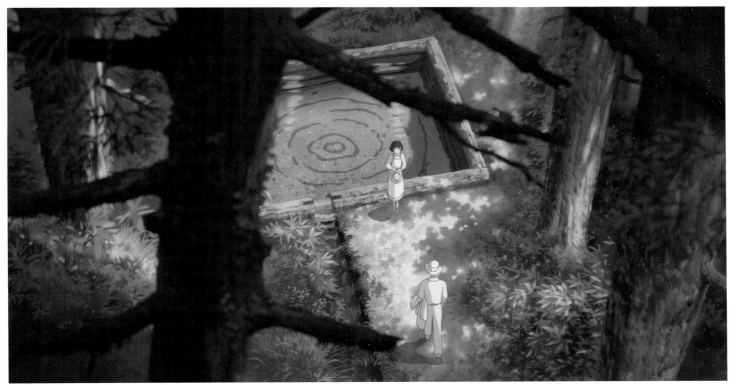

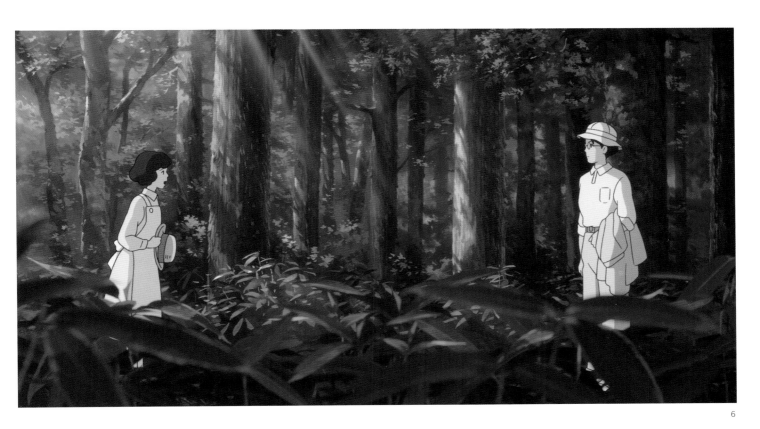

4/The sluice flowing through the bamboo grass. At the end is a pond of spring water, and Nahoko is standing there, bathed in sunlight. [Background]

5/Jiro is surprised at the unexpected meeting, but this is the reunion that Nahoko has been wishing for.

6/"We were so grateful for your help after the earthquake." "Now I remember!" They introduce themselves here for the first time.

1

2

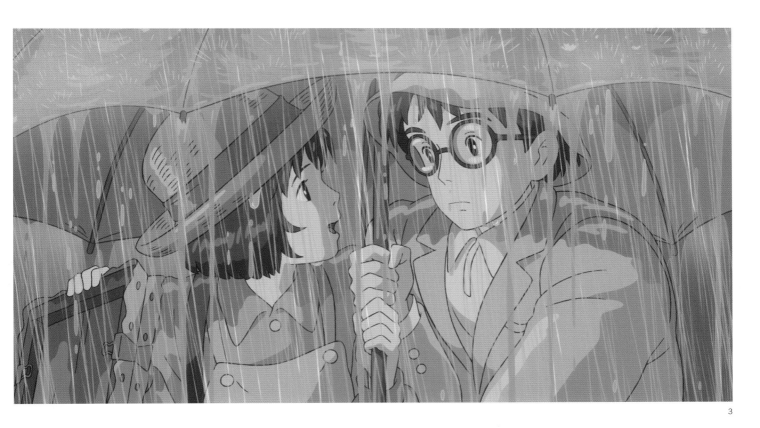

3

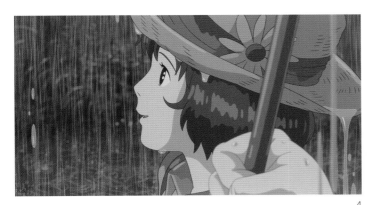

4

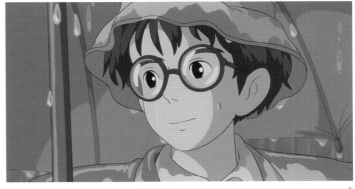

5

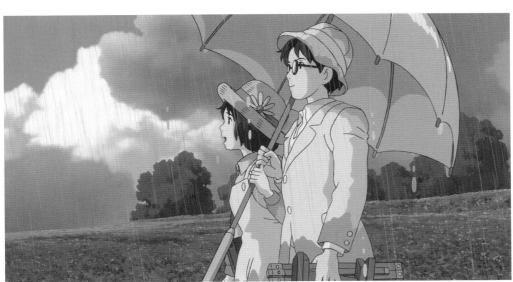

6

Under one umbrella

1/The road back to the hotel. The clear sky darkens in the blink of an eye and a heavy rain falls. [Background]

2/The shower passes, a rainbow sparkles behind the pair, and the rain makes a border in the road. [Background + book cel]

3/The rain's peak. Nahoko telling Jiro all the things that have happened, not caring if she gets wet.

4, 5/"Jiro, you were our knight in shining armor that day."

6/Jiro's spirit is soothed by Nahoko's cheerful innocence.

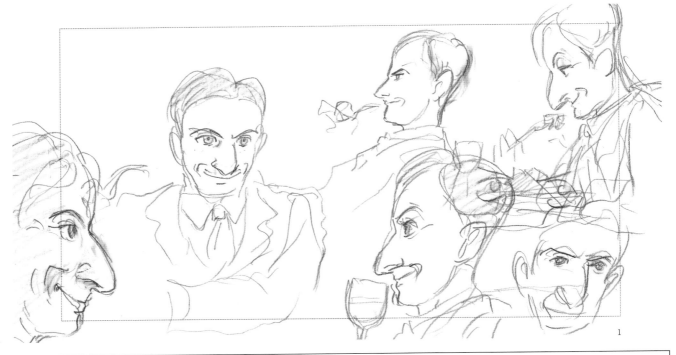

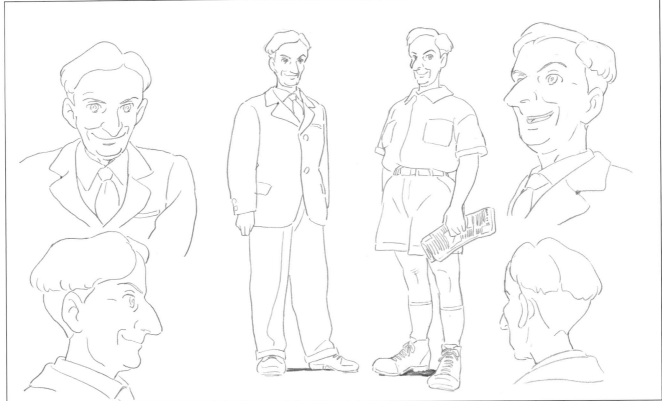

Castorp

A mysterious German Jiro meets at the Hotel Kusakaru. He knows a fair bit about the international situation and has misgivings about the future of Japan and Germany. A character whose name is borrowed from the Thomas Mann novel *The Magic Mountain*.

1/Castorp rough sketches. [Concept sketches]
2/Castorp clothing and facial expressions. [Character design]
3/Castorp talking to Jiro while smoking on the terrace. Jiro is horrified at his ominous prediction that Japan and Germany will explode.

Castorp is modeled after Steve Alpert, who used to work in Studio Ghibli's overseas operations. We had Miyazaki's rough sketches, but by looking at actual photos of him I had intended to make the character more like Alpert; it was a difficult job making it look like him without straying from the Ghibli character image.

—Supervising Animator: Kitaro Kosaka

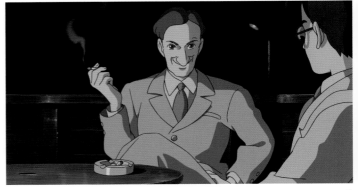

1

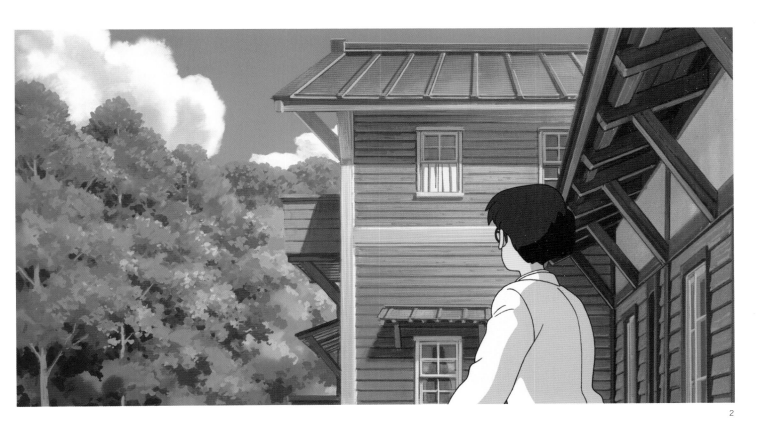

2

1/Worried after hearing from Mr. Satomi that Nahoko has a fever, Jiro looks up at the light in the Satomis' room.
2/The Satomis' table is empty the next morning, and the curtains in the window stay closed.

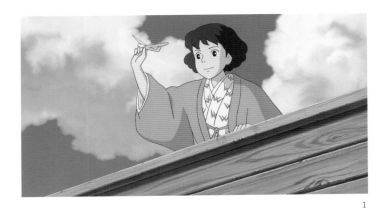

1

2

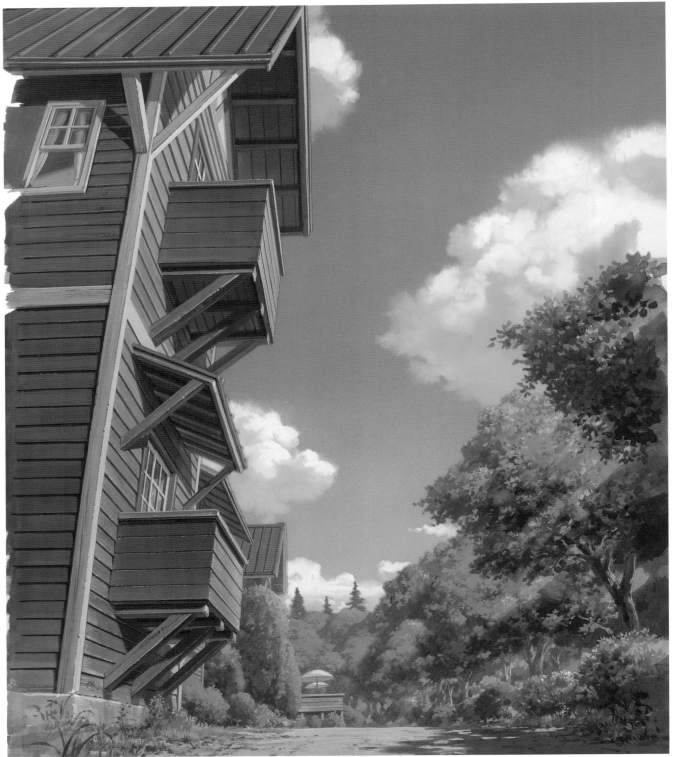

3

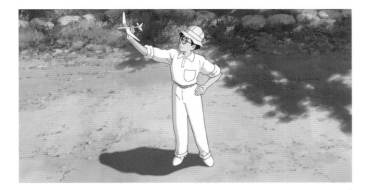

Paper airplane

1, 2/To try and make Nahoko feel better, Jiro makes a paper airplane and sends it into the air. Castorp catches it when Nahoko sends it back down, but he uses too much force and crushes it.

3/Hotel Kusakaru in the afternoon. Jiro comes out below Nahoko's room with a serious paper airplane in hand. [Background + book cel]

4, 5/Jiro makes the improved paper airplane made out of Kent paper fly with a rubber band.

6, 7/Although he fails once, the next time the plane glides magnificently to Nahoko. However, now Nahoko's straw hat falls off and drops to the ground.

8/Jiro grabs the hat even though he has to dive into the shrubbery. "Nice catch!" Nahoko's innocent laughter rings out.

4

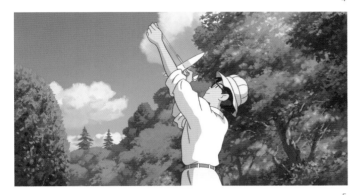

5

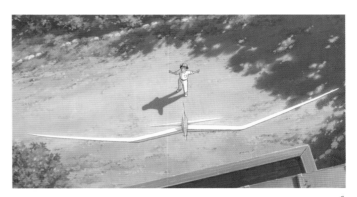

6

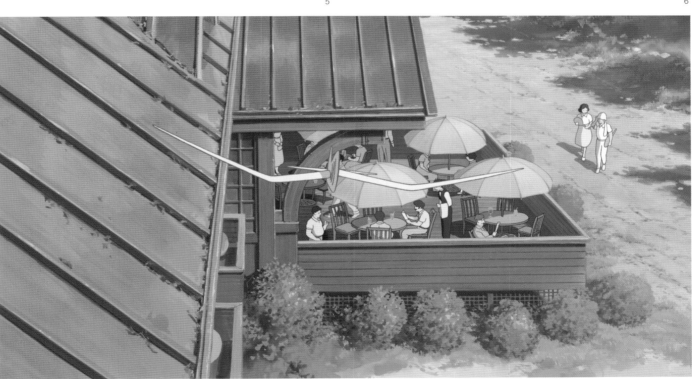

7

8

Night festival

1/The restaurant where a party is held with lanterns of all kinds strung up. Jiro and Mr. Satomi
sing "Das gibt's nur einmal" to Castorp's piano playing. [Background + book cel]
2/The bar counter. Castorp plays the piano and sings. [Background]

Courting

1/Without thinking, Jiro tells Mr. Satomi that he loves Nahoko and asks for his approval. Nahoko comes in at that moment. "I'd like you to approve, too."
2/Nahoko confesses that she has tuberculosis, but Jiro's resolve is unshaken. "Nothing is going to stop me from loving you." "I've loved you since the day the wind brought you to me."
3/The couple kissing on a hill as the wind blows.

I really wanted the color design for the scenes in Karuizawa to also be beautiful. It's the first time we see adult Nahoko, and there's the scene where she meets Jiro, so I spoke with Takeshige (Yoji) about doing something impressionistic, but that just wasn't working out somehow. I set my heart on a coloring that would feel refreshing, putting Jiro in white clothes and tinting the shadows with a kind of blue. Finally, when Nahoko appears and accepts Jiro's proposal, I tried it at first with the yellowish color she wears in other scenes, but when I did, she blended into the crowd too much. Then Miyazaki asked me to try putting her in red, so I went with a slightly darker feel. I thought it might be too flashy, but it seems like he liked it after all.

—Color Designer: Michiyo Yasuda

1

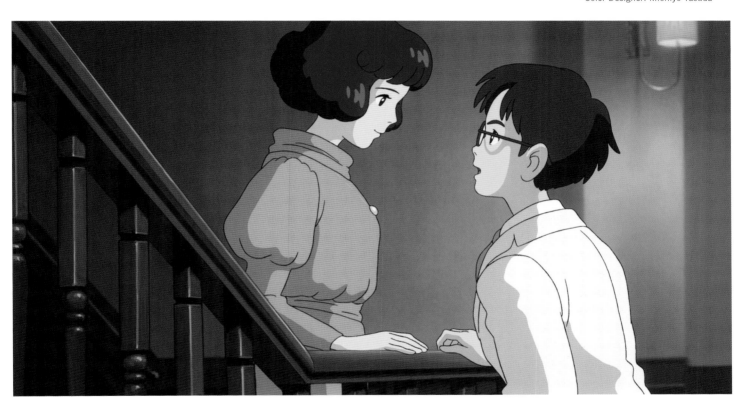

Interview
Atsushi Okui
Director of Digital Imaging

Born in 1963 in Shimane Prefecture, Okui joined Asahi Production in 1982 and was involved in photography work. *The Dirty Pair* film ('87) was his first production as director of photography. He then worked as the director of photography for *Mobile Suit Gundam Char's Counterattack* ('88) and was director of photography on the Ghibli films *Porco Rosso* ('92) and *Ocean Waves* ('93). In 1993, he transferred to Studio Ghibli. Since then, he has been director of photography for *Pom Poko* ('94), *Whisper of the Heart* ('95), *Princess Mononoke* ('97), *My Neighbors the Yamadas* ('99), and *From Up on Poppy Hill* ('11). He was also responsible for cinematography in *Spirited Away* ('01), *Howl's Moving Castle* ('04), *Tales from Earthsea* ('06), *Ponyo* ('08), and *The Secret World of Arrietty* ('10).

I paid attention to the depictions of light and shadows, centering on the natural phenomena like the wind and the clouds.

I feel like, as noted in the title itself, one theme for the creation of the images was that the audience should be able to feel the "wind" through the film. This isn't to say that I got this kind of specific direction from Miyazaki regarding the photography or image processing, or that I had started work on the film having already decided right from the start that I was going to make a certain kind of picture or that doing things this way would be best. It's just that in the end, looking back on the film, there are a lot of portrayals of nature, including weather, like the grass and trees swaying in the wind or the clouds drifting by, so I get the feeling that the director's instructions for the performance, the things the art staff were drawing–everything was aligned in the same direction.

It's not the case that all the photography and image processing is lumped together and done at the end. In the beginning, the director creates the concept with his storyboards, but after that, I'm involved in everything as the director of photography, including animation meetings and layout checks. The way it works is that all the elements of art, animation, and finish are completed, and then I do the final photography and processing with an understanding of the nuances reflected in each element, bringing the whole thing together on the screen . So I end up judging and deciding, in consultation with the director, whether to use the pictures and movements created by the art and animation staff as they are, or to add different extras to them.

In terms of "making the audience feel the wind," on-screen movements such as the plants being swayed by the wind is essentially created by the animators, but I consciously process these images depending on the scene to take advantage of the style of the background in the motion of the animation and bring out a sense of motion in the plants in the background. For instance, scenes like when Jiro and Nahoko meet at Karuizawa and a strong wind comes up or their final separation in the grass were like that.

The depictions of clouds and light were also key points in the portrayal of nature. We had so many clouds in this film: the colorful clouds of the dream sequences, the foreboding clouds of the great earthquake and the air raids, and then the rain clouds, the sunset clouds, the summer thunderclouds. I basically added in the movement digitally taking advantage of the art style or added some softness by making them a bit hazy, and I also imagined the clouds as alive for a sense of vitality.

For the light, in addition to the light shining into the dark factory and the hangar through the windows, the reflections glinting off the metal of the planes depicted in the harmonies, and the twilight of the dream sequences, I also needed to pay attention to the depictions of the brightness/darkness of the Taisho and Showa eras in which the story is set. In particular, when the characters are moving in an empty room that's darker inside like the living room at the Kurokawas' house, I tried a lot of different things to see what I could do to make it look natural, including how I added in the illumination and shadows. Even if you paint drawing paper black to make the background darker, there's a limit to the depiction of darkness for a film. So when I was shooting, I would drop the amount of light to make it darker, but since the film won't work if it's just pitch black, it was difficult to get the drop just right.

Another thing I paid particular attention to was the processing to "obscure." I say "obscure," but digitally, you have blur and lens clouding, and I used these separately, very consciously. Things that had indistinct forms like clouds or smoke were processed with blur, and I used lens clouding for processing the world through Jiro's glasses, or for giving the screen depth. Since Miyazaki doesn't really care for obscuring, I was told not to overdo it, and there are some places where it's lighter, but there ended up being a lot of shots that I felt wouldn't be finished without some blurring. As production moved forward, I think instructions from the director for lens clouding increased.

In the case of Ghibli works, the basic way of working is that the animation and art depictions are done by hand, like always. We do it in 2D, and then for effect digital processing is done as necessary; we add in the CG, and this film was no different. I don't have any memory of anything especially different or any new experiments. For the airplane scenes, we could have made a fairly good film the analog way like in *Porco Rosso*, but the number of places where we had to do special combinations, places where digital was an advantage in terms of the camera work not taking such a relatively long time, really increased for this film.

Also, conversely, you show the animation for things like the movement of the bridge in the scene where the penny steamer Jiro and Kayo are on goes under it or the scene where the Ca.60 comes up from the lake. You can make these things move digitally by adding in perspective, like in the scene with the Junkers G38 flying, but in many cases we didn't dare do that. The decision for this basically fell to Miyazaki's intention. At the other end, there were times when we had Miyazaki check it after we decided 3D would be more effective and did the processing on the spot. To realize the intention of the shot or the scene, we also decided a certain amount on the spot.

It's not the case that you can't make animation these days without using digital, so rather than reject it, I want to use digital in a way that feels like Ghibli and protect the analog-era Ghibli style while bringing it into the digital era. Whether it's the animation or the background art, we can draw it all from scratch on computers without ever picking up a pencil or a paintbrush, but our method for a long time has been to have people draw on paper and then process it digitally. Naturally, when a director or staff member comes along with new ideas, I think it's also wrong to be too set in our ways, so I'm sure this will all change from now on depending on the film and the director.

Photography Techniques in *The Wind Rises*

Glasses

This is a shot where I think the obscuring for the portrayal of Jiro's near-sightedness is relatively nicely done. For the glasses view, Miyazaki has been pretty fussy about it up to now, and rather than obscuring, he has concept shots where the right and left eyes don't have the same focal point. For the ceiling seen through mosquito netting when he wakes up from his dream, the focus isn't anywhere, neither on the mosquito netting nor on the light bulb beyond it. This was the first time I've done something like this. Also, we depicted the shots with the aircraft overlapping with a little distortion as an image seen through the lens.

Wind

For the rippling on the surface of water like the reservoir in Karuizawa as the wind blows over it, the mask of the waves running along the front of the image was the animation, with the processing of the water surface, like the details of the waves and the reflection of light, added in in photography. The advantage of digital is that mask processing is remarkably simpler than it used to be, and for places such as the paddies below brightening suddenly as they reflect the morning light when the bird-shaped plane is flying in the beginning, or the movements of the shadows in the fight scene in the German night, we animate the mask and then add in digital processing for the final look. When Jiro is writing down all his numbers too, in the past, we would have had to photograph the numbers and text backwards and then delete them, but now, we can reproduce in detail the writing while moving the mask digitally in line with the movement of the tracking.

Rain

In the days of cel animation, we used to layer cels that had been scratched with fine lines using an Exacto knife to create rain, but we couldn't do too much variation in the rain, and we couldn't use it all that often. With digital, we're now more easily able to depict a downpour like this turning into a shower and then stopping. Although I hadn't intended to go this far in the beginning, Miyazaki told me to make it stronger, so it ended up being quite a fierce downpour.

Snow

In the scene where Jiro has a nightmare in the train—and the one with the snow falling on Yatsugatake in the second half is like this too—the flurries in the clear sky are basically made to fly using a technique called "particles." The flower petals in the scene where Nahoko is walking down the hallway in the wedding scene are also particles, but the flower petals dancing in the room were animated. It's not as though we have a standard policy to use particles in certain types of shots but not in others. It's more like we play it by ear; we make the film judging all the while which would be most effective for which area.

Darkness

I think even now, when you go out into the country, there aren't very many street lamps, and it gets totally dark at night in some places. At the beginning of the Showa era, even for lighting inside the house, they would use a single 40-watt or so bulb to light up a seven-square-meter room, so it was apparently fairly dark. As part of the mood for this film, Miyazaki told me he had in mind old Japanese movies from the forties and fifties, and that the ceiling areas of the rooms in the Japanese homes that appeared in these films were very dark. But if we actually made it totally dark, the film would be hard to watch, so I worked hard to depict the darkness, adding in some variations.

Smoke/Clouds

The backgrounds with the smoke from the fires of the Great Kanto Earthquake rising up like clouds were also used for the air raid scenes in the second half of the film, albeit after a little adjustment. The silent movement of these clouds of smoke bubbling up was added in with 3DCG. In the flying scenes as well, the movement of the clouds is key; I think it's the foundation of the film. In the earthquake scene, the animation is the focus, but the shaking is camera work, and the missing parts of the garbage and clouds of dust dancing in the air were added in during processing. During production, the Tohoku earthquake and tsunami happened, and we met with some severe shaking in the studio, so there might be some parts where the depiction is different based on our own actual experience.

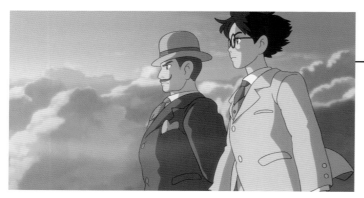

Light

In the scene where Caproni and Jiro are talking on the wing, rather than emphasize the evening light and just have the light coming from the sun off-screen, I added light to the areas drawn in the background and the clouds themselves, giving the whole thing a bit of a haze. The time changes frequently in the dream sequences, and I pulled some tricks to bring together the mood for the entire screen to go along with the backgrounds the art staff had calculated and drawn. Conversely, in the dream sequence at the beginning in which Jiro is a boy, I was more conscious of the shadows stretching off the clouds than the light—the shadows they each cast when the clouds overlap. The art staff also put in some deliberate touches, but I expanded on those even further in photography to make it look like the shadows overlap when they move.

Cigarette smoke

This film takes place in an era when it was normal for everyone to smoke, unlike nowadays. In particular, most men smoked, so this was something we couldn't run from if we were going to depict this era. But since it would just end up feeling smoky if we had this on-screen all the time, we had them put their cigarettes out in appropriate places; the one that really stays in my memory is the scene in Café Flyer. Coffee shops at that time didn't have non-smoking sections and would thus get incredibly smoky. So for just that scene, I deliberately set it up that way. Smoke other than cigarette smoke such as the smoke from a train and steam is, as a general rule, done in animation, and at the photography stage we add in processing like haze or blur.

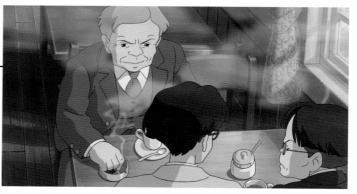

Camera mapping

Scenes where the houses and fields seen from the window when Jiro is on his way to Tokyo pass by moving three-dimensionally, or the receding scenery as Kayo sees Nahoko off from inside the bus, are 3DCG. In the scene where Nahoko—who has run away from the hospital—and Jiro walk through Nagoya station, we processed it to have the background moving while the perspective changes. Places where 3D is going to be used are basically decided at the storyboard stage, but it's also sometimes put in at the layout stage or in a decision during production itself.

The Wind Rises Production Process IV

Photography/Effects

Formerly, animation was done using a rostrum on which the background and cel frames were layered, and one frame at a time was photographed. Nowadays, that entire work process has been digitized and is done on computers. Due to the introduction of computers, depictions are much smoother for elements like complex camera work and multiple materials being brought together, synthesis with 3DCG, and portrayals of nature like rain and snow. For the work of coloring, finishing, photography, and special effects, we use a program customized by Studio Ghibli called Toonz.

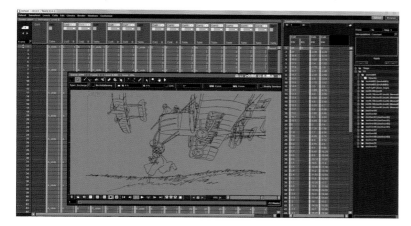

Loading the animation

At the stage where each shot is complete, all the picture elements are read with a scanner and the shots are assembled in the computer following the instructions on the dope sheet. The animation is made up entirely of line drawings, but this is made into a temporary "complete form," a form that changes sequentially as the background and finishing work are completed. The timing at which each part is done varies, so rather than putting it together once all the parts are complete, it's more efficient to put the line drawings together first.

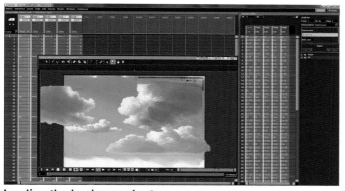

Loading the background art

Once the background art drawn by hand is done, the book cel clouds and the BG sky are each photographed with a digital camera and digitized. At Ghibli, the background art is not scanned but is photographed with a camera and loaded this way. These are then put together according to the instructions in the layout. Each of the clouds in the cel book is moved individually. Because the grass in the foreground is depicted entirely in the animation, it doesn't exist on the background. The background data put together here is inserted into the scene data with the line drawings combined.

Checking the finished image

Once the coloring of the animation is finished, it is reflected in the previously combined scene data. The match with the background art and the actual timing can be checked in a form very near that of the completed screen.

Seasoning with photography effects and special effects

After the basic movement and colors have been determined, effects are added in photography. In the case of this scene, the propeller attached to the wing of the plane in the foreground is semitransparent, for which an effect called "super (superimposition)" was used. The propeller lines were drawn with conventional special effects. In addition to these, since the edges would be overemphasized if the book cel clouds were just layered, a variety of effects were added in to blend them and create natural-feeling clouds.

Photography effects flowchart

A flowchart to see at a glance which photography effects are going to be used for each shot. The very bottom left is the BG that is the base of the image, the book cels and animations are layered on top of that, and then each level above that is set up to allow checking, changing, and arranging the effects to be added. Because there are a large number of pages for each shot and the configuration is extremely complex, managing them all with a chart like this is essential.

Jiro Horikoshi: *Thirty-One Years Old*

Separated from Nahoko, who is living in a sanatorium, Jiro throws himself into designing his new plane. But the world is steadily moving in a dark direction. After attracting the attention of the Secret Police, Jiro moves into the Kurokawa home and decides to live together with Nahoko, who runs away from the sanatorium to see him. The two hold a private ceremony with the Kurokawas as witnesses and begin their short married life. But then...

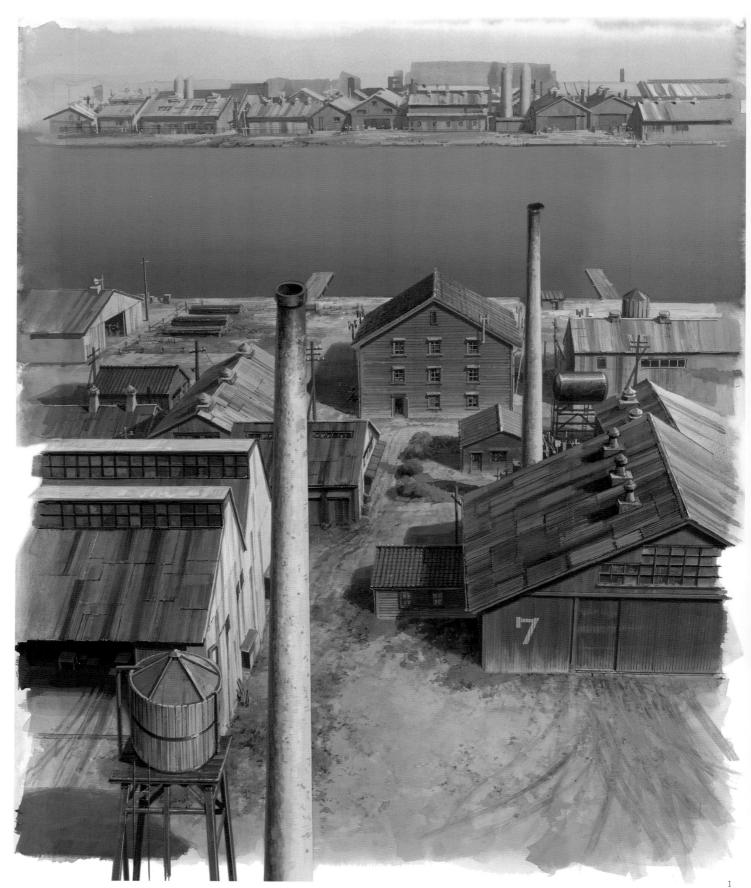

Jiro and Honjo's dream

P182–183/Jiro sees the No. 8 reconnaissance plane made by Honjo and gives his stamp of approval: "Oh, she'll fly." The pair imagine the graceful figure of the plane in the sky.

1/The Mitsubishi factory in one corner of the Chukyo Industrial Area. In the fierce heat of summer, Honjo welcomes Jiro back from Karuizawa and shows him his maiden work, the No. 8 reconnaissance plane prototype. [Background + book cel]

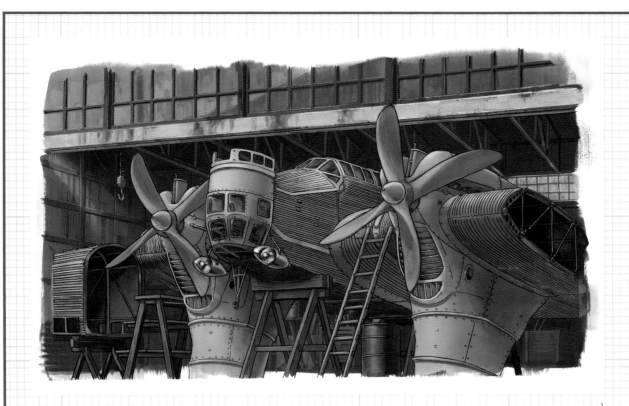

Mitsubishi Ki-1

Low wing cantilever monoplane completed by Mitsubishi in 1933 after the company received an order from the military to develop a new type of bomber. The military's demands were not met and the machine had problem points, but it was officially adopted for use, with several improvements being made. Because of its weight and poor maneuverability, it was not used very often.

1/Mitsubishi Ki-1 assembled in the factory. [Background + harmony cel]

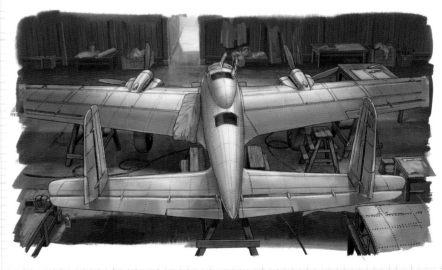

8-Shi special reconnaissance plane

The first plane Jiro's close friend Honjo is the lead designer for. Completed in 1934 at a request from the navy, it was a modernized twin-engine plane with retractable landing gear and a Junkers-style dual wing, but only one was produced.

1/8-Shi special reconnaissance plane in the factory. [Background + harmony cel]
2/8-Shi special reconnaissance plane flying in the imaginations of Jiro and Honjo. The machine demonstrates performance a step above conventional twin-engine planes.

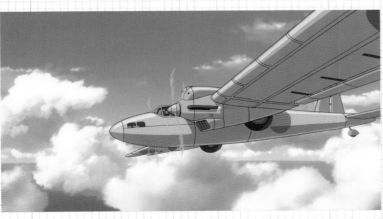

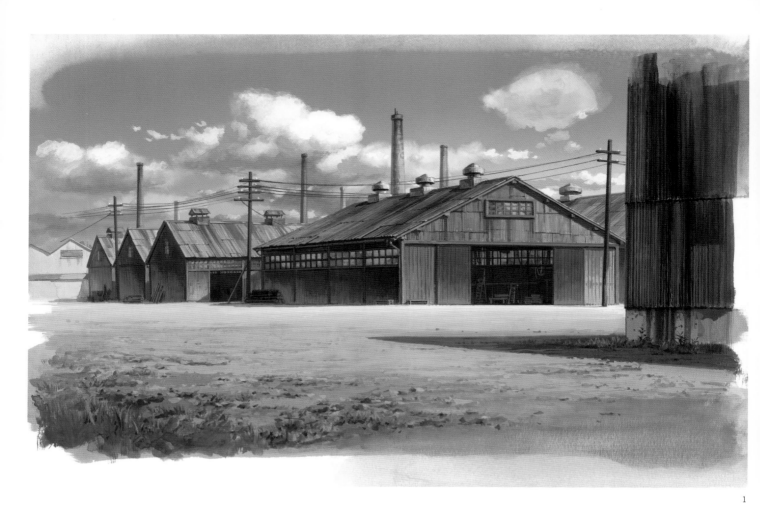

1

2

Fleeing the eyes of the Secret Police

1/The grounds of the Mitsubishi factory where the factory workers spend their lunch break. [Background]

2/The Secret Police, which investigated thought crimes, comes to investigate Jiro. Kurokawa deceives them, saying he is on a business trip, and hides Jiro for the time being in the reference room.

3/The pressed duralumin sample is delivered there. The plane of Japan's future was the all-metal, lightweight machine Jiro and Honjo were aiming for.

3

4

5

6

4/The large road in front of the factory with the setting sun illuminating the scene. At the end of the workday, employees hurried along the roads on bicycles or in buses.

5/Passenger car running through the factory town in the fading light. Jiro rides squished in between Hattori and Kurokawa. The two men try to calm Jiro, who is indignant upon hearing that the Secret Police went so far as to open his private messages.

6/In charge of the next naval plane, Jiro ends up hiding in Kurokawa's house and continuing his work. "The company will do everything to protect you. If you keep your mind on your work."

Kurokawa house

1/The guesthouse at the Kurokawas where Jiro stays. Jiro throws himself into his work while fearing the worst for Castorp who is also apparently being pursued by the authorities. [Background]
2/The phone attached to a pillar in the hallway rings.
3/Wearing one of Kurokawa's light kimono and absorbed in his calculations, Jiro learns from a phone call from Kurokawa that Nahoko has suffered a lung hemorrhage.
4/Jiro says he wants to get to Tokyo right away, and Mrs. Kurokawa sends someone to go and hold the bus.

To avoid having Mrs. Kurokawa end up resembling O-Kinu or the other maids, I decided to give her upturned eyes. I was imagining a face like the famous actress Izusu Yamada when she was young, but well...
–Supervising Animator: Kitaro Kosaka

The room in the Kurokawa house where Jiro hides himself and continues his work was modeled after the study in Natsume Soseki's old house in Uchitsuboi-machi in Kumamoto Prefecture. In terms of the period it also works, and it's been restored for display as a museum, so I referred to photos of it. Rather than being white, the walls were green and felt a little blackish, and they were also the concept for the walls in this place.
–Art Director: Yoji Takeshige

1

2

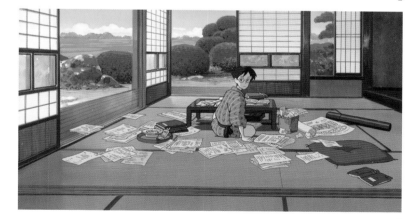

3

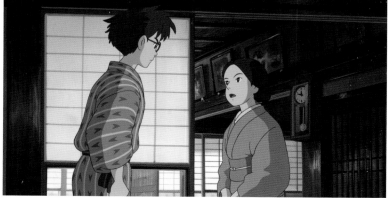

4

1

2

1/The bus that Jiiya from the Kurokawa house has kept waiting drives away with Jiro on board.
2/Returning to Tokyo after transferring from the bus to an express train, Jiro transfers to the Odakyu line and heads for the Satomi house in Yoyogi-Uehara. It is already night when he arrives.

Class C56 steam locomotive

Tender-type steam locomotive built in 1935, designed to be a combined passenger/freight train able to travel long distances. The smallest and lightest of all the locomotives built from the Showa era on.

1/Class C56 steam locomotive Jiro rides to hurry to Tokyo after receiving the news that Nahoko has hemorrhaged.

Odakyu Express Railway

The former incarnation of the modern Odakyu Electric Railway. The Odakyu Express Railway was established in 1923 to build a rail line that ran directly between Tokyo and Hakone. Although the Great Kanto Earthquake happened that year, the completed line was opened in 1927.

1/Having come to Tokyo, to get to the Satomi house Jiro boards the Odakyu Express Railway Noborito-bound train and gets off at Yoyogi-Uehara station.

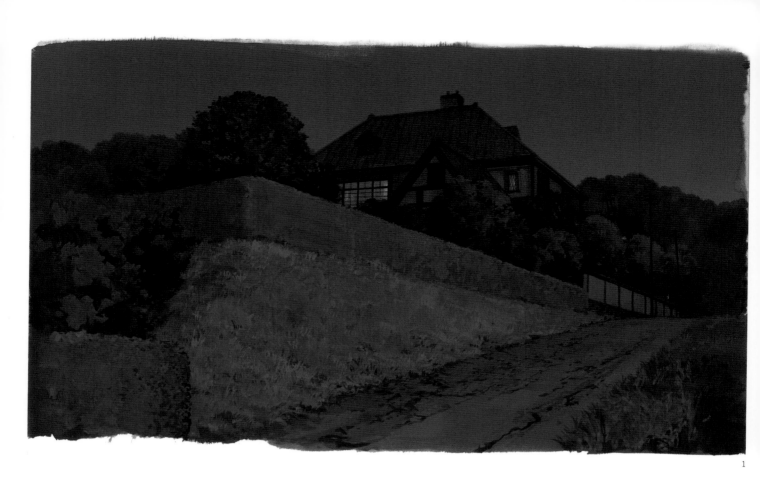

1

2

194

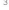
3

4

Satomi house

1/Nahoko's house, atop a hill in a new residential area. It is a grand, Western-style building. [Background]
2/The entrance in front of the cavelike steps to the house. [Background]
3/Nahoko's room left open to let fresh air in. Beyond the curtains fluttering in the wind, Nahoko can be seen lying in bed.
4/Three windows through which the faint light from the lamp is leaking. Jiro passes under these and goes into the garden.

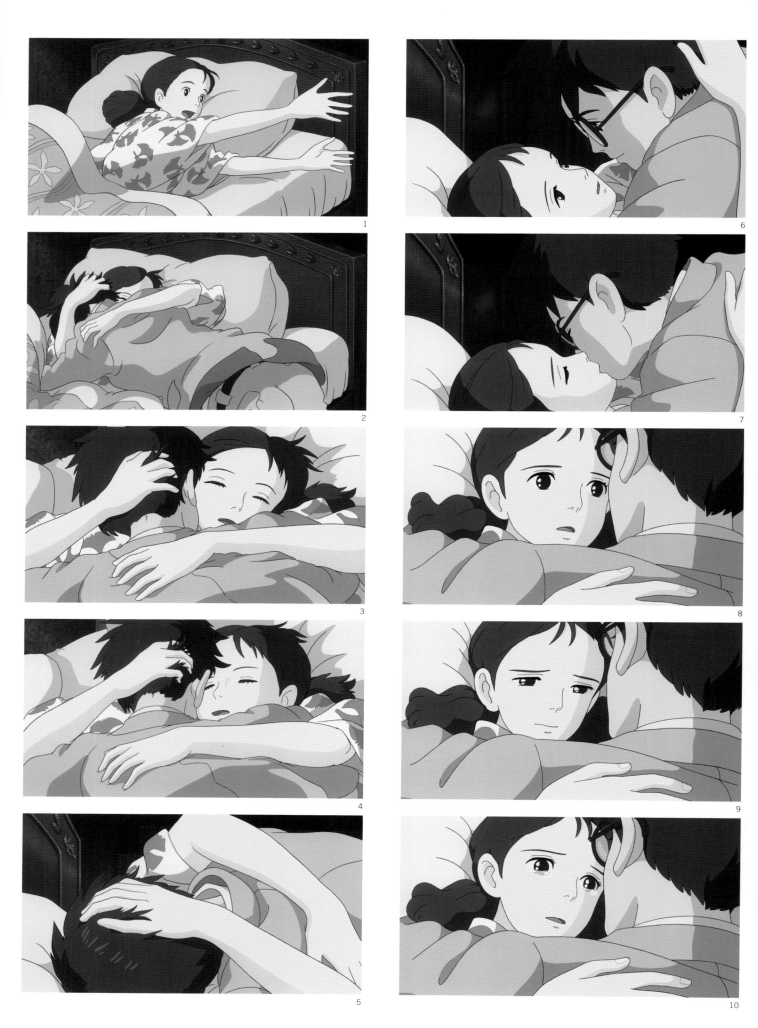

11

12

Embrace

1–10/Jiro heading straight for Nahoko, too impatient to even take off his shoes. Nahoko reaching a hand out to welcome him. It feels like their love is even stronger after they exchange a kiss.

11, 12/Mr. Satomi returns home to find Nahoko and Jiro laughing and chatting in Nahoko's room. After he sees Jiro off and comes back, Nahoko declares to her father that she is going to the sanatorium to get over her illness and live together with Jiro... [Background]

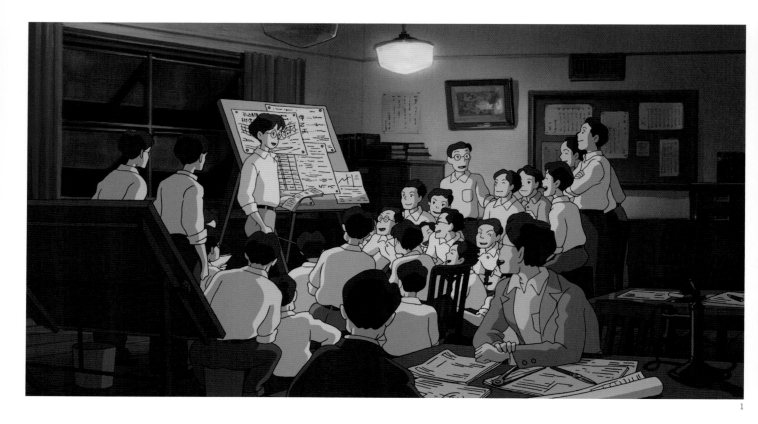

1

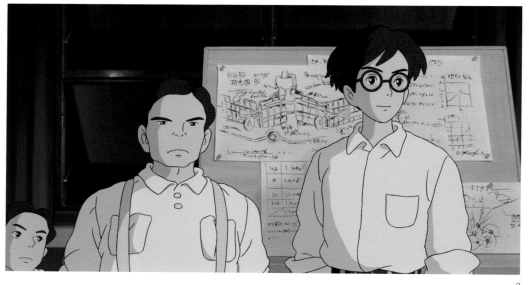

2

Voluntary research meeting

1/The younger staff members stay late in the design office, listening to Jiro. Eyes glittering at the wonder of the new fighter plane proposal bringing together the latest technologies, they all laugh loudly at Jiro's solution: "We could always leave out the guns."
2/Jiro introducing Hirayama from the construction division. To make a light and sturdy body that can fly even on the underpowered Japanese engines, the new technology of flush riveting, which hadn't yet been made use of in Japan, will be needed. Even more heated discussion. Hattori and Kurokawa leave, seemingly satisfied: "I must say, that was interesting." "It was inspiring."

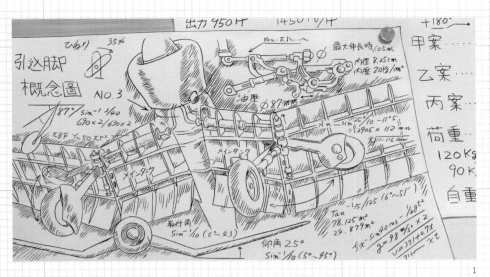

1

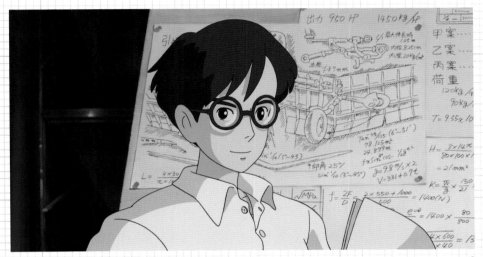

2

9-Shi single-seat fighter

The prototype Jiro designed by making use of his experience with the failure of his previous prototype. The navy ordered a number of different 9-Shi prototypes, and Jiro's design team completed the first of these in 1935. The first prototype adopted an inverted gull wing—a wing that is bent like that of a seagull is called a "gull wing," and one that is bent in the opposite direction is called an "inverted gull wing"— but from the second prototype on, a low, all-metal wing was used. After adding in a variety of improvements to the 9-Shi single seater, the navy officially adopted it as the A5M1a.

1–3/Jiro telling the design team about his ideas for the 9-Shi. The new proposal he discusses here is full of ideas that closely resemble the Zero to come later.

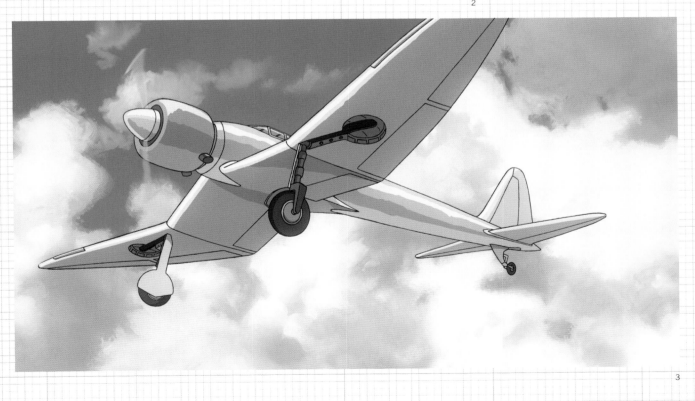

3

1

Mountaintop hospital

1/Fujimi sanatorium at the base of the already snow-capped Yatsugatake. [Background]
2/Train bridge crossing between mountains. [Background]
3/Patients wrapped up in blankets, taking air baths.
4/Nahoko reading the letters that arrive from Jiro every day. Her face clouds over knowing that he is busy with work and can't come to see her.

2

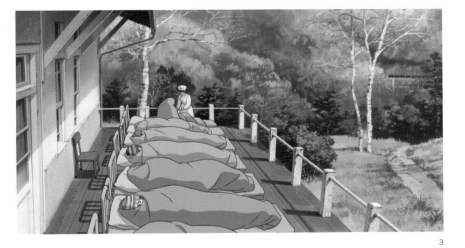

3

4

In sanatoria like the one where Nahoko is receiving treatment in this scene, Miyazaki said that the patients were wrapped up in army blankets. They're heavy, but strong and good quality. I wasn't really aware of the use of army blankets for TB patients, but for this scene and others I really didn't want to dirty Nahoko with coloring typical of a person who would be gone soon. The hat in this scene with the red lines is like this too, but even in sad scenes, I tried to give her things with cute colors, or use pretty colors.

–Color Designer: Michiyo Yasuda

5

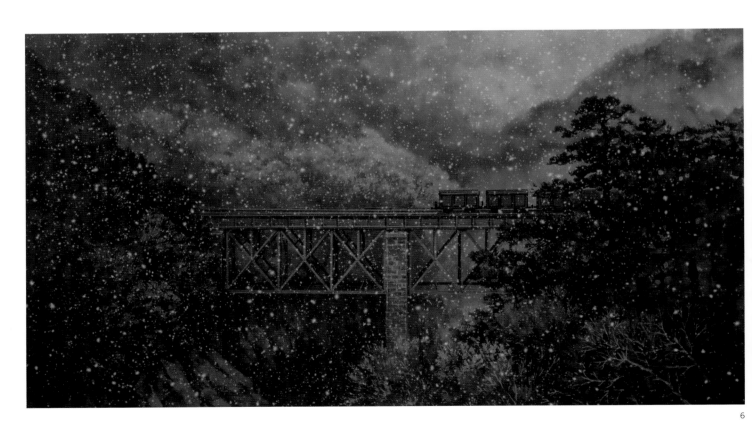

6

5/In the blink of an eye, the weather deteriorates and snowflakes begin to dance about.
6/Dusk as the snow falls. A train crosses the bridge.
7/The following morning. In some areas, snow has piled up. [Background]
8/Wanting to see Jiro, Nahoko flees the sanatorium and descends to the town of Fujimi.

7

8

2

Last stop

1/Nagoya station at dusk when the train Nahoko is on arrives. [Background]
2/The platform the train pulls into, spewing smoke and steam. [Background]
3/Near the head of the platform the locomotive stops at. [Background]
4/Nahoko seated, experiencing feelings of unease and expectation.
5/Herd of people getting off of the train and heading toward the gates. Jiro, having been informed of her coming, finds Nahoko walking from the far end of the platform.
6/The pair embracing, the crowd in the station splitting to go around them.
7, 8/"I'm going right back. I just needed to see you." "Don't go back. We should be together."

1

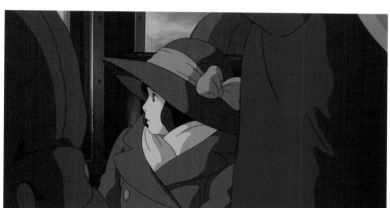

4

3

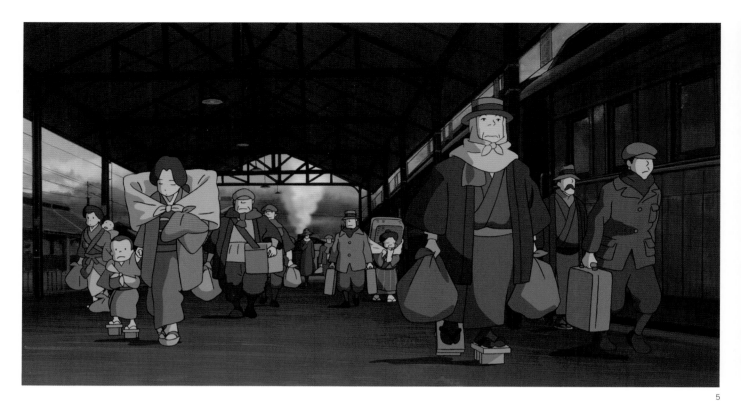

5

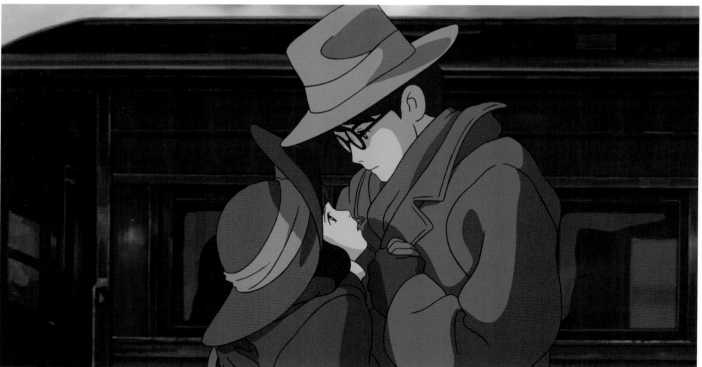

6

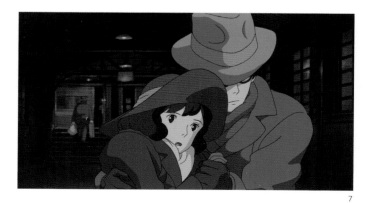

7

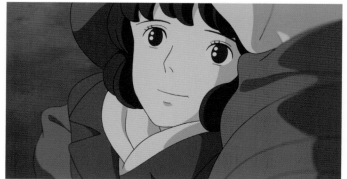

8

1

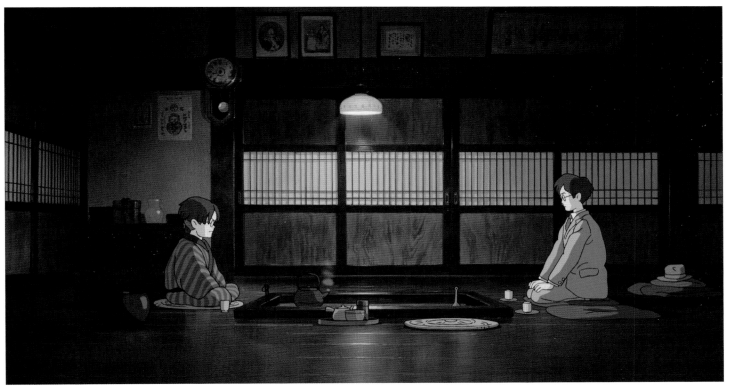

2

Go-between

1/Jiro gets in a taxi with Nahoko and heads toward the Kurokawa house.
2/Although he expresses disapproval at first, Kurokawa sees their determination and allows the pair to live in the guesthouse. Jiro and Nahoko then carry out a private wedding ceremony with the Kurokawas as go-betweens and witnesses.

1

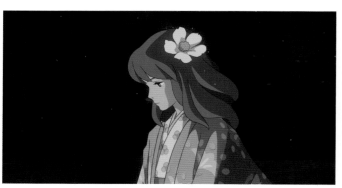

2

5

3

6

4

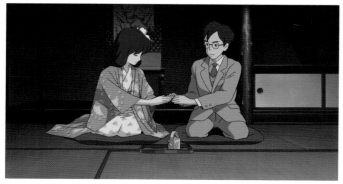

7

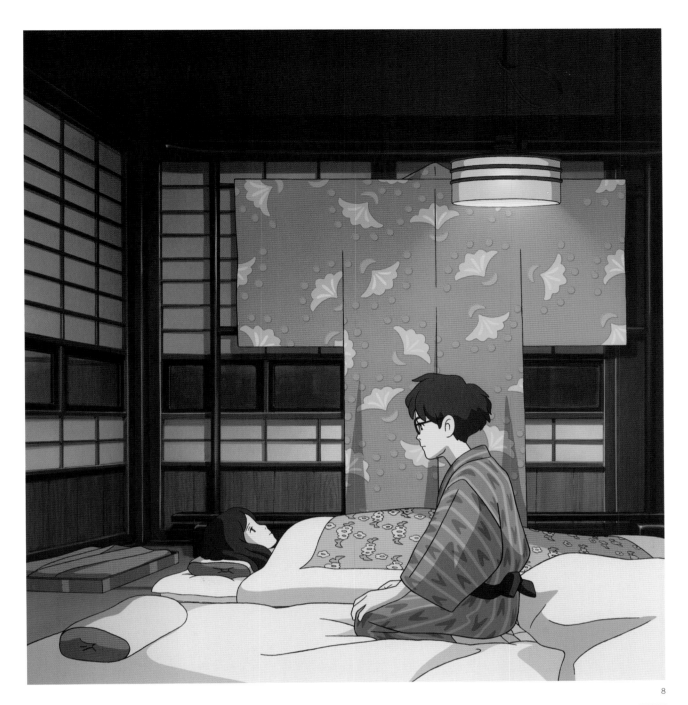

Wedding

1–7/Nahoko proceeding slowly down the hallway, led by Mrs. Kurokawa amidst the flower petals. Jiro is moved by her beauty. The modest wedding ceremony ends without problems, moving from the statement from the go-between to the sharing of the cups, to the greetings from the newlyweds.

8/Nahoko and concerned Jiro. "You must be exhausted." "This feels like a wonderful dream."

9/Their first night together grows dark around them.

Kayo's visit

1/A mild late autumn day. On behalf of their parents, Kayo pays a visit to the Kurokawa house.

2/The bus Kayo is on runs through the countryside.

3, 4/Forgetting entirely that Kayo is coming, Jiro returns home late again today. A doctor in the making, Kayo, worried about Nahoko, blames Jiro, and he moves her with his words: "Each day is very precious to us now."

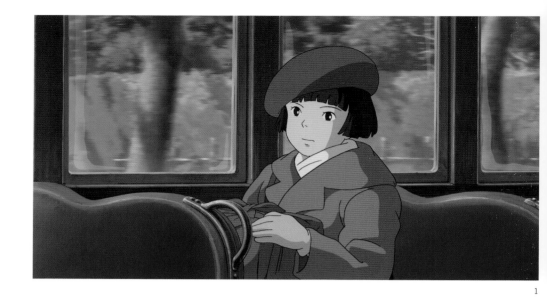

1

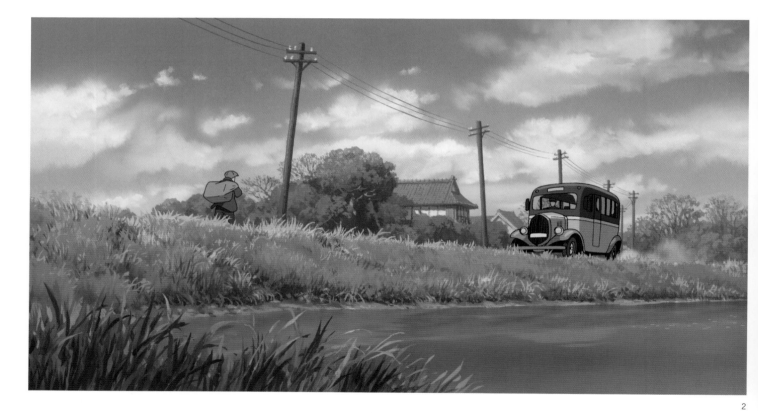

2

3

4

1

Life in love

1/"I'm home." Jiro calling out from the other room.

2–4/Nahoko gets up and talks to him about Kayo while helping him change: "She's got such a bright future."

5/Jiro spreading out his plans to start work. He holds Nahoko's hand in his left hand and manipulates his slide rule adroitly with his right.

6/Nahoko stopping Jiro from going to smoke a cigarette. "Smoke here." "It's not good for you." "I don't care." Pressed, Jiro strikes a match with one hand and takes a puff.

2

4

5

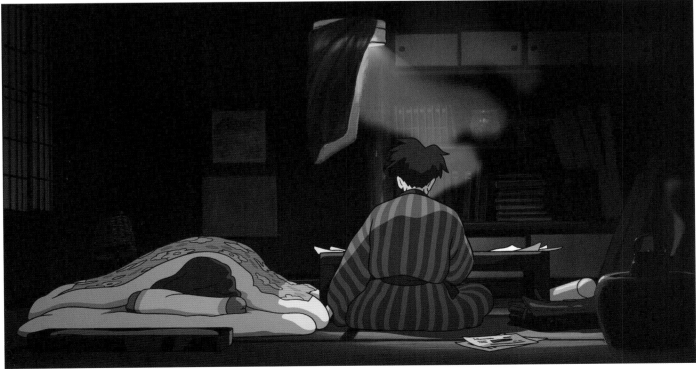

6

1

2

Nearly complete 9-Shi

1/9-Shi single seat fighter with scaffolding in one corner of the prototype factory. [Background + harmony cel]

2/Jiro adjusting the struts with the engineers in charge of the landing gear. Honjo appears after some time away and is impressed: "She's beautiful, Jiro. Like a work of art."

3/The machine body, which uses flush riveting everywhere, is still not complete, but Honjo praises it as being a very Jiro-like design. "Is it all right if I use your flush rivets and that spring-loaded hatch?" Jiro, readily agreeing, and Honjo, not using Jiro's ideas to get the jump on him, are friendly rivals bound by a deep and fair friendship.

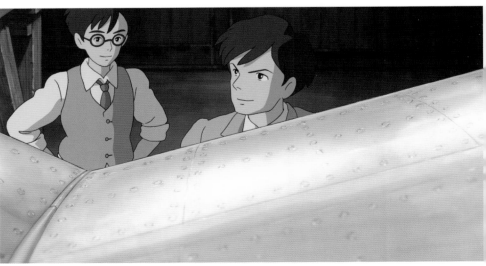

3

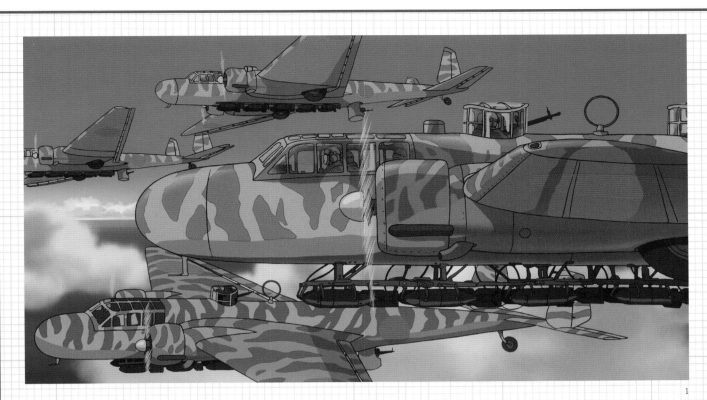

1

Ground attack planes

1, 2/Equipped with bombs, the planes fly in formation.

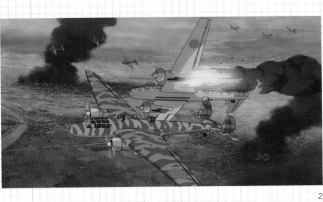

2

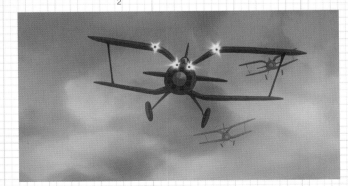

1

Polikarpov I-15

Single-seat, biplane fighter designed by Polikarpov in the central design office of the Soviet Air Force. The sKB-3 designed in 1932 was modified and fitted with an M-25 engine. The bent upper area of the main wing resembled that of a seagull, so it was nicknamed "Chaika," which is Russian for "seagull."

1, 2/Polikarpov I-15 engaging the attacking No. 9.

2

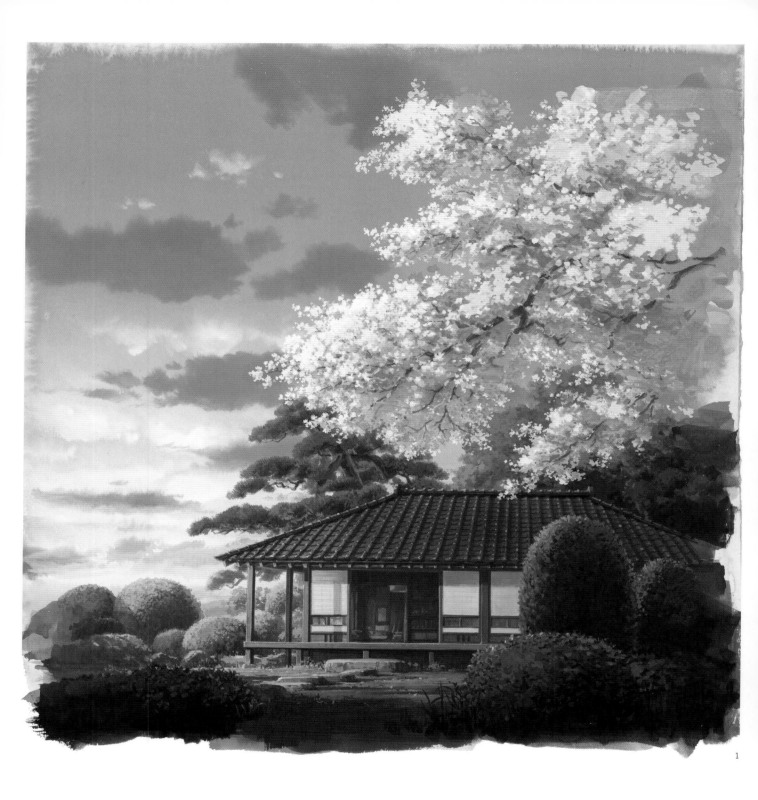

1

Spring separation

1/The Kurokawa garden and guesthouse with the cherry tree in full bloom. [Background]
2/Guesthouse room seen from the garden. [Background]
3/The gates of the Kurokawa house Nahoko passes through after saying she is going for a walk. [Background]

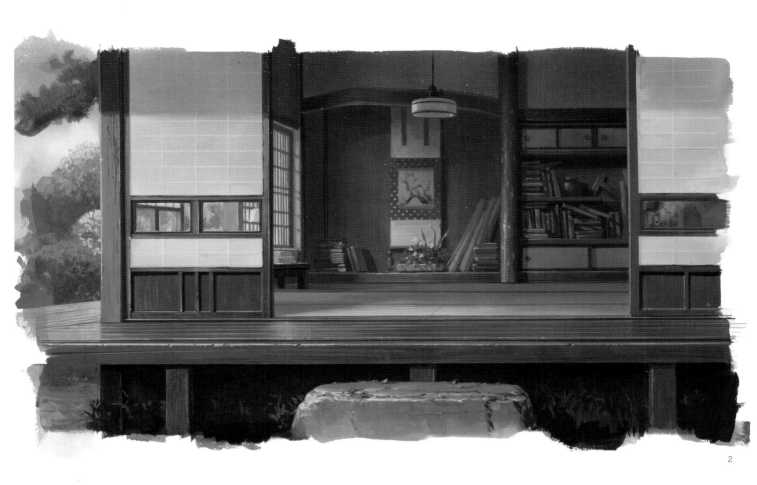

2

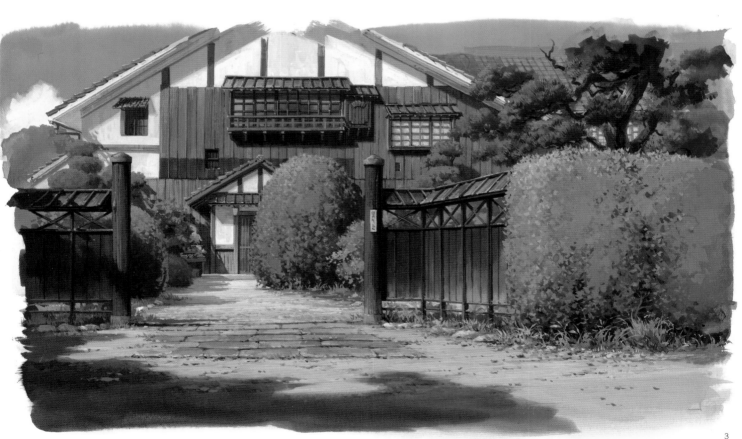

3

1

2

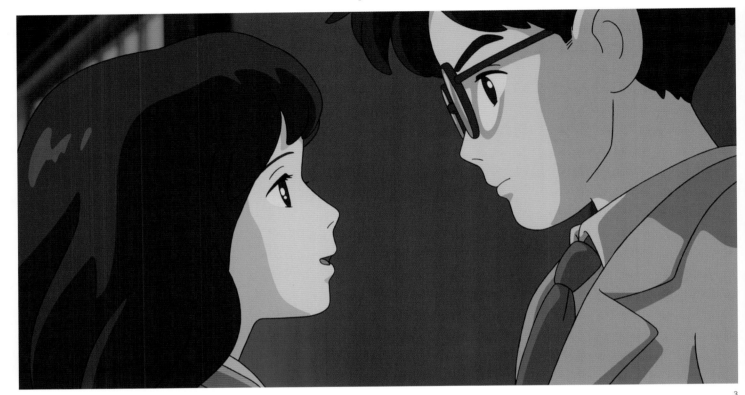

3

4

5

6

7

9

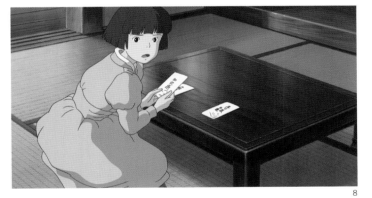

8

10

Farewell letter

1, 2/"My plane's finished. Now we'll see how she flies." "Congratulations. You've worked so hard." Having finally completed his prototype, Jiro returns home exhausted and falls asleep next to Nahoko.

3/The morning of departure. "I'm off!" "Good luck!"

4, 5/Nahoko waving and seeing her husband off. Having decided to return to the sanatorium, it is her final farewell.

6, 7/Nahoko tells Mrs. Kurokawa, who is preparing a celebratory meal, that she is going for a walk.

8/Coming to visit and also see how the patient is doing, Kayo sees Nahoko from inside the bus and is gripped with dread. She goes with Mrs. Kurokawa to the guesthouse and finds the letters addressed to them both.

9, 10/Kayo tries to go and bring Nahoko back, but Mrs. Kurokawa stops her. "She wants him to remember her as she was."

11/Nahoko looking at the spring scenery from the carriage window.

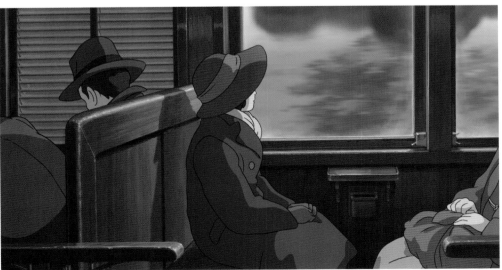

11

1

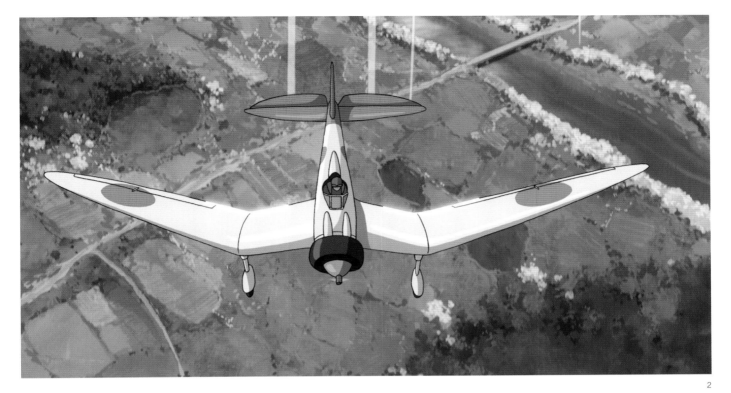

2

3

6

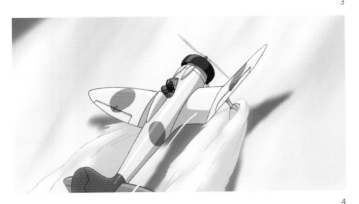

4

7

5

Beautiful dream

1/Open fields of farms spreading out below the 9-Shi single seat fighter as it continues along on its excellent test flight. Rivers of cherry trees in bloom flow along both banks of the actual river. [Background (partial)]

2/The 9-Shi's speed and maneuverability are better than any prototype so far.

3–5/Climbing at a steep angle, the plane pierces the wall of clouds and flies even higher toward the sun.

6/Watching the 9-Shi land, Jiro turns around reflexively, thinking he heard someone's voice, but...

7/The pilot wanting to shake Jiro's hand: "She flies like a dream." The development staff, including Hattori and Kurokawa, are delighted at the success. It is the moment of the birth of Japan's first modern aircraft.

Jiro Horikoshi: *Forty-Two Years Old*

The long, tragic war is over. The beautiful planes Jiro dreamed of all ended up being tools of war and did not return. Caproni and Nahoko wait for Jiro in the same field as his old dreams, as he reflects on the futility of the war. Nahoko tells him to live and disappears, and Jiro murmurs his thanks. As long as the wind blows, people must live.

Kingdom of dreams

P220/The smoke from the burning landscape rises up as clouds, and a B-29 cuts through the sky. Jiro's dream is swallowed up by the war.
P221/The remains of planes scattered in a field. On the other side of the hill, Caproni is waiting just like that day. [Background + book cel]
1/"Our kingdom of dreams." "Now it's the land of the dead." "Not quite. In some ways, yes."
2/The field shimmering in the evening light. "What about your ten years in the sun? Did you live them well?" "Yes. Things fell apart toward the end, though." "That's what happens when you lose a war." A formation of the famous Zeros that Jiro created comes flying along. "Airplanes are beautiful, cursed dreams waiting for the sky to swallow them up." [Background + book cel]

1

2

Mitsubishi A6M Zero

1–4/Mitsubishi A6M Zeros flying in formation as if to embody the conversation between Jiro and Caproni.

1

2

"You must live."

1/"Someone is waiting for you." When Jiro turns around, he sees Nahoko walking along the field, holding a parasol.
2/Standing next to a surprised Jiro, Caproni tips his hat and greets Nahoko.
3/"You must live, darling." Nahoko calls out to Jiro and he nods.
4/Seeming relieved to see that, Nahoko sparkles with light and disappears on the wind.
5/"She was beautiful, like the wind." Listening to Caproni's words, Jiro murmurs, "Thank you."

3

4

5

"You must live, Jiro. But now, shall we drop by my house? I have some very excellent wine."

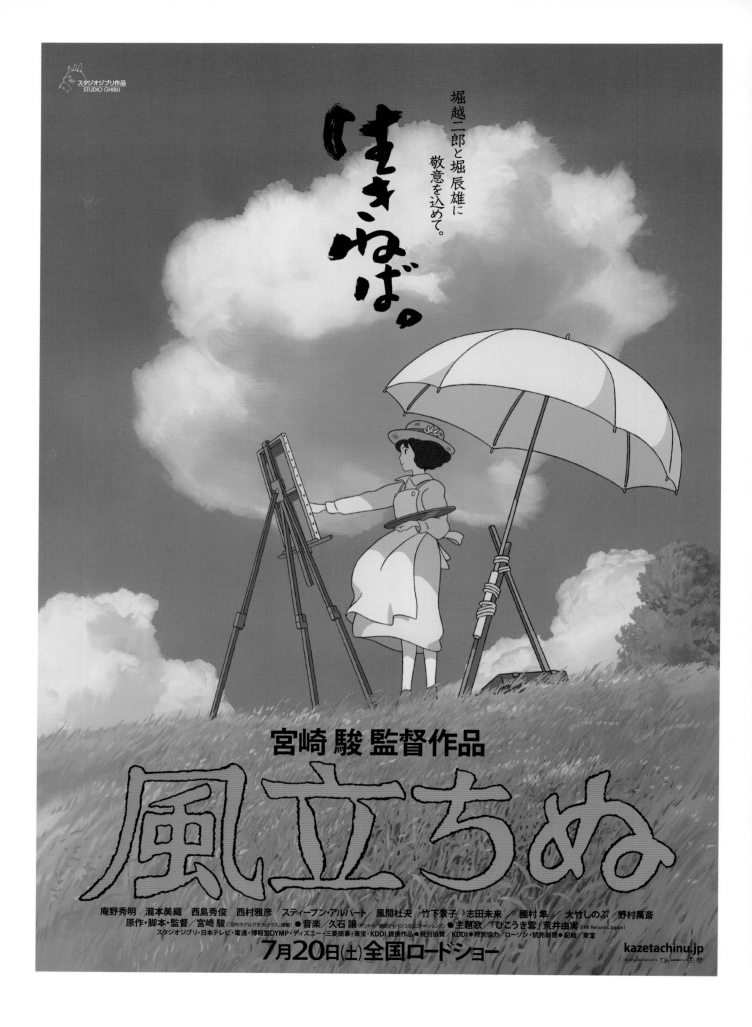

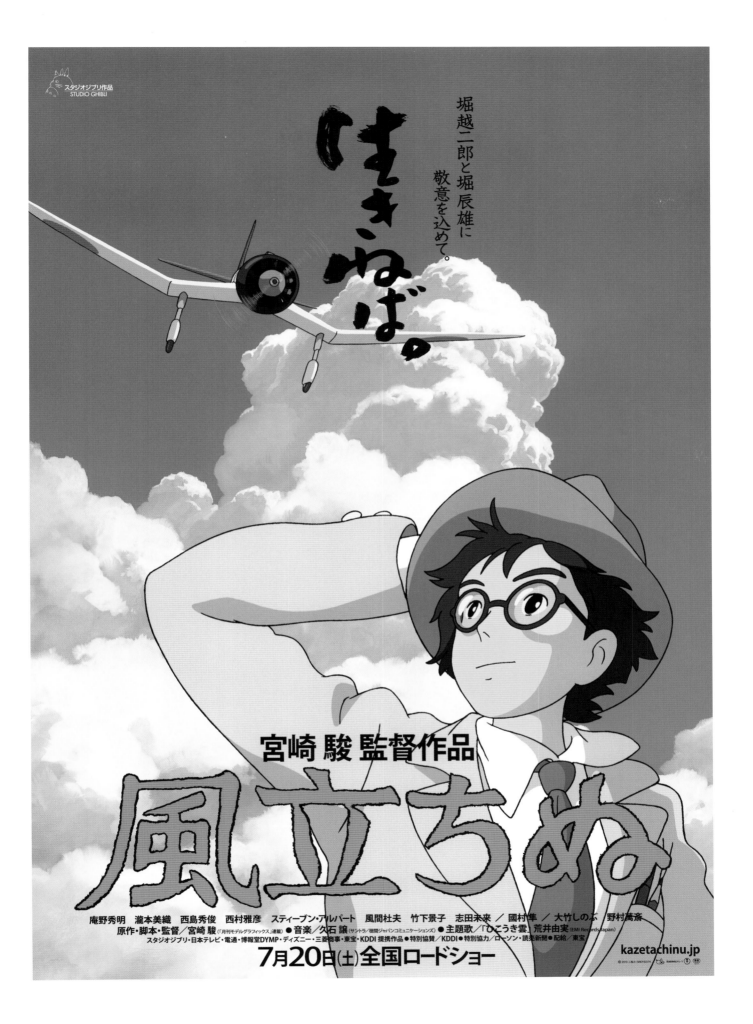

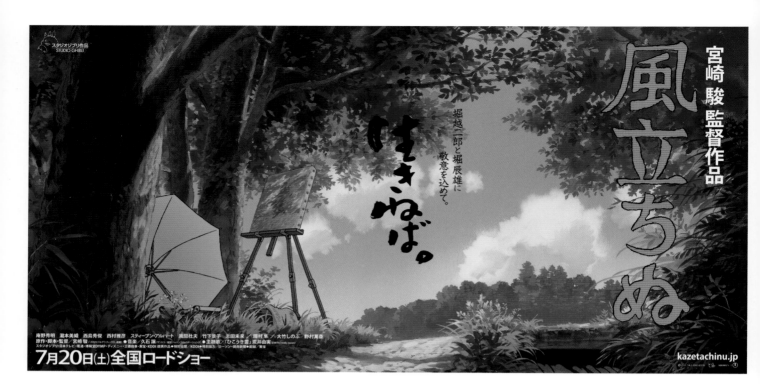

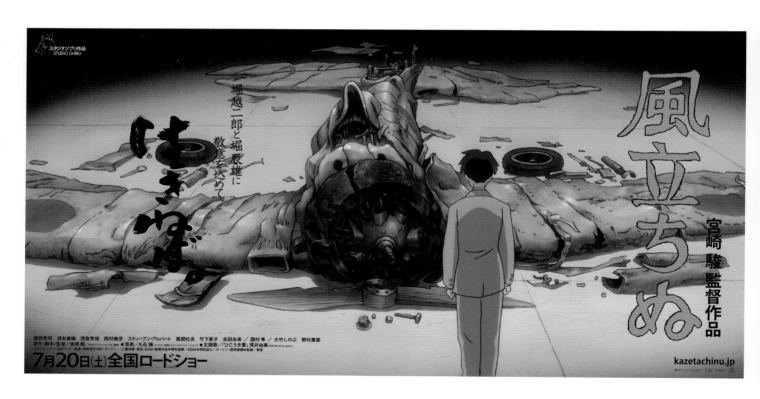

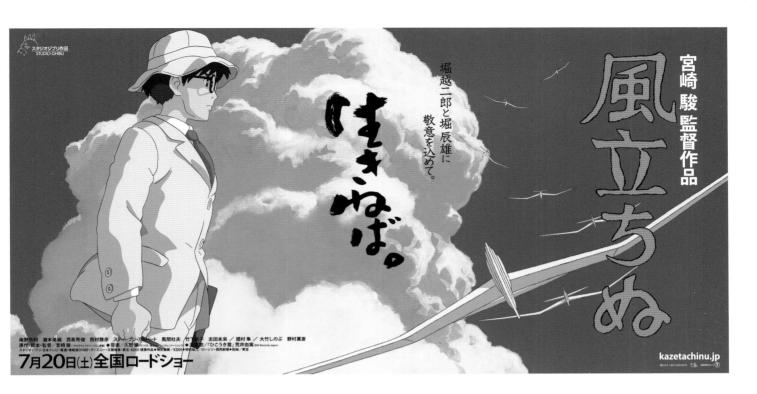

231

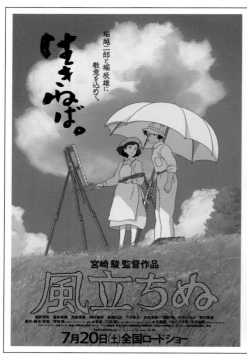
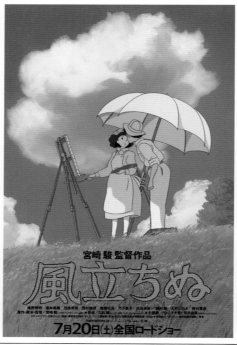

P228/First poster
P229/Second poster
P230–232/Five banners created for advertising

The imported drafting table Jiro used in the design section at Mitsubishi. Rough sketch by director Hayao Miyazaki.

THE WIND RISES

Complete English-Language Script

• Original Screenplay by Hayao Miyazaki

Translated from the Original Japanese by Jim Hubbert and Rieko Izutsu-Vajirasarn
English-Language Screenplay Adaptation by Mike Jones

Note: Final English-language motion picture release may differ from this script.

THE WIND RISES

REEL 1

MAIN TITLE FADE IN:

Le vent se leve!... Il faut tenter de vivre!

The wind is rising! We must try to live.
—*Paul Valery*

Farmland. Morning mist. Jiro's family home silhouetted against a white sky. The house is large and prosperous-looking. [The year is ca. 1916.]

The house is still quiet. A mosquito net is suspended over two sleeping children.

YOUNG JIRO (age 13) and YOUNG KAYO (age 6), asleep. Clean clothes are neatly folded by their pillows.

Beneath the netting, Jiro is dreaming.

Jiro's dream. He climbs up the roof of his house.

He reaches the peak of the house's broad tile roof. The predawn sky is cloudless. He walks along the peak of the roof.

A small monoplane is perched on a wooden platform that extends from the peak of the roof. The plane is shaped like a bird with feather-like extensions on the wing tips. A little two-stroke engine protrudes from the fuselage ahead of the open cockpit. The morning sun is beginning to touch the mountains in the distance.

Jiro climbs into the cockpit.

OUT

He primes the engine and hits the retro (at the time, cutting-edge) Bakelite ignition switch.

The engine sputters to life. Soot and sparks belch from the exhaust.

The propeller starts turning. The engine rises from a throaty putt-putt to a whine.

The wings flex in the backwash from the propeller. The plane strains at its mooring, ready to ascend. Jiro slowly rotates the throttle on the side of the fuselage.

OUT

The wings flex gently in the backwash. Jiro pulls the yoke back and the plane rises slowly, straight up.

The plane ascends into the morning air, flashing in the sunlight, like a kite ascending. The sun peeks over the mountains. The plane keeps climbing, buffeted now and then by the wind.

Jiro climbs higher. We see his house amid the expanse of paddies.

Sunlight streams over the water-filled paddies. Jiro guides the plane lower over the green landscape.

He glides lightly along the course of a stream.

Jiro flies along the stream. It winds between paddies and joins a river. He turns sharply left to follow the river, flying low over the water. A boat passes in the opposite direction, its single white sail taut in the breeze.

The plane flies lightly just above the surface of the river.

A town comes into view. Smoke rises from the chimney of a spinning mill. The plane is coming up on a bridge.

Jiro in the cockpit. The engine hums.

People and draft animals cross the bridge in both directions. People are loading and unloading goods. Jiro flies under the bridge and climbs sharply.

The Taisho Era town spreads out below him, with a spinning mill by the river. Jiro climbs past the towers of black smoke rising from the chimneys.

Young women, mill workers, crowd the balconies of the wooden buildings to get a look at his plane. A few wave.

Jiro waves back.

A swarm of black shapes, moving as if in formation, emerges from the cloud overhead. At first they are only partly seen. There is a great, low-pitched humming.

Jiro looks up and sees the shapes. The nose of a huge fantasy zeppelin peeks from the clouds. Rows of oar-like projections along the nose of the airship move in a sculling motion. Jiro gapes with surprise.

The zeppelin emerges from the clouds. Black, bomb-shaped objects are suspended from the airship at the end of long wires.

The objects pulsate like jellyfish. Murmuring, ape-like creatures, black silhouettes with glowing eyes, perch on them. Some of the objects have portholes through which the same creatures are visible.

Jiro puts on glasses and goggles and looks up at the zeppelin. The goggles are too close to his glasses; he can't focus.

Jiro sees a double image of the zeppelin. He starts to lose control of his plane. He tears his goggles off. His cap and goggles tumble through the air toward the ground.

Jiro looks up again and gasps.

The zeppelin is bearing down on him. One of the objects swings toward him.

The object falls. From above, an open cockpit in the top of the object is visible. The black object hits the plane and smashes it to bits. Jiro is thrown free.

Jiro falls. A small locomotive moves along below him. The dream ends. Jiro in his futon. He opens his eyes.

He looks at the ceiling and blinks sleepily.

Jiro's nearsighted POV. The ceiling is soft-focused and indistinct beyond the netting.

Jiro turns his head to look out into the garden.

OUT

A Japanese-style garden, also out of focus.

Jiro lies looking at the garden. He sits up, reaches for his glasses and puts them on.

The garden comes into sharp focus.

Jiro looks at the garden. The lenses of his glasses are bottle-thick.

Jiro gazes at the garden. The sounds of breakfast being prepared drift from the kitchen. He gets up and folds his futon.

The wheels of a locomotive slowly turning. Steam puffs from the smokestack.

Morning. A railway crossing. The little locomotive backs up, pushing a string of cars. Jiro waits to cross the tracks with a crowd of people.

The crowd crosses the tracks.

The spinning mill and the wharf—the same town as in the dream. People cross the bridge. Jiro and other boys of the same age are in the crowd.

The town's main street. At the end of a road off the main street is a large wooden structure, an elementary school.

Students walk through the corridors after class. Jiro stands at attention outside the door to the faculty office.

He bows to a teacher as he enters the room. The man nods. Another, younger INSTRUCTOR comes out. He holds a magazine out to Jiro.

INSTRUCTOR
Here it is.

Jiro takes the magazine. He grips it tightly.

YOUNG JIRO
May I borrow it?

INSTRUCTOR
Of course, but it's in English.

YOUNG JIRO
That's okay. I have a dictionary.

INSTRUCTOR
All right. Give it a try.

YOUNG JIRO
(bows)
Thank you.

Jiro walks along the embankment parallel to the river. He sees something and stops.

On the riverbank below, three students are tormenting one of their much younger juniors.

Jiro peers down at them.

TAKAYAMA, the leader, grabs the victim by the collar and hoists him off his feet. His buddies (BULLY A and B) laugh.

Jiro takes off down the embankment, slipping and sliding. He runs up to Takayama and grabs his wrist.

YOUNG JIRO
Knock it off.

TAKAYAMA
(angrily)
Stay out of it, Jiro!

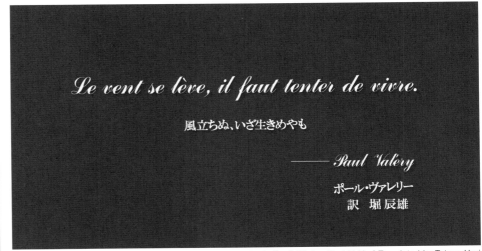

Le vent se lève, il faut tenter de vivre.

風立ちぬ、いざ生きめやも

—— *Paul Valéry*

ポール・ヴァレリー
訳　堀辰雄

"The wind is rising! We must try to live." [Below Paul Valéry] Translated by Tatsuo Hori

YOUNG JIRO
(to victim of bullying)
Go home.
(ALT)
Go home, Kai.

The victim takes off. The bullies shout angrily at Jiro, but they're beneath his interest. Their voices come across to him as distorted and unintelligible.

TAKAYAMA
Jiro... [unintelligible]

TAKAYAMA
[unintelligible]

YOUNG JIRO
(calm)
He's half your size, Takayama.

TAKAYAMA
[unintelligible]

TAKAYAMA
[unintelligible]

BULLY A
[unintelligible]

BULLY B
[unintelligible]

TAKAYAMA
[unintelligible]

Takayama grabs Jiro by the collar and shoves him. Jiro pulls Takayama's hand away and ducks.

He grabs Takayama under the crotch and throws him head over heels.

A boat sails slowly along the river. The landscape is dreamlike in the afternoon light.

Jiro sits calmly on his heels on the tatami floor at home. His face is scratched up. The afternoon sun fills the garden.

JIRO'S MOTHER is framed in the light from the garden. She raises an eyebrow at her son.

JIRO'S MOTHER
You look quite the hero.

YOUNG JIRO
(for form's sake)
Oh, I slipped and fell.

JIRO'S MOTHER
Umm hmm. Fighting is never justified, Jiro.

YOUNG JIRO
Yes, Mother.

JIRO'S MOTHER
(smiles)
You can have your snack.

YOUNG JIRO
Thanks!

Jiro reaches for his hat and schoolbag and stands up. The seat of his pants is dirty.

Kayo is in the garden, picking flowers. She turns and sees Jiro.

YOUNG KAYO
(excited)
Jiro, Jiro! You're home!

KIYO, the maid, is with Kayo in the garden. The maid has a baby on her back.

Jiro hurries toward the stairs with his snack on a plate.

YOUNG KAYO

Jiro, let's pick some bamboo grass. Jiro!
(ALT)
Good, now you can help me catch frogs.

He hurries away. Kayo runs to the veranda and calls after him.

YOUNG KAYO

Wait, where are you going?

He climbs the stairs out of sight. Kayo runs to the foot of the stairs and calls.

YOUNG KAYO

Hey! Remember!?

No answer. She hurries up the stairs.

Jiro's study. He opens the window, sits on the floor at a low desk and opens the magazine. The door behind him slides open and Kayo peers in.

YOUNG KAYO

You promised to pick bamboo grass with me.
(ALT)
You promised to help me catch frogs today!

YOUNG JIRO

(not looking up)
I've got homework.

Kayo puffs out her cheeks in frustration. She shuts the door and comes closer.

Jiro is absorbed in his magazine. Kayo stands next to him. He turns the pages. She peers down at the magazine.

YOUNG KAYO

What kind of homework is that?

YOUNG JIRO

It's an English magazine.

Jiro flips eagerly through the magazine. He comes to a photograph of Gianni CAPRONI.

Kayo points to the photo.

YOUNG KAYO

Look at his stupid moustache.

The photo. A young Caproni.

YOUNG JIRO (O.S.)
He's a very famous Italian aircraft designer.

Kayo looks on disapprovingly. Jiro riffles through a dictionary.

YOUNG JIRO

His name is Caproni. Wow, it says he's a count.

Kayo notices his scratches. She reaches out to touch them.

YOUNG KAYO

(concerned)
What happened to your face? It's all scratched!

Jiro turns his face away, but Kayo leans closer.

YOUNG JIRO

Leave it alone, Kayo?

YOUNG KAYO

You better put iodine on it. I'll do it for you.
(ALT)
I better put iodine on it. I'm a doctor. Almost.

YOUNG JIRO

Stop please...!

A night sky full of stars. Jiro is sprawled on the roof looking up at the sky.

Kayo slides down next to him on her rear.

YOUNG KAYO

What are you doing?

YOUNG JIRO

Kayo, you're not supposed to be up here.

She peers curiously at Jiro.

YOUNG KAYO

Neither are you. Where are your glasses?

YOUNG JIRO

I heard you can fix your eyesight by focusing on the stars.

YOUNG KAYO

(puzzled)
Hmm...

She lies back next to her brother and looks up at the sky.

YOUNG JIRO

Mom will be mad if you're not in your bed.

YOUNG KAYO

(points)
Oh! A shooting star!

Jiro looks for it, startled.
The stars. Indistinct blobs of light.

YOUNG KAYO (O.S.)
There's another one!
Jiro tries to spot them but he cannot see them with his poor vision.

YOUNG KAYO

They're pretty! Oh, see that one?

A meteor shower against the starry sky. Kayo points again.

YOUNG KAYO

They're so bright! Wish you could see them.

Jiro lies very still.

Jiro's dream. The starry sky gives way to a mountainous line of clouds lit by a setting sun. A line of three-engine aircraft built by Caproni Aircraft Works flies through the sky.

The sky and aircraft are reflected in Jiro's face.

OUT

Jiro stands on a windswept grassy plain and gazes upward.

A fleet of Italian Ca.3 biplanes and Ca.4 triplanes approaches. Their red propellers turn slowly.

Jiro watches at them, astonished. The aircraft approach, glinting in the sunlight.

The Ca.3s are laden with bombs. The crews ignore Jiro, but Gianni Caproni peers down curiously from the open gunner's seat in the nose of one of the planes.

Jiro is surprised to see Caproni. He takes off his wooden sandals and sprints through the waving grass to keep up with the slow-moving aircraft.

Jiro runs. The Ca.3 slowly overtakes him. Caproni leans out and calls to him.

CAPRONI

Ehi! E tu chi saresti?
[You there! Who are you?]

Jiro answers as he runs.

YOUNG JIRO

I'm a... Japanese boy.

CAPRONI

Un ragazzo giapponese? Come mai trovi qua?
[A Japanese boy? Why are you here?]

YOUNG JIRO
I'm dreaming. I think this is my dream.

CAPRONI (O.S.)
Un sogno?
[A dream?]

Caproni climbs down to the nose wheel.

CAPRONI
Fermo li. Non muoverti!
[You stay right there!]

He hangs suspended from the nose wheel just above the ground passing by under his feet. He scissors his legs rapidly, lets go and hits the ground running.

The Ca.3 rises away.

Clouds stream by. The grass sways in the wind. The aircraft keep flying by as Caproni walks up to Jiro, who quickly puts on his wooden sandals to face Caproni.

CAPRONI
This is my dream, you know.

YOUNG JIRO
I think it's mine too.

OUT

CAPRONI
Your dream? Listen, Japanese boy. So you think we are sharing this dream?

YOUNG JIRO
I know it's strange. You're Count Caproni, aren't you? I've been reading all about you.

CAPRONI
(chuckles)
Interesting. Yes, this is a dream. This world is a dream.

He extends a hand. They shake hands.

CAPRONI
Welcome to my kingdom.

YOUNG JIRO
I'm honored.

Caproni waves to the bombers passing overhead.

CAPRONI
See those?

The aircraft are laden with bombs. A gunner wearing a tricolor muffler raises his hand with a look of resolve.

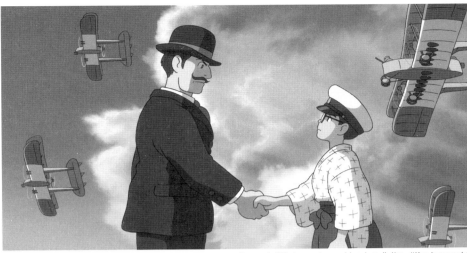

Caproni: "Welcome to my kingdom." Jiro: "I'm honored."

CAPRONI
They will bomb an enemy city. Half of them will never return.

A vision. Night, a city in flames. Caproni's bombers fly through towering plumes of smoke and waving searchlight beams. Some of them are on fire.

Jiro gazes at the vision, eyes wide. The flames are reflected in his glasses.

CAPRONI
It will all be over soon.

He motions Jiro to come.

Caproni turns on his heel. A Ca.48 triplane descends toward them. Midday. The sky is clear and deep blue. The Ca.48 gently touches down.

The triplane taxis up to Jiro. A door opens and Caproni leans out. Jiro is astonished.

CAPRONI
Come on up, Japanese boy.

A ladder extends from the plane. Jiro starts climbing up.

CAPRONI (O.S.)
This is my true dream. When the war is over, I will build this.

Jiro climbs up the ladder into a luxuriously appointed passenger compartment.

Caproni closes the hatch.

CAPRONI
What do you think? Magnificent, isn't she? Let's take off.

The Ca.48 takes off.

CAPRONI
Instead of bombs, she'll carry passengers.

Caproni opens a panel in the ceiling and climbs a ladder. Jiro follows quickly.

An open cockpit. Two pilots. Caproni continues upward on a ladder that extends from the cockpit to the upper wing. Jiro follows.

A pastoral landscape unfolds below the airplane. Caproni emerges onto the top wing through an opening. The wind is no problem—this is a dream.

CAPRONI
I find dreams are a good way to see my designs. I can go anywhere!

Jiro follows him onto the wing. The plane banks.

Caproni strolls jauntily along the wing, holding his arms out for balance.

He walks to the edge. The plane is over Lake Maggiore. Villas line the shore. He calls to Jiro. The plane's ailerons are moving up and down. Clouds drift by.

CAPRONI
Come on. Walk right along the spar.

Jiro runs lightly across the wing spar to Caproni. They look down.

CAPRONI
Look at that.

Jiro gasps with admiration.

A white Caproni Ca.60 lifts off from the deep blue waters of the lake. The plane is gigantic—three sets of triple wings a hundred feet wide, with a long passenger cabin slung beneath.

Jiro is astonished at the size of the behemoth. Caproni watches with a satisfied look.

The Ca.60 lifts majestically off the water and climbs slowly.

Jiro watches the huge aircraft rise into view. The wings are connected by a jungle of struts and wires.

The Ca.60 banks. Passengers and attendants smile and wave behind the cabin windows. Jiro and Caproni watch as the airliner flies away.

The landscape below changes abruptly—the Ca.3 is over the Mediterranean. The Ca.60 is still in sight, flying away.

The two watch as the plane departs. Caproni turns and starts walking along the wing.

CAPRONI
She's beautiful, no?

YOUNG JIRO
Yes. Incredible!

The two walk along the wing. Jiro seems lost in thought.

CAPRONI
She'll carry a hundred people across the Atlantic. Both ways!

YOUNG JIRO
Mr. Caproni, may I ask you a question?

Caproni stops and turns to Jiro.

YOUNG JIRO
I can't be a pilot because of my eyesight.

Caproni peers intently at Jiro.

YOUNG JIRO
If I'm not a pilot, can I not design planes?

CAPRONI
(grinning)
Japanese boy, I've been around planes all my life. Do you know how many I've flown? None! Zero!

OUT

Jiro is thunderstruck.

CAPRONI (O.S.)
Many can fly airplanes, but I DESIGN them!

CAPRONI
(strikes his chest proudly)
I CREATE airplanes!

Jiro's eyes widen. The scenery swoops by in the background.

CAPRONI
And so can you! An aeronautical engineer!

Jiro asleep and dreaming. He smiles ecstatically and answers Caproni out loud.

YOUNG JIRO
Yes!

The Ca.48 flies under a full moon. Caproni leans closer to Jiro.

CAPRONI
But remember this, Japanese boy. Airplanes are not tools for war. They are not for making money.

CAPRONI
Airplanes are beautiful dreams. Engineers turn dreams into reality.

Jiro cries out joyfully in his sleep.

YOUNG JIRO
Yes!

Caproni rises into the starry sky. He waves to Jiro.

CAPRONI
Arrivederci. We'll meet again.

Jiro wakes on the floor next to his desk. His mother touches his shoulder.

JIRO'S MOTHER (O.S.)
Jiro... Jiro...

JIRO'S MOTHER
Jiro, you were talking in your sleep.

He sits up halfway and blinks.

JIRO'S MOTHER
And you had a big smile on your face. Must have been a good dream.

YOUNG JIRO
Mother, I'm going to be an aeronautical engineer.

JIRO'S MOTHER
That does sound like a good dream.

Jiro lies back. He stares at the ceiling as if looking into the future.

YOUNG JIRO
He said airplanes are beautiful dreams. So I'm going to make beautiful airplanes.

Jiro's dream continues. The Ca.60 and Jiro's bird-like plane fly into the sunset. Jiro watches, then turns to go. He walks faster and faster. The wind whips the tall grass by the path.

The year is 1923. The interior of a third-class rail car. Jiro, now a young adult, looks out the window. He's wearing a boater hat. The car is dark—the train is passing through a forest. The train emerges into farmland. Sun streams through the window.

A locomotive pulls the train. The windows are open and passengers are visible inside.

Inside the car. It's packed with passengers. People stand in the aisles and sit on the aisle-side armrests. People fan themselves in the heat.

Jiro stands and takes his yellow suitcase down from the overhead rack. He calls to a young kimono-clad woman standing in the aisle as he squeezes past the aisle seat.

JIRO
Excuse me, miss. Take my seat.

JIRO
(to passenger)
Pardon me.
(to woman in aisle)
Please. I insist.

The woman bows and takes Jiro's seat.

He pushes toward the end of the crowded car.

He steps out onto the platform at the end of the car, puts his suitcase down and holds his hat against the wind. The wind swirls around his legs. He sits on the steps.

The scenery rolls by. He opens a book and starts to read, holding the pages to keep the wind from turning them.

The second-class car is the next car over. Two women come out onto the platform on their side—NAHOKO, a 13-year-old wearing Western clothes and a cloche hat, and KINU, a young woman in a kimono, a servant in Nahoko's family.

NAHOKO
Le vent se leve! Ha ha!

The wind rustles her skirt and hat.

KINU
(leans forward with concern)
Miss, you'll lose your hat.

NAHOKO
I got it.

Jiro glances at Nahoko and returns to his book. There is a gust of wind and he reaches for his hat, but it blows off before he can grab it. Nahoko leans out and grabs it in midair. She teeters and claps the boater on top of her own hat.

Nahoko teeters at the edge of the platform. Jiro jumps up. Kinu tries to pull her back. Jiro steps around the gap between the cars onto the steps in front of Nahoko.

JIRO
Hold on!

KINU
Miss!

Nahoko is sandwiched between Kinu and Jiro.

JIRO
Are you all right?

NAHOKO
(looks up at him, smiling)
Yes!

JIRO
(smiles)
Nice catch!
(puts his hat on)
What were you saying?

NAHOKO
(looks at Jiro, starry-eyed)
Le vent se leve.

NAHOKO (O.S.)
It's a French poem.

JIRO
(after a pause)
Il faut tenter de vivre.

JIRO (O.S.)
I know it well.

Jiro and Kinu bow to each other. Nahoko turns and goes back into the compartment. Kinu follows, bowing to Jiro as she backs through the door. He sees Nahoko waving to

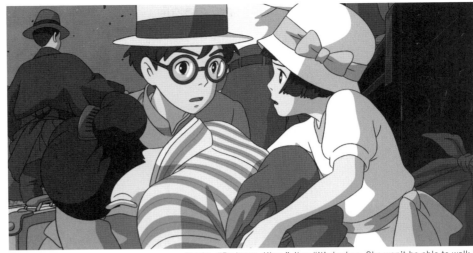

Naoko: "Be brave, Kinu." Jiro: "It's broken. She won't be able to walk."

him and he beams.

Jiro sits on the steps again.

JIRO
Le vent se leve. Il faut tenter de vivre. The wind is rising. We must try to live.

The train emerges onto the Kanto plain. Even toward the center of the city, there is still lots of forest and farmland. The sky is blue, but clouds are gathering.

The Great Kanto Earthquake. Saturday, September 1, 1923, 11:58 a.m. Darkness, the interior of the earth. The earth splits open. Red light shines from the fissures.

High over Tokyo. The shock wave spreads in a circle outward from the offshore epicenter and ripples across the capital.

The shock rips through Tokyo's old tiled-roof neighborhoods, tossing the buildings about.

The quake lifts the train and sends it speeding downhill along the tracks. The locomotive brakes. The wheels throw sparks.

Chaos inside the third-class compartment as the train is tossed about.

Jiro clutches the rail to keep from being thrown off the steps of the platform. Houses along the track collapse.

JIRO
Earthquake.

Scenes of destruction are visible from the train. The quake continues.

The train stops. Steam hisses from its brakes. The tremors die away.

The city lies devastated and silent. A baby cries. A dog barks.

People pour out of the stopped train and run in all directions. They heave luggage out the windows.

REEL 2

Passengers pour out of the train. Jiro stands outside on the embankment. He stares dazed at the destruction. The train whistle blows.

PASSENGER A
Get away! The boiler's going to blow!

People push past Jiro, trying to get away from the locomotive. He is momentarily stunned.

He turns and sees Nahoko at the foot of the steps. She is leaning toward Kinu, who is kneeling on the ground, wincing in pain.

Jiro runs to them. He puts his suitcase down and squats next to Kinu.

JIRO
What's wrong?

NAHOKO
Her leg.

JIRO
Let me see.

Jiro palpates Kinu's ankle.

KINU
(groans)
It hurts...

NAHOKO
(to Kinu)
Be brave, Kinu.

JIRO
It's broken. She won't be able to walk.

KINU
Miss, the boiler! Please save yourself! Go GO!

Jiro puts his shoulder under Kinu's right arm and pulls her to her feet. She groans in pain.

JIRO
That's nonsense.

His hat falls off as he hoists Kinu onto his back.

JIRO
Nothing's going to explode.

He carries her a few yards down the embankment where there is more open space. Nahoko follows with his suitcase and hat. He puts Kinu down and turns to Nahoko.

JIRO
We need to brace her leg.

She gives him the suitcase. Jiro opens the case and pulls out a slide rule.

He takes Kinu's leg in both hands.

JIRO
This is going to hurt a little, Kinu. Relax...

He moves the ankle back into place.

KINU
(groans with pain)

Jiro splints her ankle with the slide rule, binding it with a cloth.

JIRO
She can't walk on this.
(to Nahoko)
Where do you live?

NAHOKO
In Ueno.

JIRO
I'll get you there.

An aftershock hits.

Gasps of fear from the crowd on the embankment.

The wind picks up and stirs the grass. From far off, clouds of black smoke rise.

They turn to look at the smoke. Cries of consternation from the crowd.

NAHOKO
Fire.

JIRO
Let's go.

Jiro lifts Kinu onto his back and goes back up the embankment. Nahoko picks up his suitcase and hat.

With the fire in plain sight, the crowd is panicking. Nahoko follows Jiro. He starts walking along the tracks toward Ueno with hundreds of other people.

Nahoko catches up with Jiro.

JIRO
What about your luggage?

NAHOKO
It's not important.

Throngs of people climb onto the tracks. People carry belongings saved from their homes. People are walking and running in both directions.

Houses at the bottom of the embankment are on fire. People swarm in the streets in panic.

Nahoko plods along the tracks with Jiro's suitcase.

Jiro gasps with exertion. Kinu is heavy.

JIRO
(gasping for breath)

People stream in both directions along the tracks.

Jiro trips over a railroad tie and falls to his knees. He puts a hand on the ground and steadies Kinu's injured leg with the other.

KINU
(cries in pain)

Nahoko rushes to their side. Jiro gets back to his feet.

KINU
I'm so sorry.

JIRO
I'm sorry. Are you all right?

NAHOKO
Hang on, Kinu!

Jiro looks toward the fires.

Fire has broken out on the east side of the city. Thick smoke, sparks and burning debris rise into the air. It looks like a scene from hell. A flight of Caproni's bombers flies high above the smoke.

Jiro looks up, startled.

He realizes the bombers are airborne debris from the fire.

He lowers his gaze, stops and adjusts his hold on Kinu, and starts walking again.

JIRO
Better hurry.

Nahoko follows determinedly, lugging the suitcase.

They reach a crossing over the tracks, thronged with crowds. An overloaded two-wheeled cart tilts with one wheel broken.

People stream up the hill above Uguisudani station, seeking refuge in the shrine at the top.

The crowd streams up the hill. Jiro, Nahoko and Kinu climb with them.

The grounds of the shrine on the hilltop. They look down on the city. The crowd keeps growing.

An aftershock, followed by another and another. The crowd is terrified.

A shrine quakes violently. A dragon lantern topples. The crowd cries out in fear.

Jiro threads his way through the crowd to Nahoko and Kinu. He's carrying a soaking wet shirt. The aftershocks have died away.

Kinu looks up at Jiro.

JIRO
Here. My mother made me this shirt.
You must be thirsty.
(beat)
Don't worry. It's clean.

Kinu opens her mouth and Jiro wrings water into it.

JIRO
The "well" is almost dry.
(he looks at Nahoko)
What about you, Nahoko?

NAHOKO
Please!

She wipes her face with the shirt.

She turns to Kinu and wipes her face. Jiro sits on the ground.

JIRO
The fire hasn't reached Ueno. I'm heading for the university, so I can take you there.

NAHOKO
Yes. I'll bring someone from the house.

JIRO
Then we should go.

JIRO
(pushes his suitcase toward Kinu)
Kinu, look after my suitcase?

KINU
I will.

He gets to his feet.

JIRO
I'll bring someone to help you home. Okay?

KINU
Okay.

JIRO (O.S.)
Stay strong.

KINU
(looks up worshipfully)
I will.

The smoke from the fires rises in a towering cloud. The crowd looks down from the hill on a sea of fire.

Jiro and Nahoko make their way down the hill and through the streets, struggling to push through the crowds. They enter a quieter neighborhood. The streets are empty. As they come within sight of Nahoko's house, she runs to the gate. Her parents and servants come running out. Jiro stops a few yards short to catch his breath. Nahoko wants to go back to Jiro, but her parents and servants stop her and take her into the house. SERVANT and OVERSEER rush toward Jiro. The three run back to where Kinu is waiting. Overseer lifts Kinu onto his back.

SERVANT
Thank you very much.

JIRO
I better go.

SERVANT
Wait but... what's your name?

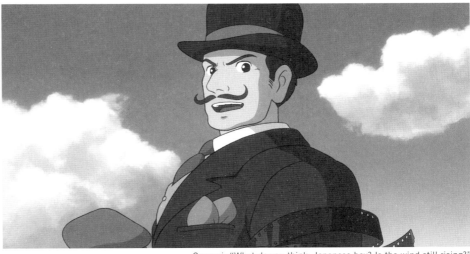
Caproni: "What do you think, Japanese boy? Is the wind still rising?"

Jiro plunges into the crowd. He turns, waves to Kinu, and disappears.

OVERSEER
That's quite a guy. Who was he, Kinu?

Jiro reaches the campus of Tokyo Imperial University. People run about in panic. The wind is blowing hard.

Leaking fire hoses snake across the flagstones. Jiro gapes in surprise.

The campus is in chaos. The library is ablaze. Trees sway in the wind.

Sparks and scraps of burning debris swirl through the air. Students work to salvage the library's collection. Books are piled under the trees. One of the students, Kiro HONJO, sees his friend Jiro.

HONJO
Well, if it isn't Jiro. You picked a lovely day to come back.

JIRO
How bad is it, Honjo?

Honjo sits in front of the books. He picks up a book at his feet and tosses it casually onto the pile.

HONJO
Bad enough. The whole east side is burning.

HONJO
(glances at the books)
We grabbed everything we could carry out of the library.
(beat)
Got a smoke?

A shaft of light falls through the smoke. The treetops dance in the wind. A large, burning object whirls through the sky.

Jiro and Honjo look up at the burning debris. Honjo has a cigarette ready. Jiro lights it for him.

HONJO
A flying door. Now I've seen it all.
They'll never stop the fire now. Tokyo's finished.
(ALT)
A flying door. Don't see that every day.
They'll never stop the fire now. Tokyo's finished.

A postcard flutters down at Jiro's feet.

He picks up the postcard. It shows Caproni and his latest aircraft—the one Jiro saw in his dream, the Ca.60.

Jiro gazes at the card while Honjo smokes. The wind is getting stronger.

The postcard. The look on Caproni's face is supremely confident.

JIRO
(smiles)
It's as beautiful as it was in the dream. I can't believe he really built it.

Lake Maggiore, 1923. The test flight of the Ca.60. Caproni stands in a rowboat with a cameraman and a camera on a tripod. The pilot looks at Caproni from the open cockpit and raises his hand. The plane slowly moves forward and lifts off. Caproni watches intently. Suddenly the giant wing arrays collapse, folding upward in a V-shape. The plane falls back onto the water.

Caproni stares at the wreck, speechless. The camera is rolling. Suddenly he rips the film magazine out.

CAPRONI
Stop! Stop! STOP!
(ALT)
Cut! Cut! CUT!

He heaves the camera into the lake.

Tokyo Imperial University. The wind is howling. Flaming debris are everywhere.

Honjo looks up at the sky and yells.

HONJO
The wind's picking up! Hurry! Hurry!
(ALT)
Damn wind's picking up! Hurry! Hurry!

He stamps on burning debris at his feet.

Caproni stands in the boat. He turns toward Jiro. His arms are festooned with film from the camera.

CAPRONI
What do you think, Japanese boy? Is the wind still rising?

Jiro works desperately to snuff out the flaming cinders falling on the books.

JIRO
Yes! A big wind!
(ALT)
Yes! It's a gale!

CAPRONI
Then you must live. Le vent se leve.

Night. The university buildings in flames. People run in panic, silhouetted by the fire.

CAPRONI (O.S.)
Il faut tenter de vivre.

Night. The flames are far away now. People walk dazed through the smoking ruins.

Sunrise, two days later. Jiro washes his face at a faucet in the ruins.

He puts his glasses on. His clothes are dirty and tattered. The sound of aircraft engines. He looks up at the sky.

An observation plane flies slowly overhead.

The Sumida River. On the bank, barracks and building foundations are under construction, with Mt. Fuji in the distance. Smoke rises from a chimney. People burn incense for victims of the earthquake and fire. Sailboats and tugboats move up and down the river. Tokyo Imperial University aeronautics students transport books and furniture on carts.

A white expanse of paper. Jiro's hand draws a perfect parabola. His pencil scribbles formulas on the paper.

Night. Jiro is in his room at his desk, studying.

Day. The university campus. Only the gate survived the fire. A sign reads: TOKYO IMPERIAL UNIVERSITY/FACULTY OF ENGINEERING/SCHOOL OF AERONAUTICS.

Jiro's classroom, a temporary wooden building. Class has just ended for lunch. Jiro opens his desktop and puts away his notebook.

HONJO
Hey Jiro. Let's eat.

JIRO
(stands)
Yeah.

Honjo and Jiro emerge from the back gate of the campus.

HONJO
Even the new buildings are old-fashioned.

They walk down the street. Many houses are being rebuilt. A biplane flies slowly through the sky.

JIRO
But the streets are a little wider.

HONJO
(cynically)
So? And even the airplanes are old.

A cheap eatery. Honjo parts the curtain and opens the door. KIMI, the waitress, greets them cheerfully.

KIMI
Welcome!

Jiro follows Honjo and closes the door.

Jiro picks up a piece of mackerel with his chopsticks.

The eatery is crowded with customers. KATAYAMA, another student, sits next to Honjo, who is across from Jiro. Jiro skillfully plucks a bone from his mackerel.

HONJO
Really? Mackerel again?

JIRO
It's always good.

HONJO
Always. Always the same lunch. Always the same lectures.

KATAYAMA
Kimi, an egg please.

KIMI
Coming up.

Honjo talks as he shovels food into his mouth.

HONJO
Meanwhile, other countries are building metal planes. We're *always* ten years behind.

Jiro carefully pulls a bone from his mouth. He stares at it intently.

HONJO (O.S.)
And you're still stuck on mackerel.

He gives Jiro a puzzled look.

HONJO
What?

Jiro's hand, holding the chopsticks and fish bone.

JIRO (O.S.)
Beautiful, isn't it?

The fish bone, close up.

JIRO (O.S.)
Look at that wonderful curve.

HONJO
Only you would get a thrill from fish bones.

CUSTOMER
(getting up from seat - puts payment on the table)
Kimi, we'll leave this here.

KIMI
Okay!

HONJO
Come on, finish up. I need coffee.

In the classroom, Jiro traces the curve of the fish bone on graph paper.

He sits in the classroom, working his slide rule and making notes.

Honjo and Katayama near the heater. An afternoon class has been cancelled.

KATAYAMA
What's Jiro working so hard on?

HONJO
(flipping through a book)
Fish bones.

The school janitor appears at the door with a package. Katayama hides his cigarette. There is a No Smoking sign on the classroom wall.

JANITOR
Is Mr. Horikoshi back from lunch?

HONJO
Jiro!

JIRO
(staring at his notes)
Honjo, listen to this! The NACA has a standard curve just like this fish bone. Maybe the Americans eat mackerel, too?

HONJO (O.S.)
Jiro, you got a visitor.

JIRO
(looks up)
Me?

JANITOR
(holds out the package)
A young lady came by and brought this package for you, Mr. Horikoshi.
(beat)
You were out so she left it with me.

JIRO
(mystified)
I see. Thank you very much.

He takes the package. The janitor leaves.

KATAYAMA
A present from your girlfriend, Jiro?

HONJO
(to Katayama)
Can it, freshman. And gimme a smoke.

Jiro unwraps the package and finds his shirt clean and pressed, the slide rule wrapped in paper, and an envelope.

Jiro unwraps the slide rule. He looks at the envelope with surprise, then out the window.

He has a vision of Kinu walking out the front gate. She vanishes.

Kayo: "You never tried to see her again?" Jiro: "I did. After the fires were out..."

Jiro jumps up, careens around the desks and out the door.

KATAYAMA
(leaning out the door)
Jiro!

HONJO
Let him go.

An early winter sky. Jiro dashes out of the gate. He looks left and right. The street is deserted. He stands there dazed.

Jiro walks along a canal, deep in thought. The late afternoon sun is golden.

A district of wooden buildings, hastily built in the wake of the earthquake. Jiro enters his boardinghouse and closes the door.

The boardinghouse entryway. Jiro puts his shoes away.

MAID
Oh, Mr. Horikoshi.

JIRO
Yes, ma'am?

MAID
Your guest is waiting upstairs.
(Jiro looks puzzled)
It's a young lady.

JIRO
(flustered - glances up the stairs)
Oh. Right.
(ALT)
Young lady?

He climbs the stairs as the maid looks on.

Jiro opens the door to his room. A young woman in a kimono sits at the window looking out.

She turns to him. It's Kayo, now 15 and looking upset.

JIRO (O.S.)
(softly)
Hello?

KAYO
Finally. Where were you?

Jiro's face shows his surprise. Once again, he's been so engrossed in his studies that he's forgotten his sister's visit.

JIRO
Kayo... I'm sorry.

JIRO
I completely forgot.

KAYO
I'm not surprised!

Jiro closes the door, unloads his schoolbag and takes off his muffler, while Kayo closes the window. They sit around a small, low table in the middle of the room.

JIRO
Where's Mother?

KAYO
At Uncle's.

JIRO
Is she staying there?

KAYO
Just for a night.

JIRO
Kayo, you've gotten so tall.
And very pretty, too.

KAYO
You're so insensitive! I'm still mad at you because you never come home.

Outside the boardinghouse. Golden light reflected in the windows as the sun sets. The front door opens. Kayo comes out wearing a wrap, with Jiro behind her. She looks at the sky.

KAYO
Oh, the sun's already down. I'm going to be late.

JIRO
I'll tell them it's my fault. Don't worry. We'll take the penny steamer.

Jiro and Kayo walk along the canal. There are few people in the street.

KAYO
She must really like you.

JIRO
I don't know. It's been two years.

KAYO
You never tried to see her again?

JIRO
I did. After the fires were out.

Flashback. Jiro runs toward the gate of Nahoko's house.

The whole side of the street where the house once stood is burned out. The houses on the opposite side are undamaged.

Jiro and Kayo walk along the canal.

JIRO
The fire had burned down her block, then stopped.

KAYO
That's terrible.

JIRO
(points to the steamer)
Let's catch this one.

The steamer dock. Jiro and Kayo board. Lights reflect off the water of the canal.

The steamer moves down the canal onto a river lined with single-story wooden houses.

Jiro and Kayo sit outside under an awning. The wind picks up.

JIRO
Are you cold, Kayo?

KAYO
No, I'm fine. I didn't think Tokyo would recover so quickly.

A bridge passes above them. Boats are tied up along the bank. Cars and buses move along the streets.

The steamer's lights come on.

KAYO
Jiro, can I stay with you?
Father won't let me live here by myself.

The shore is lined with restaurants. The light from their windows shines off the dark river.

JIRO (O.S.)
But I might be in Nagoya by the time you come.

KAYO (O.S.)
With an airplane company?

JIRO (O.S.)
I hope so.

KAYO
Men have it so good. Why can't I live in Tokyo and go to medical school?

JIRO
You should. I think you'd make a great doctor.

KAYO
(happily)
I think so too.

The steamer approaches the dock at Asakusa.

JIRO (O.S.)
When I'm home for New Year's I'll talk to father about it.

KAYO (O.S.)
Oh, thank you, big brother!

Passengers come out on deck.

The steamer draws close to the dock. People wait to board.

Morning. A sleeper berth on a train. Jiro wakes. He parts the curtain by his pillow. Dawn. The sky is blue-white.

The train crosses a river on an iron bridge.

Jiro finishes washing his face in the passageway sink and puts his jacket on.

The morning sun shines through the clouds as the train rolls along. Rice paddies reflect the sunlight. Houses sit like islands in the expanse of paddy water.

Jiro raises the window and looks out. The train whistle blows a warning. Men on the tracks scatter to either side as the train speeds by.

The men scatter down the embankment. Jiro and the men look at each other as the train speeds past.

OUT

Outside Nagoya Station. Crowds of people flow in and out.

A crowded train platform. Jiro debarks from the train carrying a large wicker trunk on his shoulder and his suitcase. He walks along the platform.

Outside the station, Honjo sees Jiro and waves.

HONJO
Jiro!

JIRO (O.S.)
Hey, Honjo!

HONJO
Heavy?

JIRO
Yeah.

HONJO
Glad you made it.

JIRO
Me too.

HONJO
We're just getting started, pal.

JIRO
We certainly are.

ALT/:

HONJO
Excited to get started, pal?

JIRO
I certainly am.

:/

244

Honjo takes Jiro's trunk and they walk on.

Honjo gets in a taxi. The driver tosses Jiro's luggage in. Jiro also gets in.

The taxi drives through the city. Traffic is light.

The two newly minted engineers chat in the back of the cab.

HONJO
They were probably heading for the city, looking for work.

JIRO
There were dozens of them.

HONJO
And they'll be hundreds more.

The taxi brakes suddenly as a throng of people runs across the road toward a bank. The crowd brings traffic to a halt.

Jiro and Honjo watch the crowd.

CAB DRIVER
Looks like we lost another bank. Kamehachi, this time.

The bank is shuttered. People press against the door, mill around and pound on the windows. Guards try to calm the crowd.

Honjo and Jiro watch from the cab.

JIRO
So many?

HONJO
They're doomed.

CAB DRIVER (O.S.)
There were rumors.

HONJO (O.C.)
The economy's in the tank. And I hate to break it to you, Jiro, but so is our new employer.

An area of reclaimed land fronting Ise Bay. People move along a road on foot and by bicycle. In the distance are the wooden buildings of Jiro's new employer—Mitsubishi Internal Combustion Engine Co. Motorized sailing vessels ply the shallow waters of the bay.

Jiro walks along the potholed road in the morning sun. Workers on bicycles pass him.

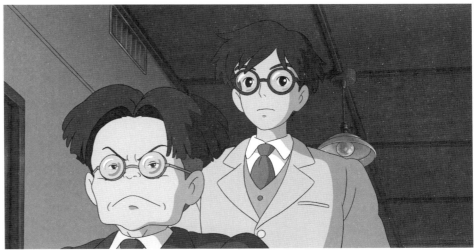
Jiro: "I was told to come anytime in April." Kurokawa: "Then you should've been here in March!"

People move busily outside the office wing. Jiro asks a man for directions to his new workplace.

Jiro walks down a corridor behind his new boss, KUROKAWA.

OUT
Kurokawa hurries down the bustling corridor with Jiro in tow. He's steamed.

KUROKAWA
Do you know the pressure we're under? We needed you a month ago.

JIRO
(unruffled)
I was told to come anytime in April.

KUROKAWA
Then you should've been here in March!

Young women wearing white smocks (blueprint tracers) smile at Jiro as he passes.

JIRO (O.S.)
(to Kurokawa)
Yes, sir.

Jiro smiles and nods to the girls.

KUROKAWA
I've got a very important assignment for you.

JIRO
Yes, sir.

The men cross from one wing to another. Kurokawa is trotting. Jiro follows, calm as ever.

KUROKAWA
It's the design for the wing strut fitting. And it's already late!

JIRO
Yes, sir.

KUROKAWA
I need the plans in the shop as soon as possible. Do what you have to do.

JIRO (O.S.)
Yes, sir!

Jiro notices a Hanriot biplane being serviced outside.

Kurokawa opens the door to the design room. Jiro is still entranced by the biplane.

KUROKAWA
(impatient)
Here!

Kurokawa strides through the door. Jiro turns and hurries after him.

OUT

Jiro peers around at his new workplace.

KUROKAWA
(gathering up some documents)
Let's get your specs. Follow me!

The design section looks like an animation studio. A line of men face drafting tables. Kurokawa walks rapidly down the line followed by Jiro.

A new-style drafting table and chair. Kurokawa spreads the documents on the table. Jiro joins him.

KUROKAWA
This is your desk. It's imported. No one likes it. Maybe you will.

JIRO
Yes, sir.

KUROKAWA
Work goes here.
(points to a row of pegs on the wall)
Hat goes there.

JIRO
Yes, sir.

Jiro hangs his hat. As he sits down, Kurokawa yells to the rest of the room.

KUROKAWA
Listen up! There's a new engineer on the Falcon project.

Jiro jumps to his feet and stands beside Kurokawa.

The engineers react in various ways. Some slowly look up from their work. Some are too engrossed in what they are doing. Some smile. One coolly checks him out.

KUROKAWA
It's that "genius" we've been hearing all about.

KUROKAWA
(to Jiro)
Name, genius?

JIRO
(confident)
Jiro Horikoshi. Very happy to be here.

KUROKAWA
(walking away)
Get to work.

JIRO
Yes, sir.

Honjo's desk is opposite Jiro's. Honjo looks up, slide rule in hand, and grins.

Jiro goes to work on the plans. He walks past Kurokawa's drafting table to a shelf of binders, pulls out a volume and begins to study it. Kurokawa watches him like a hawk. Jiro returns to his drafting table and begins working on the plans, sketching and calculating.

In his mind's eye, he sees the Falcon prototype on its test flight. The wing is transparent, its structure exposed. The anchor bracket begins to shake from the stress on the wing. Suddenly the plane breaks up and plunges earthward.

Against a background of clear blue sky, Jiro topples backward with shock and surprise. He hears Honjo's voice and finds himself back in the drafting room.

HONJO (O.S.)
Jiro. Jiro!
(on)
Let's eat.

JIRO
(dazed)
Oh.

The men walk toward the canteen. Plant workers in overalls are lined up outside. Others are coming out.

JIRO
Can we see the assembly floor?

HONJO
Can we maybe have lunch first?

Honjo and Jiro wait in line in the canteen to pick up a bowl of noodles.

HONJO
Maybe Kurokawa has it out for you. Seems harsh to have you design that strut on your first day.
(to server behind counter)
Two.

ALT/:

HONJO
Maybe Kurokawa simply hates you. Seems harsh to have you design that strut on your first day.
(to server behind counter)
Two.

:/

The prototype assembly hangar. The workers play baseball outside during the lunch break.

HONJO
(to a worker at the door)
Excuse me, could we ask a favor?

Inside the hangar. The prototype Falcon fighter sits in the dim light. The skin is not fully on. A few Duralumin panels are in place. Jiro runs toward it.

JIRO
Wow, it's really coming along!

He brings a stepladder under the wing.

HONJO
(to PLANT FOREMAN)
Thanks for making time on your break.

PLANT FOREMAN
Not at all. You young engineers should visit here more often.

Jiro climbs the ladder and peers into the exposed structural members where the strut joins the wing.

JIRO
(to Honjo)
Honjo, the strut's already installed.

HONJO
(smiles)
I knew it. Kurokawa's just hazing you. Is his fitting better than yours?

PLANT FOREMAN
(grins)
Mr. Kurokawa's always hard on new employees.

JIRO
Honjo, come up here and take a look. Something's not right.

Honjo climbs the ladder as the foreman steadies it. He grabs hold of Jiro's jacket to keep his balance. The two men peer at the wing, balanced precariously atop the ladder.

JIRO
What do you think?

HONJO
(peering at the bracket)
Looks solid to me.

JIRO
(points)
Oh this isn't good. It's just like my design.

HONJO
(poker-faced)
Then it must be bad.

ALT/:

JIRO
(points)
It's this joint. I think the stress will be too much.

HONJO
You have a better idea, right?

:/

Workers back from their break approach the aircraft.

PLANT WORKER

Foreman, lunch is over. What's going on?

PLANT FOREMAN

Quiet. They're working.

Honjo and Jiro outside, sprinting back to the design room.

JIRO

I love it! Airplanes are fascinating, aren't they?

HONJO

Yeah, yeah. But we're late!

REEL 3

Jiro's pencil moves quickly, drawing a complicated new design for the anchor bracket.

HATTORI, head of the company's design division, quietly comes and stands next to Jiro.

HATTORI

(leans down)
Young man?

Jiro finally looks up. Kurokawa is there too. For a moment nothing registers.

KUROKAWA

Jiro, this is Mr. Hattori. Our boss.
(ALT)
Your boss.

Jiro jolts up, buttoning his jacket.

HATTORI

(peers at the drawing)
Is this his first assignment?

KUROKAWA

Strut fitting for the Falcon Project, sir.

HATTORI

Mmm. Not what I expected.

KUROKAWA

(looks closer)
What?!

Jiro jumps up and stands at attention.

HATTORI

What am I looking at, young man?

JIRO

Sir, this steel leaf spring will ease the stress from the wing.

Kurokawa clicking the stopwatch in his hand.

An animation of the design for the leaf spring.

JIRO (O.S.)

This wire expands and contracts, absorbing the forces that act on the wing. I have it running through the strut and anchoring in the fuselage.

KUROKAWA

(irritated)
But we'd have to entirely redesign the length of the wing!

Jiro hardly seems to notice Kurokawa's irritation. Hattori looks intrigued.

JIRO

You're right. I'll run those calculations tonight, sir.

KUROKAWA

You're wasting your time. Where's the assignment I gave you this morning?

Jiro retrieves a roll of paper and spreads it on the desk.

JIRO

Right here, sir. I finished it.

Kurokawa stares at the drawing. He holds it up and studies it.

HATTORI

Well done.
(beat)
What do you think, Kurokawa?

KUROKAWA

It's... perfect.
(ALT)
(holding back)
It's... good.

Honjo, sitting opposite, grins at Jiro.

KUROKAWA (O.S.)

Turn your work in soon as you're done!

JIRO (O.S.)

Yes, sir.

Kurokawa stalks off with Hattori.

Dusk. The ceiling lights are on in the design room. Honjo is getting ready to leave. Jiro is still working on his calculations.

HONJO

What a day. I'm heading out.

JIRO

Me too.

HONJO

Did you already finish Kurokawa's homework?

JIRO

Just about.

The last rays of light over Ise Bay. Jiro and Honjo walk home. A herd of oxen stare at them from behind a fence next to the road.

JIRO

What are the oxen for?

HONJO

They haul the prototypes to the field.

HONJO

It takes them two days to drag it out there.
(beat)
That's how backwards we are.

JIRO

Oh, I don't know. I like them.

A team of oxen pull the Falcon prototype slowly toward the field.

The grass-covered Mitsubishi airstrip. A white marker cloth extends across the width of the runway. A knot of Army representatives in khaki uniforms stands at the edge of the strip.

Hattori, Kurokawa, and Jiro look up into the sky tensely from the end of the strip.

Kurokawa and Jiro hold stopwatches. Jiro has a clipboard.

The Falcon emerges through a gap in the clouds. It banks and descends, wings flashing in the sun.

A man with a white flag stands ready as the Falcon drops low and begins a high-speed run over the strip.

KUROKAWA
Here she comes!

Kurokawa tracks the plane with binoculars.

KUROKAWA
Almost... HERE!

The plane's approach, seen through binoculars.

KUROKAWA
Almost... THERE!

The plane nears the marker cloth. The flagman drops his white flag. Kurokawa and Jiro hit the plungers on their stopwatches.

KUROKAWA
Mark!

Kurokawa watches the plane through binoculars, then glances down to see that he hit both buttons on his stopwatch. The stopwatch hand is just twitching back and forth.

KUROKAWA
What!?

KUROKAWA
Damn it!

The plane flies low over the strip toward Jiro and Kurokawa. They duck as it passes right beside them. Jiro's hat is blown off. The plane climbs sharply.

Jiro looks at his stopwatch.

KUROKAWA
Tell me you got it!

JIRO
Thirteen point three seconds. One hundred forty-six knots.

KUROKAWA
Blast!

KUROKAWA (O.S.)
We need more horsepower!

Jiro's eyes shine with excitement.

KUROKAWA (O.S.)
She deserves better!

HATTORI (O.S.)
Hey!

Kurokawa hurries over to Hattori and a group of soldiers.

HATTORI
Mister Kurokawa!

KUROKAWA
Yes, sir.

HATTORI
A word with our clients.

KUROKAWA
Gentlemen?

SOLDIER A
Well done!

SOLDIER B
Your Falcon is a helluva plane.

SOLDIER C
I bet Mitsubishi couldn't do it. *Now* I'm buying drinks tonight.

Jiro goes to retrieve his hat.

SOLDIERS (O.S.)
(laugh)

KUROKAWA (O.S.)
(laugh)

Jiro walks along the field, watching for the plane. It appears high up, between breaks in the clouds. Suddenly the plane rolls over and dives. Everyone looks up. The plane plunges toward the ground.

KUROKAWA
Power dive. He's trying to break two hundred.

The Falcon dives. In the cockpit, the test pilot struggles against the G forces. One wing shudders and gives way.

A view into the interior of the wing. Its structural members shudder from stress.

The wings tear away in midair. The fuselage corkscrews through the air and down. The pilot is thrown free. Debris rains down on the field. The fuselage plunges into the ground just off the airstrip. The pilot's parachute opens. (This is the first time that a parachute has been used in Japan—Jiro is impressed that it works.)

JIRO
His chute!

HATTORI
Go get him!

Kurokawa dashes toward the parachute. Jiro runs after him, trailed by several others. The Army reps look on.

Kurokawa combs through the wreckage in the rain. Jiro quietly joins him.

JIRO
Mr. Kurokawa, let's investigate what happened when the weather clears. It'll be easier.

KUROKAWA
How's the pilot?

JIRO
He's okay.

KUROKAWA
(his back to Jiro, still combing the wreckage)
That's good.

JIRO
Let's go, Mr. Kurokawa. We'll regroup for Falcon 2.

Kurokawa turns to Jiro and eyeballs him.

KUROKAWA
Jiro, be straight with me. Do you think the strut fitting failed?

JIRO
(after a pause)
No. I think the problem is much deeper and more complicated than we thought.

JIRO
I will never forget what I saw today.
It's like an endless road opened up before my eyes. We can fix that strut, Mr. Kurokawa.

KUROKAWA

There won't be a Falcon 2. The Army has decided to go with a competing design.

KUROKAWA (O.S.)

Today was our last shot to change their minds.

KUROKAWA

(positive spin)

So we're shifting course. We're going to build a heavy bomber... with help from the Germans.

Kurokawa tosses a scrap of wreckage on the ground.

KUROKAWA

You are going to Germany to study Dr. Junkers' designs. I approved it.

He walks away. After a pause, Jiro follows.

Night. A streetcar moves through a dimly lit neighborhood.

Jiro rides the streetcar home. Homeless men huddle under the passing street lamps. Jiro gets up and heads for the door.

The streetcar brakes to a stop. A laborer gets off, then Jiro. The conductor rings the bell and the streetcar moves off into the dark neighborhood. Jiro crosses the street.

He passes a row of cheap drinking stalls filled with homeless laborers.

A lonely street. One shop is still open. Under a nearby street lamp, a girl stands with a baby on her back while her younger brother squats on the ground playing. Jiro peeks into the shop.

JIRO

Hello? Still open?

SHOPKEEPER (O.S.)

Ah, welcome back.

The shop sells baked goods: bread, cake, sweets.

SHOPKEEPER

Your usual?

JIRO

Yes, but two slices this time.

SHOPKEEPER

Coming up.

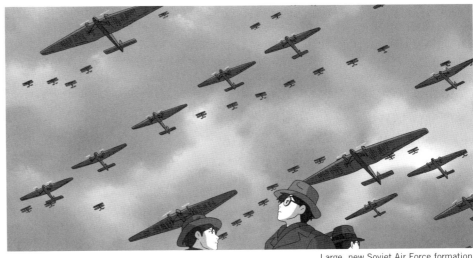

Large, new Soviet Air Force formation.

Jiro looks at the little girl. Their eyes meet. She looks away.

Jiro looks at her with pity and concern. The shopkeeper passes him the sponge cake wrapped in newspaper.

SHOPKEEPER

Here you go.

JIRO

(hands over some coins)

Who looks out for them?

SHOPKEEPER

Their parents work late. They wait there every night. I feel bad closing the place up.

JIRO

I see. Well, thanks.

SHOPKEEPER

See you tomorrow.

Jiro walks past the children, stops, and goes back to them.

The children react with apprehension. The little boy clutches his sister's sleeve.

JIRO

Hey, are you hungry?

I have two slices of sponge cake here.

JIRO

You can have them. I just bought them.

The kids stare at the package.

Jiro opens the wrapping and shows them the cake.

JIRO

Really! See?

The girl eyes him suspiciously. The little boy looks at his sister, then longingly at the cake and Jiro.

JIRO

Go ahead, take it.

BIG SISTER

(to her brother)

Come on!

The girl runs off, pulling her brother by the hand.

The kids run down the dark street and disappear into an alley.

Jiro stands alone under the street lamp.

Light comes from a few shacks under an iron bridge as a train crosses slowly.

Jiro and Honjo's comfortable rooming house.

The door to Jiro's room opens. Honjo peeks in.

HONJO

Jiro?

He enters without waiting and shuts the door.

Jiro lies on his bed, eyes closed.

HONJO

Wake up! I heard they axed the Falcon Project. I need details.

JIRO

(coming to)

Oh... Yeah.

HONJO
(opens the package on the table and takes out a piece of cake)
Sponge cake again? How do you live like this?
(ALT)
Sponge cake again? How do you stay alive?

Jiro has just finished telling Honjo about the children. Honjo munches sponge cake while Jiro makes tea.

HONJO
What did you expect? Did you think she was going to smile and say thank you, sir?

Jiro shakes his head.

JIRO
Of course not!
(pauses)
Well, maybe I did.
(ALT)
I only... wanted them to eat something.

HONJO
If you want a mouth to feed there are plenty of other hungry kids in this neighborhood.

Honjo sips his tea, then continues:

HONJO
And their parents are probably hungrier.
It's shameful, and I bet it gets worse before it gets better.

JIRO
I don't understand why this country is so poor.

HONJO
Poor Jiro. Stuck in his dreams. What Japan is paying the Germans for their technology they could feed every single man, woman and child a mountain of sponge cake.

HONJO
But if they want airplanes, then *I'm* going to make the most of it.

JIRO
They're sending you too?

Honjo drinks the last of his tea.

HONJO
They told me today.

JIRO
Really? That's great.

HONJO
Jiro, the fact is this poor country pays you a lot to design war planes.
(beat)
Embrace the irony.

HONJO
(stands, grinning)
I'm going to Tokyo tomorrow.
Going to get married.

JIRO
Married?

HONJO
To work hard at the office you need a family at home. More irony for you. Good night.

Honjo goes out and shuts the door.

Jiro sits alone by the open window, smoking pensively.

A locomotive crosses the forested plain of Siberia. [The year is 1929.]

An onion-domed Orthodox church passes by on the other side of the river.

A group of Japanese in overcoats and scarves. Jiro and Honjo are with them.

The group has arrived in Moscow on the day of a military parade. They watch as a formation of Soviet aircraft flies overhead. The sky is leaden with clouds.

The Junkers factory in Dessau. The sky is gray. Leaves are falling from the trees. The Mitsubishi delegation walks past the building.

The delegation walks across the grass-covered airstrip, preceded and followed by Germans.

HONJO
These tight-fisted Germans aren't letting us see any of Dr. Junkers' work.

The delegation walks toward a huge hangar.

JIRO
I don't see any oxen.

HONJO
Jiro, the airstrip's right next to the plant.

JIRO
Wow, everything is so big.

The guide smiles proudly as the electric hangar doors (another example of German technology) slide back to reveal a huge, four-engine Junkers G.38 airliner.

The Japanese visitors murmur in awe. The guide motions the delegation forward. Jiro and Honjo bring up the rear, followed by Junkers security guards.

JIRO (O.S.)
The G.38. Is this what we're buying?
HONJO (O.S.)
Yep. To convert to a bomber.

The visitors examine the aircraft's enormous undercarriage.

JIRO (O.S.)
Who's the Army planning to bomb with this?

HONJO (O.S.)
America, probably. Not that they could.

HONJO
It's quite something.

JIRO
It's amazing.

JIRO
(looking up at the plane)
Look. Passengers sit in the wings. Be a shame to put bombs there.

HONJO (O.S.)
That's the job, pal, This is our chance to get their all-metal technology.

Jiro and Honjo notice an argument in progress at the door to the airplane. The delegation's interpreter is trying to explain something to the Junkers rep.

Honjo watches the argument, but Jiro's gaze is fixed on something else, out of frame to the left.

HONJO
What!? They're not letting us in?

Honjo walks off toward the group. Jiro turns and exits frame left with an entranced expression.

Jiro approaches a small aircraft under construction in a corner of the hangar. The aircraft is skinned in shiny, silver Duralumin.

JIRO
(sighs, eyes sparkling)
Beautiful.

The sound of jackboots approaching. Two guards approach Jiro. One puts a hand on his shoulder.

JUNKERS GUARD
(in German - segue to English)
Japaner, komme nicht näcker.
You are not authorized to—!

Honjo runs over and grabs the guard by the arm.

HONJO
Get your hands off him.

Honjo and the guards eyeball each other warily.

HONJO
You've been slamming doors in our faces all day!

JUNKERS GUARD
Because you Japanese copy everything. This technology belongs to Germany.

HONJO
Oh, I get it. You're afraid we'll actually improve it?

JIRO
Honjo, let me talk to them.

JIRO
(to guards, in German)
Sir, we have signed an agreement to license Dr. Junkers' designs.

JIRO
Therefore we have a right to be in this hanger, examining this airplane. I understand you are just doing your job. I'm just doing mine.

JIRO
When I saw Dr. Junkers' single-engine plane here, I had to see for myself. I'm not a soldier. Simply an engineer admiring a fellow engineer's work.

JUNKERS GUARD
Well as a *soldier*, my orders are not to let you Japanese wander around!

HUGO JUNKERS (O.S.)
(in German)
One moment!

A man in a suit beckons from a short distance away. The guard runs over to him.

Jiro, Honjo and the other guard watch. Jiro recognizes Junkers, removes his hat and bows. Honjo notices too and takes off his hat.

Junkers says something to the guard. Honjo bows. Junkers waves at Jiro and Honjo as he walks away.

The two men look on reverently as Junkers walks off.

HONJO
That's Dr. Junkers.

Jiro and Honjo in the navigator seat in the Junkers nose.

JIRO
I know. What an engineer.

JUNKERS GUARD
Dr. Junkers says you can go inside.

The G.38 in flight. The winter sky over northern Germany is gray and overcast.

The north German plains spread to the horizon, gray-green and brown. The plane trails black diesel exhaust.

Jiro and Honjo sit in the tiny navigator's cabin in the plane's nose.

HONJO
So Jiro, what do you think?

JIRO
There's more vibration than I expected.

HONJO
(looking through the window to the wing compartment)
Our bosses are kids in a candy store.

MITSUBISHI EMPLOYEE leans into the cabin.

MITSUBISHI EMPLOYEE
(whispers)
Hey, let the Army reps sit in here.

JIRO
Yes, sir.

Jiro and Honjo stand to relinquish their seats.

Outside the navigator's cabin, the Army reps wait to enter.

MITSUBISHI EMPLOYEE
(to Army reps)
Just a moment.

ARMY OFFICER
It's fantastic! What a fortress!

A dim passage leads through the enormous wing to the engines, which can be serviced in flight.

HONJO
(peering down the passage)
Hey look. You can walk through the wing. Amazing.

Honjo moves down the passage followed by Jiro.

Honjo peeks into the engine compartment. The plane's huge water-cooled engines throb.

HONJO
(shouting)
It's like being inside a power plant.

A flight engineer stands a few feet away reading a bank of dials and gauges indicating the status of the engine. He notices the two men.

FLIGHT ENGINEER
Wer ist da!
(translation)
Who are you?

FLIGHT ENGINEER
Heir ist der Zutritt verboten!
(translation)
You can't come in here.

HONJO
Guten tag. We have permission from Dr. Junkers.
Would you tell us about your station?

251

FLIGHT ENGINEER
(goes back to his gauges)
Das ist unser Stolz.
(translation)
Here is the engineer's station.

HONJO
This is such a marvelous aircraft.

FLIGHT ENGINEER
The pride of Germany.

Jiro peers down the dark passage that leads further into the wing.

FLIGHT ENGINEER
But you can't go any further.
(in German)
Da besteht Lebensgefahr.
(translation)
We cannot guarantee your safety.

HONJO
(smiles)
Of course, my friend.
(to Jiro)
Are you seeing this?

JIRO
Yes, it's incredible.

A view of the wing from above, from the base of the wing toward the tip. The skin is transparent. The interior structure is visible, with Jiro and Honjo standing inside.

HONJO (O.S.)
A triumph of German industrial technology.

The skin of the wing materializes.

The G.38 flies on, trailing black exhaust.

Night. A car speeds along a cobblestone street. The stones glint in the headlights.

A small hotel on a dark street. A car drives by. There are lights in some of the windows.

Jiro and Honjo's room. Jiro sits looking absentmindedly out the window. An ashtray overflowing with butts sits on the windowsill. He watches the tail lights of a car disappear and exhales a cloud of smoke.

Honjo sits at a desk poring over documents from the Germans, presumably about the G.38. Without taking his eyes off the documents, he extends a hand toward a pack of cigarettes.

HONJO
Junkers lets us in, the Germans shut us out.

These specs are useless.

The pack is empty. Honjo crumples the pack and throws it into a wastebasket.

HONJO
(staring at the plans)
Got a cigarette, Jiro?

Jiro stares out the window and doesn't seem to hear.

HONJO (O.S.)
Jiro?

JIRO
Hmm?

HONJO
Gimme a smoke.

JIRO (O.S.)
We're out.

HONJO
(frustrated)
Aaar.

Honjo selects a butt from the ashtray, lights it and goes back to studying.

JIRO
It's cold outside, but this room is quite cozy.

He stubs out his cigarette and peers at the steam radiator next to the wall.

JIRO (O.S.)
You know that Junkers makes these radiators too?

JIRO
(touches the radiator)
Funny, they look just like his planes.
Such strong, parallel lines...

HONJO
Okay, okay. I get it. German technology is so superior that they can put wings on anything and fly it, including their damn radiators. Would you give it a rest, please?

Honjo slumps down in his chair and holds the documents at arm's length.

HONJO
We can't learn anything from these government specs. It's just a bunch of pretty numbers.
(imitates German guard)
This technology belongs to Germany.

JIRO
(suddenly inspired)
Honjo, maybe we don't need their technology. Wood and canvas could be just as good as metal.

HONJO
(dismissive - waves the documents)
Jiro, we can't be stuck in the past forever. We're already twenty years behind.

He goes to the wardrobe and takes out coats and hats.

HONJO
Let's get some air. My brain is going to explode.

REEL 4

Jiro and Honjo walk the dark cobblestone streets of Dessau.

HONJO
It's as if we're a hare chasing a tortoise with a twenty-year lead.

HONJO (O.S.)
But in our little story the hare doesn't sleep. We can close the gap, but how can we beat it?

JIRO
We'll always be chasing it.

HONJO
But what choice do we have?
Keep running and maybe they trip someday?

JIRO
I wonder if there's a different way to run, Honjo.

Jiro stops.

HONJO
What is it?

A light is on in a second-floor window. The window is half open. Someone is playing a recording of Schubert.

JIRO
Schubert's *Winter Journey*.

HONJO
Just perfect for us. A masterpiece of misery and woe.

The men walk on.

ALT/:

HONJO (O.S.)
Ugh, I need a smoke.

:/

As they pass a park on their left, a man leaps over the fence and runs across the road, cutting between them. They stop, surprised. The sound of boots on cobblestones.

A flashlight clicks on and shines in their faces. Honjo winces in the glare. Three men, but their faces are hard to see.

JUNKERS GUARD
(in German)
Dieser Japaner!
(translation)
It's those Japanese.

MAN B (O.S.)
(in German)
Da drüben!
(translation)
Over here!

Man C snaps off his flashlight and the three men run off.

MAN C
(running - in German)
Geh zurüch nach Japan!
(translation)
Go back to Japan!

The men disappear around the corner of a building.

JIRO
What was all that about?

HONJO
We saw him in the hangar.
(ALT)
Secret police. Let's get off the streets.

The men walk back past the building where they heard the record playing. The window is closed and dark now. In a dark alley, a group of men are running and struggling, casting ominous shadows onto the building walls.

Jiro's dream. Night. He walks alone across a snowy plain in his overcoat and scarf. Aircraft wreckage is scattered over the ground. A train slows to a stop and he walks toward it. The train blows its whistle. Steam jets from its brakes.

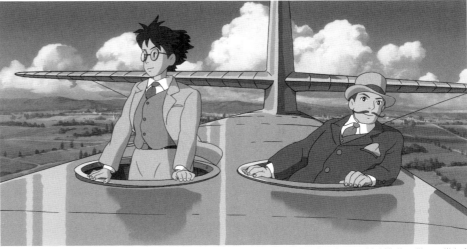

Caproni: "Well, what do you think?" Jiro: "Incredible."

Jiro looks up. Out of the clouds, a G.38 with rising sun markings plunges earthward, trailing flames. It crashes. A large section of wing wreckage knifes into the snow in front of him. The train blows its whistle again. Jiro keeps walking toward it.

HONJO (O.S.)
Jiro?

The hotel room. Honjo, with a towel over his shoulders, looks down at Jiro, who is dead-to-the-world asleep.

HONJO
Jiro, I'm done. Bath is yours.

HONJO
Dead to the world because he thinks he's shouldering the future of Japanese aviation.

There's a knock at the door.

Honjo opens the door. Mitsubishi Employee is standing in the hall.

MITSUBISHI EMPLOYEE
There's a telegram from headquarters.

HONJO
Come in.

MITSUBISHI EMPLOYEE
No need. Some of us are returning to Japan right away. You're staying behind.

MITSUBISHI EMPLOYEE (O.S.)
Jiro will continue west and return to Japan.

HONJO (O.S.)
West?

MITSUBISHI EMPLOYEE (O.S.)
They want him to see the world.

HONJO (O.S.)
(concerned)
Alone?

Jiro's dream, continued. The train moves across a vast plain at dusk. The horizon is red.

A compartment on the train. Jiro is alone, looking out the window. Caproni comes and takes the seat next to him.

JIRO
(surprised)
Mr. Caproni.

CAPRONI
Is the wind still rising?

JIRO
It sure is.

CAPRONI
(stands - smiling)
A perfect time to embark on my final flight. Join me.

Caproni turns on his heel. Jiro jumps up and follows him into the passageway.

JIRO
You're retiring?

Caproni grins and opens the car door. Outside it's dark, with snow swirling through the light from the windows.

CAPRONI
It's a big jump.

Caproni leaps into the blizzard. Jiro hesitates.

CAPRONI (O.S.)
Come on!

Jiro jumps.

He tumbles down the snowy embankment. As he comes to a stop, he's in a sunny meadow full of flowers. He hears delighted giggling.

CAPRONI'S GIRLS (O.S.)
(giggling)
Jiro adjusts his glasses and looks up to see...

...what looks like a silver balcony. CAPRONI'S GIRLS, a bevy of busty young women, crowd the balcony and smile down at him. The sky is the blue of summer. Caproni pushes his way through the girls and beckons to Jiro.

CAPRONI
Let's go! Why are you just sitting there!

The balcony is the nose of Caproni's latest creation, the Ca.90. Jiro gets to his feet. People look at Jiro from windows in the belly of the huge biplane. A pace car stands by with engine running.

CAPRONI
(gestures to Jiro)
There's a hatch under the fuselage!

CAPRONI
Hurry!

JIRO
(runs toward fuselage)
Okay.

CAPRONI
(to girls - turning to go)
Let me through.

Jiro runs under the fuselage. Men call to him from the open hatch in the belly of the plane.

GUY
Up here!

Jiro puts a foot on the bottom rung of the ladder. The plane's wheels creak and start turning. Jiro struggles to climb. The girls cheer him on.

Arms reach down through the hatch, grab Jiro and pull him up into the fuselage along with the ladder.

Jiro is inside the passenger cabin in the belly of the fuselage. The hatch in the floor slides shut.

The Ca.90 moves smoothly forward. The pace car accelerates.

CAPRONI'S GIRLS
Go! Go! Fly!

The huge plane begins to rise slowly. Passengers peer excitedly out the windows.

Inside the cabin, the passengers are yelling with excitement. The swaying cabin is packed with people. Everyone is in a party mood.

CAPRONI
These are all my workers and their families. Practically the whole village.

The pace car speeds alongside the plane as it floats free of the runway.

CAPRONI (O.S.)
I thought we'd take a little jaunt before we deliver this bomber to the government.

The girls wave their handkerchiefs from the belly turret as the plane ascends.

Caproni climbs out onto the top of the fuselage followed by Jiro. They peer at the engines and huge dual wings.

CAPRONI
Well, what do you think?

JIRO
Incredible.

JIRO
It's like a building out of ancient Rome.

CAPRONI
Fact is this plane is too big to be used for fighting. But the military has a weakness for big things.

They walk forward between the huge externally mounted engines. The thin skin of the plane flexes as they walk, making a metallic sound.

JIRO
Japan could never build something like this. The country is too poor and backwards.

A Ca.73, identical to the Ca.90 but smaller, rises up alongside them.

CAPRONI (O.S.)
Inspiration is more important than scale.

Several people stand in the open gunner's station in the nose of the Ca.73.

CAPRONI
Inspiration unlocks the future.
I've found technology eventually catches up.

Caproni's family in the nose of the Ca.73. He waves to them.

CAPRONI
(grins proudly)
That's my family.

Jiro hurriedly buttons his coat and bows to Caproni's family.

CAPRONI
We Italians are also poor. Too many mouths to feed.

The Ca.73 banks away. The party in the hold of the Ca.90 is getting rowdier. The fuselage shakes. Caproni leans over and yells down at the passengers.

CAPRONI
Hey! Settle down or the bottom will fall out.
(to Jiro)
Come.

Jiro and Caproni edge past the huge propellers.

CAPRONI
Be careful. This may be a dream, but you can still lose your head.

Caproni climbs up one of the huge struts supporting the upper wing. Jiro follows.

They walk along the upper wing.

CAPRONI
Which would you choose? A world with pyramids? Or without?

JIRO
What do you mean?

CAPRONI
Humanity dreams of flight, but the dream is cursed. My aircraft are destined to become tools for slaughter and destruction.

JIRO
I know.

CAPRONI (O.S.)
But still I chose a world with pyramids in it.

CAPRONI
Which world will you choose?

JIRO
I only want to create beautiful airplanes.

CAPRONI
(turns to look behind them)
Like that?

A white, inverted gull wing fighter plane, like a wind tunnel model, approaches from the rear and flies close over their heads. They turn to watch it fly on.

The fighter dives, climbs and swoops in the setting sun.

The fighter settles just above the wing of the Ca.90. Jiro gives it a push, like sending a boat out into a stream.

CAPRONI
Very graceful.

JIRO
I have a long way to go. I don't even have an engine or a cockpit yet.

Jiro walks to the edge of the wing and releases the fighter. The Ca.90 pilot and CAPRONI'S GIRLS watch from below. The fighter sails smoothly away.

The fighter dives, swoops upward and disappears.

CAPRONI
(watching the fighter)
Bravo! A beautiful dream.

Jiro climbs up the wing; Caproni lends him a hand to help him up.

Jiro and Caproni walk along the wing. Camera pans down past the plane to a Japanese harborfront below.

CAPRONI
This is my last design. Artists are only creative for ten years. We engineers are no different.
(O.S.)
Live your ten years well, Japanese boy.

Summer 1929. Jiro, alone in the design room, working. The building is new. Beyond the open windows, the lights of offshore fishing boats.

The aircraft plant, morning. Steam rises from the boilers. Workers walk between the buildings. It's the spring of 1932, well into April.

Jiro starts up a flight of stairs outside the design room. The door to the room opens and Kurokawa leans out.

KUROKAWA
Jiro, let's go get some coffee.

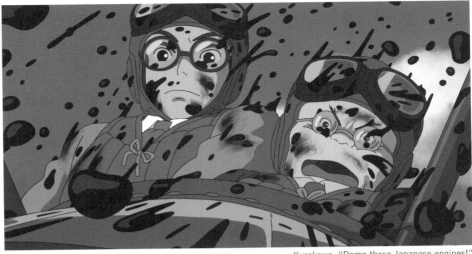
Kurokawa: "Damn these Japanese engines!"

JIRO
I've got a meeting—

KUROKAWA
Cancel it.

A row of new buildings behind the plant. One is a cafe. Jiro walks toward it.

Inside Café Flyer, a gramophone plays a classical record.

Jiro sits at a table next to Kurokawa, across from Hattori. There are no other customers yet. Jiro is reading a binder of documents.

JIRO
(staring at the page)
This is a very tall order.

KUROKAWA
(exhales a cloud of smoke)
They're always tall.

Jiro turns the pages of the binder, lost in thought.

HATTORI (O.S.)
How long have you been with us, Jiro?

Jiro doesn't respond.

KUROKAWA
Jiro?

JIRO
Mm?

KUROKAWA
How long have you been here?

JIRO
Five years.

HATTORI
(stubbing out his cigarette)

Jiro, we are going to bid for the Navy's carrier-based fighter. We think you're ready to be the plane's chief designer.

KUROKAWA
(insistent)
It's a plum job.

Jiro looks off in the distance, lost in thought.

KUROKAWA
(impatient, louder)
IT'S A PLUM JOB—!

Hattori motions Kurokawa to be silent. He takes a sip of coffee and watches Jiro. The gramophone needle reaches the end of the record. The record continues to spin.

HATTORI (O.S.)
(to Jiro)
What do you think?

JIRO
I can do it.

HATTORI
Good.

Hattori smiles and finishes his cup of coffee.

JIRO
I'd like Honjo on the team.

KUROKAWA
Not a good idea.

KUROKAWA
You'd end up competing. Friendship's more important.

HATTORI
Relax. Finish your coffee.
(to waitress)
Check please.

Hattori goes to pay the bill. Jiro and Kurokawa stand up.

KUROKAWA
We've got other plans for Honjo.

Kurokawa follows Hattori out. Alone, Jiro sits down and returns to the binder.

The documents. Jiro turns the pages.

A Mitsubishi B1M biplane flies through a clear blue sky.

Kurokawa and Jiro jammed side by side in the navigator's seat.

Beneath them, a little aircraft carrier (Hosho) is visible, accompanied by a destroyer. The biplane banks sharply.

The biplane approaches the carrier for a landing. The engine starts to cough. The propeller slows. Smoke belches from the engine. Oil flies back and spatters Jiro and Kurokawa.

The biplane is almost on the carrier, but looks as if it will undershoot the flight deck and crash into the stern. The engine belches smoke and oil.

KUROKAWA
Damn these Japanese engines!

On the flight deck, sailors brace for impact. At the last instant the engine catches and the biplane climbs just enough to set down on the deck, still belching smoke. It hits the barrier, bounces back and comes to a stop.

Deck crew surround the plane.

KUROKAWA
Damn these short runways!
[Note: Kurokawa means that this is the flight deck the new fighter must be capable of taking off from. The Hosho was the smallest carrier in the fleet.]

Below deck in the officer's lavatory, the two men soap up, trying to get the oil off.

A sailor stands by waiting, carrying clean uniforms.

SAILOR
Fresh uniforms!

JIRO
(covered with suds)
Oh, thanks.

On the flight deck, three Nakajima A1N biplanes prepare to take off. Their engines rise to full power. Kurokawa and Jiro emerge onto the platform at the edge of the flight deck and join a naval officer. The platform is about a meter lower than the deck.

KUROKAWA
These are nice uniforms.

OFFICER
Yes. We're ready.

The deck officer drops his flag. Deck crewmen remove the chocks from the wheels of the first aircraft. It rolls forward and takes off as Jiro and Kurokawa watch.

The second biplane jolts forward and moves down the flight deck.

OUT

Kurokawa gets another face full of oil.

The second plane's engine cuts out. It loses speed, runs off the end of the carrier and flops into the water.

Jiro and Kurokawa look on in shock as crewmen rush to the end of the flight deck.

DECK OFFICER
Man overboard!

The plane is half-submerged just off the carrier's bow. Men dive into the water. A motor launch is lowered. Crewmen mill on the flight deck.

Sunset over the anchorage. A launch moves away from the carrier, followed by seagulls. Jiro stands silently on the deck.

Summer 1933. Jiro walks toward a grassy runway. Behind him, ground crew push Jiro's prototype toward the strip. Jiro is tense with anticipation.

Heat waves rise from the field. Jiro walks onto the airstrip and turns to face the fighter.

The plane shudders to a halt. The crew members disperse to either side. Others chock the wheels. A mechanic climbs down from the cockpit.

MAN IN PLANE
Stop!

The test pilot climbs into the cockpit, helped by ground crew. The fuselage is studded with protruding rivets.

A ground crewman inserts the handle for the inertia starter. He and another crewman turn the crank, throwing their backs into it.

Jiro stands in the burning sun, full of anticipation.

The pilot engages the clutch and the propeller begins to revolve. Ignition. Clouds of white smoke pour from the exhaust. The plane shudders as the motor builds power.

The pilot increases power and the plane shudders more. Smoke from the exhaust is mixed with flame. The pilot signals to Jiro that he's ready.

Jiro bows to the pilot and steps away from the plane.

Chocks away. The pilot opens the throttle. The exhaust smoke is replaced by flame.

The fighter rolls past Jiro. He turns to watch it move down the field.

The fighter comes speeding down the runway.

Jiro watches intently. The wind picks up.

The tires shudder as the plane picks up speed. The fighter gently lifts off.

The design team, Hattori, and Kurokawa watch the fighter's progress intently.

JUNIOR DESIGNER
She's airborne!

Jiro stands to one side, looking up at the sky. The fighter flies toward the towering summer clouds.

A rack-and-pinion railway line in the mountains. An electric locomotive slowly climbs the steep grade.

A view of mountains from the train window. The entrance to another tunnel is visible far below.

The train crosses the red brick bridge at Usui Pass.

Jiro, somewhat dazed to be on vacation, walks along the crowded main street of the mountain resort of Karuizawa.

Jiro walks along a sun-dappled path in the woods.

Nahoko paints at an easel on a breezy embankment overlooking a reservoir. She stands under a large white parasol. Ten years have passed since the earthquake.

The canvas is a riot of color. She uses her knife to apply a bright green blob of paint.

She takes paint from her palette and looks at the scenery, then sees Jiro at the base of the embankment.

Jiro walks along the path at the foot of the embankment. Nahoko watches him, then notices someone else. She smiles.
An older man steps out of the trees in a white suit and panama hat, carrying a walking stick. He's walking toward Jiro.

Nahoko waves to the man.

NAHOKO
Father!

Jiro glances up at her and keeps walking.

Mr. Satomi, Nahoko's father, waves his walking stick in greeting. Jiro and Satomi approach each other.

The two men pass each other.

Nahoko watches. Suddenly a strong gust of wind sweeps across the reservoir, ruffling the surface of the water. The blue sky reflected in the water is replaced by silver ripples.

The gust hits Nahoko, blows her canvas off the easel and sends the parasol aloft.

NAHOKO
(reaching for the canvas)
Ah!

The parasol flies down the embankment as Satomi watches from halfway up. It flies straight toward Jiro, who is walking away from it.

Jiro approaches the edge of the trees. He turns to see the parasol bearing down on him. He manages to grab the shaft, but gets dragged off the path by the wind. His hat flies off.

Nahoko holds onto her canvas and her hat in the wind as she watches Jiro, amused.

NAHOKO
(chuckling)
Well!

Jiro manages to stop the parasol and close it. Nahoko waves to him.

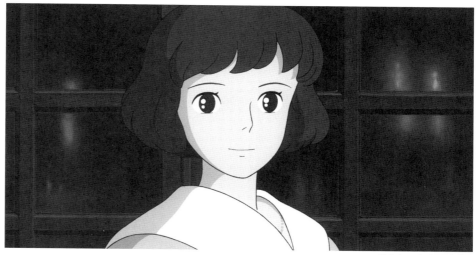

Nahoko, staring at Jiro.

NAHOKO
Bravo! Nice catch.

Jiro waves back. Satomi walks down toward him. Jiro meets him halfway.

SATOMI
It nearly took you away. Are you all right?

JIRO
(gives him the parasol)
I'm fine. Here you are.

SATOMI
Thank you. I'll make sure it stays grounded.

JIRO
Well, I better go.

Jiro retrieves his hat from the grass, puts it on, and walks on into the woods.

Nahoko watches him go. Satomi comes up the embankment with the parasol.

NAHOKO
I wanted to say thank you to him.

She begins to fold up the easel.

SATOMI
(watches Jiro go)
Nice young man. Don't worry. He's staying at our hotel. You'll have a chance to say thank you.

The front gate of Kusakaru Hotel. The building has a Western feel. A foreign woman on a bicycle rides up. [Note: she is German.] Guests are arriving.

Late afternoon. Jiro enters his Japanese-style room. The light is dim. He shuts the door behind him. He looks tired, perhaps a bit depressed. He unties his shoes, steps up onto

the tatami, takes off his hat and coat and hangs them up.

He hears faint laughter from outside. He opens the door to the room's tiny balcony. Through the pines across the way he can see tennis players in white outfits moving about on the court.

He leaves the door open and steps back into the room. The breeze moves the curtains. He stretches out on his back on the tatami.

Jiro's memory. The test flight. His fighter plunges earthward.

The vertical tail fin's structural members begin to creak, then finally give way under the stress. The plane breaks up in midair and wreckage rains down. The fuselage plunges straight into the ground.

Jiro's room. The wind swings the balcony door shut. He opens his eyes and gazes at the ceiling.

Jiro's memory. A darkened hangar. He stares at fragments of wreckage from his fighter, piled on the floor and illuminated from above. He turns and walks away.

The resort. A sunset sky full of rain clouds.

Hotel guests in the smoking lounge look out at the rain. Many are non-Japanese. A bellhop runs in from the terrace. Guests are coming downstairs to dinner.

Nahoko and her father descend the stairs. Satomi looks at the rain and says something to his daughter. Nahoko peers around casually, looking for Jiro.

The hotel restaurant. The adjoining room is a bar. As Nahoko walks with her father to a table, she notices Jiro already seated, having his soup. Hans CASTORP, another guest, is at the table between Nahoko and Jiro, reading a folded newspaper.

A waiter holds Nahoko's chair. She keeps gazing at Jiro. Jiro seems lost in thought. Nahoko notices the waiter holding her chair and finally sits.

A waiter delivers a huge watercress salad to Castorp. Jiro glances toward him but can't see Nahoko on the other side—the waiter is standing in the way. Castorp dives eagerly into his salad. Jiro absently munches a piece of bread.

Castorp grins as he digs into his salad. Jiro can't help glancing over at him. Castorp picks up his paper and reads as he eats. Jiro finally notices Nahoko gazing at him. He smiles and nods. Nahoko is startled. She puts on a properly formal smile and inclines her head. Just as she does so, a waiter brings Jiro's main course, putting an end to the interaction.

Satomi opens his menu. Nahoko is still looking across the room at Jiro.

SATOMI (CONT'D)
What is it?

NAHOKO
(casually - spreading her napkin)
Nothing. Just that man who caught the parasol.

SATOMI
He seems to be here by himself.

ALT/:

SATOMI
What is it?

NAHOKO
(whispers)
That man. I know him from somewhere.

SATOMI
You do? Where?

:/

REEL 5

Small white clouds float through a blue sky. Jiro is out for a walk. He carries his jacket over his arm. He seems to be searching for something. The path follows a small stream.

At the edge of the forest, Jiro sees an easel, a folding chair, and a parasol. He looks for the painter, but no one's around.

The path continues into the woods, with a tiny watercourse flowing next to it. A short walk brings Jiro to a clearing with a square pool, the source of the stream. Water rises from the spring.

Nahoko stands before the pool, looking into the water. She turns and is surprised to find Jiro there. Jiro smiles and nods. Nahoko smiles and nods, but with tears in her eyes.

He steps toward her, but she turns away.

JIRO
(confused)
I'm... I'm sorry. I'd better go.

He turns to go.

NAHOKO
(turns back to him)
No, please. I was giving thanks to this spring.

NAHOKO
I asked it to bring you here, to me.

Jiro stops and slowly turns in surprise.

NAHOKO
(tears welling up)
You haven't changed at all from that day years ago. You look just the same.

NAHOKO
We were so grateful for your help after the earthquake. I wanted to see you again and thank you.

JIRO
Now I remember! On the train!

NAHOKO
(bows deeply)
I am Nahoko Satomi.

JIRO
I'm Jiro Horikoshi.

Clouds gather. Raindrops on the white dust of the path. The rain rustles the leaves. Gradually the rain rises to a downpour.

Jiro and Nahoko make their way back to the hotel under the parasol. It's pouring rain.

JIRO
This umbrella is useless. Are you all right?

NAHOKO
Oh, I fine.

Inside the parasol, the two are getting soaked. The parasol was meant to keep off sun, not rain. Nahoko has to speak loudly to be heard over the downpour.

NAHOKO
Kinu searched for you for years.
She found you just before she got married.

NAHOKO
She cried for joy after she dropped off your shirt.

NAHOKO
You were our knight in shining armor that day.

JIRO
Your knight?

NAHOKO
Yes. Like a knight on a white horse.
(ALT)
Yes, we were so scared, but you were so calm.

JIRO
(looks up at the leaky umbrella)
Well, I'm not doing much now to keep you dry.

NAHOKO
That's okay. I don't mind at all. Kinu will be so excited when I tell her... I found our hero again.

As they walk along under the parasol, the sky lightens and the rain suddenly lets up.

JIRO
(looks at the canvas)
Oh, your painting is ruined.

NAHOKO
It's not. I'll always remember this day when I look at it.

JIRO
Look, it's clearing up.

The rain stops. Jiro lowers the parasol. Nahoko looks up at the sky. The sun is coming out.

NAHOKO
(joyous)
Ooh...

NAHOKO
(looks at the path)
Ah!

The damp ground ends clearly in a line across the path. Beyond that it's dry. Entranced, Nahoko skips ahead onto the dry ground.

NAHOKO
It's like another land.

She turns to look at Jiro and sees a rainbow in the sky behind him.

NAHOKO
Oh look!

They turn to look at the rainbow.

JIRO
I'd almost forgotten what rainbows look like.

NAHOKO
Life is wondrous, isn't it?
(ALT)
Sometimes life is wonderful.

Jiro looks at her, suddenly moved. She turns to go.

NAHOKO
Let's go. My father's probably worried sick.

Jiro follows.

Satomi emerges from the trees and hurries toward them. He's carrying two umbrellas. He waves his walking stick in greeting.

NAHOKO
There he is.
(calls to Satomi)
Father!
(to Jiro)
Come, I'll introduce you.

She hurries toward Satomi.

JIRO
(following after her)
Okay.

Nahoko runs up to her father.

SATOMI
You're soaking wet.

NAHOKO
Oh, I'm fine. I was with Mr. Horikoshi. He saved me again.

JIRO
(joining them - takes off his hat and bows)
Jiro Horikoshi.

SATOMI
(bows)

The person Jiro waits for does not come.

I'm Satomi. It's so very good to meet you, Mr. Horikoshi.

Dusk. The lights in the hotel are on. From the garden, guests can be seen on the terrace and in the dining room. The dinner hour is beginning.

Jiro comes down the stairs. He pauses to look for Nahoko and Satomi, but they haven't arrived.

The bar. It's full of guests, Japanese and non-Japanese, chatting before dinner. Jiro strolls through the bar and onto the terrace. He goes to the railing at the edge, looks out at the dark woods beyond, and takes a deep breath of twilight air. He casually glances back at the hotel. Guests are coming down to dinner.

Jiro sits where he can keep an eye on the staircase and the dining room. He lights a cigarette.

CASTORP (O.S.)
May I sit here?

Jiro looks up to see a smiling Hans Castorp.

JIRO
(smiles)
Certainly.

Castorp puts his newspaper down and takes a seat. Jiro goes back to his cigarette and his vigil. The smoking area just off the terrace is empty; everyone's gone to dinner, but Nahoko has not arrived. Jiro catches the aroma of Castorp's cigarette and glances at him.

Castorp smiles. English [Japanese in the original] is not his first language.

CASTORP
German tobacco. I've been saving it. Last one.

JIRO
(speaking slowly, clearly)
Know how you feel. Japanese cigarettes always taste like home to me.

CASTORP
You visit Germany, yes? To Dessau.

JIRO
Wow, you must be Sherlock Holmes.

CASTORP
(knowingly)
Well, you read German magazines about airplanes. All Japanese engineers visit Dessau. It's elementary, my dear Watson.

JIRO
(laughs)

CASTORP
(laughs)

JIRO
You cracked the case.

Castorp leans forward and lowers his voice.

CASTORP
Dr. Junkers is in trouble.

JIRO
(tensing)
He is?

CASTORP
He fights the hand that feeds him. And he will lose.

JIRO
He fights Mr. Hitler's government?

Castorp peers intently at Jiro.

CASTORP

The Nazis are a gang of hoodlums.

CASTORP

(suddenly cheerful)
This is a good place. No mosquitos. Not hot. Good watercress.

CASTORP

A good place to forget bad things... isn't that right?

Jiro extends his pack of cigarettes.

JIRO (O.S.)

Cigarette? I'm afraid they're Japanese.

CASTORP (O.S.)

(takes one)
Thank you.

Castorp lights up, exhales a cloud of smoke and sits back.

CASTORP

It is a nice night. Hier ist Der Zauberberg.

JIRO

The Magic Mountain. Thomas Mann?

CASTORP

That's right. A good place for forgetting.

Castorp looks once more as if he's sizing Jiro up.

CASTORP

Make a war in China. Forget it.
Make a puppet state in Manchuria. Forget it.

Jiro winces slightly.

CAPRONI (O.S.)

Quit the League of Nations. Forget it.
Make the world your enemy. Forget it.

CASTORP

Germany will blow up. Japan will blow up, too.

JIRO

(concerned)
Will Germany go to war again?
(ALT)
Will Germany really go to war?

CASTORP

Yes. They must be stopped.

Satomi appears on the terrace and hurries toward Jiro. Jiro turns toward him.

Jiro stands up. He senses something wrong.

SATOMI

I'm sorry to keep you waiting.

SATOMI

Nahoko has a fever. We'll have to cancel our dinner plans.

JIRO

(worried)
Oh, I'm sorry to hear that.
I hope she feels better soon.

Satomi's expression suggests that Nahoko's condition is worse than he's letting on.

SATOMI

(uneasy)
The... doctor will be here soon. I must go.

He hurries away.

Jiro watches him go. He bows and turns back to Castorp. He's gone. A thin line of smoke rises from the ashtray.
Jiro walks slowly down the stairs from the terrace to the garden. He strolls along a gravel walk, stops, and gazes up at a lighted guest room window. The stars twinkle above the hotel. He lingers for a few moments and walks on.

Midnight. Jiro lies in his futon. He's reading a collection of poetry when he hears some sort of commotion.

The corridor outside Jiro's door. At the far end of the corridor, a nurse hurries past toward another wing, carrying a basin.

Jiro listens tensely. He can't contain his curiosity and gets up to see what's going on.

The hotel corridor. One of the staff walks past the end of the corridor carrying a bucket of ice. Jiro's door opens. He leans out as silence returns. He goes back inside and closes his door quietly.

Jiro goes out on the balcony and looks up at Satomi's suite. A single light casts a soft glow. He sits down at a small table on the balcony and gets out a cigarette. The glow of the match lights up his face.

Morning. The Satomi table is empty. Castorp reads the paper as he stirs his morning coffee. Jiro walks by, glances at the empty table, and goes upstairs to his room. As he walks, he recalls a poem.

JIRO (V.O.)

Who has seen the wind?

Jiro steps out onto the balcony of his room. He looks up at the window of Nahoko's room. A light wind moves the curtains at the open window.

JIRO (V.O.)

Neither I nor you:

JIRO (V.O.)

But when the leaves hang trembling.
The wind is passing through.

Jiro's hands skillfully cut a folded sheet of paper with scissors.

He sits at the table on the balcony and puts the finishing touches on a paper airplane. He adjusts the pitch of the wings. [The poem is by Christina Rossetti (1872). The next line is Jiro's improvisation.]

JIRO

Let the wind carry these wings to you.

Jiro sends the airplane off the balcony into the breeze. The airplane noses earthward, hits an updraft and soars higher. It circles back and lands on the roof above Jiro's head, close to the balcony. One of the wings sticks out over the edge of the roof. It looks as if the wind might blow it away any moment.

Jiro steps up onto the wooden wall around the balcony to retrieve the plane. He holds onto the roof with his right hand and stretches out his left, but his reach is just short. He stretches further. One of his feet lifts off the balcony. He glances up at Nahoko's balcony just as Nahoko, standing on the balcony, notices him. Their eyes meet.

NAHOKO

(astonished)
Jiro?

JIRO

(happily)
Oh, Nahoko!

The corner of the wall around the balcony is rotted and comes away under Jiro's feet. His hold on the roof keeps him from falling. Startled, Nahoko leans over her balcony.

The paper airplane slips off the roof and glides past Jiro. He reaches for it and misses. The plane glides downward. The wind catches it and it skitters upward.

Castorp strolls below Jiro's balcony. He notices the airplane and turns to watch as it dances in the breeze. The plane soars upward and comes to rest behind Nahoko on her

balcony. She doesn't notice it.

Nahoko is still watching Jiro standing precariously above the ground.

NAHOKO
Be careful!

Jiro manages to hop back onto his balcony. He waves cheerfully to Nahoko.

Nahoko smiles and waves back. Jiro pantomimes the flight path of the paper airplane onto her balcony. She's is puzzled at first, then turns to look behind her. She smiles at Jiro and disappears from sight as she goes to retrieve the plane.

Nahoko launches the plane from her balcony. It swoops and soars toward Castorp, who has been watching all along from below. He rushes back and forth in an effort to catch it, but when he finally does, he opens his hand to see that he's crushed it. His mouth opens in surprise.

CASTORP
Ohh!

A few days later, afternoon. The air is sultry. Jiro walks past the terrace, armed with a sturdier, more elaborate paper airplane. On the terrace, Castorp looks up from his newspaper and smiles.

Jiro strolls beneath Nahoko's balcony. Castorp glances at him from the terrace. Jiro stops and looks up. On the balcony, the edge of a yellow parasol is visible. The parasol disappears. Nahoko appears at the edge of the balcony wearing a straw hat. She waves at Jiro.

Jiro holds up the new airplane and bows. Nahoko giggles with anticipation and leans out over the balcony.

Jiro puts a rubber band in a notch on the airplane's nose and draws it back. He aims the plane and lets fly.

The plane flies straight toward Nahoko, then suddenly banks and dives. She reaches for it but misses. The plane circles back toward Jiro. He reaches high to catch it, loses his balance, and falls backward into the bushes off the path.

Nahoko leans over the balcony and looks down at him.

NAHOKO
(laughs)

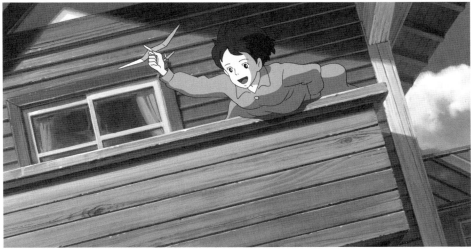
Naoko: "Nice catch."

Jiro solemnly draws the paper airplane back against the rubber band and releases it.

The plane comes flying upward. Startled by its speed, Nahoko makes a grab for it but misses. She watches the plane soaring and diving. The plane heads back toward her and she leans out to catch it. This time she succeeds, but almost topples over the balcony. Her straw hat comes off. She watches it fall.

Jiro dashes forward to catch her, then rushes back to chase after her hat. He recovers it like a running back catching a long bomb. He runs and falls into a bush, but we can see that he got the hat.

NAHOKO
Nice catch.
(laughs)

Jiro stops beneath Nahoko's balcony. He holds a hat in each hand, ceremoniously places Nahoko's hat on his head, smiles and bows.

Nahoko launches the paper airplane. Jiro runs after it.

Castorp has been watching all this from the terrace. He looks up at the sky with a smile and shrugs his shoulders.

Castorp's hands on the keyboard, playing the piano.

Later that evening. The hotel is holding a party. There are lanterns, confetti on the floor, guests dancing. Castorp plays a tune from The Congress Dances, a German hit film. A foreign woman dances like the star of the movie. Castorp glances over at Jiro's table and smiles.

Satomi arrives. Jiro stands as Satomi approaches the table. Castorp's newspaper and cigarettes are there in front of an empty chair. Satomi bows and sits in another chair. A waiter appears and Satomi orders. Jiro sits down. Castorp winks at him and turns back to the keyboard.

CASTORP
(sings)
Das gibt's nur einmal, das kommt nicht wieder

JIRO
Das ist vielleicht nur Traumerei!

SATOMI
Das kann das Leben nur einmal geben

CASTORP
Vielleicht ist es morgen schon vorbei!

JIRO/SATOMI/CASTORP
Das kann das Leben nur einmal...

Castorp stops playing, rises and turns to Jiro. He sings the last verse slowly.

CASTORP
Denn jeder Fruhling hat nur einen Mai!

He empties his glass and heads for Jiro's table.

Castorp shakes hands briefly with Jiro, sits down and bows to Satomi.

SATOMI
Bravo!

CASTORP
Is your daughter feeling better?

SATOMI
Yes, much better, thank you.

CASTORP
Of course!

CASTORP
(to Jiro - grinning)
This is the magic mountain. It cures everyone.

JIRO
(smiles - he's in love)
I think you're right.

CASTORP
(to Satomi)
At the beginning, this young man was very gloomy. Now he is very happy.

CASTORP
(looks at Jiro)
Because he's in love.

JIRO
Yes.
(ALT)
Well.

Satomi peers at Jiro questioningly.

CASTORP
(to Jiro)
But summer love is seasonal. You will go down the mountain and forget all about it.

Satomi looks at Castorp, then at Jiro, with increasing apprehension.

JIRO
Not true.

SATOMI
This love you're talking about wouldn't be my daughter, would it?

Castorp looks triumphant. Jiro turns to Satomi.

JIRO (O.S.)
Yes. I love her very much.

CASTORP
(happily)
Oh!

Satomi looks dumbfounded.

JIRO
(confident)
And I hope you'll approve, Mr. Satomi.

SATOMI
(flustered)
But... I don't...

NAHOKO (O.S.)
Father!

The men turn toward her voice.

Nahoko slowly descends the stairs and stops in the middle.

NAHOKO
I'd like you to approve, too.

CASTORP
Now there's a beauty.

Satomi is aghast. Jiro goes to the stairs and looks up at Nahoko across the bannister.

Nahoko comes down the stairs to Jiro.

NAHOKO
(to Jiro)
But Jiro, there's something you need to understand.

JIRO
Anything.

NAHOKO
(calmly)
My mother died of tuberculosis two years ago. I have it too.

JIRO
(not swayed)
Nahoko, nothing is going to stop me from loving you.

NAHOKO
(with joy)
I've loved you since the day the wind brought you to me.

JIRO
(softly, with a smile)
Please marry me.

NAHOKO
(without any hesitation)
Yes. But first I'm going to get well. Will you wait for me?

JIRO
I will.

Jiro lays his hand on Nahoko's hand on the bannister.

JIRO (O.S.)
Even if it takes a hundred years.

Castorp shakes Satomi's hand. Satomi is dazed. His eyes are misty.

CASTORP
Congratulations! He is a nice young man and your daughter is wonderful.

CASTORP
This is a summer... to remember!

Nahoko at the top of the embankment, painting. The wind sways the grass. Jiro comes climbing up the slope. He looks at the canvas. Nahoko looks at him as if to say, what do you think? He kisses her impulsively.

Late summer, 1934. The Mitsubishi aircraft plant. Lunch hour. Smoke rises from the chimneys. Barges ply the canal. Jiro walks toward one of the buildings with a rolled-up sheet of tracing paper.

Jiro walks past one of the assembly buildings. A Ki-1 bomber is visible inside, looking like a prehistoric fish. The workmen relax on their break.

Honjo stands outside the entrance to the next assembly hangar. He waves at Jiro. One year has passed since they last met.

HONJO
Long lost Jiro!

JIRO
(running toward him)
Honjo!

HONJO
When did you get back?

JIRO
Two days ago.

HONJO
Hot, isn't it? He enters the hangar, followed by Jiro.

Inside the hangar, the ventilation fan revolves slowly.

HONJO
Come take a look.

Honjo's first aircraft, a heavy bomber (later the Mitsubishi G3M). Its Duralumin skin gleams. It is clearly far more advanced than the Ki-1. Jiro and Honjo walk up to the twin-engine bomber. Jiro looks up, visibly impressed.

JIRO
She's beautiful.

Jiro walks around the plane, scanning it with a practiced eye.

OUT

262

JIRO
Good clean lines.

HONJO
They gave me free rein.
So I designed something radical.
But it won't amount to anything
if she doesn't fly.

Jiro climbs a wide stepladder to the rear of
the plane to get a better view.

His chest swells with emotion and
enthusiasm.

JIRO
Oh, she'll fly. I feel the wind rising.

As he speaks, Jiro is surrounded by blue skies
and white clouds. The wind ruffles his hair.

In Jiro's vision, the building disappears. The
bomber flies through the air and he watches
from behind. The bomber climbs, flashing in
the sun. Jiro and Honjo watch side by side as
the bomber flies away.

The vision ends.

JIRO
You've closed the gap, Honjo. In one huge
step.
(regretful)
My plane was just a tin duckling.
(more cheerful)
Look, I have an idea for you.
I thought of it too late to use in my plane.

He hands the roll of tracing paper to Honjo.
Honjo unrolls it and looks at the diagram.

A diagram of an aircraft component, part
of the fuselage. Honjo studies the diagram
intently as Jiro explains.

JIRO
It's a way to reduce drag by using flathead
screws on all the access hatches and the
fueling port.

A simulation of Jiro's idea. Several access
panels on the wing open. One has four screws
holding it shut. The four screws unscrew, rise
and fade away. Close up of one panel secured
by a single flathead screw sealing a hinged
hatch.

Jiro points to the diagram.

JIRO (O.S.)
And maintenance will be easy with a hinge on
one side.

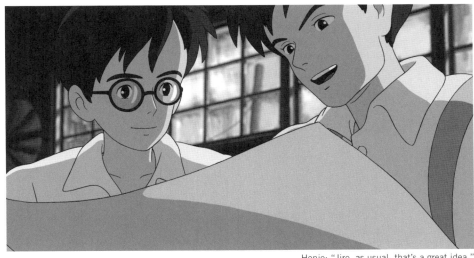

Honjo: "Jiro, as usual, that's a great idea."

JIRO
A spring about this stiff should be fine.

HONJO
Jiro, as usual, that's a great idea.

JIRO
You should use it.

HONJO
(grins)
Thanks, pal, but not this time.

JIRO
(surprised)
Hmm?

HONJO
(rolls up the diagram)
I'll keep these but I'm not going to use them
before you. This belongs in your next plane.

JIRO
(nods, appreciating Honjo's friendship)
Thanks, Honjo.

HONJO
(grins)
You're welcome. But hurry up.

Kurokawa rushes in. He's in a panic.

KUROKAWA
Jiro! Where are you!?

HONJO
(descends the stepladder - sees Kurokawa)
Mr. Kurokawa.
(to Jiro)
Jiro.

JIRO
(coming down the ladder - to Kurokawa)
Yes?

KUROKAWA
Get back to the office.

JIRO
Coming. Thanks, Honjo.

HONJO
(waving as Jiro runs out after Kurokawa)
Come to the house for a drink next time.

JIRO (O.S.)
Sure.

A bicycle is parked outside. A siren
announces the end of lunch hour.

KUROKAWA
Jiro, you pedal.

Jiro gets on the bike. Kurokawa hops on the
back.

Jiro pedals past workers returning to their
tasks.

KUROKAWA
The Secret Police are looking for you.

JIRO
What?

KUROKAWA
The thought crime boys.

JIRO
(glances back in surprise)
But why me?

KUROKAWA
Didn't ask! I told them you were away.

The feet of two men descend the stairs of the
main building. White shoes and trousers.

The white-suited men jump into a black car. The car pulls away. [Jiro is being investigated due to his friendliness toward Castorp, who may be a spy working for the Soviets. The model would be the real-life spy Richard Sorge.]

Kurokawa watches them go from the window of a room on the third floor. Jiro sits at a table behind him.

KUROKAWA
(watching the car)
They're just pretending to leave.
We won't fall for that. You'll work up here today. I'm having your things brought in.

JIRO
Why are they after *me*?
I don't understand.

Kurokawa walks to the door and puts his hand on the knob.

KUROKAWA
They arrested some of my friends. *None* of them understood why.

A knock. Kurokawa puts his ear to the door as if listening for the code word.

KUROKAWA
(whispers)
Quietly.

Two cheerful young engineers, SONE and KUBO, enter carrying a drawing board, tracing paper, etc.

SONE
(loudly)
Here's your stuff!

SONE
(putting Jiro's things on the table)
I think we got everything.

KUBO
I'll go back and check.

KUROKAWA
(loudly)
No, just leave it and go!

As Kurokawa stands by the open door, another young man (DAIKICHI) rushes in with a wooden box, followed by CHUKICHI.

DAIKICHI
Jiro, the flange is here!

CHUKICHI
Let's take a look!

KUROKAWA
(frustrated)
Mmm!

Kurokawa closes the door reluctantly and goes to the table to see what's just arrived.

Jiro's hands, opening the box. Newspaper is packed around an object. Jiro pulls the paper away to reveal a dull-silver metal object.

Everyone peers into the box.

DAIKICHI
(impressed reaction)

Jiro gently lifts an extruded Duralumin flange from the box and examines it carefully.

SONE
It's perfect.

CHUKICHI
Yeah, I wish we'd had that a year ago.

KUBO
What do you think, Jiro?

JIRO
(happily)
Our next plane will be a full-grown duck, not a duckling.

SONE/KUBO/DAIKICHI/CHUKICHI
(laugh)

KUBO
A full metal duck.

SONE
Mr. Kurokawa, what do you think?

KUROKAWA
(takes the flange from Jiro)
I think it's quite a luxury to use extruded aluminum alloy.

KUROKAWA
(to everyone)
That's it. Back to work.

REEL 6

Dusk. Workers stream out the gate of the Mitsubishi plant on foot and bicycle. A car pulls through the gate. The windows are open. Hattori and Kurokawa are in the back seat.

KUROKAWA
(looking behind them)
The coast looks clear.

HATTORI
Okay, Jiro.

Jiro struggles up from his hiding place between Hattori and Kurokawa. Both men peer warily out of the car, like secret agents on a mission.

JIRO
(exhales with relief)

HATTORI
You should keep a low profile for a few days just in case.

HATTORI
We'll try to smooth things over.

KUROKAWA
I'll put you up at my house.

JIRO
But... can we stop by my apartment and check my mail?

HATTORI
(looks at Jiro intently)
Is it sensitive?

JIRO
Yes, it's very sensitive.

KUROKAWA
The police will be opening all your mail.

JIRO
It's from my fiancée.

Kurokawa's mouth opens in astonishment.

JIRO
(half to himself - indignant)
This is outrageous. Such things shouldn't happen in a modern country.

HATTORI
(bursts out laughing)
You're engaged?

HATTORI
(goes on laughing)

KUROKAWA
You're human after all!

HATTORI
I can't believe it!

KUROKAWA
I thought you would marry an airplane!

HATTORI/KUROKAWA/DRIVER
(laugh heartily)

JIRO
That's not funny.

KUROKAWA
(serious again)
Of course it's not funny. The police are waiting for you at your apartment. If they want to read your love letters, let them!

HATTORI
Jiro, we need you to re-focus on the fighter project.

HATTORI
That's why we sent you away to rest after the crash.

HATTORI
The company will do everything to protect you—

Jiro's indignant expression changes to concern as he realizes the seriousness of his predicament.

Kurokawa completes Hattori's words:

KUROKAWA
If you keep your mind on your work.

Jiro writes a letter with a fountain pen. The page reads:

JIRO (V.O.)
I can't bear being apart from you. Why do you suppose the police are looking for Mr. Castorp?

Jiro in his room at Kurokawa's house, seated before a low table. He stops his pen and looks into the distance.

JIRO (V.O.)
He left so suddenly.

Flashback. Jiro and Nahoko out for a walk at the resort. A car honks its horn. They turn to see Castorp flash by in an open car. He raises a hand in farewell. Nahoko waves back, followed by a slightly dazed Jiro (Castorp hadn't told them about his departure).

Jiro continues writing.

JIRO (V.O.)
I pray every day that he managed to leave Japan safely.

Night. From Kurokawa's garden, Jiro can be seen writing. MRS. KUROKAWA brings Jiro a cup of tea.

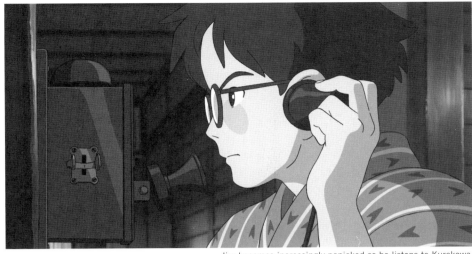
Jiro becomes increasingly panicked as he listens to Kurokawa.

Day. A telephone on the wall in a corridor of the house rings. Mrs. Kurokawa runs to the phone.

Jiro's room. Mrs. Kurokawa appears in the doorway.

MRS. KUROKAWA
Jiro, you have a telephone call.

Jiro is sitting at the table working on something.

JIRO
Coming...

Mrs. Kurokawa shows Jiro to the phone. The receiver is off the hook.

MRS. KUROKAWA
The telephone is there.

JIRO
Thank you, Mrs. Kurokawa.
(picks up receiver)
Hello?

Mrs. Kurokawa withdraws.

KUROKAWA (O.S.)
Jiro? It's me. You have a telegram.

JIRO
(numb)
Yes?

KUROKAWA (O.S.)
Your landlord received it two days ago and brought it here just now.

JIRO
Would you read it?

KUROKAWA (O.S.)
Now?

JIRO
Yes.

Kurokawa at his desk in the office.

KUROKAWA
"Nahoko... has had a lung..."

Close-up of the telegram.

KUROKAWA (O.S.)
"Hemorrhage. Satomi."

Jiro's vision of Nahoko's hemorrhage. Blood spills onto a canvas.

Nahoko on her hill above the reservoir in Karuizawa. Blood pours from her mouth onto the canvas.

Jiro is dazed. He stands holding the receiver.

KUROKAWA (O.S.)
Jiro? Are you still there?

JIRO
(mechanically)
Thank you. I have to go.

KUROKAWA (O.S.)
(as Jiro hangs up)
Jiro, wait...

Jiro hangs up and stands there stunned. Mrs. Kurokawa approaches him.

MRS. KUROKAWA
(concerned)
What is it?

On hearing her voice, Jiro comes to his senses.

JIRO
What's the quickest way to get to Tokyo?

MRS. KUROKAWA
Tokyo? Today?

JIRO
Yes. I have to be there as soon as possible.

MRS. KUROKAWA
Let me see. If you take the noon bus you can catch the express. I'll send someone to hold the bus for you. Go get your things.

JIRO
Thank you!

MRS. KUROKAWA
(walks off, calling her servant)
Jiya! Quickly!

Jiro dashes back to his room and begins changing frantically into street clothes. His eyes well up with tears. He's in such a hurry that he has difficulty buttoning his shirt. He tramples on his papers and falls over, but is in such a hurry that he doesn't care. He throws a few things into his briefcase.

The bus waiting at the bus stop. The conductor leans out the door impatiently. Jiro comes running and boards the bus. The door closes and the bus drives off in a cloud of dust. The elderly servant sent to hold the bus bows.

The express to Tokyo crosses an iron bridge.

Jiro sits in the open air on the steps of the car outside the passenger compartment. He works his slide rule and makes notations using his briefcase as a desk. Tears fall on the paper.

Jiro's tears flow freely. The wind blows them away. The express races toward Tokyo.

Evening, around nine p.m. Yoyogi-Uehara Station, Tokyo. A train pulls in. Jiro gets off and hurries toward Nahoko's house.

A large, Western-style residence. Jiro spots a light in a room looking out on the garden. He enters the front gate and makes his way where the French doors of the room face the garden.

Nahoko lies under a coverlet in bed, eyes are closed. She senses a presence and looks toward the garden. Jiro climbs the steps from the garden. He sees Nahoko, kicks his shoes off, and runs toward her.

Nahoko is surprised and overjoyed. He throws himself into her arms.

NAHOKO
Darling!

They embrace. She strokes his hair.

They kiss.

JIRO
I'm sorry I wasn't here sooner.

NAHOKO
(murmurs sadly)
You'll catch it.

JIRO
You're beautiful.
She shakes her head sadly (No, I'm not beautiful.)

JIRO
I love you.

She holds him tight. Her eyes fill with tears.

Satomi removes his shoes in the entryway as the head maid takes his hat and briefcase.

SATOMI
Jiro? Through the garden?

Satomi, now changed out of his street clothes, goes down the corridor toward Nahoko's room. He knocks on the doorframe, then enters the room.

NAHOKO (O.S.)
(laughs happily)
Come in, Father.

Nahoko sits on her bed. Jiro sits in a chair next to the bed.

NAHOKO
Look! Look who's here!
Jiro came all the way from Nagoya. But he has to leave right away.

Jiro stands and nods to Satomi.

JIRO
(to Nahoko)
I'll use the front door next time.

NAHOKO
The garden is faster.

JIRO
(gently)
Okay, the garden it is.

NAHOKO
(they touch hands)

Take care, darling.

JIRO
Sleep well.

SATOMI
I'll see you out.

The two men exit through the door to the garden as Nahoko watches them go.

SATOMI (O.S.)
You'd better hurry if you're going to catch the last train, Jiro.

Satomi and Jiro stand at the front gate.

JIRO
I wish I could look after her, Mr. Satomi. She looks so pale.

SATOMI
The last thing Nahoko wants is to be a burden to you. You'd better go.

Jiro bows and leaves. Satomi watches him go.

Nahoko sits on her bed looking down at her lap. The sound of Satomi's clogs from the garden. He enters.

SATOMI
Nahoko? Are you all right?

Satomi comes and sits in the chair next to Nahoko.

NAHOKO
I'm going to the sanatorium in the mountains. The one the doctor recommended.

SATOMI
But why? It's so far. You'll be there by yourself.

NAHOKO
Because I want to get better, Father. I want to have a life with Jiro.

Jiro walks through the dark neighborhood.

Morning. Jiro and Kurokawa hurry to meetings at Mitsubishi headquarters. Jiro is straight off the night train from Tokyo and his suit is wrinkled.

KUROKAWA
Just made it.
(O.S.)
The whole board is waiting.

The boardroom. Some directors read the Navy's specifications for its fighter competition for 1934. Others are arguing [The specifications for the aircraft, which

became the Mitsubishi A5M, called for a seemingly impossible combination of capabilities.] Hattori is present, and along with Kurokawa is looking very tense. Jiro seems confident and relaxed.

BOARD MEMBERS
(talking at once)

PRESIDENT
(to Jiro)
So, are you ready?

Jiro smiles dutifully and sits ramrod straight.

JIRO
I'll do my best.

Jiro and Kurokawa stride down the hall to another conference room.

KUROKAWA
Now the Navy. They're the client.

A group of naval officers argue over whether the specifications are appropriate. [At the time, there was little consensus within the Japanese Imperial Navy as to what sort of fighter was needed.]

NAVAL OFFICERS
(ad lib - arguing about the prime requirements for a fighter)

NAVAL OFFICER A
It needs more firepower!
More artillery!
More guns!

NAVAL OFFICER B
Speed! It must have speed!

NAVAL OFFICER C
It must look imposing! Threatening! Like a hawk!

JIRO
(same delivery)
I'll do my best.

Jiro and Kurokawa walk quickly down the corridor.

KUROKAWA
You weren't even listening.

JIRO
Nope.

Night. The design room. Jiro stands in front of an easel with a large sheet of tracing paper tacked to it. The paper is covered with calculations and da Vinci-like drawings of different airplane designs—wing sections,

landing gear, etc. The department is clustered around Jiro in a semicircle.

DESIGN TEAM
(hearty laughter)

JIRO
...so I gave up on that idea.

DESIGN TEAM
(laugh)

Kurokawa stands by the door with a dour expression. He'd like to participate but holds himself back—it's time for the new generation to show what it can do. Hattori peeks in.

DESIGN TEAM
(laugh)

HATTORI
Everyone's here rather late.

KUROKAWA
Jiro doing a review with the team.

HATTORI
(intrigued)
Oh?

The design team gazes up at Jiro with fire in their eyes, eagerly taking in every word he says. Jiro is in his element.

JIRO
I wanted this design to use the latest aeronautical advances. Take a look.

Jiro points to a sketch of retractable landing gear.

SONE (O.S.)
Retractable undercarriage!?

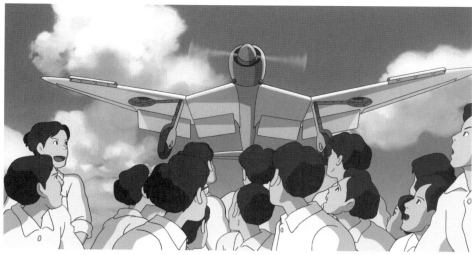

The design takes off into the air.

JIRO (O.S.)
It is built to reach two hundred and seventy knots.

DAIKICHI
That's five hundred kilometers an hour!

Kurokawa and Hattori, standing behind the circle, look astonished.

KUBO
I thought the Navy only asked for two twenty knots?

JIRO
(confident - smiling)
Two twenty will be obsolete by next week.

DESIGN TEAM (O.S.)
(chuckle)

JIRO
The wing load is one hundred and twenty kilos per square meter.

DESIGN TEAM
(impressed/surprised reactions)

JIRO
Minimal drag is the key...

JIRO (O.S.)
I pushed the design to the limits of technology.

A vision of a silver aircraft. Landing gear descend from the wings. The lines suggest Jiro's future Zero fighter, the Mitsubishi A6M.

The fighter's split flaps descend, changing the flow of air over the wings.

JIRO (O.S.)
With split flaps, and slats on the leading edges.

With slats deployed, the airflow at the wing tips moves smoothly over the wing.

The silver fighter flies over the heads of the design team. They turn to watch it fly slowly past.

A vast green landscape. The fighter flies low over the ground. Its entire skin is Duralumin. The resemblance to the future Zero fighter is striking.

A deep blue ocean. The fighter flies low, overtaking a destroyer and a torpedo boat that are trailing white wakes.

End of vision. The design room returns. The team is elated. A variety of reactions: laughing, talking, nodding, looks of resolve. Kurokawa is deeply impressed.

DESIGN TEAM
(excited buzz)
Whoah!

DESIGN TEAM
(excited buzz)
Come on! What's stopping us!?

JIRO
(thoughtful - looks at his calculations)
Well, weight becomes the big problem.

The room falls silent. The team looks expectantly at Jiro.

JIRO
(smiling)
We could always leave out the guns.

DESIGN TEAM
(laugh)

HATTORI/DESIGN TEAM
(laugh)

Kurokawa is silent, but deeply moved.

JIRO
So I decided to put this design on the shelf.

DESIGN TEAM
(various reactions: laughter, surprise, applause)

HATTORI
(to Kurokawa)
Too bad. Great idea.

KUROKAWA
(disappointed)
He nearly had it.

JIRO
(taking charge)
But we are not going to give up because our engines are underpowered. Instead we'll build a light, strong airframe.

JIRO (O.S.)
We'll cut every ounce of excess weight and minimize drag with a smooth skin.

JIRO (O.S.)
We're going to build an all-metal fighter, boys. Like nothing the world has ever seen.

The team erupts, excited.

DESIGN TEAM (O.S.)
(raise hands)
I have a question!
(etc.)
But how can we cut *more* drag?

JIRO
(holds up a hand for silence)
Mr. Hirayama, if you please.

HIRAYAMA leaves his place in the circle and faces them.

JIRO
Mr. Hirayama is our production engineer.

HIRAYAMA
(bows)
Thank you.

JIRO
He's going to tell us about the new rivets he's developing.

HIRAYAMA
I believe it is possible to match the strength of conventional rivets with rivets that are flush.

HATTORI
(whispers)
What is he talking about?

KUROKAWA
(whispers)
A new way to cut drag.

JIRO
We're going to skin the entire plane with flush rivets to make a nimble, fast aircraft.

DESIGN TEAM
(raising hands)
Question!
I have a question!
(etc.)

Hattori and Kurokawa walk down the dimly lit corridor outside the design room.

HATTORI
I must say, that was interesting.

KUROKAWA
It was inspiring.

Winter. A sanatorium at the foot of the Yatsugatake range in Nagano Prefecture. On the sun deck, TB patients are lined up on lounge chairs, wearing woolen caps and wrapped in blankets.

One of the patients is Nahoko. A nurse brings her mail.

NURSE
Today's letter, Miss Satomi.

NAHOKO
(takes the letter)
Thank you.

Under the blanket, Nahoko opens the envelope and starts reading the letter. Her face darkens with disappointment as she reads. Snowflakes begin swirling in the air. Her face appears from under the blankets. Her expression is sad. It starts snowing in earnest.

Dawn. The sky outside the sanatorium is cold and clear.

The main entrance. The door opens quietly and Nahoko steps out, dressed for cold weather. She closes the door softly and hurries away toward town and the train station.

The design room at Mitsubishi. The room is full of energy. Everyone is working hard.

Jiro reviews a drawing as a young engineer passionately explains his idea. An ASSISTANT approaches the desk.

ASSISTANT
Chief, you have a phone call.

JIRO
I'll call back.

ASSISTANT
I think it's an emergency.

The offices of the design department. Jiro is on the phone.

JIRO
Hello, Mr. Satomi. Good to hear from you.
(tensing)
Yes? What?

Dusk. Nagoya Station. Trains arrive and depart.

The passenger compartment of a train approaching the platform. People stand and gather their luggage to debark. Nahoko sits looking out the window, tense and expectant.

In the fading light, the train pulls slowly into the station. It stops and passengers debark, laden with luggage. Nahoko is the last off. She steps onto the platform as people stream by and looks uncertainly around her. She starts walking.

Jiro pushes through the crowd on the platform. He spots Nahoko and runs toward her, bumping into people going the other way. She sees him. They run into each other's arms.

NAHOKO
(face buried in his chest)
Jiro! Jiro!

JIRO
(takes her hands in his)
I'm here, now. I'm here.

He puts his arm around her.

JIRO
Are you all right? Can you walk?
(ALT)
Are you all right, my love? Can you walk?

NAHOKO
(smiles and nods)
Mm-hm.

JIRO
Come.

Jiro and Nahoko walk along the platform.

NAHOKO
I'm going right back. I just needed to see you.

JIRO
Don't go back.

She looks up at him with surprise. This is more than she hoped for.

JIRO
We should be together.

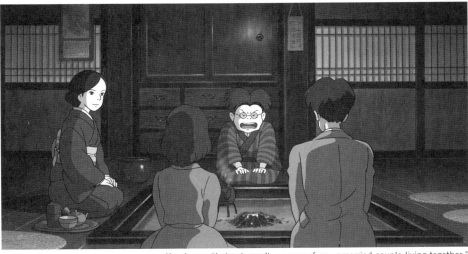
Kurokawa: "I simply can't approve of an unmarried couple living together."

Night. Nahoko and Jiro in a taxi heading for the suburbs.

The entryway of the Kurokawa residence. Jiro opens the door and steps inside, followed by Nahoko. He closes the sliding glass door.

Mrs. Kurokawa meets them in the entryway.

MRS. KUROKAWA
You must be Nahoko.

NAHOKO
(bows)
Pleased to meet you.

MRS. KUROKAWA
I'm glad you're here.

KUROKAWA
(joining them)
Jiro?

JIRO
Mr. and Mrs. Kurokawa, we have a request.

The main room of the residence. Nahoko and Jiro sit opposite Kurokawa, across a sunken hearth. A kettle steams over the charcoal. Mrs. Kurokawa sits to her husband's right.

KUROKAWA
Hmm...

MRS. KUROKAWA
(hands him a cup of tea)
We have plenty of room, dear.

KUROKAWA
(serious)
I know that we have the room! That's not the problem at all. I simply can't approve of an unmarried couple living together.

Mrs. Kurokawa smiles at Nahoko.

JIRO
We will marry tonight. Mr. Kurokawa, Mrs. Kurokawa—will you please be our witnesses?

KUROKAWA
(dumbfounded)
What!? Tonight!? We—!!

MRS. KUROKAWA
(interrupting)
We would be honored, dear! Nahoko was very brave to travel all this way to be with Jiro.

NAHOKO
(glances thankfully at Mrs. K)
My doctors know about this.
And my father has given his blessing.

JIRO
Please help us.

Kurokawa is stunned. His wife nods to the couple.

MRS. KUROKAWA
(to Mr. K)
The bride and I have work to do, and so do you.
(to Nahoko - standing up)
Come, Nahoko.

Outside the main room. Shadows on the shoji doors. The door opens and Mrs. Kurokawa steps out, followed by Nahoko.

MRS. KUROKAWA
(cheerfully but quietly)
Don't mind him, he's always like that.

In the main room the men are silent. Steam rises from the kettle. The clock's pendulum swings back and forth.

KUROKAWA

If you care about her at all, Jiro, you'll send her back on the morning train.

JIRO

I'd have to give up the fighter project, Mr. Kurokawa. Because I would go with her.

KUROKAWA

(sharply)
Is that your heart or your ego talking?
(ALT)
Is that your heart or your head talking?

JIRO

Nahoko doesn't have much time. We've made our decision.

Kurokawa is silent for a moment. He stands up.

KUROKAWA

I see.

KUROKAWA

(joyous resolve - almost shouting)
All right. On with the wedding!

Against a background of swirling snowflakes, Mrs. Kurokawa proceeds slowly along a connecting corridor, holding a lantern and followed by Nahoko, who wears an improvised wedding gown garlanded with flowers.

Kurokawa sees them approaching. He's holding a tray with a bottle of sake and a cup for the nuptial exchange.

KUROKAWA

Here they come.

Jiro waits in his room for the arrival of his bride. Kurokawa rushes in with the tray, closes the shoji door and takes his seat.

KUROKAWA

She's coming!

Mrs. Kurokawa and Nahoko approach the shoji door to the room. Mrs. Kurokawa kneels and slides open the door, holding the lantern.

MRS. KUROKAWA

Hear me. I bring to you a lovely maiden who has come from the mountains to be with her beloved. She has given up everything for him. What say you?

KUROKAWA

(nervous)
Hear me. The man I present is an insensitive chucklehead without even a home to call his own.

(nervous - he forgets to use the formal style)
If that's what she wants, come in.

MRS. KUROKAWA

Then they shall exchange vows.

She opens the door wider, revealing Nahoko.

Nahoko stands before Jiro in her wedding finery. He gasps, jumps up, and helps her over to their seats on the floor. Mrs. Kurokawa enters.

JIRO

(eyes misting)
You are beautiful.

Mrs. Kurokawa closes the door. Sake is poured into the nuptial cup. Nahoko slowly raises it to her lips and sips. She offers it to Jiro. He takes it and drinks the rest, not knowing the proper procedure. Nahoko rises and moves to sit before Mr. and Mrs. Kurokawa. She places her hands before her on the tatami, preparing to bow. Jiro hurriedly follows her example. Nahoko bows deeply before the Kurokawas.

Nahoko raises her eyes to the witnesses.

NAHOKO

Mr. Kurokawa, Mrs. Kurokawa. All Jiro and I have in this world is each other. I cannot thank you enough for letting us into your home. We will never forget our debt to you.

She bows again, hiding her tears.

MRS. KUROKAWA

Come now, there is no debt to repay.
We are both happy that you have found each other.
(touches Mr. K lightly)
Aren't we, dear?

KUROKAWA

(trying to hold back tears)
Yes... yes!
You're both very... brave. This is wonderful.

Clouds move through the night sky, lit by the full moon.

Jiro's room, seen from the moonlit garden. He closes the shutters.

Jiro and Nahoko's outer garments hang on a rack in the bedroom. Nahoko is already in her futon.

JIRO

You must be exhausted.

NAHOKO

This feels like a wonderful dream.
The room is spinning.

JIRO

Better get some rest, then.

NAHOKO

(gently)
Come here.

JIRO

But... are you sure?

NAHOKO

(throws back her futon)
Come here.

Jiro turns off the ceiling light and disappears out of frame.

A balmy autumn day. A bus moves along the same road Jiro and Nahoko took to the Kurokawa house.

Kayo on the bus. She's wearing a beret and has a package wrapped in cloth on her lap.

She signals the conductress that she wants to get off. She stands and looks out the window at the farmland passing by.

The bus stop. Kayo gets off the bus. It drives on. She starts walking.

REEL 7

Kayo sits alone by the hearth in the main room of the Kurokawa home. It is around eleven p.m.

She hears someone returning and turns. Jiro opens the door. He's carrying a large document tube, hat, coat, and briefcase. As he closes the door, he notices Kayo.

JIRO (O.S.)

Kayo!

KAYO

(completely steamed)
You're going to tell me you completely forgot I was coming?

JIRO

(coming into the room)
Yes. I... completely forgot... you were coming.

He sits down by the hearth.

KAYO
You're so insensitive.
(ALT)
I'm not surprised.
She bows formally. He returns the bow.

JIRO
Congratulations on finishing medical school.

KAYO
Congratulations on your marriage.
I came to thank the Kurokawas on behalf of the family.

JIRO
Are they still up?

KAYO
They've gone to bed.

JIRO
So you met Nahoko?

KAYO
Yes.

Angry, formality ends as Kayo exclaims:

KAYO
Jiro, what are you going to do!? She's alone in that room all day!

KAYO
You wouldn't know it because you come home so late! And she puts rouge on her cheeks in the morning so you won't worry!

KAYO
Nahoko's condition is much worse than you think, Jiro! I know because at school I've watched people...
(starts to sob)
She's my sister, now. And I really like her. How can you do this to her?

Jiro just gazes at her without answering.

KAYO (CONT'D)
Does she really have to stay here?

JIRO
Yes.

JIRO
Because each day is very precious to us now.

Kayo looks stricken as the implications of this sink in.

JIRO
Get some rest. We can talk more in the morning.
(beat)

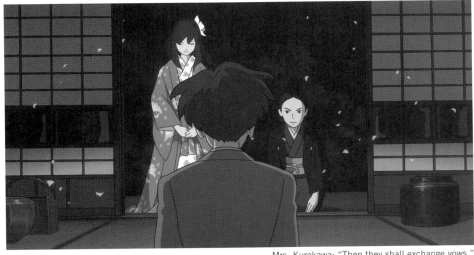
Mrs. Kurokawa: "Then they shall exchange vows."

I'm glad you're here.

He leaves her sitting by the hearth.

Nahoko lies in her futon in the darkened bedroom. She opens her eyes and looks toward the door. It opens. Light from the next room.

Jiro stands in the door.

JIRO
(softly)
I'm home.

NAHOKO
I must have dozed off.

JIRO
Go back to sleep.

He closes the door.

In the next room, Jiro is taking off his shirt. Nahoko enters and puts a robe over his shoulders.

JIRO
Oh please don't get up.

NAHOKO
I want to. Did you see your sister?

JIRO
Yes.

NAHOKO
(folding his clothes)
I like her a lot. Confident and strong. She's got such a bright future.
I told her I wanted her to be my doctor.

NAHOKO
And she brought me a gift from your mother. This nightgown and robe, see? She made it

for me.
(spreads her arms)
(happily)
I feel like a part of your family.

In the bedroom, Jiro puts a cloth over the light hanging from the ceiling. Nahoko is back in her futon.

JIRO
Is that too bright?

NAHOKO
(smiles)
No, that's fine.

A circle of light falls on the table next to the futon. Jiro sits at the table and extracts a sheaf of plans from the tube. He stares at them intently.

JIRO
I have to finish the design by tomorrow.

NAHOKO
Your mackerel bones?

JIRO
(laughs)
You remembered. I think I have a way to make it a bit lighter.

NAHOKO
Come a little closer.

JIRO
(moving the table closer)
Mm-hm.

Nahoko's hand appears from under the futon.

NAHOKO (O.S.)
Give me your hand.

Jiro puts his left hand in hers. She holds it tight.

NAHOKO
I like to look at you while you work.

Jiro uses his free hand to work the slide rule. He puts it down and jots some figures.

JIRO
In a contest for one-handed slide rule users I'd win first prize for sure.

JIRO
Look at that. I think I can make each rib half an ounce lighter.

NAHOKO
Really? That's good.

JIRO
Thirty ribs almost make a pound.

NAHOKO
See, I knew it.

NAHOKO
You work better when you're holding my hand.

Jiro is trying to concentrate, but Nahoko is making it hard for him.

JIRO
(jotting figures - murmurs)
You're right. If only I could leave my hand here for the test flight.

He looks at her and leans toward her suddenly. He gives her a kiss.

JIRO
I'll keep holding your hand. You should get some sleep.

NAHOKO
You won't let go?

JIRO
No. I won't let go.

Jiro works on his plans. Minutes pass in silence.

JIRO
I need a cigarette. Can I let go for a minute?

NAHOKO
No. Smoke here.

JIRO
It's not good for you.

NAHOKO
I don't care.

Jiro lights a cigarette with one hand and exhales a cloud of smoke.

Night. The Mitsubishi assembly plant. Two workers install rivets on Jiro's prototype fighter. The wing assembly is held in place with clamps. Honjo appears and strolls around the plane, inspecting it. Jiro talks to one of the workers as they peer at the undercarriage.

JIRO
Hey, Honjo.

HONJO
Can I take a look?

JIRO
Sure. I hear good things about your heavy bomber.

HONJO
It's not bad.

HONJO
(walking around the plane)
She's beautiful, Jiro. Like a work of art.

HONJO
(stroking the metal skin)
The infamous flush riveting.

HONJO (O.S.)
Feels a little rough.

JIRO
Yeah, we're still learning how to do it.

HONJO
You'll get it. You've already left the Germans behind. I'm still stuck with them.

HONJO
This design is classic Jiro, right down to the mackerel bones.

HONJO
Hey, pal. Is it all right if I use your flush rivets and that spring loaded hatch?

JIRO
Of course.

The two friends walk from the assembly building toward the design department.

JIRO
A redesign?

HONJO
Yeah. I wanted to redo the whole thing, but they'll only let me touch the fuselage.

JIRO
But what about the wings?

HONJO
That's what keeps me up at night. The wings still carry all the fuel. And I can't shield them because she has to fly over 1800 miles with a huge payload. We can't add even an ounce of weight.

A formation of Honjo's bombers. Each carries bombs on racks under the fuselage.

HONJO (O.S.)
So without a redesign, Japan's first advanced bomber only needs two or three hits and she'll burn like a torch.

In the air somewhere in China. Smoke rises from a bombing attack on a city. The formation of bombers approach the city. A swarm of Soviet-made i15 fighters attacks the bombers. A few tracer bullets strike the wing of a bomber. It bursts into flame and plunges earthward.

Jiro and Honjo walking side by side.

JIRO
Who are they going to bomb?

HONJO
China. Russia. Britain. The Netherlands. America.

JIRO
Japan *will* blow up.

The men reach the entrance to the building.

HONJO
We're not arms merchants. We just want to build good aircraft.

JIRO
You're right.

HONJO
(walking off)
See you, pal. I need to lie down.

JIRO
(going inside)
Sleep well, all right?

Jiro at his desk. The other engineers are heading home.

DESIGNER A
We're calling it a day, boss.

DESIGNER B
Good night, sir.

JIRO
Night.

Dusk. The cherry trees are blooming in the Kurokawas' garden.

Nahoko in her futon in the dim light of the bedroom. He sits quietly next to her.

She opens her eyes and smiles. She's lost weight.

NAHOKO
Welcome home.

JIRO
My plane's finished. Now we'll see how she flies.

NAHOKO
Congratulations. You've worked so hard.

He lies down next to her with his arm for a pillow.

JIRO
The oxen are taking her to the field now. I'll probably have to spend a few nights there.

NAHOKO
You must be tired, my love.

JIRO
(closes his eyes)
Just a little.

Nahoko strokes his face. He's dropping off already.

NAHOKO
I'm sure it will fly beautifully.

JIRO
Yes, she will.

He opens his eyes sleepily and gazes at her.

JIRO
I couldn't have done it without you here.

NAHOKO
I love you, Jiro.

JIRO
(drops off)
Nahoko...

The next moment he's asleep. Nahoko gently removes his glasses and puts them next to her pillow.

She moves her futon to cover Jiro. She lies on her side next to him and puts an arm over him.

Naoko: "I'm sure it will fly beautifully." Jiro: "Yes, she will."

Dawn. A team of oxen transport Jiro's prototype to the field. Jiro kisses Nahoko goodbye.

JIRO
I'm off.

NAHOKO
Good luck.

Jiro waves his hat to Nahoko as he heads off. Nahoko waves to him until he is out of sight.

The main room of the house. Mrs. Kurokawa and her staff are preparing a celebratory meal for the anticipated successful flight. Mrs. Kurokawa looks up to see Nahoko.

MRS. KUROKAWA
Nahoko. You're up.

Nahoko is wearing the same clothes she arrived in. Her coat and hat are on the floor beside her.

NAHOKO
Yes, I'm feeling much better today, Mrs. Kurokawa, so I thought I'd take a walk.

MRS. KUROKAWA
Be careful. Don't tire yourself out. It's a big day.

NAHOKO
I won't.

NAHOKO
The room's still a mess. But I'll straighten up when I get back.

MRS. KUROKAWA
All right. Kayo's coming today, you know. For her brother's celebration.

NAHOKO
Yes. I'll be back soon.

She picks up her coat and hat and goes out.

Nahoko steps out the front door. She closes the door quietly, puts her hat on, and walks out of the gate with her hands in her pockets and down the road.

A bus drives along the same road. Inside the bus, Kayo glances out the window and sees Nahoko. She leaps to her feet in surprise; Nahoko is quite far from the house. Nahoko crosses the road and disappears.

The entryway of the house. Kayo has just given Mrs. Kurokawa her report.

MRS. KUROKAWA
(pale - concerned)
Then please come in.

Kayo hurriedly steps out of her shoes.

Mrs. Kurokawa hurries down the corridor to Nahoko's room, followed by Kayo.

She throws the door open.

MRS. KUROKAWA
Oh no.

The room is tidy and neat.

Mrs. Kurokawa sinks to the floor. Kayo spots something in the next room.

Kayo finds three letters on the table, one each addressed to her, Jiro and Mrs. Kurokawa.

KAYO
She left letters! This one is for me.

Kayo takes the letter addressed to her from the envelope. She quickly scans the letter and turns pale.

KAYO
She says she's going back to the sanatorium! I'll find her!

Kayo rushes past Mrs. Kurokawa, still holding the letter. Mrs. Kurokawa is leaning against the door frame as if stricken by the situation. She calls to Kayo in a commanding voice.

MRS. KUROKAWA
No. Let her go.

Kayo stops and turns. She looks about to cry.

MRS. KUROKAWA
We shouldn't do anything until her train leaves.
(after a pause)
She wants him to remember her as she was.

Kayo looks torn. She runs off.

She dashes out of the house and looks down the road.

Kayo stands in the middle of the road holding Nahoko's letter.

KAYO
(brokenhearted sobbing)

The spring countryside passes by the window of a train.

Nahoko sits alone looking out the train window.

Jiro's fighter prototype on its test flight. It performs a perfect Immelmann turn. The spring landscape, cherry blossoms, and the Kiso River spread out below. The fighter is supremely airworthy. It climbs nimbly toward the clouds and emerges into the sunlight.

Jiro, Kurokawa, and Hattori watch from the ground along with the mechanics and design staff.

HATTORI
Wonderful. Just look at her—a true Japanese fighter.

Kurokawa turns to the timekeepers a few yards away and yells. Hattori turns to look at the timekeepers too.

KUROKAWA
What about speed? How did she do?

TIMEKEEPER
The numbers are off the charts! We're checking them again.

Jiro keeps looking at the sky.

HATTORI
(yells)
How fast!?

TIMEKEEPER (O.S.)
Two four oh.

KUROKAWA
(surprised)
Two forty!

Everyone except Jiro runs over to the timekeeper's table to confirm the results. Jiro watches as the fighter descends for landing.

The plane comes in for a landing.

Jiro's face shines with pride. He suddenly starts, as if someone whispered in his ear. He turns and looks behind him. [Note: It is a few days after Nahoko quietly left the Kurokawa residence. Jiro has a premonition of her death here.]

The fighter is over the strip. Jiro isn't watching—he's staring off into the distance. He seems dazed. The rest of the group runs past him toward the fighter, which is now on the ground. Everyone is overjoyed. Hattori looks up from the timing data and grins.

TEAM MEMBERS
(cheering, clapping)
Unbelievable!
Fantastic! We did it!
(etc.)

The team is throwing their hats in the air. Kurokawa runs up to Jiro.

KUROKAWA
Hey, Jiro!

Jiro doesn't respond. Kurokawa grabs his arm and turns him toward the plane.

KUROKAWA
Jiro.

The pilot strides rapidly over to Jiro. The staff gathers around them.

TEST PILOT
(shakes Jiro's hand)
She flies like a dream. Thank you.

Jiro smiles.

The team continues to cheer. Spring, 1935. Japan's first modern fighter is born.

1945. B-29s send contrails across the sky above a city ablaze.

Jiro's dream. A field covered with aircraft wreckage. A solitary figure picks his way through the wreckage.

Scraps of Duralumin protrude from the long grass. The grass waves in the wind.

Jiro walks slowly among the wreckage. He climbs a hill. The setting sun lights the clouds from below.

Caproni waits at the top of the hill. He turns and calls to Jiro.

CAPRONI
We meet again, Japanese boy.

JIRO
Hello, Mr. Caproni.

They stand together at the top of the hill.

JIRO
I remember this place.
This is where we first met.

CAPRONI
Yes. Our kingdom of dreams.

JIRO
Now it's the land of the dead.

CAPRONI
Not quite. In some ways, yes. But what about your ten years in the sun? Did you live them well?

JIRO
Yes. Things fell apart toward the end, though.

CAPRONI
That's what happens when you lose a war. There's your Zero fighter.

A vision. A swarm of Zero fighters flies across the plain. Caproni looks impressed. Jiro watches sadly. One of the pilots raises a hand. Jiro waves back. Caproni touches the rim of his hat.

The Zeros climb into a cloudless, deep blue sky. Thousands of planes stream past high above. The Zeros climb to join them.

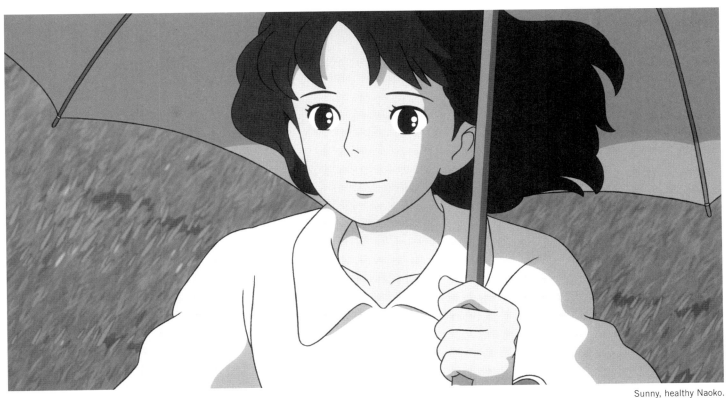
Sunny, healthy Naoko.

Jiro and Caproni watch them go. Jiro's hand falls to his side.

CAPRONI
Truly... a masterful design.

JIRO
Not a single one returned.

CAPRONI
There was nothing to return to. Airplanes are beautiful, cursed dreams waiting for the sky to swallow them up.

CAPRONI
Someone is waiting for you.

Caproni motions with his jaw. Jiro's gaze follows.

A woman with a white parasol walks toward them around the windswept plain. She gets closer—it's Nahoko. She's smiling and waving.

Jiro takes a step forward. The wind is blowing hard.

JIRO
(murmurs)
Nahoko...

CAPRONI
She's been waiting here a long time.

Nahoko looks young, beautiful, healthy. [Note: Jiro and Nahoko's marriage was a very short

one, just a few months from late 1934 to early 1935.]

NAHOKO
You must live, darling.

Clouds stream by in the strong wind. Jiro wants to run to her but seems unable to leave the spot where he's standing.

Nahoko seems to be swaying, flickering.

NAHOKO
You must live.

Jiro leans forward and nods again and again.

JIRO
(murmurs, acknowledging Nahoko)

Nahoko's face. She looks joyous and relieved. The wind blows her hair.

The wind carries her parasol into the air. A blue summer sky with white clouds.

Nahoko seems to fade away and unite with the wind.

The parasol lies on the grass. The wind tumbles it over and over. It grows smaller in the distance and disappears.

Jiro and Caproni look out over the plain. Clouds stream by.

CAPRONI
She was beautiful, like the wind.

Jiro's face is ecstatic, like a child again. He gazes in the direction where Nahoko stood.

JIRO
(murmurs)
Thank you. Thank you.

Shadows of clouds moving across the plain. Caproni beckons to Jiro.

CAPRONI
You must live, Jiro. But now, shall we drop by my house? I have some very excellent wine.

Together they walk down the hill and out of sight.

END

"Who Has Seen the Wind?"
by Christina Rossetti

Who has seen the wind?

Neither I nor you:

But when the leaves hang trembling,

The wind is passing through.

Who has seen the wind?

Neither you nor I:

But when the trees bow down their heads,

The wind is passing by.

The song Jiro hums while he is making his paper airplane when he is in Karuizawa. It is "Who Has Seen the Wind?" by English poet Christina Rossetti (1830–1894), translated into Japanese by poet and songwriter Yaso Saijo (1892–1970). It was published in the April 1921 issue of the fairy tale and nursery rhyme magazine *Akai Tori*.

"Hikoki Gumo"

Lyrics, Music and Performed by Yumi Arai
(EMI Records Japan)

A white sloping path runs up into the sky
A gently swaying, misty haze,
surrounding and holding
Unnoticed by anyone, all alone
Soaring upward
Not afraid of anything,
Dancing up

Longing to be in the sky
Speeding through the sky
A whole life, a vapor trail

Even before dying,
from that window, up high
watching the sky,
now no one understands
No one would understand
All they could think was…
"Too young"
Yet… happy

Longing to be in the sky
Speeding through the sky
A whole life, a vapor trail

Longing to be in the sky
Speeding through the sky
A whole life, a vapor trail

"Hikoki Gumo" is the title track from the first album by Yumi Matsutoya, Hikoki Gumo (1973/under the name Yumi Arai). It was the first track on side A of the LP and the last track on side B. Yumi Arai wrote the song when she was in high school, and in addition to her on the piano, the song features Masataka Matsutoya, Haruomi Hosono, Tatsuo Hayashi, and Shigeru Suzuki, members of Tin Pan Alley, as the backing band.

HIKOUKIGUMO
Lyrics : Yumi Arai
Music : Yumi Arai
©1973 by ALFA MUSIC, INC.

Credits

Studio Ghibli, Nippon Television Network, Dentsu, Hakuhodo DYMP, Walt Disney Japan, Mitsubishi, Toho and KDDI present

KAZE TACHINU (THE WIND RISES)

A Tribute to Jiro Horikoshi and Tatsuo Hori

VOICES

Hideaki Anno
Miori Takimoto

Hidetoshi Nishijima
Masahiko Nishimura
Stephen Alpert

Morio Kazama
Keiko Takeshita
Mirai Shida
Jun Kunimura

Shinobu Otake
Mansai Nomura

Katsuhiko Tamura	Teruo Seki	Yasuhiro Ohara
Masahiro Yoshino	Yasumasa Oba	Akiyoshi Sakurai
Tetsuro Ishibashi	Fumihiro Awano	Kazumasa Sagawa
Yuichi Saito	Tomonori Yanagibashi	Kensuke Komai
Akane Fujisaki	Haruka Shibuya	Ayako Umemura
Sascha	Berndt Otto	Mayu Iino
Kaichi Kaburagi	Taichi Umezawa	Maki Shinta
Kanako Takagi	Kentaro Takagi	

PRODUCTION STAFF

SUPERVISING ANIMATOR
Kitaro Kosaka

KEY ANIMATION
Takeshi Inamura	Akihiko Yamashita	Megumi Kagawa
Atsuko Tanaka	Kenichi Yamada	Eiji Yamamori
Kazuyoshi Onoda	Hiromasa Yonebayashi	Masafumi Yokota
Makiko Futaki	Hideaki Yoshio	Shogo Furuya
Atsushi Tamura	Taichi Furumata	Fumie Imai
Shunsuke Hirota	Satoko Miura	Akiyo Okuda
Katsuya Kondo	Shinji Otsuka	

Kazuhide Tomonaga	Kiyotaka Oshiyama	Yoshimi Itazu
Hideki Hamasu	Sachiko Sugino	Tsutomu Awada
Hiroomi Yamakawa	Shinya Ohira	Hiroyuki Aoyama
Atsuko Otani	Hiroko Minowa	Michiyo Suzuki
Masaaki Endo	Kazuki Hoshino	Takeshi Honda

ANIMATION CHECK
Hitomi Tateno

IN-BETWEEN / CLEAN-UP ANIMATION
Rie Nakagome	Akiko Teshima	Mayumi Omura
Masaya Saito	Alexandra Weihrauch	Katsutoshi Nakamura
Mariko Matsuo	Makiko Suzuki	Kaori Fujii
Minoru Ohashi	Shinichiro Yamada	Moyo Takahashi
Asami Ishikado	Megumi Higaki	Masako Akita
Masayo Ando	Yui Osaki	Emi Ota
Yasumi Ogura	Naoko Kawahara	Sachiko Kunitake
Misa Koyasu	Kengo Takehana	Emi Tamura
Shoko Nagasawa	Tomoyo Nishita	Yoshie Noguchi
Shiori Fujisawa	Yui Matsuura	Asako Matsumura
Naoya Wada	Miki Ito	Misaki Kikuta
Yuko Tagawa	Mitsuki Chiba	Yeefeng Chan
Ryosuke Tsuchiya	Yuka Matsumura	Yojiro Arai

Seiko Azuma	Sumie Nishido	Kiyoko Makita
Yayoi Toki	Keiko Tomizawa	Hisako Yaji
Maya Fujimori	Mariko Suzuki	

Kumiko Tanihira	Yukari Yamaura	Mai Nakazato
Masami Nakanishi	Masakiyo Koyama	Akane Otani
Ayaka Saito	Yukari Furiya	Rie Eyama
Kumiko Terada	Kaori Ito	Yu Okuwaki
Setsuya Tanabe	Shotaro Imai	Natsumi Kan
Ayano Sugai	Naoki Fuchigami	Ryuji Iwabuchi
Ryuichi Yamauchi	Tatsumasa Shirota	Hirofumi Yamada
Haruyasu Watanabe	Shuichi Onda	Taichi Sato

SUPPORTING ANIMATION STUDIOS
Anime Torotoro	Studio Takuranke	Nakamura Production
Telecom Animation Film	Studio Khara	

ART DIRECTOR
Yoji Takeshige

BACKGROUNDS
Noboru Yoshida	Takashi Omori	Yumi Ishii
Shiho Sato	Yoichi Nishikawa	Yoshikazu Fukutome
Mitsuo Yoshino	Kikuyo Yano	Sayaka Hirahara
Ryoko Ina	Naomi Kasugai	Masako Nakazato

Tatsuya Kushida	Satoko Nakamura	Yuka Nitta
Ayae Kanbe	Sadaaki Honma	Kiyoshi Sameshima
Yoichi Watanabe	Yuxuan Liu	

HARMONY TREATMENT
Noriko Takaya

COLOR DESIGN
Michiyo Yasuda
COLOR SETTING
Kanako Takayanagi Fumiko Numahata
COLOR SETTING ASSISTANTS
Kazuko Karube Yukie Tamura Yuki Kashima
DIGITAL INK AND PAINT CHECK
Misato Aita

DIGITAL INK AND PAINT
Hiromi Takahashi	Naomi Mori	Rie Kojo
Hiroaki Ishii	Junya Saito	Eiko Matsushima
Takeshi Nakamura	Yuki Komatsu	Tomoya Shinmi
Nana Takei		

Yukiko Kakita	Kumi Nanjo	Akiko Shimizu
Yoshimi Shibata	Natsumi Watanabe	Natsuko Inohara
Yuina Iizuka	Ritsuki Miyamoto	Kotaro Beppu

SUPPORTING DIGITAL INK AND PAINT STUDIO
T2 Studio / Kentaro Takahashi

DIRECTOR OF DIGITAL IMAGING
Atsushi Okui

DIGITAL CAMERA AND COMPOSITE OPERATORS
Junji Yabuta Atsushi Tamura Hidenori Shibahara
COMPUTER GRAPHICS
Norihiko Miyoshi Miki Umezawa Yoichi Senzui
SPECIAL EFFECTS
Keiko Itogawa
PROGRAMMERS
Masafumi Inoue Shun Iwasawa

SUPPORTING DIGITAL CAMERA AND COMPOSITE OPERATORS
Assez Finaud Fabric.
Atsuko Okui Kanae Ouchi

SOUND DESIGNER / SOUND RE-RECORDING MIXER
Koji Kasamatsu

DIALOGUE RECORDING DIRECTOR
Eriko Kimura

DIALOGUE RECORDING ENGINEER
Hajime Takagi
DIALOGUE RECORDING ASSISTANT ENGINEER
Shuji Suzuki
FOLEY ARTIST
Mika Yamaguchi
ASSISTANT TO SOUND DESIGNER
Reiji Kitazato
SOUND EFFECTS PRODUCTION
digitalcircus
RE-RECORDING STUDIO
Toho Studios Post-Production Center
TECHNICAL SUPPORT
Fusako Kitagawa
TECHNICAL SUPPORT ASSISTANT
Daisuke Yokoyama
VIDEO PLAYBACK OPERATOR
Hideho Kikuchi
STUDIO COORDINATOR
Sadaaki Nishinoo Chiaki Tachikawa
CASTING
Ryuji Hayashi Takuro Okada
SOUND PRODUCTION SUPPORT
Tohokushinsha Film Tokyo T.V. Center
Toho Studios Toho Studio Service Nichion

CONDUCTOR, PIANO
Joe Hisaishi
MUSIC PERFORMED BY
Yomiuri Nippon Symphony Orchestra, Tokyo
MUSIC RECORDING ENGINEER
Suminobu Hamada
MUSIC RECORDED AT
Tokyo Metropolitan Theatre Victor Studio
MUSIC PRODUCTION
Wonder City
Maki Fujisawa Yasuhiro Maeda Akiko Suzawa

SONG
"Das gibt's nur einmal"
LYRICS BY
Robert Gilbert
COMPOSED BY
Werner Richard Heymannn
©1931 by Universal Music Publ. Group Germany
POETRY RECITAL
"Who has seen the wind?"
ORIGINAL POEM BY
Christina Rossetti
JAPANESE TRANSLATION BY
Yaso Saijo (Nippon Columbia)

EDITING
Takeshi Seyama
EDITING ASSISTANTS
Rie Matsubara Hiromi Sasaki

LINE PRODUCER
Tamaki Kojo
PRODUCTION DESK
Yumiko Miyoshi
PRODUCTION ASSISTANTS
Kenji Imura Takao Sakamoto Kyohei Ito
Mine Shibuya Emi Gunji
ASSISTANTS TO THE DIRECTOR
Ryosuke Kiyokawa Shintaro Nakazawa

PRODUCTION MANAGER
Shinsuke Nonaka
PRODUCTION ADMINISTRATION
Taisei Ishiseko Toshiyuki Kawabata Daisuke Nishikata
Tetsu Shinagawa Minako Nagasawa Yoichiro Kugimiya
ASSISTANTS TO THE PRODUCER
Nobuko Shiraki Chieko Tamura Yoko Ihira
Shuhei Tadano Chiaki Okuda
PRODUCER IN TRAINING
Nobuo Kawakami
PUBLIC RELATIONS
Shin Hashida Setsuko Kurihara Nozomu Ito
Yumiko Nishimura Chihiro Tsukue Kazumi Kobayashi
MERCHANDISING DEVELOPMENT
Tomomi Imai Koichi Asano Mika Yasuda
Naomi Atsuta

PUBLISHING MANAGER
Yukari Tai
PUBLISHING
Hisanori Nukada Chikashi Saito Kyoko Hirabayashi
Yuri Morita Masumi Takakura
SPECIAL EVENTS
Kazuyoshi Tanaka Kan Miyoshi Ryoko Tsutsui
Kenzo Ochiai Takayuki Aoki Ayano Fujiwara
Noriko Takami

PERSONNEL MANAGER
Yuichiro Mochizuki
STUDIO ADMINISTRATION
Miyuki Shimamiya Hisayo Ito Satomi Sasaki
Tamami Yamamoto Hiroyuki Saito Yukiko Miyasaka
Natsuki Ebisawa Miyuki Ishii Saori Uchida
Yuko Nomura Ryuhei Yamazaki Tokuko Sato
Masahiro Suzuki Tomomi Hagihara Maho Honobe

Hikari Hayama Sueko Numazawa Masako Fujita
Kiyoko Tsuge Keiko Kido Shunichi Iwasaki
Tsuneo Sawai

FINANCE MANAGER
Noriyoshi Tamagawa
ACCOUNTING
Takayasu Ito Akio Ichimura Satoshi Otsuka
Hiromi Ito Junko Ito
CORPORATE DEVELOPMENT
Kazumi Inaki
SYSTEM MANAGEMENT
Noriyuki Kitakawachi Yugo Hayashi Shoji Makihara

OVERSEAS PROMOTION MANAGERS
Geoffrey Wexler Mikiko Takeda
OVERSEAS PROMOTION
Nao Amisaki Evan Ma Noriko Tsushi
Satoko Takano

AUDITOR
Hirotaka Nakao

With Gratitude to Tadao and Nobuko Horikoshi

SPECIAL THANKS TO
Makoto Abe Kaku Arakawa Tomoe Iijima
Fumiko Isomae Miyuki Ito Shinsaku Ueda
Hitomi Ueno Yoshito Oyama Tomoko Okada
Koichi Katsushima Hiroshi Kadowaki Osamu Kawada
Seigo Kimata Kana Kimura Naho Kimura
Takeyasu Koganezawa Ai Kodama Hideaki Kobayashi
Jiro Koyasu Nobue Saito Yoshichika Sakamoto
Toshikazu Sato Yuki Sato Taketoshi Sado
Masahiro Shinoki Yasuhiro Suzuki Mami Sunada
Seiichiro Sekine Tadashi Setomitsu Hideo Tanaka
Michiko Nagai Atsuhiko Nakata Satoshi Nakano
Keiko Niwa Yoshiyuki Hatori Yasuhisa Harada
Takashi Hiraoka Takahiro Hirao Haruna Hirose
Tomomi Fukao Tadahiro Hoshi Satoshi Matsushita
Hiroshi Miyashita Naoya Moritani Masaki Morita
Maiko Yahata Hiroki Yamamoto Keizo Yoshikawa
Katsuhiko Yoshida Norifumi Yoshida Kenichi Yoda
Monthly Magazine Model Graphix

PROMOTIONAL SPONSOR
KDDI

SPECIAL MEDIA SUPPORT
Lawson The Yomiuri Shimbun

ADVERTISING PRODUCERS
Akito Takahashi Tomoko Hosokawa

ADVERTISING
Kenichi Arao Saori Ueda Rieko Matsuki
Yukari Nishikawa Yukio Shinohara Genji Sakai
Kazue Tsukagoshi Yukari Nomura
Masaru Yabe Michiyo Koyanagi Mieko Hara
Hiroshi Yajima Hiroyuki Orihara Aya Maruyama
Hajime Murata Aki Tsutagawa Shoichiro Saito
Fumino Watanabe

FILM PREVIEW PRODUCTION
Keiichi Itagaki

"THE WIND RISES" PRODUCTION COMMITTEE
Nippon Television Network
Yoshio Okubo Hiroshi Watanabe Tomoko Jo
Suzuko Fujimoto Hiroko Miyazaki Nana Keneshima
Naoki Iwasa Naoto Hatakeyama Mayumi Hirakata

Dentsu
Tadashi Ishii Yoshio Takada Toshihiro Yamamoto
Yutaka Ishikawa Shuichi Machida Ryuichi Ikeda
Akitoshi Maeda Misato Kamei

Hakuhodo DY Media Partners
Hisao Omori Akio Kobayashi Yoshikuni Murata
Michio Yamamoto Toshihiro Komatsu Madoka Hosoya
Masato Tachibana

Walt Disney Japan
Paul Candland Takayuki Tsukagoshi Masami Takahashi
Koji Kishimoto Yuko Muranaka Yukio Yamashita
Hidetaka Kokubu Ayako Dan

d-rights
Daizo Suzuki Toru Itabashi Toshiya Takasaki
Kino Arai Asako Hio

Toho
Hideyuki Takai Yoshishige Shimatani Satoshi Chida
Minami Ichikawa Shimpei Ise Taichi Ueda
Hikaru Onoda

KDDI
Makoto Takahashi Toshitake Amamiya Takashi Suga
Koichi Kawakami Masako Yano Shingo Niori
Jun Okabe San Kim Takahiro Kishi
Takahiro Hirato

ASSOCIATE PRODUCERS
Seiji Okuda Ryoichi Fukuyama Naoya Fujimaki

DIGITAL LAB
IMAGICA
 DATA CONFORM
 Naoto Hosonuma
 DATA MANAGEMENT
 Sho Ogoshi
 COLOR MANAGEMENT
 Wataru Matsumoto Toshiki Yura
 DIGITAL CINEMA MASTERING
 Mizue Yamada Takafumi Yano
 LAB COORDINATION
 Yuriko Sato
 LAB MANAGEMENT
 Kazunori Nagasawa

THEME SONG
"Hikoki Gumo"
LYRICS, MUSIC AND PERFORMED BY
Yumi Arai
(EMI Records Japan)

MUSIC
Joe Hisaishi
(Original Soundtrack Album / Tokuma Japan Communications)

PRODUCTION
Koji Hoshino Studio Ghibli

PRODUCER
Toshio Suzuki

ORIGINAL STORY AND SCREENPLAY WRITTEN AND DIRECTED BY
Hayao Miyazaki

THE ART OF
THE WIND RISES

Based on a Studio Ghibli Film by Hayao Miyazaki

English Adaptation/Jocelyne Allen
Design & Layout/Yukiko Whitley
Copy Editor/Rebecca Downer
Editors/Nick Mamatas, Michael Montesa
Sr. Editorial Director/Masumi Washington

Printed in China

Published by VIZ Media, LLC
1355 Market Street, Suite 200
San Francisco, CA 94103

First printing, April 2014

Visit www.viz.com